THE
WOUNDED
STORYTELLER

This book is dedicated to my parents,

with love, NGF

THE WOUNDED STORYTELLER

*The Traumatic Tales of
E. T. A. Hoffmann*

Translated by
Jack Zipes

Drawings by
Natalie Frank

Foreword by
Karen Russell

Yale University Press
New Haven and London

Published with support from the Fund established in memory of Oliver Baty Cunningham, a distinguished graduate of the Class of 1917, Yale College, Captain, 15th United States Field Artillery, born in Chicago September 17, 1894, and killed while on active duty near Thiaucourt, France, September 17, 1918, the twenty-fourth anniversary of his birth.

The publisher gratefully acknowledges the support of Richard J. Massey Foundation for Arts and Sciences as well as that of Kathleen and Chris Loughlin.

yalebooks.com/art

Library of Congress Control Number: 2022944809

ISBN 978-0-300-26319-0

A catalogue record for this book is available from the British Library.

This paper meets the requirements of ANSI/NISO Z39.48-1992 (Permanence of Paper).

10 9 8 7 6 5 4 3 2 1

Jacket illustrations by Natalie Frank

CONTENTS

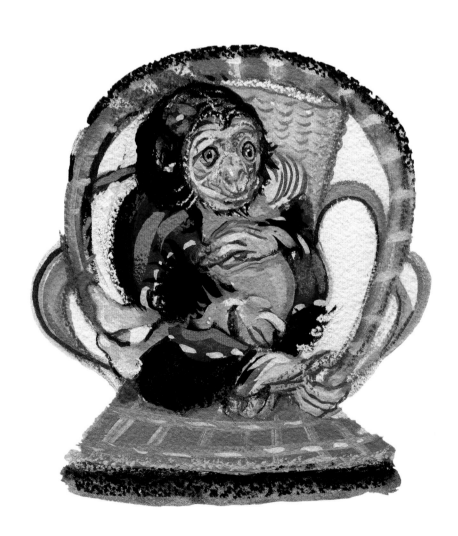

FOREWORD

Influence is mysterious—we're so rarely aware of who or what is moving the levers inside us. When Natalie Frank first asked me if E.T.A. Hoffmann was an influence on my work, I sheepishly admitted that I was not familiar with these tales. But as I read them, I realized that I was wrong; I had a strong sense of déjà vu from the very first line. I felt like I was doing dream-genealogy, filling in a high branch on the family tree. He is one of the great-grandfathers of my imagination, and probably yours, too.

There are the influences we claim—the ones we are conscious of, the teachers we seek out. And then there are people like E.T.A. Hoffmann, the nineteenth-century German Romantic writer, composer, and artist whose visions were so powerful they spread across every continent and discipline, and continue to circulate among us. Hoffmann's influence turns out to be everywhere, and like pollen generalized in the atmosphere, it often goes undetected. His uncanny tales have been so thoroughly assimilated into popular culture that he now exists in what the Italian folklorist and fabulist Italo Calvino called "the mute and anonymous molds of thought."

Reading him, I found myself continuously astonished by how far his voice has carried, echoing through the works of Stephen King and William Blake; Gogol and Poe; Joy Williams's *The Changeling* and Octavia E. Butler's *Parable of the Sower*; the erotic feminist fairy tales of Angela Carter and the ecological utopias and world-multiplication of Ursula K. Le Guin; the female automata in Philip K. Dick's *Do Androids Dream of Electric Sheep?* and the humanoid Cylons in *Battlestar Galactica*; the soulless shell of Donald Sutherland in *Invasion of the Body Snatchers* and the fugitive wisdom of the children in *The Night of the Hunter*; David Lynch's doppelgängers and Jordan Peele's *Us*; and the scariest episode of *Black Mirror*, in which a sadistic programmer traps replicas of his colleagues' consciousnesses in a virtual world that he controls.

As renowned fairy-tale scholar and translator Jack Zipes laments in his excellent introduction, "E.T.A. Hoffmann, the Wounded Storyteller": "Paradoxically, in the western world, Hoffmann is celebrated mainly at Christmas, as the author of the 'sweet' glistening ballet *The Nutcracker and the Mouse King*. However, the ballet was not based on Hoffmann's story, but on Alexandre Dumas père's adaptation." In the original version, the horror comes not only

from seven-year-old Marie's blood-red battle with a tyrannical rodent king—certainly terrifying in its own right—but from its aftermath. Her retelling of this experience is dismissed by everybody in her family as "nonsense," and Marie is left alone to defend the reality of what she survived, and remembers. I recently described the unruly darkness and leisurely strangeness of Hoffmann's fairy tale to a friend who is a soloist for the New York City Ballet; he laughed in shock and said, "Wow, I guess Balanchine really shifted the emphasis to the sugar plums."

The transmission of a nightmare down the centuries can take many forms. Even if you believe that you are new to the works of E. T. A. Hoffmann, these stories know you. If you have ever been the child who feels so alone with what she knows; the bumbler whose "buttered bread always [falls] to the ground on the buttered side"; the wanderer who hears a secret song in the woods; the idealist who struggles to be taken seriously; "the gracious reader" meeting a story on its own terms, then you will find yourself in the enchanted mirror of this book.

You might meet here, as I did, one of the secret authors of your dreams.

An advocate for the imagination, Hoffmann was also a rigorous investigator and philosopher. His fairy tales always foreground the potency of the perceiver, often via direct address to his readers. Hoffmann treats the reader not as a story's passive recipient but as its cocreator. His narrator frequently asks us to electrify the world of a story, to perform its haunting music in the symphony halls of our minds, and to simulate stupendous events inside our bodies; he pauses midtale to thank us for our efforts.

"Gracious reader," he implores us, "your active imagination, for the sake of Anselmus and me, will have to be obliging enough to enclose itself for a few moments in the crystal. You are drowned in dazzling splendor, and everything around you appears illuminated . . ."

A story is also a kind of experiment, a counterfactual that reveals truths about people and the world. The scholar John Tresch describes the ways that fantastic literature and the positive sciences during this period "traced the same journey in opposite directions," linked in "a dialectic of doubt and certainty." Although they use different tools of discovery, both evince "a restless hunger for reality that [is] bound up with skepticism." As Tresch notes, "Science's desire for certainty puts everything—even the testimony of the eyes—into question."

Hoffmann asks the same questions of reality in a different register. Can we be certain we *didn't* hear a bell-like voice in the woods? Was that sublime midnight vision merely a symptom of exhaustion, intoxication? How do we know that the netherworld revealed by the "feeble glimmer" from a candle is any less real than Marie's childhood bedroom on a Tuesday morning, or the Linke Tavern that is Anselmus's *Cheers* bar in Dresden? By suspending an uncanny

hesitation between possibilities, Hoffmann plunges his readers into a state of epistemic humility. Like Elis in "The Mines of Falun," watching the "walls of rock [grow] as transparent as pure crystal," we are jolted by the mutability of self and world, and by the limitations of what we can know about either. Stories like "The Sandman" and "The Golden Pot" relentlessly call the testimony of the senses into question. As readers, we go tap-tapping along, just as we do in life, testing the ground beneath our feet, listening for the ring of truth versus the hollow note. Hoffmann's fantastic fiction reminds us that we are always making up the world through the hearsay of our senses, while treating seriously the longing for and possibility of transcendence.

If the children in Hoffmann's tales emerge scathed but victorious from their battles with cruel adults and rodent kings, witches and gnomes, their souls scarred, but their faith in themselves and their imaginations intact, the adults do not often fare as well. If enough people tell you that what you see and feel is not real, you might end up like poor Nathaniel in "The Sandman," flinging yourself from the top of an ontological waterfall. Time and again, characters like Anselmus, Nathaniel, and Elis wonder if what they are experiencing is actually occurring in consensus reality or only unfolding in their own minds. It is a difficult test to run in-house, without controls. A test that ends tragically for Nathaniel in "The Sandman" and Elis in "The Mines of Falun," and one that leads to new beginnings for children like Marie and adults like Anselmus, who learn how to travel between the world of noonlight in Germany and the spirit realm without getting lost in either.

Do these challenges sound familiar to you? To me, they seem like problems we all face, transposed to a higher octave and played on an alien instrument. Your grumpy boss and future father-in-law turns out to be the Prince of the Spirits of Atlantis. Your tutor is actually a sadistic gnome who can attack you in the body of a terrifying fly. Your beloved is a green snake, not to be confused with the transparent white serpent that gluts on your blood and moonlights as a door knocker.

Meaningfully, in Hoffmann's tales, these eruptions of the fantastic occur in a Germany that follows rules we recognize. A world where rent comes due and abusive bosses freak out over minor mistakes and children annoy their parents. Even the wildest stories feature cash-strapped families and everyday struggles. A good day for Anselmus is a day when he doesn't lose a button. Actions have important and often irremediable outcomes. When Nathaniel leaps from the tower at the conclusion of "The Sandman," the fall kills him. Yet, in Hoffmann's fusion of naturalism and fantasy, Nathaniel's shattering fall against the stones is described with the same fidelity as the towering blue flames and red-hot tongs of the diabolical Coppelius. The pooling blue eyes of Serpentina are painted with the same numinous brushstrokes as the golden waves of the

Elbe River. We begin to see the mystery that is always present with us, to which we so easily become inured. In these five tales, "the world of fantasy" and "the world of reality" commingle. Hoffmann challenges that precarious binary, asking in both Dresden and Atlantis: What is true? What is possible? He reminds us that, at any moment, another reality might pierce the one to which we've grown accustomed, overtaking it and changing it forever.

As the narrator of "The Sandman" tells us, "The miraculousness and strangeness of [Nathaniel's] life filled my entire soul, and for this very reason, my dear reader, I had to make you just as inclined to tolerate the uncanny, which is no small matter."

There is something that feels musical to me about Natalie Frank's drawings, the way a single breath can soar up to hold a piercing note and then plummet to an underworld octave. In every drawing, I feel Frank's openness to the elements. Her thrilling instinct for alchemy, spontaneity, and subversion at work in collaboration with Hoffmann, her hands guided by his sorcerous prose in a kind of public seance to which we are invited. Like Hoffmann, she effaces the boundary lines, levitating between the natural and the supernatural, figuration and abstraction. Frank doesn't sketch first. As she told me, "When I read the stories, a clear image comes to mind from the text and then I compile images based on photographs I take of people I cast as the characters. I combine this with found photography of environments. Then I carve up space and lay in figures and build."

By mixing materials in unexpected ways, layering gouache and chalk on paper instead of canvas, Frank's drawings develop a paradoxical mix of density and lightness. They feel to me like exhalations of dream, with a powdery quality that makes them seem endlessly mutable, made of shifting sands that might rearrange themselves beneath a strong breath. They are spring-loaded with potential energy. Wide-awake and restless, not sleeping like certain paintings. At any moment it seems as though Anselmus might smash through the crystal, or the comically wide-eyed bats might stretch the violet membranes of their wings and fly off. Olympia, the singing automaton who ultimately destroys Nathaniel's fragile ability to distinguish between inner and outer reality, has one of the most realistic and nuanced faces of any of Frank's subjects. My own eyes were permanently unsettled by this drawing, toggling between two realisms: the taupe flesh and warm-blooded expressivity of Olympia's face, lit from within, and the exposed clockwork below her chest, the looming double in submarine blue. Frank's work is full of such incredible visual echoes of Hoffmann's doppelgängers and inversions. The viewer plays an active role in animating the shadowy interlopers that flit around these drawings' edges. They seem to grow

more definite the longer you stare at them, flames solidifying into form under a long, wondering gaze.

The individual body parts that Frank draws are characters in their own right. Hands capture the viewer's attention in Frank's drawings—hovering on laps, clutching at a throat, casting spells over a cauldron. They are fleshy doppelgängers, almost bloated in the foreground, as if brooding on future actions or swelling with potential, equally capable of evil or good, a slap or a caress. Eyes are winged with lashes and perched inside of chests. Like Hoffmann, Frank has a gift for dramatizing the roiling world of perception just under the waterline of consciousness and below the neck. Eyes have a special autonomy, migrating between worlds, looking inward and outward, seeing beyond appearances, into the ultraviolet. In one wonderfully perverse drawing, an eye opens up in the libidinal shadows between Marie's legs. Frank reminds us that Hoffmann's children are alert to deep and dark truths (the adults often feel like somnambulists by comparison). The children's eyes in the drawings for "The Mystifying Child" are particularly moving to me, mutely crying out to us with their horror, rapture, suffering, and wisdom. Frank's art feels charged with the wild, androgynous "child spirit" that moves through (and often materializes within) Hoffmann's stories.

Hoffmann writes with great lucidity and good humor about the challenge of converting experience into language. Even the strangest of stories, he tells us, is an underestimation of life's strangeness. Words in a row can feel so flat-footed and shallow, ill-matched to the radial detonation of action and to those secret and fast-moving realms within us. Natalie Frank translates Hoffmann's tales back into something closer to their original idiom. She conjures the streaming simultaneity of being onto paper: memory, sensation, emotion, and imagination collide in deltas of swirling color. So many tonalities coexist in one frame, rearing off the page. Serpentina's magical, erotic world overlaps with the claustrophobia of Anselmus's imprisonment in a Dresden office. (Serpentina, as rendered by Frank, is a gloriously subversive fusion of Eve and the serpent—she does not lead Anselmus out of paradise, but into it.) Secret symmetries inside the drawings begin to make their own meaning, to weave together in a tale that can be apprehended in one glimpse, if never fully comprehended.

Hoffmann famously originated the idea of the doppelgänger, and this book is structured as groupings of reflected, drawn marginalia, laced with thirty-five full-page drawings of five of his tales: "The Golden Pot," "The Sandman," "The Nutcracker and the Mouse King," "The Mystifying Child," and "The Mines of Falun." Startling juxtapositions occur both within and between drawings—one of my favorites is the hair-raising doubling of Anselmus and the serpent door knocker, which seems to quiver holographically between comedy and horror.

I wonder if E.T.A. Hoffmann had a presentiment that Natalie Frank would one day channel his tales into her art. This passage from "The Sandman" makes me think he might have anticipated this book you hold in your hands, and cheered at the sight of Frank's drawings, which perform the longed-for miracle he describes: "In response, you may have endeavored to draw the picture in your mind, in all its glowing colors, in all its light and shade, and you may have tried to find just the right words to begin. . . . If you had first drawn an outline of the internal picture with a few daring strokes, like a bold painter, you might have easily painted the layers of color brighter and brighter, and the living throng of various shapes would have carried your friends away with it. Then they would have seen themselves, like you did in the picture that your mind had generated."

Madness, I'd venture, does not always come from the nightmare, the terribly private encounter. Madness often begins at dawn, when you wake up and discover that your nightmare is invisible to everyone around you.

Jack Zipes describes Hoffmann as a "wounded storyteller," a special kind of wounded healer, someone whose stories teach us how to listen to nature, who knows that no wound can heal if we pretend it's not there. A story can be a mirror of its author's trauma, but it is not only that. The "wounded storyteller" is a kind of alchemist, capable of taking the strong life-wish that helped him survive ridicule and failure, hunger and pain, rejection and abandonment, and using it to power an imaginary cosmos, bringing hidden realms not just to light but to life. We've been trained to discount happiness in fiction as sentimental dreck, to our own detriment, I think. Atlantis in "The Golden Pot," the emerald fairy realm of the Mystifying Child, the "sparkling Christmas forests" far from Marie's family's bourgeois home—these utopias can strike the jaded adult reader as escapes from reality, instead of encounters with possibility. If we can remember how to travel to these places alongside Hoffmann's children—how to escape the bottles in which we've imprisoned ourselves—we return to our lives changed. With seedlings, inklings, inspiration. New ideas and their substrate, hope.

One of the happiest surprises in the "The Mystifying Child" occurs near the story's conclusion, when Felix and Christlieb transmit their conviction in the golden light of the "fairy realm" to their mother, who responds: "I don't know why I feel compelled to believe in this story of yours today, nor how my believing in it seems to have taken away all my sorrow and anxiety. Let us continue on our way with confidence."

When I was four or five years old, I froze on the stairs that led down to our backyard. A large oil slick of a snake was sunning itself on the middle step. My parents were seated within earshot but out of sight, chatting under the yellow

patio umbrella that suddenly felt a thousand miles from where the snake and I were regarding one another. I wondered what it saw. I thought I could probably jump over it, but the snake began moving in unpredictable ways, changing size and hue, tasting the air very close to my bare toes. Its body shivered from green to black to silver. I called for my parents, who told me not to be silly. They believed (not without reason) that the snake lived in my imagination, present to me but invisible to everybody else. "Come on down! There's no snake!" But I was hypnotized with dread, watching the snake contracting on the redbrick middle step. Everything was honey slow and hibiscus bright—it was a summery sort of dread, this being Miami. I didn't so much hold my ground as surrender to my terror. Eventually, my Dad came to check on me, and I watched his irritation melt into a kind of awed surprise: "Damn, Jan. She was telling the truth. There *is* a snake up here . . ."

I'm a mother myself now, with a two-year-old daughter and a five-year-old son who spend most of their daylight in a land of make-believe. This can get exasperating at four A.M. when I am on Nightmare Patrol in our house, checking their closets for monsters and ghosts. I am sure I'd have my parents' exact reaction to the green snake. Who wants to get up in hundred-degree Floridian heat to fact-check a kid's delusion? Yet, this story has endured perversely in the memory of our family. My Dad is particularly troubled by it; he loves to retell it. He is a kind and sensitive man, very much in the spirit of Hoffmann, and to this day he still apologizes to me: "You were *right*. There really was a snake."

The years pass and its meaning goes on shifting. Now we think it must have been a garter snake, very common in South Florida, and entirely harmless. That is surely what it was, the limbless dragon I saw on a July morning—or was it?

When I read Hoffmann's tales alongside Frank's drawings, I am transported back to that threshold on the stairs. They return me to that rapt state that is neither belief nor disbelief but swings between the two, a pendulous interior movement. It crosses and connects them—doubt and certainty, fear and hope, terror and wonder, all coiling together. What will happen if I take the next step? Will the snake strike or disappear? What is possible? What is true?

"Do make an effort to recognize the well-known forms that hover around you even in ordinary life," implores the narrator of "The Golden Pot." "You will then find that this glorious kingdom lies much closer than you ever supposed."

—Karen Russell

INTRODUCTION

E.T.A. Hoffmann, the Wounded Storyteller

Jack Zipes

The past need not stay silent. It wants to speak. Sometimes we try to dismiss it because of the wounds we have suffered. However, a more effective way to bury past disturbing events is to confront them with stories. This is the great accomplishment of Ernst Theodor Amadeus Hoffmann.

There are many historical German writers of folktales and fairy tales—far more than the Brothers Grimm, who were and still are significant because they were gifted artists who knew how to bring the past into the present through the power and style of their extraordinary writings. Sometimes, as is the case with Hermann Hesse, their tales have lost appeal because the ideas and conflicts they depict do not concern or touch us anymore. Such tales fade and become fond memories of "once upon a time." Since these once-popular works do not cry out to us, we return to them basically to satisfy nostalgia.

This is not at all the case with regard to E.T.A. Hoffmann and his works. His fairy tales have been called sick, weird, marvelous, queer, strange, horrific, dark, senseless, upsetting, and frightening. Never enlightening. Yet, writers, musicians, dramatists, artists, and filmmakers have been drawn to Hoffmann's tales, and—because they have found something vital in them—adapted them for stage and screen. It is as if their strangeness holds some therapeutic value. Some of these creators have come close to grasping the uncanny elements of Hoffmann's works, perhaps because they have suffered as he has. In this vein, one can look to Maurice Sendak, who was known to be equally wounded and subversive, as one of the only writers successful in adapting Hoffmann's stories for children. For the most part, these stories are too complex and shocking for a young audience. Sendak was but one among many major writers and poets who were influenced by Hoffmann; others include Iginio Ugo Tarchetti, Edgar Allen Poe, Charles Baudelaire, Nikolai Gogol, and Charles Dickens, proving the ability of his work to inspire as well as unsettle.

Paradoxically, in the western world, Hoffmann is celebrated mainly at Christmas, as the author of the "sweet" glistening ballet *The Nutcracker and*

the Mouse King. However, the ballet was not based on Hoffmann's story, but on Alexandre Dumas père's adaptation of Hoffmann's tale and set to music by Pyotr Ilich Tchaikovsky and choreographed by Marius Petipa. The disturbing trauma that is at the core of Hoffmann's story is generally wiped out, or perhaps I should say "smoothed over." If any musician has come close to understanding the essence of Hoffmann's writing, it is Jacques Offenbach and his opera *The Tales of Hoffmann* (*Les contes d'Hoffmann*, 1881).[1] Offenbach had seen the play *Les contes fantastiques d'Hoffmann* (The eerie tales of Hoffmann), written by Jules Barbier and Michel Carré, and he later collaborated with Barbier to adapt three tales ("The Sandman" ["Der Sandmann," 1816], "The Cremona Violin" [known in German as "Rat Krespel," 1819], and "The Lost Reflection" [known in German as "Die Abenteuer der Silvester-Nacht," 1815]) for his opera, which he sadly did not see because he died in 1880 before the premiere. The opera is dazzling, for the music and plot explore both Hoffmann's suffering and his inability to fulfill his dreams of love and love of poetry. He constantly defeats himself. There is no happy end, and Offenbach's exquisitely mysterious music, I believe, captures Hoffmann's despair.

In his perceptive and groundbreaking study *The Wounded Storyteller*, Arthur W. Frank states: "This book presents ill people as wounded storytellers. I hope to shift the dominant cultural conception of illness away from passivity—the ill person as 'victim of' disease and then recipient of care—toward activity. The ill person who turns illness into story transforms fate into experience; the disease that sets the body apart from others becomes, in the story, the common bond of suffering that joins bodies in their shared vulnerability."[2]

Though Frank does not deal precisely with trauma, it is clear from his use of the words *illness* and *disease* that he is discussing the traumas some people experience. Many people are struck by inexplicable or devastating occurrences that torment them throughout their lives, and storytelling provides one of the most effective means of asserting agency. Frank states: "As wounded, people may be cared for, but as storytellers, they care for others. The ill, and all those who suffer, can also be healers. Their injuries become the source of the potency of their stories. Through their stories, the ill create empathic bonds between

1. I should mention that recently the brilliant Russian filmmaker Stanislav Sokolov has directed a film called *Hoffmaniada* (*Gofmaniada*, 2018), which captures the essence of Hoffmann and his tales. In this full-length puppet animated film, Sokolov, similar to Jacques Offenbach, portrays a traumatized Hoffmann as an artist seeking recognition and love. However, unlike the wounded Hoffmann in Offenbach's opera, the protagonist in *Hoffmaniada* is able to heal his illness in an unusual ending.
2. Arthur W. Frank, *The Wounded Storyteller: Body, Illness and Ethics* (Chicago: University of Chicago Press, 1995), xi.

themselves and their listeners. These bonds expand as the stories are retold. Those who listened then tell others, and the circle of shared experience widens. Because stories can heal, the wounded healer and wounded storyteller are not separate, but are different aspects of the same figure."[3]

Hoffmann's storytelling may have had roots in his own traumas, and it is clear that he became a healer for those willing to listen to and read his poignant tales. He endured an unhappy childhood that stayed with him for most of his life, but he channeled those disturbances, as well as the many other misfortunes that he encountered, into art. In my opinion, this is why Hoffmann's tales still have such a powerful effect. If Hoffmann is significant today—and he clearly is—it is because he was greatly concerned about the treatment of children and their marginalized place in society. This concern is at the heart of his contemporary appeal to readers throughout the world, when the rights of children are subject to the whims of their adult caretakers or varying policies set by individual governments.

In 2012, Elisabeth Young-Bruehl, an American psychoanalyst, published a remarkable study, *Childism: Confronting Prejudice against Children*, which may help us approach and understand the essence of many of Hoffmann's tales. Young-Bruehl's major thesis is clear and simple: "People as individuals and in societies mistreat children in order to fulfill certain needs through them, to project internal conflicts and self-hatreds outward, or to assert themselves when they feel their authority has been questioned. But regardless of their individual motivations, they all rely upon a societal prejudice against children to justify themselves and legitimate their behavior."[4]

Given this widespread prejudice, adult decisionmakers often act against children even while trying to advocate in their interest. In other words, our society sets up an authoritarian relationship toward children, dictating what they should learn and how they should behave, sometimes dismissing their needs and wants and disregarding their developmental capacities. We govern their education and growth. To a greater or lesser degree, we are all guilty of childism, and Young-Bruehl argues for the necessity of using terms such as *childism* and *childist* so that we can more consciously overcome our prejudices. However, she does not provide solutions to childism—because there are none. Consequently, we all carry the traumas of our own childhoods with us into the adult world.

The diverse kinds of traumas that children experience include being spurned, terrorized, isolated, exploited, corrupted, or denied an emotional re-

3. Ibid., xii.
4. Elisabeth Young-Bruehl, *Childism: Confronting Prejudice against Children* (New Haven: Yale University Press, 2012).

sponse. Such mistreatment can determine a child's development and later behavior as an adult; this can also hamper the individual unless he or she at some point develops an awareness of childism's effects. In Hoffmann's case—and I do not intend to psychoanalyze him and his works—it is clear that he experienced severely traumatic episodes in his youth and beyond. One just has to read his letters, notes, and diaries, which were gathered by friends and researchers during and after his life. These wounds played a powerful role in both his writings and his relations with other people. In fact, Hoffmann worked through many of the problematic aspects of childism in his writing and music. We can never fully rid ourselves of the traumas we endure during the civilizing processes, but we can choose to confront the causes of our traumas and use our imaginations to transform those traumas into art in order to survive in the world.

Before I examine how trauma plays an enormous role in the five tales in this present volume, I want to briefly review the trajectory of Hoffmann's life and career to demonstrate that his writing assumed a form of coping with hardship. Moreover, I want to argue that his writing so resonates because childism and the trauma of youth is a universal experience. Indeed, none of us can entirely avoid experiencing trauma during the civilizing processes that demand and enforce obedience and loyalty to arbitrary laws and traditions. We are all groomed by our parents and society, and that guidance has the potential of molding us into automatons or causing us to become ill, something that Hoffmann sought to reveal in the stories "The Sandman" and "The Mines of Falun" ("Die Bergwerke zu Falun," 1819). What is, however, more drastic about his writing is that he uncovers just how horrific "normal" society is. Most of the young people in Hoffmann's works desire and imagine a dreamlike future, an artificial paradise, but their futures are dictated by banal, sociopolitical expectations and demands that drive them mad. Though Hoffmann eventually became a member of the ruling class in Berlin, he was never happy in this position, and at the time of his death, he was still trying to expose the injustices that young people had to tolerate.

Hoffmann was born on January 24, 1776, in the city of Königsberg (now Kaliningrad, Russia) to cousins, Christoph Ludwig Hoffmann and Luisa Albertine Doerffer. The marriage was an unhappy one. Before Hoffmann was born, his parents had two other sons. The first died, and the second was eventually taken away by the father when the couple separated in 1779. Thereafter, Hoffmann's father and surviving brother were completely absent from his life.

Although we do not know for sure how traumatic this separation was for Hoffmann, there is a great amount of evidence indicating that he suffered from it. This may be why the father figure, often portrayed as an omniscient advisor, ghost, bogeyman, or devil's emissary, pervades his writing. Whatever the case may be, Hoffmann's early childhood was defined not only by the absence of

his father but by the strict monitoring of his early education by an extensive Doerffer family. After being abandoned by his father, his mother returned to her family home, a dysfunctional household run by her domineering mother, two strange aunts, and an incompetent uncle. Hoffmann's mother suffered from depression and virtually relinquished her son to her own mother's care and did not develop an affectionate relationship with him.

Hoffmann was unhappy living with the Doerffer family and immersed himself in music and writing. He was an excellent student of jurisprudence and passed his first law examinations at sixteen. By March 1800, he passed a second set of exams with honors and was assigned a post as state official in Posen, a small provincial city in Poland about two hundred miles east of Berlin, that had become part of Prussia. Hoffmann broke all relations with the Doerffer family and lived a convivial bachelor's life for a while, enjoying what little cultural activities there were in Posen.

By 1802, he married Maria Thekla Michaelina Rohrer, whom Hoffmann called "Mischa." She came from a middle-class Polish family. Despite her limited education and Hoffmann's infatuation with other women, he remained devoted to her for the rest of his life. Soon after this marriage, he lost his job after becoming embroiled in a scandal stemming from his comical sketches of aristocratic Prussian officers. He was reassigned to the tiny town of Plock (now called Plozk) in the Polish provinces in punishment. To survive the dearth of culture in his new surroundings, Hoffmann threw himself into the study of the great composers; this was yet another trauma that nevertheless furthered the development of Hoffmann's artistic career.

In 1804, Hoffmann found some reprieve after obtaining a governmental position in Warsaw, which was under Prussian control. Content and fully immersed in the musical culture of a major city, he composed a *Singspiel* called "The Merry Musicians" ("Die lustigen Musikanten," 1804). His family life also saw some momentary joy as Mischa gave birth to their daughter, Cäcilia. Sadly, this brief period of satisfaction came to an end when the French invaded the city after Prussia joined the allies in their battle against Napoleon. Hoffmann lost his position as a result, and he sent his wife and daughter to Posen to stay with Mischa's relatives while he tried to make a living in Warsaw.

By the middle of August 1807, Hoffmann, already depressed, learned of the death of two-year-old Cäcilia. After struggling with unemployment and even lacking for food, Hoffmann made a radical shift, pursuing a career in music. He was appointed director of the music theater in the small city of Bamberg, in southern Germany, and by the fall of 1808 he moved there with Mischa. Hoffmann started writing short stories, and his first tale, "The Knight Gluck" ("Ritter Gluck") was published in 1809. He supplemented his living by giving music lessons to the children of wealthy families and in 1811, he became in-

fatuated with one of his students, Julia Marc, a thirteen-year-old singer. His obsession with her became public and caused a great scandal, forcing him into itinerancy once more.

In 1813, Hoffmann took the position of conductor for an opera company in Leipzig and Dresden. In the ensuing period, he finished his opera, *Undine*, in collaboration with his friend Friedrich de la Motte Fouqué, who wrote the libretto. This period also saw the publication of two volumes of short stories, *Fantasy Pieces* (*Fantasiestücke*, 1814), and his most famous fairy tale, "The Golden Pot" ("Der goldene Topf," 1814). However, Hoffmann's disagreements with the opera company's leadership led to his dismissal after sixteen months, leading to another period of difficulty and dire financial straits.

When Hoffmann and Mischa moved to Berlin in September 1814, he learned that his fantasy stories and fairy tales had been extremely well received by literary circles throughout Germany, and for the next eight years until his death in 1822, he attained the status of a minor celebrity. It was in this period that he completed two novels, *The Devil's Elixirs* (*Die Elixiere des Teufels*, 1815-16) and *Tom Cat's Views on Life* (*Lebensansichten des Kater Murrs*, 1820-22), and he published "The Nutcracker and the Mouse King" ("Nußknacker und Mausekönig," 1816) and "The Mystifying Child" ("Das fremde Kind," 1816) in two volumes, *Children's Fairy Tales* (*Kindermärchen*, 1816-17), which included stories by Fouqué and Carl Wilhelm Salice Contessa. In this most prolific period of his career, he collected his fairy tales, novellas, and fantasy stories in two volumes with the title *Night Pieces* (*Nachtstücke*, 1815-17), and in four volumes with the title *The Serapion Brothers* (*Die Serapionsbrüder*, 1819-22).

Hoffmann began to hold weekly salons with luminaries of the romantic movement in Germany, including Fouqué, Contessa, Adelbert von Chamisso, Ludwig Tieck, Clemens Brentano, and David Ferdinand Koreff, as well as the famous actor Ludwig Devrient. Hoffmann depicted the members of this group fictitiously in *The Serapion Brothers*, and it is clear that he drew on his own life experience as well. When his opera, *Undine*, was finally performed in 1816, he had reached the pinnacle of his fame, and he freely offered social commentary. Yet, the year 1819 marked the beginning of a period of right-wing censorship that dominated Germany until the 1848 revolutions. Hoffmann was not a radical and had indeed been appointed by the King of Prussia to a commission to investigate subversive activities after the end of the Napoleonic adventure. Political liberalism, French sympathies, support of Napoleon, local nationalism, and many other areas of thought and action all fell into the category of subversion. Hoffmann, who refused to take part in what he saw as the suppression of free thought, then became the target of high-profile political recriminations that affected him profoundly.

His final story, "Master Flea" ("Meister Floh," 1822), was a satirical por-

trayal of the Berlin Commissioner of Police that served as Hoffmann's last laugh at the corrupt bureaucracy that he had so loyally served. Yet, by this time he was suffering greatly from atrophy of the liver and degeneration of the spinal marrow, and he died soon afterward at the age of forty-six on June 25, 1822.

Hoffmann lived a life full of traumas—large and small. The American Psychological Association has indeed categorized trauma as an emotional response to a terrible event, such as an accident, loss of a child, or death of a loved one. Trauma can also be a response to any event a person finds physically or emotionally disabling, threatening, or harmful. One of the best definitions of *trauma* can be found in Christa Schönfelder's study *Wounds and Words: Childhood and Family Trauma in Romantic and Postmodern Fiction*: "The definition that I use as a starting point is that of trauma as a profoundly distressing, painful, or shocking experience that affects the individual so deeply as to cause a disruption in, injury to, or breach within the structures of the mind and psyche and that, as a result, may have a persistent impact on an individual, especially regarding his or her relation to identity, memory, and the social environment."[5]

Hoffmann's many traumas include his abandonment by his father when he was three years old, his strict upbringing, the stress placed on him by his family to become a lawyer, the scandals ensuing from his love affairs, multiple job losses, the shocking death of his daughter Cäcilia, and the public attacks he drew as a liberal judge in Berlin. Each of these emotional wounds seem to have impelled Hoffmann to respond to these events continually through his art. As soon as he was settled in Berlin during 1814 and felt secure in his position at the supreme court, he flourished as one of the foremost romantic writers in Germany, not because of his eccentricity but because his imagination and skill as a writer and an artist allowed his own catharsis to resonate with his readers. Hoffmann's best stories and novels were published between 1814 and 1822, a comparably stable period in his life when he could contemplate and express his feelings without fearing his life might come apart. With a sense of ironic humor, Hoffmann consistently employs child figures to contest the "childism" of his times. His innocent, intelligent, and talented protagonists speak back to the adults who are preventing them from reaching their potential. Conversely, his adult characters seek to crush the children's imaginations and control them. All the protagonists in these tales exhibit extraordinary talents as would-be poets who endeavor to understand the world through their imaginations, not through reason. They are romantic "heroes" and "heroines" par excellence. Moreover,

5. Christa Schönfelder, *Wounds and Words: Childhood and Family Trauma in Romantic and Postmodern Fiction* (Zurich: Transcript Publishing, 2013): 20-21.

the women are depicted as courageous figures of love who have the power to heal the male protagonists living almost on the brink of insanity. None of the women in Hoffmann's tales are stereotyped.

In the five tales presented here, some of the protagonists are tragically overcome by their traumas, while others regain a sense of themselves and find happiness. We cannot be sure that this happiness will last in a society in which it is normal to deprive young people of agency. The fantastic conflicts in all five tales reflect Hoffmann's concern for young people and how resistance to what is considered normalcy and propriety is the key to survival.

In "The Golden Pot," Anselmus, the university student, who is about twenty years old, does not seem to have parents upon whom he can rely. They are simply absent, echoing Hoffmann's own circumstances. He is a bumbling, innocent, gifted student, but is traumatically torn apart throughout the narrative by the conflicts between the provocative Lindhorst, who supports Anselmus's artful talents, and the ugly old witch, Liese, who is more or less an agent of philistinism and tries to solidify his relationship with the social climber Veronica. In the end, Anselmus finds the strength and courage to resist conformity and manages to make his way to Atlantis, thanks, of course, to his father figure, Lindhorst, whose daughter Serpentina will liberate him from a superficial society. If there is any hope in Hoffmann's story, it is represented by Serpentina, who is a symbol of utopia.

In the tragic fairy tale "The Sandman," we are introduced to another student, named Nathaniel, an amateur writer of novels and stories, through letters that inform the reader of his traumatic childhood. Once again, we see echoes of Hoffmann's own biography: his father dies during Nathaniel's childhood, and his helpless mother does not play much of a role. Instead, his friends Clara and Lothar, her brother, representing the sensible and stable world of the bourgeoisie, seek to nurse him back to his good senses, especially after Professor Spallanzani and the wicked Coppelius exploit him and make him part of a humiliating experiment, pretending that their automaton, Olympia, is a real human being. Driven crazy by his own hallucinations and exploitation by Spallanzani and Coppelius, Nathaniel tries to kill Clara, but she is saved by her brother. Sadly, in the course of his fit, Nathaniel falls from the tower to his death. In this tragic story, Hoffmann demonstrates how too much imagination can lead to delusion. In other words, managing trauma through storytelling can turn deadly if one does not learn to master his or her skill. In this respect, Clara is his only hope, but her love for Nathaniel is not strong enough to save him, for he cannot see and grasp what is happening to him. Here, the question of sight and insight is linked to the question of imagination. Because Nathaniel, like Anselmus, is blind to the factors that impact him, he is driven to madness. The tragedy unfolds when these protagonists lose control of their own narratives.

"The Mines of Falun" brings a similar end to the young sailor Elis Fröbom, who returns from a long voyage only to discover that his poor mother has died and his home is occupied by nasty strangers. Since his father had already died, he has no place to go and he thinks about suicide. As is usual in many of Hoffmann's tales, the young man meets a stranger, an old miner named Torbern, who says to him: "You must have suffered a profound disaster, young man, if you wish to die just when life should really be starting for you." This man is, in fact, a legendary figure or ghost, who convinces Elis to become a miner and give up the sea. That is, the old man seems to help Elis overcome a traumatic event in his life, as do Pehrson Dahlsjoe, the owner of a mine, and his daughter, Ulla. Elis works hard to impress the girl and her father. He is determined to find his role in life as a miner, but Torbern demands complete devotion to the queen of the underground treasures. As a result, Elis is more or less punished for wanting to live a normal life, and his death is similar to that of Nathaniel's in "The Sandman." Like Nathaniel, Elis fosters an imagination that veers into delusions that distract him from overcoming the traumas of his past.

In contrast to "The Mines of Falun" and "The Sandman," "The Nutcracker and the Mouse King" ends on a joyful note, even though the seven-year-old Marie must actually fight against her mother and father, her brother, Fritz, and Godfather Drosselmeier, who cast doubt on all that she experiences during Christmas time. In fact, after Marie injures herself while watching Nutcracker fight Mouse King, and later, while she is recuperating from a journey to fairy realms with Nutcracker, Marie is disturbed by the way her family treats her. As a result, Hoffmann writes: "Marie did not dare say anything more about her adventures. But the memories of that fairy realm were unforgettable, and the lovely music of that delightful happy country still rang sweetly in her ears. Whenever she allowed her thoughts to dwell on all those glorious days, she would envision them again, and so it came about that, instead of playing as she used to do, she sat quiet and meditatively absorbed within herself. Everybody found fault with her for being such a little dreamer. This is the name that they called her." In this case, Marie manages to survive the mockery of her family by living her life as a fairy tale. Typical of many of Hoffmann's heroines, she represents the imaginative spirit of hope that enables her to rebel against traumatization. In this spirit, she later weds the nephew of Drosselmeier with her imagination intact.

This is also the case in "The Mystifying Child." Without the power of their imagination, that is, without the power of seeing through art, Christlieb and Felix would have led a paltry life and succumbed to the pressure of pretentious mercenary teachers and upper-class relatives. Their imagination is vital for their well-being—their imagination defeats the horrid tutor and instills a love not only for nature but also for all material objects. Despite the death of

their father and the subsequent forced abandonment of their small estate, the children keep faith in their imagination. To be a dreamer in this tale, like Marie in "The Nutcracker and the Mouse King," is a positive attribute and provides hope that the children will have a role in determining their futures.

In the tales published in this collection, as in Hoffmann's wider body of work, there is an impetuous element in his style and plots that emphasizes art as a life-and-death matter. In this, we see a complete devotion to the make believe—and to making his readers believe that life without devotion to art was deplorable or meaningless. In particular, he rejected the homogenization of children and instead celebrated the imagination. Clearly, he wanted to point his readers to alternatives, and he especially sought to encourage young people to take control of their own stories.

Hoffmann was by no means the eccentric that many academics try to make out of him. He was a profound thinker, avant-garde in all that he attempted, and hence suspect in the eyes of the established social classes in Germany. His concepts of insanity, genius, music, hypnotism, dream, and aesthetic theories are all what we would define as modern. He was a man ahead of his times, an aesthete, but not a man without a sense of justice and compassion. As a matter of fact, one might argue that his idea of society and justice was so fine and ideal that his experiences with real society and justice as a lawyer and judge "sickened" him, caused the duality and conflicts, both in his life and in his writings—a yearning for a place in bourgeois society and a detestation of the banal conditions, morals, and ethics of this very same bourgeois society, not to mention aristocracy. Hoffmann dreamed of an earthly paradise, a utopia, in which man as *homo ludens* might work and create (free from repression) the kind of happiness that we associate with beauty and the sublime. The man or woman who risks his or her life for the sublime in the age of banality—this is the Hoffmann protagonist—and all his works leave us with hope that we can overcome the trauma in our lives without harming young and old, even if doing so goes against society's expectations.

A WORD ABOUT THE TRANSLATION

Hoffmann's tales and novels are somewhat difficult to translate because he switches styles, moods, grammar, and forms without providing transitions and explanations. In the twentieth and twenty-first centuries, however, there have been a number of excellent translations of his works, mostly by British writers, and at times, I have consulted them when I was baffled by what Hoffmann was expressing. Otherwise, I have tried to "modernize" the language of the tales in standard American English. In some cases, I have kept German names and expressions to try to retain the original settings and moods of the tales. The one major title change I made is "Das fremde Kind," which is usually translated as the "The Strange Child." Since the child is not simply strange, but somewhat baffling, I opted for "The Mystifying Child," which, I believe, better describes the child, who is much more than strange.

—*Jack Zipes*

The
Stories

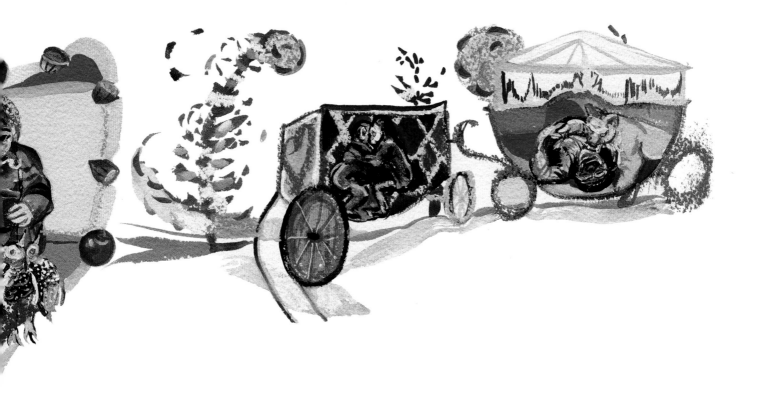

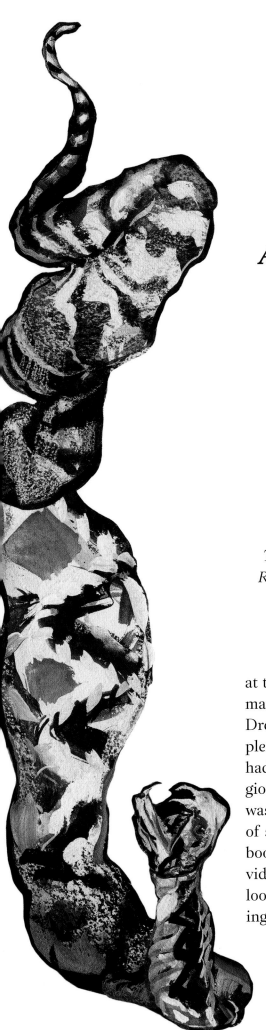
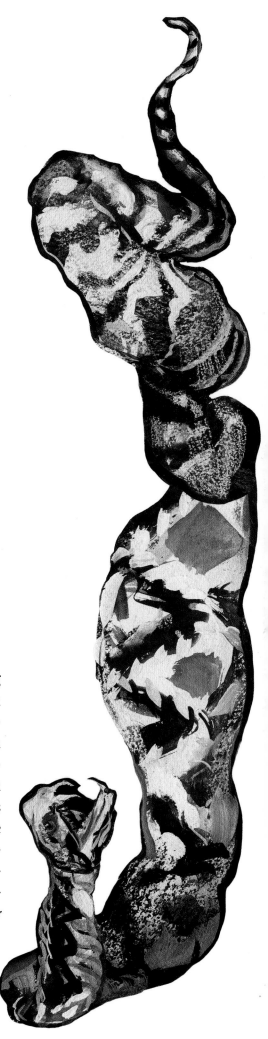

The Golden Pot

A Modern Fairy Tale

First Vigil

*The mishaps of the student Anselmus.
Rector Paulmann's tobacco box and the
gold-green snakes.*

ON ASCENSION DAY,
at three o'clock in the afternoon, a young
man dashed through the Black Gate in
Dresden and bumped into a basket of ap-
ples and cookies that an ugly old woman
had set out for sale. The crash was prodi-
gious. What wasn't squashed or broken
was scattered in all directions, and hordes
of street urchins delightfully divided the
booty that this hasty young man had pro-
vided for them. There was quite a hullaba-
loo as soon as the old hag began scream-
ing, and her fellow vendors immediately

1

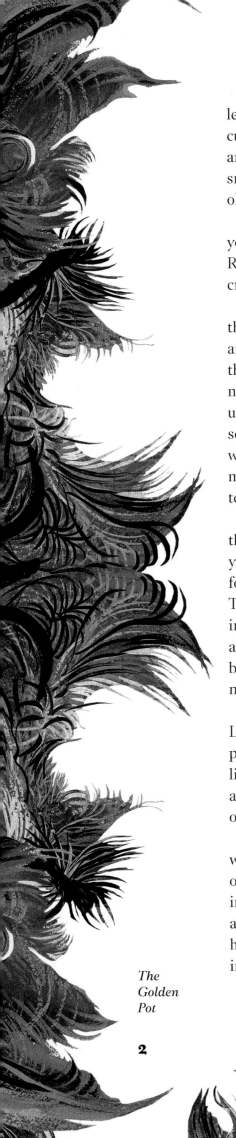

left their cake and brandy tables, surrounded the young man, cursed him, and beat him in a very rough manner. Out of shame and annoyance, he didn't say anything, but merely held out his small, and by no means particularly well-filled wallet, which the old woman eagerly and greedily grabbed and stuck into her pocket.

Soon the tight circle of onlookers opened up, and as the young man ran away, the old woman yelled at him, "Oh, yes! Run, run away, you measly wimp! You're bound to end up in the crystal! In the crystal!"

The squealing and croaking voice of the woman had something so horrible about it that passersby stopped in amazement, and all their laughter, which was contagious and had spread among them, instantly faded. The student Anselmus (for that was the young man's name) felt overcome by a feeling of excruciating horror, even though he hadn't understood the old woman's baffling words at all. He was now frightened, and so he spurred himself on until he was almost running. Indeed, he desperately wanted to escape the curious looks of the crowds of people staring at him. As he made his way through the throng of well-dressed people, he heard them muttering on all sides: "Poor young fellow! Oh, what a damned old witch!"

The strange, inarticulate words of the old woman, oddly enough, had given this ludicrous adventure such a certain tragic turn that the previously neglected young man was now regarded with a certain sympathy. The ladies forgave him for being so clumsy and for wearing clothes that were utterly out of fashion. They cared more about his fine figure and handsome face, which the glow of inward anger rendered still more expressive. His bluish-gray coat was shaped as if the tailor had only known the modern style by hearsay, and his well-kept black satin pants gave him a certain pedagogic air, to which his gait and manner did not at all correspond.

When the student had almost reached the end of the alley that leads to the Linke Tavern, he was out of breath and could no longer stand such a speedy pace. So, he stopped running and started meandering. However, he didn't dare lift his eyes from the ground because he still saw apples and cookies dancing around him, and each friendly look from this or that girl seemed to him to be only a reflection of the mocking laughter at the Black Gate.

This was the way he was when he reached the entrance of the Linke Tavern, where groups of people, dressed in festive clothes, were entering a large hall, one after the other. The music from the wind instruments could be heard from inside, and the crowd of merry guests was growing noisier and noisier. Tears almost appeared in the eyes of the poor student Anselmus, for Ascension Day had always been a special family day for him, and he had hoped to participate in the bliss of paradise inside the tavern. Indeed, he had even intended to treat

himself to a half a cup of coffee with rum and a whole bottle of very strong beer. Moreover, he had stuck more money in his wallet for this occasion than was advisable. But now, by accidentally kicking the apples and cookies, he had lost all the money that he had carried with him. He couldn't even think about coffee, beer, music, or looking at the pretty girls. In short, everything he had dreamed about and that gave him pleasure had evaporated.

So, he crept by the people and slowly took the path toward the bank of the Elbe River, which at that time happened to be deserted. Once there, he found a pleasant patch of green grass beneath an elder tree, which had grown and pierced the wall. Once he sat down, he filled a pipe from the first-aid box that his friend Rector Paulmann had recently given to him as a present.

The yellow and golden waves of the beautiful Elbe River splashed and rippled before his eyes, and on the other side of the bank, the marvelous city of Dresden stretched, bold and proud with towers shooting upward into the fragrant sky. Further away, the Elbe turned and bent itself down toward flowery meadows and fresh green forests. In the twilight, a range of jagged mountain peaks pointed toward remote Bohemia. But Anselmus could not enjoy the view. He was too gloomy and just blew clouds of smoke from his pipe into the air. His chagrin finally became audible, and he began complaining to himself: "In truth, I was born to live a life of trouble and misery! As a boy, I could never play hide-and-seek because I could never catch anyone. My buttered bread always fell to the ground on the buttered side. But I don't want to talk about all this shame. And yet, now that I've become a student, despite the demonic devil that oppresses me, I'm still as bumbling as ever and will always be a bumbler! It seems to be my fate. Must I always put on a new coat and get grease on it the first day? Must I always tear a cursed hole in the coat on some nail or other? Must I always greet and bow to a court councilor or a fine lady by flinging my hat, or even slipping on the smooth pavement, and taking an embarrassing fall? When I was in Halle, didn't I have to pay three or four silver coins every market day because I would always smash some plates and dishes all because the devil put it into my head to dash straight ahead like a maniac? Have I ever arrived on time for the lectures or any other place for my appointments? Did it ever matter whether I set out half an hour early and plant myself at the door with the knocker in my hand? Just as the clock is going to strike, the devil douses me with a basin full of water, or I run into some fellow coming out of the lecture hall and become involved in endless quarrels until I miss everything the professor has said.

"Ah, well. Where have you gone, you blessed dreams of future happiness when I egotistically thought that I might even attain the position of privy coun-

The Golden Pot

3

cilor? Haven't I made enemies of my best patrons? For instance, I had a letter of introduction to the councilor I was supposed to see and heard that he could not stand close-cropped hair. So, with immense difficulty and effort, the barber managed to attach a little pigtail to the back of my head. However, the first time I bowed, the damned knot came loose, and the pigtail fell to the ground. Then a little dog, which had been sniffing around me, ran off to the councilor with the pigtail in its mouth. I ran after it in alarm and stumbled against the table, where the councilor had been working at breakfast. The result was that cups, plates, inkwell, and sandbox crashed to the floor. Then a flood of chocolate and ink flowed over the report that the councilor was writing.

"'Sir, what the devil has gotten into you?' the furious privy councilor bellowed, and he shoved me out of the room.

"What does it matter now that Rector Paulmann gave me hope that I might obtain a position as a copyist? Will my unlucky star, which pursues me everywhere, permit it? Even today, it has tormented me! Think of it! I had intended to celebrate Ascension Day with good cheer and not worry about the cost. I wanted to do things in an orderly fashion. I could have gone into the Linke Tavern and proudly ordered: 'Waiter, a bottle of your best beer—your very best, if you please.' I could have sat until late at night, close to this or that attractive party of well-dressed, beautiful ladies. I know it for certain. I could have summoned my courage. I would have been quite a different person. In fact, I might have managed it in such a way that, if one of the girls had asked, 'What time is it? Or, what music are they playing?' I could have stood up gracefully without overturning my glass, or stumbling over the bench. Then I would have made a graceful bow, moved a step and a half forward, and answered, 'If you permit me, Mademoiselle, it is the overture to *The Danube Mermaid*.' Or, if one of them had asked for the time, I might have said, 'It is about to strike six, Mademoiselle.' Could any mortal in the world have taken offence? No! I say, the ladies would have looked over at me, smiling mischievously, as they always do when I have enough confidence to show them that I, too, am worldly and know how ladies should be treated. However, it was the devil himself, who led me into that cursed apple basket, and now I must sit and mope in solitude, with nothing but a poor pipe filled with tobacco."

Here the student Anselmus was interrupted in his soliloquy by a strange rustling and swishing that rose close to him in the grass and soon glided up into the twigs and leaves of the elder tree that stretched out over his head.

It was as if the evening wind were shaking the leaves, as if little birds were twittering among the branches, moving their little wings in a capricious flutter back and forth. Then he heard a whispering and lisping, and it seemed as if the blossoms were tinkling like little crystal bells. Anselmus listened and listened. Then, before long—and he had no idea how this happened—the whispering, lisping, and tinkling became faint and scattered words: "This way, that way; between the branches, between the blossoms, come shooting, come twisting, and twirling! Sisters, sisters we! Swing upon the shining light, up and down, quickly, quickly, on and off! The sun is setting. The winds are rising and now the blossoms begin to sing. Sing with the blossoms; sing with the branches! Stars will soon glitter; and off we go. In and out, up and down, this way, that way come shoot, come twist, come twirl, sisters we!" And so, it continued in confused and confusing speech.

"Well, it must just be the evening wind, which tonight is truly whispering distinctly enough," Anselmus commented to himself.

But at that moment a triple harmony of clear crystal bells sounded above his head. He looked up and saw three little snakes, glittering in green and gold, coiled around the branches, and stretching their heads toward the evening sun. Then, a whispering and twittering in the same words as before began again, and the little snakes went slithering and winding up and down through the twigs; and while they moved rapidly, it was as if the elder tree were scattering a thousand glittering emeralds through the dark leaves.

"It is the light of the evening sun playing on the elder tree," the student Anselmus thought. But the bells rang out again, and Anselmus noticed that one snake stuck out its little head toward him. Suddenly, he felt an electric shock that penetrated all his limbs. Although his heart was quivering, he kept gazing up into the leaves, where he saw a pair of glorious dark-blue eyes looking down at him with unspeakable longing. Now, an unknown feeling of exuberance and deepest sorrow nearly ripped his heart apart. As he looked and continued to gaze into those tender eyes, full of burning desire, the crystal bells sounded louder, in harmonious accord, and the sparkling emeralds fell down and encircled him, flickering around him in a thousand reflections and resplendent threads of gold. The elder tree stirred and spoke: "You are lying in my shadow, and my fragrance has flown around you, but you haven't understood it. The fragrance is my speech, when love kindles it."

Then the evening wind came gliding past and said: "I stroked your tem-

ples, but you did not understand me. The breeze is my speech, when love kindles it."

The sun broke through the clouds, and its rays burned, as though in the words: "I doused you with glowing gold, but you did not understand it. That glow is my speech, when love kindles it."

Now Anselmus gazed at those glorious eyes and became deeply absorbed. Indeed, his longing grew keener, his desire warmer. And everything around him moved as if awakening and glad to be alive. Flowers and blossoms shed their odors around him, like the lovely singing of a thousand soft voices, and what they sang rebounded like an echo on the golden evening clouds, as they flitted away into far-off lands. But as the last sunbeam abruptly sank behind the hills, and the twilight threw its veil over the scene, a deep hoarse voice seemed to reach Anselmus from far away:

"Hey! Hey! What's all chattering and murmuring over there? Hey! Hey! Who's searching for the sunshine behind the hills? Enough sun, enough sun! Hey! Hey! Through bush and grass, through grass and stream. Hey! Hey! Come dow-w-n, dow-w-w-n!"

So, the voice faded away, as if in the rumbling of a distant thunder, but the crystal bells broke off in sharp discord. Everything became mute, and Anselmus watched how the three snakes, glittering and sparkling, glided through the grass toward the river. Rustling and hustling, they rushed into the Elbe and over the waves, where they vanished, a green flame shot up and crackled. After flying obliquely, it fizzled and vanished in the direction of the city.

Second Vigil

How the student Anselmus was looked upon as a drunk and a madman.
The crossing of the Elbe. Bandmaster Graun's bravura aria,
and the bronzed apple woman.

"The gentleman seems to be sick in the head!" exclaimed a respectable burgher's wife, returning from a walk with her family. She had paused nearby, crossed her arms, and looked at the crazy behavior of the student Anselmus. He

The Golden Pot

6

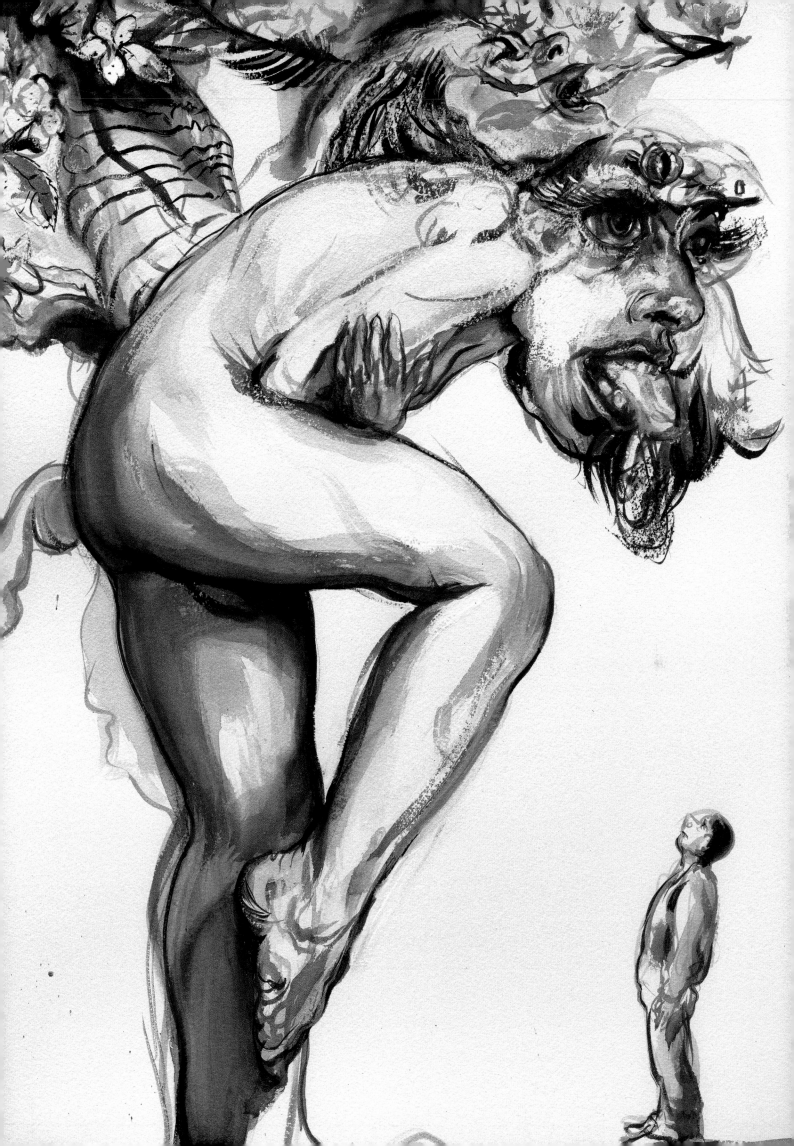

had embraced the trunk of the elder tree and was call-ing incessantly up to the branches and leaves: "Oh, glitter and shine once more, dear golden snakes. Let me hear your little bell voices once more! Look at me once again, oh, tender eyes, or else I shall die in agony and longing!"

All this pitiful sighing and sobbing came from the bottom of his heart, and in his eagerness and impatience, he shook the elder tree back and forth. However, instead of sending any reply, it rustled unintelligibly with its leaves and seemed to mock the student Anselmus and his sorrows.

"This gentleman is certainly demented in some way!" said the respectable lady. Indeed, Anselmus felt as if someone had shaken him out of a deep dream, or poured ice-cold water on him to waken him instantly out of sleep. It was the first time that he clearly realized where he was and recalled that a strange phantom had assaulted him or had beguiled his senses. All this caused him to break out into a loud conversation with himself. In astonishment, he gazed at the woman and finally snatched his hat, which had fallen to the ground. Still in a daze, he wanted to leave the spot as soon as he could. In the meantime, the prickly woman's husband had come toward him and put the child he was carrying down on the grass. He had been leaning on his staff and looking and listening to the student with amazement. He now picked up the pipe and tobacco box that the student had dropped, and extend-ing them to him, said: "Don't bawl so much, my worthy sir, or alarm people in the darkness when nothing is the matter after all, but a drop too much liquor. Go home, like a good fellow, and sleep it off."

Anselmus felt exceedingly ashamed of himself, and he could utter nothing but a most lamentable "Ah!"

"Now! Now!" said the husband of the respectable woman. "Never mind. Don't take it to heart. It can happen to the best of us. On good old Ascension Day, a man may easily enough forget himself in his joy, and gulp down a drop too much. A clergyman himself is no worse for it. Indeed, if I might presume, my worthy sir, you are a divinity student. But, by your leave, sir, I shall fill my pipe with your tobacco. Mine was used up a little while ago."

The good man uttered this last sentence while the student Anselmus was about to put away his pipe and box. Now the man gradually and deliberately cleaned his pipe and began slowly to fill it. Several girls from this neighbor-hood had appeared, and they spoke secretly with the woman and each other, tittering as they looked at Anselmus. The student felt as if he were standing on prickly thorns, and burning needles. No sooner did the man return his pipe and tobacco box, than Anselmus darted off as fast as he could.

The Golden Pot

All the strange things he had witnessed seemed to have disappeared from his memory. He only recollected having babbled all sorts of foolish stuff beneath the elder tree. This was all the more disturbing to him because he had an inner dislike of all soliloquists. It is the demonic devil, who chatters out of them, his friend the rector claimed, and Anselmus had honestly believed him. But to be regarded as a divinity student, drunk on Ascension Day! The thought was unbearable.

Taunted and burdened by all this, he was just about to turn up Poplar Alley near the Kosel Garden, when a voice behind him called out: "Anselmus! Anselmus! For the love of heaven, why are you in such a hurry?"

The student stopped, as if rooted to the ground, for he was convinced that some new accident would now happen to him.

The voice rose again: "Anselmus, my dear fellow, come back! We've all been waiting for you here by the river!"

And now the student recognized his friend Rector Paulmann's voice. So, he went back to the Elbe and found the rector with his two daughters, as well as Registrar Heerbrand, all about to step into a gondola. Rector Paulmann invited the student to come with them across the Elbe and spend the evening at his house in the suburb of Pirna. Anselmus accepted this proposal gladly, thinking he might escape the fateful destiny that had been haunting him the entire day.

Now, it so happened that, just as they were crossing the river, some fireworks exploded on the farther bank in Anton's Garden. Sputtering and hissing, the rockets zoomed into the sky, and their blazing stars flew to pieces in the air, scattering a thousand stars and flashes around them. Anselmus was sitting next to the gondolier, sunk in deep thought, but when he noticed in the water the reflection of these darting and wavering sparks and flames, he imagined they were the little golden snakes that were playing in the waves. All the wondrous and miraculous things that he had seen at the elder tree sprang to life again in his heart and mind. Once more, he was seized by the unspeakable longing, the glowing desire that had agitated his heart before in painful spasms of rapture.

"Ah! Is it you again, my little golden snakes? Sing now! Oh, sing! Let those lovely, dark blue eyes again appear to me in your song. Ah! Are you beneath the waves, then?"

This was how the student Anselmus began shouting, and at the same time, he made a violent movement, as if he were going to plunge into the river.

"Are you bewitched, sir?" exclaimed the gondolier, who grabbed him by the lapels of his coat. The girls, who were sitting near him, shrieked in horror and fled to the other side of the gondola. Registrar Heerbrand whispered some-

thing in Rector Paulmann's ear, and the rector answered at considerable length, but in a low tone so that Anselmus could not discern anything but the words: "Such attacks more than once? Never noticed them before."

Directly after this, Rector Paulmann rose and then sat down, with a certain earnest, grave, and official mien, beside the poor student, taking his hand and saying: "How are you feeling, Anselmus?"

The student was on the verge of losing his wits, for in his mind there was a crazy contradiction, which he was endeavoring in vain to reconcile. He could now plainly see that what he had taken for the gleaming of the golden snakes was nothing but the reflection of the fireworks in Anton's Garden. Yet, a feeling that he had never experienced until now—and he did not know whether it was rapture or pain—gripped his heart. So, when the gondolier struck the water with his oar so that the waves curled as if in anger and then spluttered and moaned, he heard a soft whispering in their din: "Anselmus! Anselmus! Do you see how we are still swimming along with you? Sister is watching you again. Believe, believe, believe in us!"

And he thought he saw three green, glowing streaks in the reflected light, but when he gazed full of sadness into the water to see whether those gentle eyes would not look up to him again, he realized all too well that the gleam was only a reflection of the windows in the neighboring houses. All this caused Anselmus to sit silently in his place and struggle with himself until Rector Paulmann repeated, now with still greater emphasis: "How are you feeling, Anselmus?"

With the most rueful tone, the young man replied: "Ah! Rector Paulmann, if you only knew what strange things I have been dreaming all day, quite awake, with open eyes, and just now, under an elder tree at the wall of Linke Tavern, you would not take it amiss if I am a little absentminded."

"Well, come now, my fine Anselmus!" interrupted Rector Paulmann. "I have always taken you for a solid and respectable young man. But to dream, to dream with your eyes wide open, then, all at once, stand up and try to jump into the water! This, I must say, is what only fools or madmen would do."

Anselmus was deeply hurt by his friend's harsh reprimand. But then Veronica, Rector Paulmann's eldest daughter, a most pretty, blooming girl of sixteen, came to Anselmus's defense.

"But, dear father, something strange must have happened to Anselmus, and perhaps he only thinks he was awake, while he may have really been asleep,

and so all sorts of foolish and wild stuff have come into his head, and they are still occupying his mind."

"And my dear Mademoiselle! Worthy Rector!" cried Registrar Heerbrand. "Isn't it possible to fall into a kind of dreaming state even when you are awake? I myself have had such fits. One afternoon, for instance, during coffee time and in the special hour of corporeal and spiritual digestion, I suddenly recalled, as if by inspiration, where I had left a missing manuscript. Then just last night, a glorious large Latin text came dancing out before my eyes in the very same way."

"Ah! Most honored Registrar," answered Rector Paulmann, "you have always had a tendency to be somewhat poetic, and so you tend to fall prey to such hallucinations and immerse yourself in fantasies and romantic displays."

Meanwhile, Anselmus was particularly gratified that, in this most difficult situation, someone would take his side while in danger of being considered drunk or crazy, and although it was already fairly dark, he thought he noticed for the first time that Veronica had really very beautiful dark blue eyes, and he did this without remembering the strange glance that had peered out at him from the elder tree.

On the whole, the adventure under the elder tree had entirely vanished from Anselmus's mind. He felt so relieved from his brooding that he offered a helping hand to his fair advocate Veronica without any fear of clumsiness, just as she was stepping from the gondola. Without further ado, as she put her arm in his, he escorted her home with so much dexterity and good luck that he only missed his footing once. Since this was when he crossed the only wet spot on the whole road, he spattered Veronica's white gown incidentally and very little. Rector Paulmann did not fail to notice this happy change for the better in Anselmus. Indeed, his fondness for the student returned at once, and he begged him to forgive the harsh words that he had uttered earlier.

"Yes," he admitted, "we have many examples to show that certain hallucinations may rise and torment a man so that he feels plagued. But this is a physical disease, and leeches, if applied to the right part of the body, are good for it, as a certain learned physician, now deceased, has shown."

Anselmus did not know whether he had been drunk, crazy, or sick, but at any event, the leeches seemed entirely superfluous, for these supposed hallucinations had completely vanished, and the student himself was growing happier and happier the more he succeeded in showering a variety of polite attentions on the pretty Veronica. As usual, after the frugal meal at Rector Paulmann's home, they played music. Anselmus took his seat at the harpsichord, and Ve-

ronica accompanied his playing with her pure, clear voice.

"Dear Mademoiselle," said Registrar Heerbrand, "you have a voice like a crystal bell!"

"She certainly does not!" exclaimed Anselmus, and he scarcely knew why he became so unnerved. "Crystal bells in elder trees make a very strange sound. Very strange!" Anselmus continued, mumbling half aloud.

Then Veronica laid her hand on his shoulder and asked: "What do you mean, my dear friend?"

Anselmus promptly regained his normal cheerfulness and began playing. Rector Paulmann gave him a grim look, but Registrar Heerbrand laid a sheet of music on the stand and sang one of Bandmaster Graun's bravura arias with a ravishing grace. After that, Anselmus accompanied much more of the music that followed, such as a fantasy duet, which he and Veronica performed. Rector Paulmann was composed once again and managed to change the atmosphere of the little company and bring everyone into a cheerful mood.

It was now pretty late in the evening, and Registrar Heerbrand was picking up his hat and stick, when the rector came up to him with a mysterious air and said: "By the way, if you please, honored Registrar, before you leave, do not reveal to the good young man Anselmus—you know—what we were discussing before."

"Your wish is my command," said Registrar Heerbrand, and having placed himself in the middle of the little group, he began, without further ado, as follows:

"In this city there is a strange and eccentric man. People say he studies all sorts of occult sciences. But since there are no such sciences, I take him rather for an antiquary, and in addition, for an experimental chemist. I mean no other than our Privy Archivist Lindhorst. He lives, as you know, by himself, in his remote and isolated old house, and when he is away from his work in his office, he can be found in his library or in his chemical laboratory. However, he will not allow any strangers to enter. Aside from the many curious and rare books he has in his home, he possesses a number of manuscripts, partly Arabic, Coptic, and others written in mysterious characters that do not belong to any known language. I have heard that he wishes to have the manuscripts and books copied properly, and for this purpose he needs a man who can draw with the pen and transfer these unique characters on parchment in India ink with the greatest accuracy and fidelity. The work is to be done in a separate room of his house under his own supervision. Besides free board during working hours, he will pay his copyist a silver coin daily, and he also promises a handsome

reward once the copying is properly completed. The hours of work are from twelve to six daily. From three to four, the copyist is to take a rest and have an early dinner.

"Archivist Lindhorst tried one or two young people as copyists for these manuscripts, but it was in vain. Consequently, he contacted me to help him find an expert calligrapher, and so I have been thinking of you, my dear Anselmus, for I know that you not only write very neatly but also that you draw elegant lines with the pen to great perfection. Now, in these bad times, and until your future is decided and you have a permanent job, if you would like to earn a silver coin each day, and a gratuity over and above your salary, you may go tomorrow precisely at noon and call upon the archivist, whose house I am sure you know. But be on your guard against blots! If one single blot falls on your copy, you must begin it again. If the ink falls on the original, the archivist will think nothing of throwing you out the window, for he is a hot-tempered man."

Anselmus was overcome with joy at Registrar Heerbrand's proposal; for not only could the student write and draw well with the pen, but he enormously enjoyed copying letters with the most laborious calligraphic skill. So, he thanked his patrons in the most grateful terms and promised not to fail to be at the archivist's house at twelve noon the next day.

That night, Anselmus saw nothing but bright silver coins and heard nothing but their lovely jingling and clinking. And who could blame the poor young man? For he had been cheated of so many hopes by a capricious fate. Indeed, he had been obliged to be careful with every penny he possessed, and thus to forego so many joys that a young heart needs.

Early in the morning, he took out his black lead pencils, his raven quill pens, and his India ink because he thought that the archivist would not be able to find better materials anywhere in the country. Above all, he gathered together and arranged his calligraphic masterpieces and his drawings to show them to the archivist, as proof of his ability to do what was desired. Everything was now going well for the student. A peculiar, happy star seemed to be presiding over him, and he managed to put on his tie correctly at the very first attempt. No button came off; no thread gave way in his black silk stockings; his hat did not fall into the dust after he had trimmed it. In short, he was ready at precisely half-past eleven, and so Anselmus, in his gray tailcoat and black satin pants, carried a roll of calligraphic specimens and pen drawings in his pocket, and stood now in Herr Conradi's shop in Castle Gate and drank one or two glasses of the best cordial, for here, thought he, slapping his pocket, which was still empty, for here silver coins would soon be jingling. So he hoped.

The Golden Pot

13

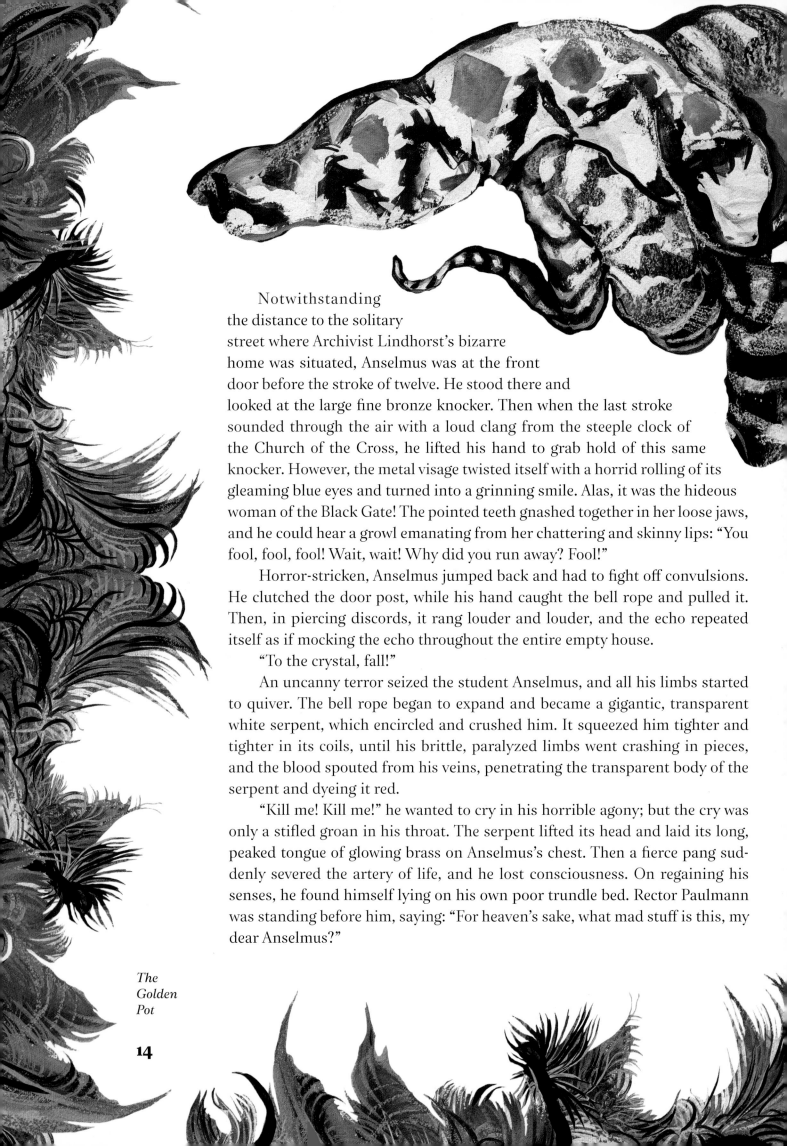

Notwithstanding the distance to the solitary street where Archivist Lindhorst's bizarre home was situated, Anselmus was at the front door before the stroke of twelve. He stood there and looked at the large fine bronze knocker. Then when the last stroke sounded through the air with a loud clang from the steeple clock of the Church of the Cross, he lifted his hand to grab hold of this same knocker. However, the metal visage twisted itself with a horrid rolling of its gleaming blue eyes and turned into a grinning smile. Alas, it was the hideous woman of the Black Gate! The pointed teeth gnashed together in her loose jaws, and he could hear a growl emanating from her chattering and skinny lips: "You fool, fool, fool! Wait, wait! Why did you run away? Fool!"

Horror-stricken, Anselmus jumped back and had to fight off convulsions. He clutched the door post, while his hand caught the bell rope and pulled it. Then, in piercing discords, it rang louder and louder, and the echo repeated itself as if mocking the echo throughout the entire empty house.

"To the crystal, fall!"

An uncanny terror seized the student Anselmus, and all his limbs started to quiver. The bell rope began to expand and became a gigantic, transparent white serpent, which encircled and crushed him. It squeezed him tighter and tighter in its coils, until his brittle, paralyzed limbs went crashing in pieces, and the blood spouted from his veins, penetrating the transparent body of the serpent and dyeing it red.

"Kill me! Kill me!" he wanted to cry in his horrible agony; but the cry was only a stifled groan in his throat. The serpent lifted its head and laid its long, peaked tongue of glowing brass on Anselmus's chest. Then a fierce pang suddenly severed the artery of life, and he lost consciousness. On regaining his senses, he found himself lying on his own poor trundle bed. Rector Paulmann was standing before him, saying: "For heaven's sake, what mad stuff is this, my dear Anselmus?"

The Golden Pot

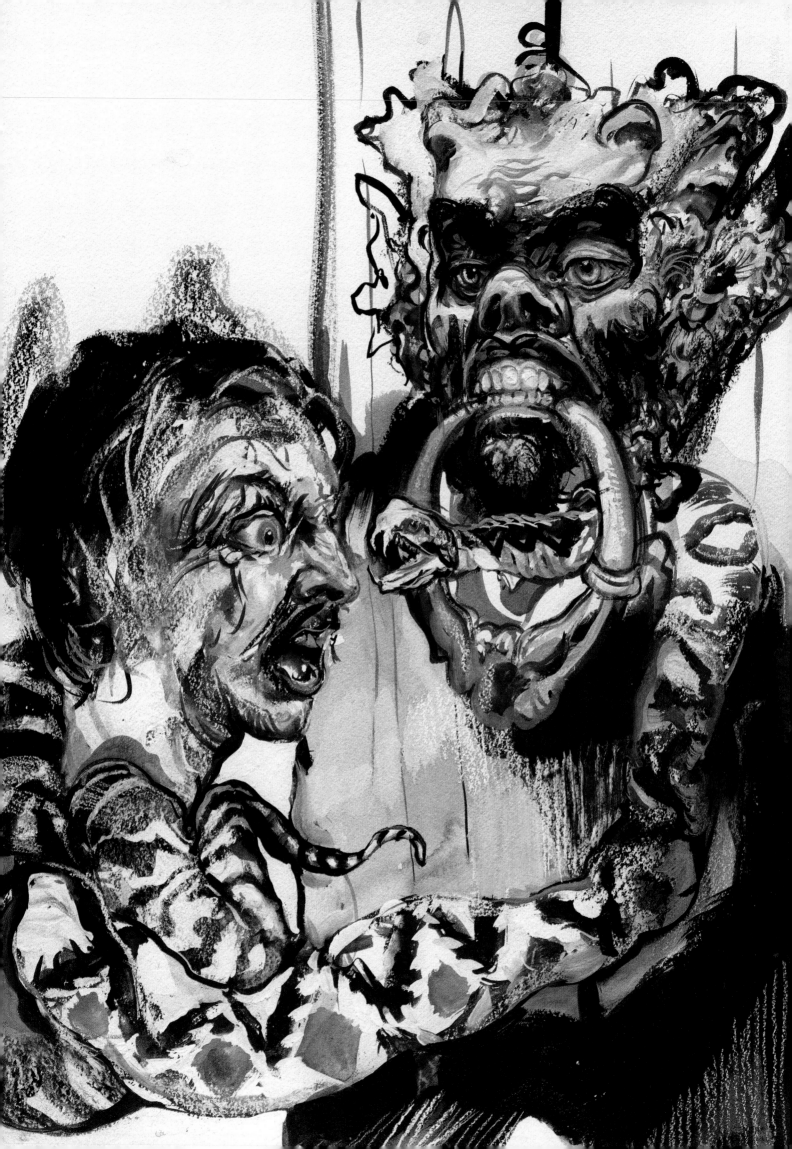

Third Vigil

Revelations about Archivist Lindhorst's family.
Veronica's blue eyes. Registrar Heerbrand.

The spirit gazed at the water, and the water stirred itself and churned in foaming waves. Then it plunged and thundered down into the abysses, which opened their black throats and greedily swallowed it. Like triumphant conquerors, the granite rocks lifted their jagged heads, protecting the valley, until the sun took it into her maternal bosom. Clasping the valley with her rays, as if she had glowing arms, the sun cherished and warmed it. Then a thousand seeds, which had been slumbering under the desert sand, awoke from their deep sleep and stretched their little leaves and stalks toward the sun, their mother's face, and like smiling infants in green cradles, the flowers rested in their buds and blossoms, until they, too, wakened by their mother, decked themselves in light, which she tinted in a thousand varied hues to please them.

But in the midst of the valley, there was a black hill, which rose up and down like the breast of man when warm longing swells it. Steaming vapors mounted from the abysses there and rolled themselves together into huge masses, striving malignantly to hide their mother's face. But she called the storm, which rushed there and scattered them away. And, when the pure sunbeam rested again on the bleak hill, a glorious fire lily opened her fair leaves like gentle lips in excessive rapture to receive the sweet kiss of her mother.

Now a gleaming splendor entered the valley. It was the young Phosphorus, and once the lily saw him, she was overcome by a passionate longing of love.

"Be mine forever, fair youth!" she begged. "For I love you and shall die if you forsake me!"

"I shall be yours, fair flower," Phosphorus replied. "But then, like a thankless child, you must leave your father and mother. You will forget your playmates and will strive to be greater and stronger than all the flowers that now rejoice with you as your equal. The longing that now kindly warms your whole being will be scattered into a thousand rays and will torture and vex you, for the mind will give birth to the senses, and the highest rapture of the spark that I shall kindle and cast into you will be the hopeless pain in which you will perish only to spring up anew in exotic shape. This spark is thought!"

"Ah!" the lily mourned. "Can't I be yours in this ardor as it now burns

inside me? Can't I still be yours? Can't I love you more than I do now? Can I behold you if you were to annihilate me?"

Then Prince Phosphorus kissed the lily. And as if shining with light, it blazed into flame, out of which a strange being appeared that quickly flew from the valley, roamed forth into endless space, no longer caring about former playmates, nor the young man it had loved. This youth mourned for his lost beloved, for he, too, loved her. Indeed, love for the fair lily had brought him to the lone valley, and the granite rocks lowered their heads in participation of his grief.

But one of these rocks opened its bosom, and a black-winged dragon flew out of it and said: "My brothers, the metals are sleeping in there; but I am always brisk and awake and shall help you."

Rising and falling on his black pinions, the dragon at last caught the creature, which had sprung from the lily, carried it to the hill, and enfolded it with his wings. Then it became the lily again. However, thought, which accompanied it, lacerated its heart, and its love for Phosphorus became a cutting agony that breathed poisonous vapors, causing the flowers that had once rejoiced in the fair lily's presence to fade and die.

Prince Phosphorus put on glittering armor, reflecting the light in a thousand hues, and he fought the dragon, who struck the armor with his black wing and made it ring loudly. Thanks to the loud clanging, the flowers came to life again, and like all kinds of different birds, fluttered around the dragon, whose strength and power vanished, and who was compelled to hide himself in the depths of the earth. Consequently, the lily was freed, and Prince Phosphorus embraced her, full of warm longing and of heavenly love. And in a triumphant chorus, the flowers, the birds, and even the high granite rocks, paid homage to her as Queen of the Valley.

"Forgive me, my worthy Archivist, this is Oriental bombast!" said Registrar Heerbrand, "We asked you, you know, to tell us something about your own most remarkable life, as you usually do, for instance, something about your adventures during your travels—above all, something that is true."

"Let me assure you," answered Archivist Lindhorst, "this very tale I have told is the truest I could produce for you, my friends, and it is part of my life, too, in a certain sense. For I come from that very lonely valley, and the fire lily, who ended up reigning as the queen there, was my great-great-great-great-grandmother. And so, properly speaking, I myself am a prince."

The Golden Pot

17

All his listeners burst out laughing.

"All right, laugh until you burst!" Archivist Lindhorst continued. "What I have told you is, of course, a very inadequate account, and you may think it is mere crazy nonsense. Nevertheless, it is far from absurd or even allegorical. In short, it is literally true. Had I known, however, that the splendid love story, to which I owe my existence, would not please you, I might have told you some of the news I heard from my brother when he visited me yesterday afternoon."

"What, what are you saying? Do you really have a brother, Archivist? Where is he? Where does he live? Is he in his majesty's service, or is he a private scholar?" asked a chorus of voices.

"No!" replied the archivist, who was quite cool and composed while taking a pinch of snuff. "He has joined the bad side. He has joined the dragons."

"What do you mean by that, my worthy Archivist?" cried Registrar Heerbrand. "Joined the dragons?"

"Joined the dragons?" resounded like an echo in the ears of the bewildered listeners.

"Yes, he joined the dragons," continued Archivist Lindhorst. "It was sheer desperation, I believe. You know, gentlemen, my father died a short while ago. It is but three hundred and eighty-five years ago at most, and I am still in mourning. Since I was his favorite son, he left me a magnificent onyx, which my brother very much wanted. We quarreled about it over my father's body in such an unseemly manner that the good man jumped up, lost his patience, and threw my wicked brother downstairs. This irritated my brother so much that he joined the dragons on the spot. That's what I meant when I said he went and joined the dragons. At present, he lives in a grove of cypress trees, not far from Tunis, where he has been assigned the task of guarding a famous mystical carbuncle. A necromancer, a devil of a fellow, who has just moved into a summer residence in Lapland, has his eye on this carbuncle so that my brother can only leave his post for the odd quarter of an hour, while the necromancer is tending his salamander beds in the garden, to bring me the latest news from the source of the Nile."

For the second time, the assembled company burst into laughter, but Anselmus began to feel quite dreary, and he could scarcely look at Archivist Lindhorst's grave and intense face without shuddering internally in a way that he himself found inexplicable. Moreover, the archivist's harsh but strangely metallic voice had a wondrous penetrating quality that shook Anselmus to the core.

There seemed no chance today of attaining the real purpose for which Registrar Heerbrand had taken him to the coffee house. After the incident at Archivist Lindhorst's door, Anselmus had withstood all inducements to risk a second visit. According to his own sincere conviction, it was only chance that had saved him—if not from death, at least from the danger of insanity. Rector Paulmann had happened to pass Anselmus on the street while he was lying unconscious outside the door, tended by an old woman, who had laid her basket of cookies and apples aside. Rector Paulmann had promptly called for a sedan-chair and had him carried home.

"Think what you will of me," Anselmus stated. "Call me a fool or not, as you wish. I say, the accursed face of that witch at the Black Gate was grinning at me from the door knocker. As for what happened next, I'd rather not talk about it, but if I had recovered from my blackout and seen that infernal apple woman beside me—for that's who the old woman was who was tending me—I would have instantly been struck by apoplexy or else gone stark mad."

No amount of persuasion and sensible arguments on the part of Rector Paulmann and Registrar Heerbrand had the slightest effect on Anselmus, and even the blue-eyed Veronica herself could not divert him from a certain pensive mood in which he had sunk. In fact, his friends thought he might be going somewhat insane, and they considered ways to divert him and help him regain his sanity. Registrar Heerbrand thought that the best way would be to help him obtain the job offered by Archivist Lindhorst, namely the copying of manuscripts. All that he had to do was to introduce Anselmus to the archivist in some appropriate fashion, and since the registrar knew that the archivist was accustomed to visit a certain coffee house almost every evening, he had invited Anselmus to drink a glass of beer and smoke a pipe at his expense until he could somehow be introduced to the archivist and agree to undertake the copying of the manuscripts. Anselmus had gratefully accepted this offer.

"God will reward you, worthy Registrar, if you bring the young man to his senses!" Rector Paulmann declared.

"God will reward you!" repeated Veronica, piously raising her eyes to heaven, and vividly thinking that Anselmus was already a most handsome young man, even with or without his senses.

Now, just as Archivist Lindhorst picked up his hat and staff and was making for the door, Registrar Heerbrand briskly grabbed Anselmus by the hand and almost dragged him to meet the archivist.

"Most esteemed Herr Archivist," he said, "here is the student Anselmus.

If you remember, I told you about his extraordinary talent in calligraphy and drawing. Well, I think he would make an excellent choice as a copyist of your rare manuscripts."

"Thank you very much indeed," answered Archivist Lindhorst sharply. Then he quickly threw his three-cornered military hat on his head, and shoving Registrar Heerbrand and Anselmus aside, he rushed downstairs, making a great deal of noise so that both of them were left standing in great perplexity, gaping at the door, which he had slammed in their faces so hard that the hinges made a large rattling noise.

"He is a very strange and peculiar old gentleman!" Registrar Heerbrand exclaimed.

"Very strange!" stammered Anselmus, feeling as if a stream of ice-cold water was flowing throughout his veins, causing him to become stiff as a statue. All the guests, however, laughed and said: "Our archivist is on his high horse today. But, tomorrow, you'll see, he will be as meek as a lamb and won't utter a word. Instead, he'll just watch the smoke coiling from his pipe, or read the newspapers. Don't let him disturb you."

"True enough," thought Anselmus. "Why should anyone get upset by such behavior? Didn't the archivist tell me he was particularly glad to hear that I would undertake the copying of his manuscripts? Why did Registrar Heerbrand step directly in his way, when he was about to go home? No, no, when all is said and done, he is a good man, this Privy Archivist Lindhorst, and surprisingly liberal, though he does some very odd things. But what's that to me? Tomorrow at the stroke of twelve I'll go to his house even if a hundred bronze apple women try to hinder me!"

Fourth Vigil

*The melancholy mood of the student Anselmus. The emerald mirror.
How Archivist Lindhorst flew off in the shape of a kite,
and Anselmus met nobody at all.*

Gracious reader, I would like to ask you some questions, if I may: Have you ever had hours, perhaps even days or weeks, in which all your customary activities did nothing but cause you to become annoyed and dissatisfied, and when everything that you usually consider valuable and important seemed trivial and worthless? At such a time, did you know what to do, or where to turn? Did a

dim feeling pervade your heart so that you felt you had higher desires that must be fulfilled, desires that transcended the pleasures of this world, yet desires that your mind, like a timid child, did not even dare to utter? In this longing for an unknown *something*, a longing that hovered above you no matter where you were, like an airy dream with thin, transparent forms that melted away each time you tried to touch them, for you had no voice in the world about you. You wandered back and forth with a troubled look, like a rejected lover, and no matter what you saw that people attempted or attained in the struggle for a varied existence, nothing wakened either sorrow or joy in you. It was as if you had no part in the affairs of this world.

If, gentle reader, you have ever been in such a mood, you know the ill condition into which Anselmus had fallen. Therefore, I hope, courteous reader, that I have been able to depict the student Anselmus with true vividness. For in these vigils where I record his unique history, there is still so much more of the marvelous—which is likely to make the everyday life of ordinary mortals seem pallid—that I fear in the end you will believe in neither the student Anselmus nor Archivist Lindhorst. Indeed, you may even have misgivings about Registrar Heerbrand and Rector Paulmann, though these two distinguished men, at least, are still walking the streets of Dresden.

Do make an effort, generous reader, to believe what I am recounting— while in the fairy realm of glorious miracles, it evokes the highest rapture and deepest horrors with simultaneous thrills. While you are in this realm that the mind lays open to us in dreams, the earnest goddess herself will discard her veil so that you may see her face—though a smile often glimmers in her sincere glance, a good-natured teasing before perplexing enchantments, comparable to mothers nursing and playing with their children. Do make an effort to recognize the well-known forms that hover around you even in ordinary life. You will then find that this glorious kingdom lies much closer than you ever supposed. It is this kingdom that I now sincerely desire to convey to you and to depict in the remarkable story of the student Anselmus.

As I have already told you, ever since that evening when Anselmus met Archivist Lindhorst, he had sunk into a dreamy, musing state of mind that made him insensible to every outward contact with daily life. He felt that something, perhaps some unknown force, stirred within him and caused a rapturous pain of longing and desire for some loftier existence. He took great pleasure in wandering alone through fields and forests, where he felt relief from all that tied him down to the banal necessities of life. Indeed, he thought he could, so

*The
Golden
Pot*

21

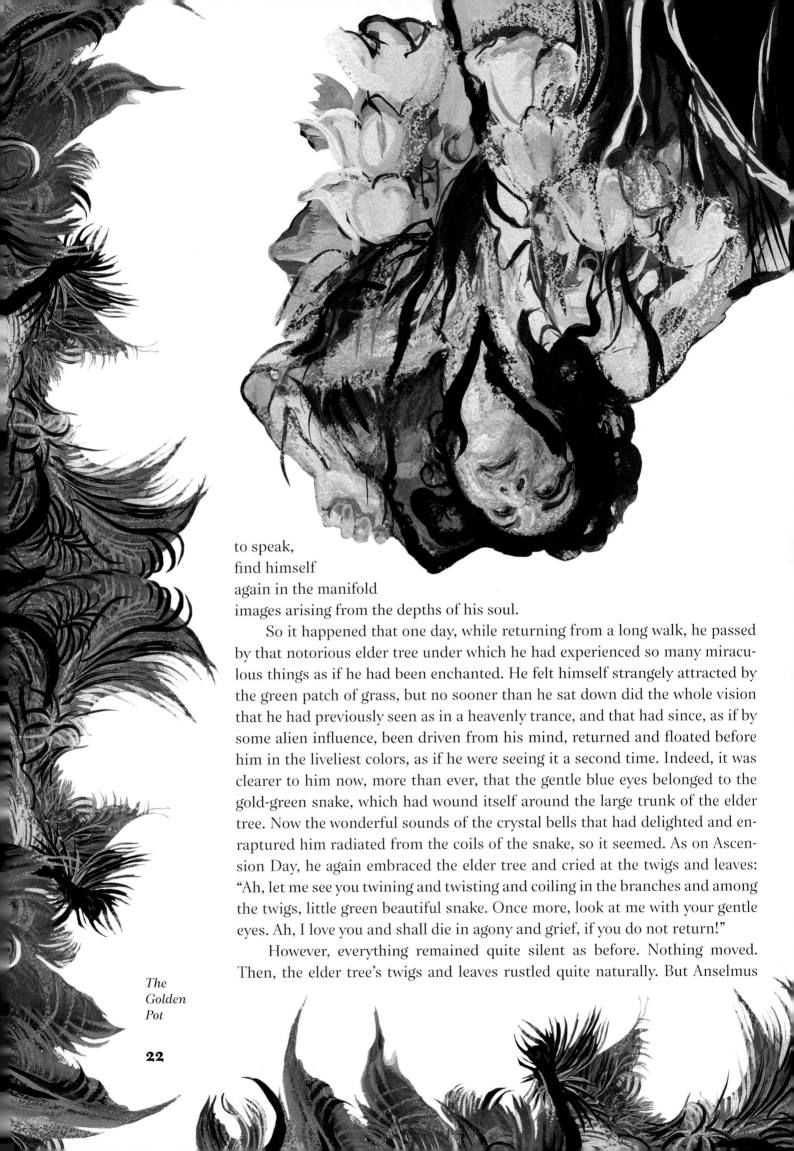

to speak,
find himself
again in the manifold
images arising from the depths of his soul.

So it happened that one day, while returning from a long walk, he passed by that notorious elder tree under which he had experienced so many miraculous things as if he had been enchanted. He felt himself strangely attracted by the green patch of grass, but no sooner than he sat down did the whole vision that he had previously seen as in a heavenly trance, and that had since, as if by some alien influence, been driven from his mind, returned and floated before him in the liveliest colors, as if he were seeing it a second time. Indeed, it was clearer to him now, more than ever, that the gentle blue eyes belonged to the gold-green snake, which had wound itself around the large trunk of the elder tree. Now the wonderful sounds of the crystal bells that had delighted and enraptured him radiated from the coils of the snake, so it seemed. As on Ascension Day, he again embraced the elder tree and cried at the twigs and leaves: "Ah, let me see you twining and twisting and coiling in the branches and among the twigs, little green beautiful snake. Once more, look at me with your gentle eyes. Ah, I love you and shall die in agony and grief, if you do not return!"

However, everything remained quite silent as before. Nothing moved. Then, the elder tree's twigs and leaves rustled quite naturally. But Anselmus

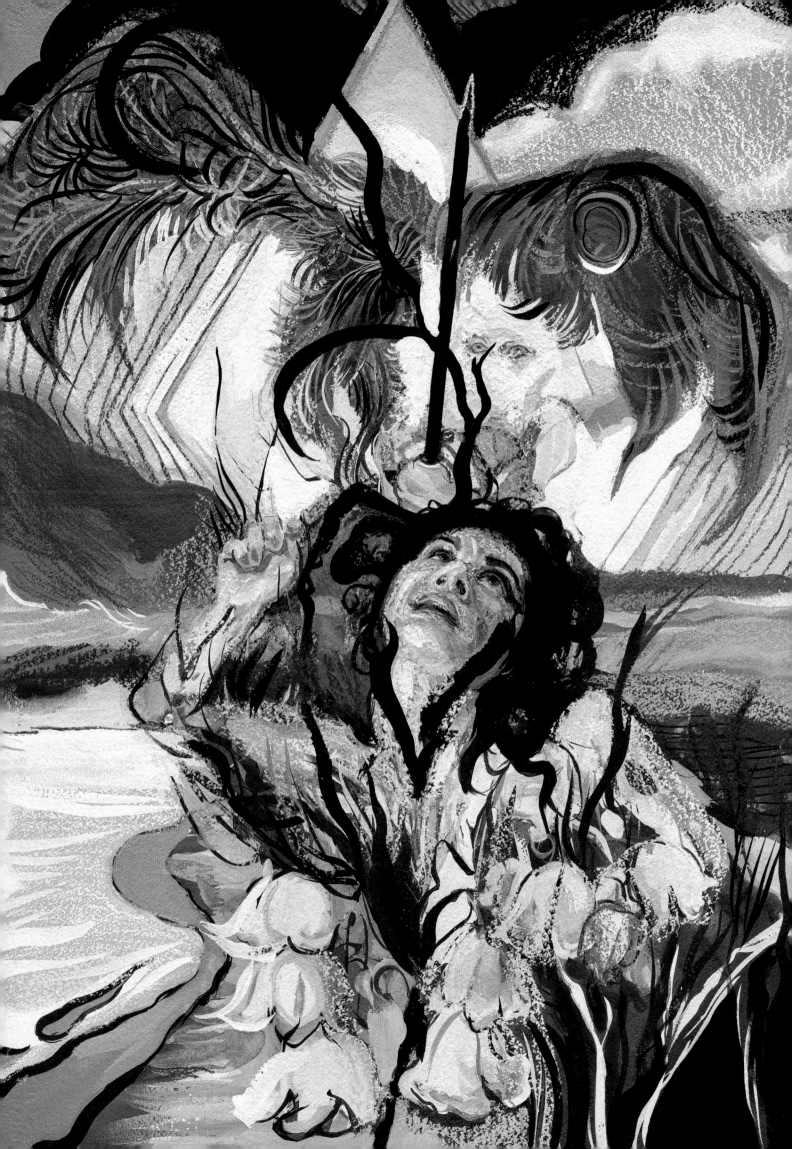

now felt as if he knew what it was that stirred and upset his heart. Indeed, his breast was torn, and he suffered from the pain of an infinite longing. "What else can it be?" he asked. "Clearly, I love you with all my heart and soul. I shall love you until I die, glorious little golden snake. I cannot live without you and I shall perish in hopeless misery, unless I find you again, unless you become the beloved of my heart. But I know it! You will be mine; then all those glorious dreams, which have promised me another higher world, will be realized."

From this moment on, the student Anselmus could be seen beneath the elder tree every evening, when the sun spread its bright golden light over the peaks of the trees. He cried out from the depths of his heart in the most pitiful tones. His voice reached into the branches and leaves, pleading for a sight of his beloved, of his little gold-green snake. Once, while he was carrying on like this, a tall, lean man suddenly appeared before him. He was wrapped in a wide, light gray coat and stared at him with large fiery eyes.

"Hey, hey!" he exclaimed. "What is all this whining and whimpering about? Hey, tell me, is this the student Anselmus, who is supposed to copy my manuscripts?"

Anselmus was stunned and frightened when he heard this voice, for it was the very same one that on Ascension Day had yelled: "Hey, hey! Who's doing all this chattering and jingling?"

Anselmus was so frightened that he could not utter a word.

"What's the matter with you, my boy?" continued Archivist Lindhorst (for the stranger was none other than he). "What do you want with the elder tree, and why haven't you come to see me? Why haven't you started your copying?"

In fact, Anselmus had not yet managed to bring himself to pay a visit to Archivist Lindhorst's home a second time, even though he had decided he would do it. But now, at this moment, when he saw his sweet dreams being torn apart, and, too, by the same hostile voice that had once before carried off his beloved, a sort of desperation came over him, and he exploded fiercely with the following words: "You may think that I'm crazy, or perhaps not, Herr Archivist! It is all the same to me! But here in this tree, on Ascension Day, I saw the gold-green snake. Yes! She is the beloved of my soul, and she spoke to me in glorious crystal tones, while you, sir, yelled and shouted horrible things from across the river."

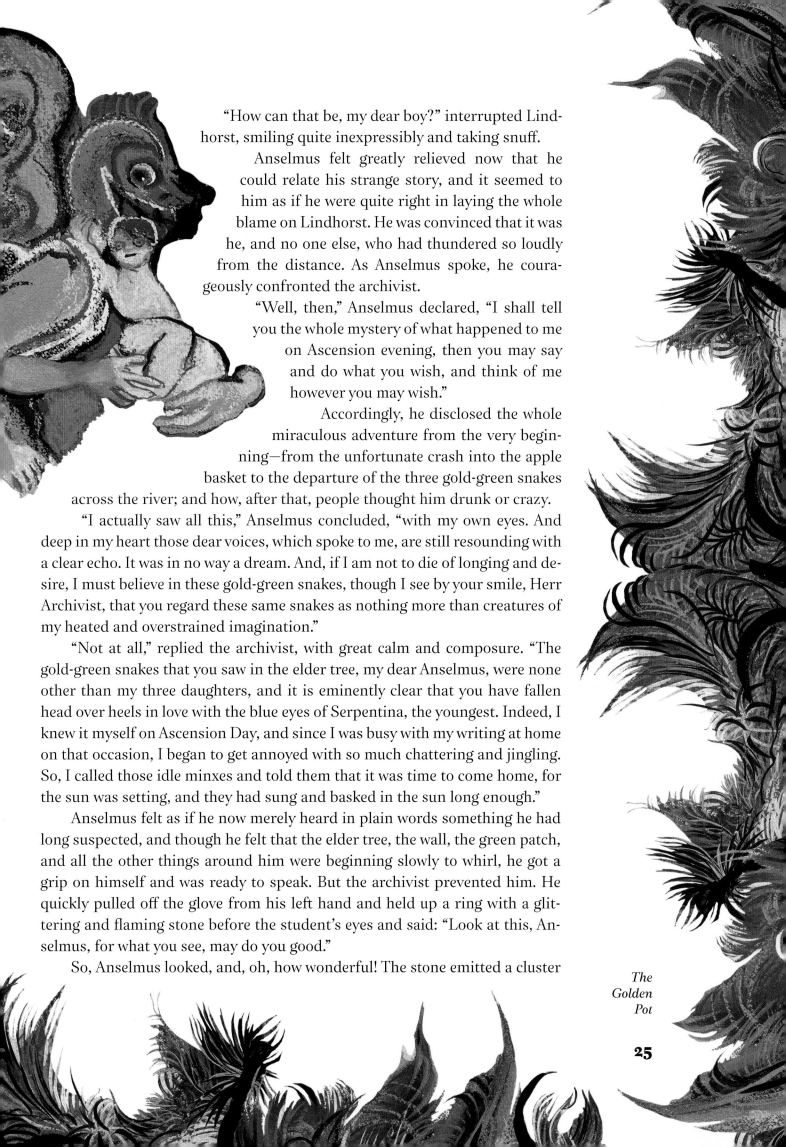

"How can that be, my dear boy?" interrupted Lindhorst, smiling quite inexpressibly and taking snuff.

Anselmus felt greatly relieved now that he could relate his strange story, and it seemed to him as if he were quite right in laying the whole blame on Lindhorst. He was convinced that it was he, and no one else, who had thundered so loudly from the distance. As Anselmus spoke, he courageously confronted the archivist.

"Well, then," Anselmus declared, "I shall tell you the whole mystery of what happened to me on Ascension evening, then you may say and do what you wish, and think of me however you may wish."

Accordingly, he disclosed the whole miraculous adventure from the very beginning—from the unfortunate crash into the apple basket to the departure of the three gold-green snakes across the river; and how, after that, people thought him drunk or crazy.

"I actually saw all this," Anselmus concluded, "with my own eyes. And deep in my heart those dear voices, which spoke to me, are still resounding with a clear echo. It was in no way a dream. And, if I am not to die of longing and desire, I must believe in these gold-green snakes, though I see by your smile, Herr Archivist, that you regard these same snakes as nothing more than creatures of my heated and overstrained imagination."

"Not at all," replied the archivist, with great calm and composure. "The gold-green snakes that you saw in the elder tree, my dear Anselmus, were none other than my three daughters, and it is eminently clear that you have fallen head over heels in love with the blue eyes of Serpentina, the youngest. Indeed, I knew it myself on Ascension Day, and since I was busy with my writing at home on that occasion, I began to get annoyed with so much chattering and jingling. So, I called those idle minxes and told them that it was time to come home, for the sun was setting, and they had sung and basked in the sun long enough."

Anselmus felt as if he now merely heard in plain words something he had long suspected, and though he felt that the elder tree, the wall, the green patch, and all the other things around him were beginning slowly to whirl, he got a grip on himself and was ready to speak. But the archivist prevented him. He quickly pulled off the glove from his left hand and held up a ring with a glittering and flaming stone before the student's eyes and said: "Look at this, Anselmus, for what you see, may do you good."

So, Anselmus looked, and, oh, how wonderful! The stone emitted a cluster

of rays, and the rays wove themselves together into a clear, gleaming crystal mirror in which he saw the three gold-green snakes dancing and coiling, flying apart and twisting together. And when their slender forms, glittering with a thousand lights, touched each other, marvelous tones resounded, as if crystal bells were ringing, and the middle one of the three snakes stretched forth her little head from the mirror, as if full of longing and desire. Then her dark blue eyes said: "Do you know me? Do you believe in me, Anselmus? Only in belief alone can you discover love. Can you love?"

"Oh, Serpentina! Serpentina!" Anselmus cried in mad rapture. But then Archivist Lindhorst suddenly breathed on the mirror, and with an electric sputter, the rays sank back into their focus; and on his hand there was nothing but a little emerald, now covered by the archivist's glove.

"Did you see the golden snakes, Anselmus?" the archivist asked.

"Oh, good heaven, yes!" replied the student. "And the lovely Serpentina."

"Hush!" Lindhorst continued. "Enough for now. As for the other matter, if you decide to work for me, you may see my daughter often enough, or rather, I shall grant you this real satisfaction if you stick tightly and truly to your task—that is to say, copy every mark, sign, and character with the greatest clarity and exactitude. But you have never once called on me, my good student Anselmus, although Registrar Heerbrand promised I would see you very soon, and I have waited several days in vain."

Not until he heard the mention of Registrar Heerbrand's name did Anselmus feel again as if he were really standing with his two feet firmly on the ground. Indeed, he began to realize that he was really the student Anselmus, and a man talking to a man who was really Archivist Lindhorst. The tone of indifference, with which the archivist spoke, was in such rude contrast to the wondrous sights that he, like a genuine necromancer, had called forth, that a certain horror was wakened in the student. This effect was heightened by the piercing look of those fiery eyes, glowing from their bony sockets in the lean visage, as if from some leather case. All this aggravated the student's condition. Once again, Anselmus was overcome by the same uncanny feeling that had taken possession of him in the coffee house when Archivist Lindhorst had

talked so wildly. With a great effort, Anselmus re-
gained his self-control, and as the archivist again
asked, "Well, why haven't you come to see me?"
the student exerted all his energy and told him
what had happened at the front door.

"My dear Anselmus," said the archivist, when
the student had finished, "dear Anselmus, I know
this apple woman whom you mentioned. She is
a disgusting old hag who plays all sorts of vile
tricks on me. But the fact that she has turned
herself into bronze and taken the shape of a door
knocker to deter pleasant visitors from calling on
me, is indeed very bad, and truly not to be endured.
Would you please, worthy Anselmus, come tomor-
row at noon, and if you notice any more of this
grinning and growling, please be so good as to let a
drop or two of this liquor fall on her nose? It will fix
everything immediately. And now, adieu, my dear An-
selmus! I must rush off. Therefore, I would not advise
you to think of returning to town with me. Adieu, till
we meet again. Tomorrow at noon!"

The archivist had given Anselmus a little vial with a
gold-colored liqueur in it, and he walked rapidly away, so rapidly
that in the twilight, which had now arrived, he seemed to be floating in
the air down to the valley rather than walking to it. He could already be seen
near the Kosel Garden. The wind blew inside his large, wide coat and spread
its skirts apart so that they fluttered in the air like a pair of large wings. The
student Anselmus was amazed as he looked at the path taken by the archivist.
It seemed as if a large bird were spreading its wings for rapid flight. And now,
while the student kept gazing into the dusk, a gray-white kite with a creaking
cry soared up into the air, and he now saw clearly that the white flutter that he
had thought was the archivist must have been this kite, though he still could
not grasp how and where the archivist had vanished so abruptly.

"Perhaps he flew away in his own person, this Herr Archivist Lindhorst,"
Anselmus said to himself. "For I now see and feel clearly that all these foreign
shapes of a distant, wondrous world that I never saw before except in peculiarly
remarkable dreams have entered my waking life and are mocking me. But be
this as it may! You live and are glowing in my heart, lovely, gentle Serpentina!
You alone can calm the infinite longing that rends my soul to pieces. Oh, when
shall I gaze into your lovely eyes, my dear Serpentina?" cried Anselmus.

"That is a vile, unchristian name!" murmured a deep voice beside him,

which belonged to somebody who was returning home from a walk. As soon as Anselmus heard this, he was reminded about where he was and rushed off at a quick pace, thinking to himself: "Wouldn't it be a real misfortune now if Rector Paulmann or Registrar Heerbrand were to meet me?"

But neither of these gentlemen crossed his path.

Fifth Vigil

Councilor Anselmus's lady. Cicero's De Officiis.
Monkeys and other strange creatures.
Old Liese. The equinox.

"I am about to wipe my hands of Anselmus," Rector Paulmann declared. "All my good advice, all my admonitions, are fruitless. He won't apply himself to anything—though, I must admit, he is also a fine classical scholar, and that is the foundation of all learning."

But Registrar Heerbrand, with a sly, wondrous smile, replied: "Let Anselmus take his time, my dear Rector! He is a strange young man, this Anselmus, but there is much more to him than we can see, and when I say *much*, I mean he could easily become a privy secretary, or even a court councilor one day.

"A court—" began Rector Paulmann in amazement, but the words stuck in his throat.

"Be quiet!" continued Registrar Heerbrand. "I know what I know. These past two days he has been with Archivist Lindhorst, copying manuscripts. And last night the archivist met me at the coffee house and said: 'You have sent me the perfect man for the job, dear neighbor! There is good stuff in him!' And think of Archivist Lindhorst's influence—so, keep quiet! We shall talk about it a year from now."

And with these words, the registrar, his face still wrinkled with the same sly smile, departed, leaving the astonished rector speechless and curious. He felt as if he had been glued to his chair by some kind of enchantment.

Meanwhile, this conversation had made an even greater impression on Veronica.

"Didn't I know all along," she thought, "that Anselmus was a most clever and handsome young man, who will do great things and become famous one day? If I could only be certain that he is really fond of me. That night when we rowed across the Elbe, I felt him press my hand twice. And then didn't he

look at me as we sang our duet with glances that pierced my very heart? Yes, yes! He really *is* fond of me, and I . . ."

At this point, Veronica abandoned herself to sweet dreams of a happy future, as young ladies are wont to do. She dreamt about herself as the privy councilor's wife who occupied a fine house on the Schlossgasse, or in the Neumarkt, or on the Moritzstrasse. Her fashionable hat and new Turkish shawl suit her admirably, and she pictures herself breakfasting on the balcony in an elegant negligee, giving daily orders to her cook: "Be careful, if you please, and don't spoil that dish. It is the councilor's favorite."

Then, when two dandies come strolling by her home and glance up, she hears distinctly: "Well, she really is a divine woman, the councilor's wife. Just see how beautiful she looks in the lace cap!"

About this time, Madame Ypsilon, the wife of a court official, sends her servant to ask if it would please Madame Privy Councilor to drive as far as the Linke Tavern today.

"Many thanks, but I am extremely sorry. I already have an engagement for tea with the president of the chamber."

Then Privy Councilor Anselmus comes back from his office. He is dressed in attractive clothes that are at the height of fashion.

"Ten, I declare," he cries, making his gold watch repeat the time. And after giving his young wife a kiss, he asks, "How are things, my little wife?"

"Guess what I have here for you?" he continues, in a teasing manner, and pulls out a pair of beautiful earrings from his waistcoat pocket. They have been designed according to the latest fashion, and he puts them on her in place of the old ones.

"Ah! What exquisite earrings!" Veronica cried aloud as she jumped from her chair, throwing aside her work to see those fair earrings with her own eyes.

"What is going on here?" Rector Paulmann asked. He was roused by the noise while deeply immersed in his contemplation of Cicero's *De Officiis*. He almost dropped the book as he exclaimed, "Are we having hallucinations, like Anselmus?"

Yet, just at this moment, the student Anselmus, who, contrary to his custom, had not been seen for several days, entered the room, leaving Veronica astonished and uncomfortable, for, in truth, his whole bearing seemed altered. He now spoke of new possibilities in life with a certain lucidity that was far from usual for him, and he talked about wonderful prospects that were opening for him, but that many men did not have the skill to discern. Rector Paulmann, who recalled Registrar Heerbrand's puzzling remarks, was even more struck and could scarcely

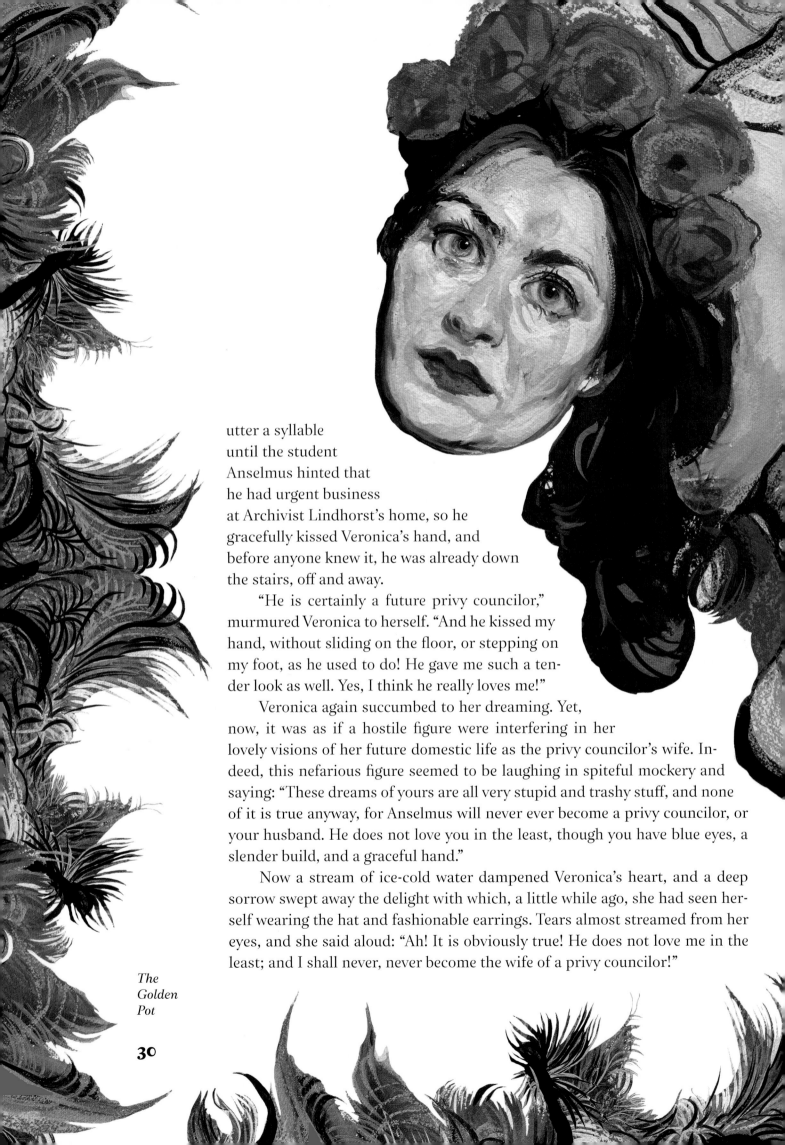

utter a syllable
until the student
Anselmus hinted that
he had urgent business
at Archivist Lindhorst's home, so he
gracefully kissed Veronica's hand, and
before anyone knew it, he was already down
the stairs, off and away.

"He is certainly a future privy councilor,"
murmured Veronica to herself. "And he kissed my
hand, without sliding on the floor, or stepping on
my foot, as he used to do! He gave me such a ten-
der look as well. Yes, I think he really loves me!"

Veronica again succumbed to her dreaming. Yet,
now, it was as if a hostile figure were interfering in her
lovely visions of her future domestic life as the privy councilor's wife. In-
deed, this nefarious figure seemed to be laughing in spiteful mockery and
saying: "These dreams of yours are all very stupid and trashy stuff, and none
of it is true anyway, for Anselmus will never ever become a privy councilor, or
your husband. He does not love you in the least, though you have blue eyes, a
slender build, and a graceful hand."

Now a stream of ice-cold water dampened Veronica's heart, and a deep
sorrow swept away the delight with which, a little while ago, she had seen her-
self wearing the hat and fashionable earrings. Tears almost streamed from her
eyes, and she said aloud: "Ah! It is obviously true! He does not love me in the
least; and I shall never, never become the wife of a privy councilor!"

*The
Golden
Pot*

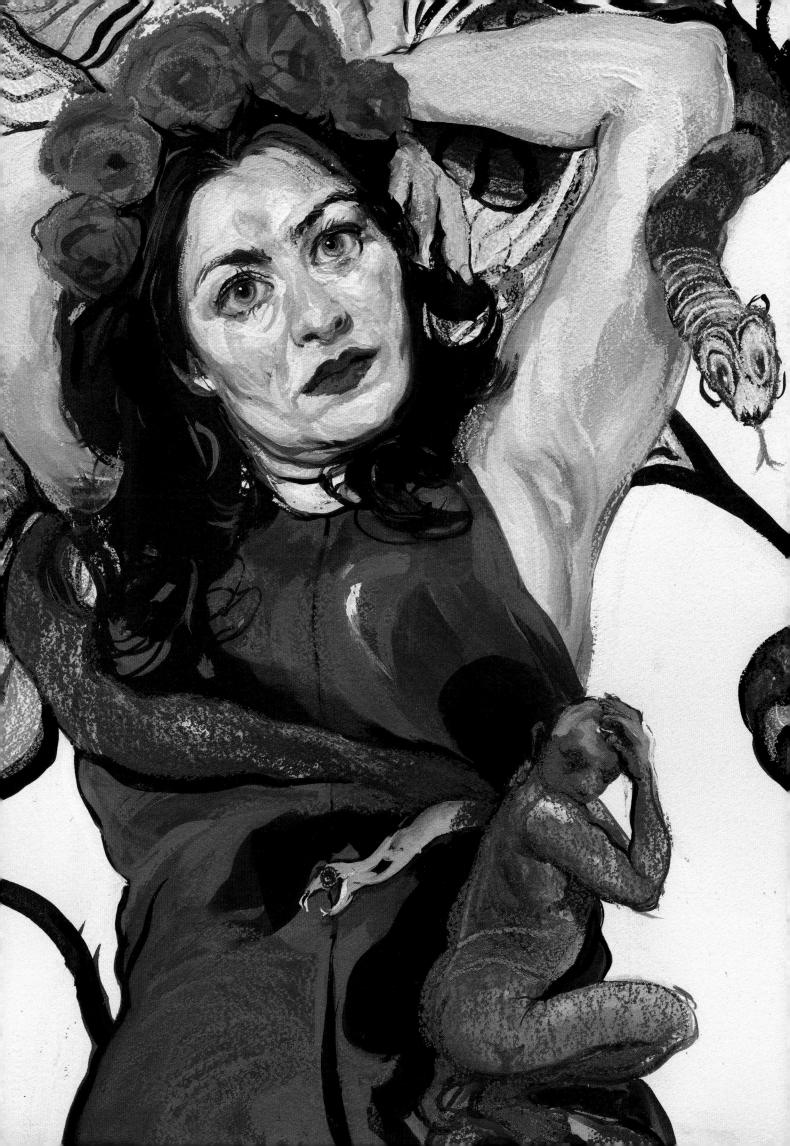

"Romantic rubbish! Romantic rubbish!" cried Rector Paulmann, who grabbed his hat and stick and rushed from the house in a rage.

"This was all I needed," sighed Veronica and felt annoyed by her little sister, Frances, a girl of twelve, because she sat so unconcerned and kept sewing on her frame, as if nothing had happened.

Meanwhile, it was almost three o'clock, and time now to clean the apartment and arrange the coffee table, for Mademoiselles Oster had announced that they were coming to pay a visit. But from behind every sewing box that Veronica lifted, under the notebooks that she took away from the harpsichord, behind every cup, and behind the coffeepot that she took from the cupboard, the nefarious figure appeared like a manikin and laughed in spiteful mockery. Then it snapped its little spider fingers and cried: "He'll never be your husband! He'll never be your husband!"

Even when she threw everything away and fled to the middle of the room, it peered out again with a long nose in gigantic bulk, from behind the stove, and snarled and growled: "He will never be your husband!"

"Don't you hear anything? Don't you see anything?" cried Veronica, trembling with fright, and not daring to touch anything in the room. Meanwhile, young Frances rose from her embroidery frame, quite grave and quiet, and said, "What's troubling you today, sister? You are just making a mess of everything. I see I must help you."

But just at this moment, the gay young visitors came running into the room with brisk laughter, and at the same time, Veronica realized that what she had taken for a nefarious figure was only the stove handle, and the creaking stove door had been the malign voice that had spoken to her. Yet, her feeling of terror persisted, and she could not recover her composure quickly enough to hide the strange excitement from the mademoiselles that was betrayed by her paleness and agitated looks. Consequently, they immediately cut short their merry talk and urged her to tell them what, in heaven's name, had happened. So, Veronica was now obliged to admit that certain strange thoughts had come into her head, and suddenly, in broad daylight, a dread of hallucinations, which she did not normally feel, had gotten the better of her. She described in such vivid detail how a gray manikin, peeping out of all the corners of the room, had mocked and annoyed her. This caused Mademoiselles Oster to look around with timid glances and have all sorts of uncanny notions. But Frances entered at this mo-

ment with the steaming coffeepot, and the three visitors regained their composure and laughed outright at their folly.

Angelica, the elder of the Osters, was engaged to an officer. The young man had joined the army, and his friends had not heard from him for such a long time there was little doubt but that he was dead, or at least grievously wounded. Such bad news had caused Angelica to fall into a deep depression, but today she was cheerful, even a bit boisterous. All this surprised Veronica so much that she felt she had to inquire about it.

"My dear friend," said Angelica, "do you think that my Victor is not in my heart and thoughts all the time? It is because of him I am so happy. Thank heaven! I am happy to be so blessed in my whole life! I am sure that my Victor is well. Soon he will be home and promoted to captain and decorated with the honors that he has won. He suffered such a deep, but not dangerous, wound in his right arm that he received from a French hussar's sword. Since the army keeps moving and changing quarters, he is prevented from writing, for he will not consent to leave his regiment, and all this makes it impossible for him to send me tidings. But tonight, he will be ordered home, until his wound is healed. Tomorrow, he will set out for home; and just as he is stepping into the coach, he will learn of his new promotion to captain."

"But, my dear Angelica," interrupted Veronica, "how do you know all this?"

"Do not laugh at me, my friend," continued Angelica. "Surely you won't laugh, otherwise the gray manikin might punish you by peeping out from behind the mirror there. I cannot put aside my belief in certain extraordinary things because I have often enough seen and felt their manifestations in my life. For example, I don't consider it so strange and incredible, as many others do, that there are people gifted with a certain faculty of prophecy. In the city, there is an old woman who possesses this gift to a great degree. She doesn't use cards, nor molten lead, nor coffee grounds, like ordinary fortune-tellers, but after certain preparations, in which you yourself participate, she takes a polished metallic mirror, and she mixes the strangest figures and forms in it until they rise. Then she interprets these manifestations and answers your questions. I was with her last night and received news of my dear Victor, and I have not doubted this information for a moment."

Angelica's story seemed to light a spark in Veronica's mind, and it instantly kindled her desire to consult this old prophetess about Anselmus and her hopes

for the future. She learned that the crone was called Frau Rauerin, that she lived in a remote street near the Seethor and could only be consulted on Tuesdays, Thursdays, and Fridays, from seven o'clock in the evening until sunrise, and that she preferred her clients to come alone. Since it was now Thursday evening, Veronica decided, under pretext of accompanying the Osters home, to visit this old woman, and that is what she did.

Consequently, no sooner had her friends, who lived in the Neustadt, separated from her at the Elbe Bridge than she hurried toward the Seethor. It did not take her long to reach the remote narrow street described to her. At the end of it, she saw the little red house in which Frau Rauerin was said to live. She could not get rid of a certain dread, that is, of a certain horror, as she approached the door. At last, she summoned her courage, in spite of her inner terror, and she bravely pulled the bell. When the door opened, Veronica groped her way through the dark passage for the stairs, as Angelica had directed, which led to the upper story.

"Does Frau Rauerin live here?" Veronica yelled into the empty hallway, because no one had appeared. Instead of an answer, however, she heard a long, clear "Miaow," and a large black cat appeared, with its back arched and swishing its tail back and forth in wavy curls. Slowly, the cat moved in front of her to the door of the apartment, which opened on a second "Miaow."

"Ah, what do I see now? Have you come to visit me already, my daughter? Come in, my dear, come in!"

A strange figure walked toward Veronica, and her appearance made the poor girl freeze on the spot. A tall, lean woman, wrapped in black rags from head to foot, appeared and began talking. While she spoke, her chin wagged back and forth; her toothless mouth, overshadowed by a bony hawk nose, twisted itself into a ghastly smile, and gleaming cat eyes flickered in sparkles through large spectacles. From beneath a multicolored scarf, wrapped around her head, clumps of black wiry hair were sticking out, but what caused her haggard face to exude absolute horror were two large burnt scars that ran from her left cheek to her nose. Veronica's breathing seemed to fail her, and the scream, which was about to burst from her choked throat, became a deep sigh, as the witch's skeletal hand seized her and led her into the adjoining room.

Here, everything was awake and moving. There was nothing but noise and chaos—squeaking, meowing, croaking, and piping all at the same time. The

crone struck the table with her fist and screamed: "Quiet down, you vermin!" Immediately, the cats whimpered and climbed to the top of the large bed. The little monkeys all ran beneath the stove, and the raven fluttered up to the mirror. As if the rebuke did not apply to him, the black cat kept sitting at his ease on the cushioned chair, upon which he had leapt directly after entering.

So, soon as the room became quiet, Veronica took heart. She felt less frightened than she had outside in the hall. Now, the crone herself did not seem to be so hideous. For the first time, Veronica looked around the room. All sorts of odious stuffed beasts hung from the ceiling. Strange household implements were scattered in confusion on the floor; and there was a scanty blue fire in the grate that only now and then sputtered yellow sparkles; and at every sputter, a rustling from above and monstrous bats could be heard, like distorted laughter of humans that resounded all over the place. Sometimes the flames shot up, licking the sooty wall, then the sounds of howling and woeful tones shook Veronica with fear and terror.

"With your permission, Mamsell!" the crone said, knitting her brows and seizing a brush, which she dipped into a copper skillet and then shook over the grate. The fire went out; and as though it had filled with thick smoke, the room grew pitch-black, but the crone, who had gone into a closet, soon returned with a glowing lamp. Now Veronica could not see any beasts or instruments in the apartment. To her surprise, it was a common and meagerly furnished room. The crone came up to her and said with a creaking voice: "I know what you wish, little daughter. You want me to tell you whether you will marry Anselmus when he is a privy councilor."

Veronica froze with amazement and terror, but the crone continued: "You revealed this to me at your father's home, when the coffeepot was standing before you. Indeed, I was the coffeepot! Didn't you recognize me? Listen to me, my daughter! Give up! You must give up this Anselmus! He is a nasty creature! He stamped on my little sons and crushed them! My dear little sons, the apples with the red cheeks that glide away after people have bought them. Whisk! They roll out of their pockets and back into my basket. That young man Anselmus is no good. He is on the old fellow's side. Only the day before yesterday he poured that cursed ointment on my face, and I nearly went blind. You can still see the burn marks. My dear little girl, give him up, give him up! He does

not love you. Instead, he loves the gold-green snake. He will never become a privy councilor because he has joined the Salamanders, and he intends to marry the green snake. Give him up! You must abandon him!"

Veronica, who had a firm, steadfast character and was able to conquer her dreadful feelings, now stepped back and said, with a serious and resolute tone: "Old woman! I heard of your gift of reading the future and intended, perhaps too curiously and thoughtlessly, to learn from you whether Anselmus, whom I love and value, could ever be mine. But if, instead of fulfilling my desire, you keep annoying me with your foolish, insensible babble, you are doing me a wrong! I asked nothing from you other than what you grant others, as I well know. Since you are apparently acquainted with my innermost thoughts, it might have been an easy matter for you to reveal to me much that now pains and grieves my mind. But now, after your silly slander of the good Anselmus, I do not care to talk anymore with you. Good night!"

Veronica started to leave hastily, but the crone, with tears and lamentation, kneeled down and, grabbing the young lady's gown, exclaimed: "Veronica! Veronica! Have you forgotten old Liese? Your nurse who had so often carried you in her arms and bounced you tenderly on her knee?"

Veronica could scarcely believe her eyes, for here, in fact, was her old nurse, marked only by great age and by the two burns. The crone was, indeed, old Liese, who had vanished from Rector Paulmann's house some years ago. Nobody knew where she had gone. Moreover, the crone had quite another look now. Instead of the ugly kerchief, she was wearing a decent cap, and instead of the black rags, she had on a bright, multicolored jacket. Clearly, she was neatly dressed, the way she was many years ago. Now, she rose from the floor and, taking Veronica in her arms, proceeded to speak to her: "What I have just told you may seem crazy, but unfortunately, it is too true. Anselmus caused me a good deal of trouble, though it is not his fault. He has fallen into the hands of Archivist Lindhorst, and this weird man intends to wed him to his daughter. Let me tell you, Archivist Lindhorst is my deadliest enemy. I could tell you thousands of things about him, which, however, you would not understand, or at best, you would simply be too frightened to understand. He is a wise man, it seems; but I am a wiser woman. So, let it be! I see now that you love this Anselmus, and I will help you with all my powers so that you may be happy and wed him like a pretty bride, as you wish. . . ."

"But tell me, for heaven's sake, Liese . . ." interrupted Veronica.

"Be quiet, child! Shut up!" cried the old woman, interrupting Veronica in her turn. "I know what you want to say. I have become what I am because it was meant to be. I had no choice. Well, then! I know a remedy that will cure Anselmus of his fascination for the green snake. He will become the most handsome privy councilor you know, and I shall lead him into your arms. But you yourself must help."

"Tell me, Liese. I will do anything and everything to win him, for I love Anselmus very much!" Veronica whispered in a very low voice.

"I know you," continued the crone. "I know that you are a courageous child. I could never frighten you to sleep with bogeyman stories. Instead, the instant I told them, your eyes would open, and you would go into the darkest room without a candle. Sometimes you would put on your father's coat and terrify the neighbor's children. Well, then, if you are serious about defeating Archivist Lindhorst and the green snake with the help of my art, if you are serious about calling Anselmus your handsome privy councilor and your husband, then, at the next equinox, about eleven o'clock at night, sneak out of your father's house and come here. I will go with you to the crossroad nearby in the open field. We shall take what is needed, and whatever wonders you may see will not harm you in the least. And now, my dear, good night! Your father is waiting for you to begin supper."

Veronica immediately hurried away. She was determined not to neglect the night of the equinox.

"Old Liese is right," she thought to herself. "Anselmus has become entangled in strange affairs, but I will free him from them and call him mine forever. He will be mine forever, and he shall also be known as Anselmus, the privy councilor."

Sixth Vigil

Archivist Lindhorst's garden, with some mocking birds. The Golden Pot. English cursive script. Horrid pothooks. The Prince of the Spirits.

"It may be, after all," the student Anselmus said to himself, "it may be the special and potent liqueur I drank somewhat freely in Herr Conradi's shop

The Golden Pot

that's the cause of all these shocking hallucinations that frightened me outside Archivist Lindhorst's door. Therefore, I'm determined today to stay sober, and I shall ward off all those mischievous forces that might attack me."

On this occasion, just as he had done before during his first visit to Archivist Lindhorst's home, Anselmus stuffed his pen drawings and calligraphic masterpieces, his bars of India ink, and raven quill pens that were well sharpened into his pockets. As he was about to leave, his eye caught sight of the vial with the yellow liqueur, which he had received from Archivist Lindhorst. All at once, he began recalling in vivid colors those strange adventures he had experienced, and his heart was pierced by a drastic feeling of rapture and pain. Unable to control himself, he exclaimed in a most pitiful voice, "Ah, gentle, lovely Serpentina, am I going to the archivist's home just to see you?"

At that moment, he felt as if Serpentina's love might be the reward for some perilous and arduous task that he would have to undertake successfully, and it was as if this task were nothing but the copying of Lindhorst's manuscripts. If this were the case, he anticipated all sorts of incredible things that might happen at the entrance to the house, or even outside it, just as he had experienced such uncanny conditions before. So, he stopped thinking about Herr Conradi's strong liqueur. Instead, he put the vial of liqueur into his waistcoat pocket so he would be able to follow the archivist's strict instructions if the bronze apple woman should appear and make all sorts of weird faces at him. He was right to do so, for her pointed nose jutted from the door, and she flashed her green cat eyes at him from the door knocker as he was about to raise his hand to it at the stroke of twelve.

Without hesitating a second, Anselmus squirted the liqueur onto the hor-

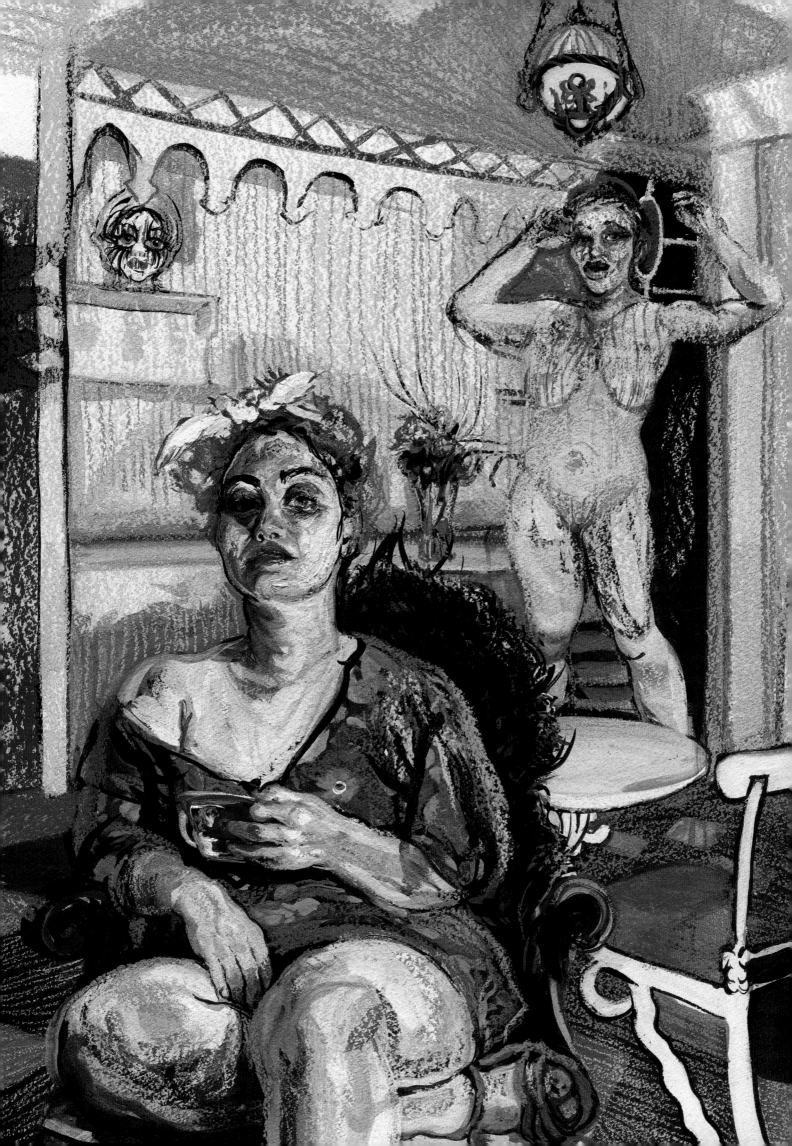

rid fatal face, and it folded and molded itself instantly into a gleaming round door knocker. Consequently, the door opened, and the bells sounded beautifully all over the house: "Kling-a-ling—in-in—quick-quick—skip along—ting-a-ling!"

Anselmus cheerfully entered and climbed the fine broad stairs, enjoying the scent of some strange odor that was floating through the house. Somewhat confused, he paused in the hallway because he did not know where he should knock. Fortunately, Archivist Lindhorst, dressed in a damask dressing gown, emerged from one of the rooms and said: "Well, it is a real pleasure, my good Anselmus, to see that you have kept your word at last. Come this way, if you please. I must take you straight to the laboratory."

With these words, he strode rapidly through the hall and opened a little side door that led into a long corridor. In high spirits, Anselmus followed the archivist. They passed from this corridor into a hall, or rather, a magnificent conservatory, for all sorts of rare, wondrous flowers grew on both sides up to the ceiling, along with large trees, strangely formed leaves, and blossoms. A dazzling magical light gleamed over the entire room, though it was impossible to tell where it came from, since not a single window could be seen. As Anselmus peered inside through the bushes and trees, long avenues seemed to stretch into a remote distance. In the shadows of dense cypress groves, he saw glittering marble fountains, out of which rose wondrous figures, sprouting crystal jets that fell, splashing into the gleaming lily cups. Strange voices murmured and rustled through the forest of unusual plants and trees, and the sweetest odors streamed up and down and all around.

The archivist had vanished, and Anselmus saw nothing but a huge bush of glowing fire lilies before him. Intoxicated by the sight and the sweet fragrance of this fairy garden, Anselmus stood as though he were glued to the spot and could not move. All of a sudden, there was a giggling and tittering on all sides of him. Clear, tiny voices began teasing and mocking him.

"My dear student, how did you get in here? Why did you spruce up in such a stylish way, Herr Anselmus? Will you chat with us for a minute or two and tell us how grandmother sat down upon the egg and squashed it, and how the young count got a stain on his Sunday waistcoat? Have you already memorized the new aria that you learned from Daddy Starling? How very impressive you are with your glass wig and brown paper boots!"

No matter where he turned, Anselmus was inundated by all this chatter-

ing and mocking that he heard from every corner of the large room. Indeed, the student now saw that all sorts of multicolored birds were fluttering above him and teasing him. Just at that moment, bushes of fire lilies advanced toward him, and he realized that it was Archivist Lindhorst, whose flowered dressing gown, glittering in red and yellow, had deceived his eyes.

"I beg your pardon, my good fellow, for leaving you alone," the archivist said. "But I decided to take a quick peek at my fine cactus while we were walking in the hallway, because it is supposed to bloom tonight. So, tell me now, how do you like my little garden?"

"Good heavens! It is amazingly beautiful, Herr Archivist," the student replied. "However, these multicolored birds have been bantering me a great deal."

All at once, the archivist yelled angrily at the bushes, "What do you think you are doing?"

Then, out of nowhere, a huge gray parrot flew and perched itself on a myrtle bough next to the archivist. Looking at him with uncommon seriousness and gravity through a pair of spectacles that stuck on its hooked bill, the parrot stated, "Don't take it amiss, Anselmus, my boys are a bit wild at times and have perhaps overdone things, but I must confess that you, my dear student Anselmus, have nobody to blame in the matter, for——."

"Be quiet! Be quiet, I say!" interrupted Archivist Lindhorst. "I know the rascals, but you must keep them under better control, my friend! Now come along, Anselmus."

The archivist strode forth again through many strangely decorated rooms so that Anselmus had trouble keeping up with him and had very little time to look at all the glittering, wondrous furniture and other unfamiliar objects with which all the rooms were filled. At last, they entered a large chamber, where the archivist stopped and looked above him so that Anselmus had time to feast his eyes on the magnificent sight, afforded by the simple ornaments in this room. Jutting from the azure-colored walls, the gold-bronze trunks of tall palm trees arose and wove their colossal leaves, glittering like bright emeralds and forming an arch just below the ceiling. In the middle of the room, three Egyptian lions, cast out of dark bronze, supported a porphyry plate on which a simple flowerpot made of gold was standing. As soon as Anselmus saw it, he could not take his eyes off the pot. It was as if, in a thousand gleaming reflections, all sorts of shapes were playing on the brightly polished gold. Sometimes he saw his own

The Golden Pot

41

form, with arms outstretched in longing for Serpentina. Alas! He was beneath the elder tree and could not reach her—and Serpentina was slithering up and down, and once again gazing at him with her lovely kind eyes. Anselmus was aroused and could not control his rapture.

"Serpentina! Serpentina!" he yelled. Lindhorst whirled around abruptly and exclaimed, "What is going on, Herr Anselmus? If I am not wrong, you have done my daughter the honor of calling for her. However, she is in the other part of the house at present, taking a lesson on the harpsichord. Let us move on."

Anselmus barely knew what he had done and just followed the archivist, scarcely conscious of his surroundings. He saw and heard nothing more until Archivist Lindhorst suddenly grabbed his hand and said: "This is the place!"

Anselmus awoke as if from a dream and realized that he was in a room with high ceilings lined on all sides with bookshelves similar to an ordinary library or study. In the middle stood a large writing table with a stuffed armchair before it.

"This," said Archivist Lindhorst, "is your workroom for the present. Whether you may work some other time in the blue library, where you so suddenly shouted my daughter's name, I'm not sure yet. But for now, I would like you to convince me of your ability to do the work assigned to you in the way I wish and need it."

Anselmus summoned all his courage, more than certain that he would impress and please Archivist Lindhorst, and so he pulled out his drawings and specimens of his penmanship from his pocket. But no sooner had the archivist examined the first page of writing in the finest English style than he smiled very oddly and shook his head. He did the same with every page shown to him so that Anselmus felt the blood mounting to his face. And at last, when the archivist's smile became quite sarcastic and contemptuous, Anselmus exploded in anger.

"Well, Archivist Lindhorst seems to be an expert and not content with my poor talents!"

"My dear Anselmus," Archivist Lindhorst responded, "you are, indeed, capable in the field of calligraphy. But, in the meantime, it is clear enough that I must depend more on your diligence and good will than on your skill and achievements."

In his defense, Anselmus spoke at length about how people had often

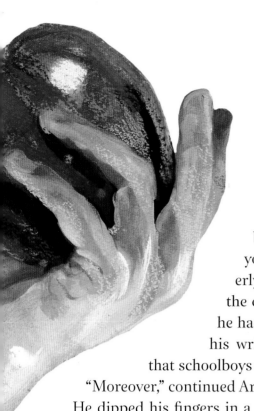

commended his perfection in this field of art, about his fine Chinese ink, and high-quality raven quills. But Archivist Lindhorst just handed him the sheet with English on it and said, "You be the judge yourself!"

When he saw how wretched his handwriting appeared, Anselmus felt as if he had been struck by lightning. It was miserable beyond measure. The pressure had not been properly applied. There was no proportion between the capital and single letters. Every now and then, he had some modest success, but for the most part, his writing was spoiled by those terrible pothooks that schoolboys often scrawled.

"Moreover," continued Archivist Lindhorst, "your ink will not last."

He dipped his fingers in a glass of water, and as he skimmed them over the lines, they vanished without a trace. Anselmus felt as if some monster were throttling him. He could not utter a word. There he stood with the unfortunate sheet of paper in his hand while Archivist Lindhorst laughed loudly and said, "Never mind, my dear Anselmus, don't be discouraged. What you could not do so well in the past, you will perhaps have better success here with me in the future. At any rate, you will have better materials than you have been accustomed to using. So, pluck up your spirits, and get to work."

Then the archivist opened a cupboard and brought out a fluid black substance that emitted a peculiar odor. He also fetched sharply pointed pens in strange colors along with a sheet of paper, exceptionally white and smooth, and finally, an Arabic manuscript. As soon as Anselmus sat down to work, the archivist left the room.

Anselmus had often copied Arabic manuscripts before. Therefore, the first task did not seem all that difficult. "How those pothooks got into my fine English cursive script, only God and the archivist know," he said, "but they are not from my hand, and I will swear that they are not from my hand until I die!"

Every new word that he inscribed on the parchment increased his spirit as well as his adroit skill. The pens wrote exquisitely, and the wondrous ink flowed pliantly and jet black on the bright white parchment. As he worked, so diligently and with such intense concentration, he began to feel more and more at home in the solitary room and confident that he would and could finish the task before him.

Then, at the stroke of three, the archivist called him into the side room to share a delicious lunch. The archivist was in an especially good mood at the table. He inquired about Anselmus's friends Rector Paulmann and Reg-

istrar Heerbrand, and he had many inter-
esting anecdotes to tell about the latter in
particular. Anselmus took great pleasure in
the good old Rhine wine, which made him
more talkative than usual. At the stroke
of four, he rose to resume his work, and
this punctuality appeared to please the
archivist.

The copying of these Arabic manu-
scripts had gone very well before the meal, but
now the work continued to be even better. In-
deed, Anselmus himself was amazed by the
rapidity and ease with which he managed
to succeed in transcribing the curlicues
of this foreign script. But it was as if
there were a voice whispering audible words
in his innermost soul: "Ah! Could you have ac-
complished so much if you were not thinking of *her*,
and if you did not believe in *her* and in *her* love?" Then faint
whispers and crystal tinkling could be heard floating through
the room: "I am near, near, near! Have no fear. I can help. Be brave, be
steadfast, dear Anselmus! I am working with you so that you may be mine!"

And as soon as he heard these sounds, he felt such rapture that it helped
him to understand the unknown characters more clearly. He scarcely had to
look at the original at all. In fact, it was as though the letters were already
traced in pale ink on the parchment, and he had nothing more to do but fill
them in with black ink by his practiced hand.

So, Anselmus continued working, surrounded by inspiring tones and a
soft, sweet breath until the clock struck six and Archivist Lindhorst entered
the room. He moved toward the table with a singular smile, as Anselmus rose
in silence. The archivist still looked at him with that mocking smile, but no
sooner did he glance at the copy than the smile transformed itself into a deep
solemn earnestness, which every feature of his face adapted itself to express.
He no longer seemed the same. His eyes, which usually gleamed with sparkling
fire, now looked with considerable mildness at Anselmus. A soft red tinted
his pale cheeks. And instead of the irony that, at other times, compressed his
mouth, the softly curved, graceful lips now seemed to be opening for wise and
soul-persuading speech. He stood taller and more dignified. The white dressing
gown spread itself like a royal mantle in broad folds over his chest and shoul-
ders, and through the white locks that lay on his high, open brow, there was a
thin band of gold.

The Golden Pot

"Young man," began the archivist in a solemn tone, "before you were aware of it, I knew all about you and the secret relations that bind you to my dearest and most sacred possession! Serpentina loves you, and a unique destiny, whose fateful threads were spun by evil enemies, will be fulfilled when she becomes yours, and when you obtain her dowry, the Golden Pot, which rightfully belongs to her. But your happiness in a better and higher life can only be gained through effort and struggle. Hostile forces seek to deter you, and only your inner strength, which will help you resist their attacks, can save you from disgrace and ruin. By working here you will be serving your apprenticeship and learning how belief and full knowledge can move you closer to your goal. If you are tenacious, you will succeed. Carry *her* always in your heart and thoughts. Remember, my daughter Serpentina loves you. If you do, then you will discover the marvels of the Golden Pot and be happy forever. Farewell! Archivist Lindhorst expects you to arrive tomorrow noon in his cupboard. Farewell!"

With these words, Archivist Lindhorst gently pushed the student Anselmus out the door and then locked it. Anselmus found himself in the room where he had eaten. Its only door led out to the corridor. Completely stupefied by these strange phenomena, Anselmus lingered at the street door. Then he heard a window open above him and he looked up. It was Archivist Lindhorst, quite the old man again, in his usual light gray gown.

"Hey, Herr Anselmus," the archivist called to him. "What are you pondering over there? Is the Arabic still in your head? Please give my regards to Rector Paulmann, if you see him, and come tomorrow precisely at noon. You'll find the payment for your work today in the right-hand pocket of your waistcoat."

Indeed, the student Anselmus found the silver coins in the indicated pocket, but he derived no pleasure from it.

"What is to become of all this?" he asked himself. "I can't tell, but even if it is some mad delusion and conjuring work that has taken hold of me, my dear Serpentina still lives and moves deep in my heart, and I would sooner die than leave her, for I know that the feeling in me is eternal, and no evil force can destroy it. But is this feeling nothing else but Serpentina's love?"

The Golden Pot

45

Seventh Vigil

How Rector Paulmann emptied his pipe and went to bed.
Rembrandt and Brueghel. The magic mirror and Doctor Eckstein's
prescription for an unknown illness.

At last, Rector Paulmann knocked the ashes out of his pipe and said: "Now then, it is time to go to bed."

"Yes, indeed," replied Veronica, frightened by her father's sitting so late, for the clock had struck ten long ago. Accordingly, no sooner had the rector withdrawn to his study and bedroom, and Frances's heavy breathing signified that she was asleep, than Veronica, who, to save appearances, had also gone to bed, rose quietly out of it again, put on her clothes, wrapped her coat around her, and glided through the open door.

Ever since Veronica had left old Liese, she continued to imagine a life with Anselmus, and it seemed as if a voice that was strange to her kept repeating in her mind that he was reluctant because he was held prisoner by an enemy and that Veronica, by secret means of magic, could break these bonds. Her confidence in old Liese grew stronger every day, and even the impression of unearthliness and horror had become less frightening by degrees so that all the mystery and strangeness of her relation to the crone appeared before her only in the color of something singular, romantic, and mildly attractive. Accordingly, she had a firm purpose, even at the risk of startling her parents and encountering a thousand inconveniences, to undertake the adventure of the

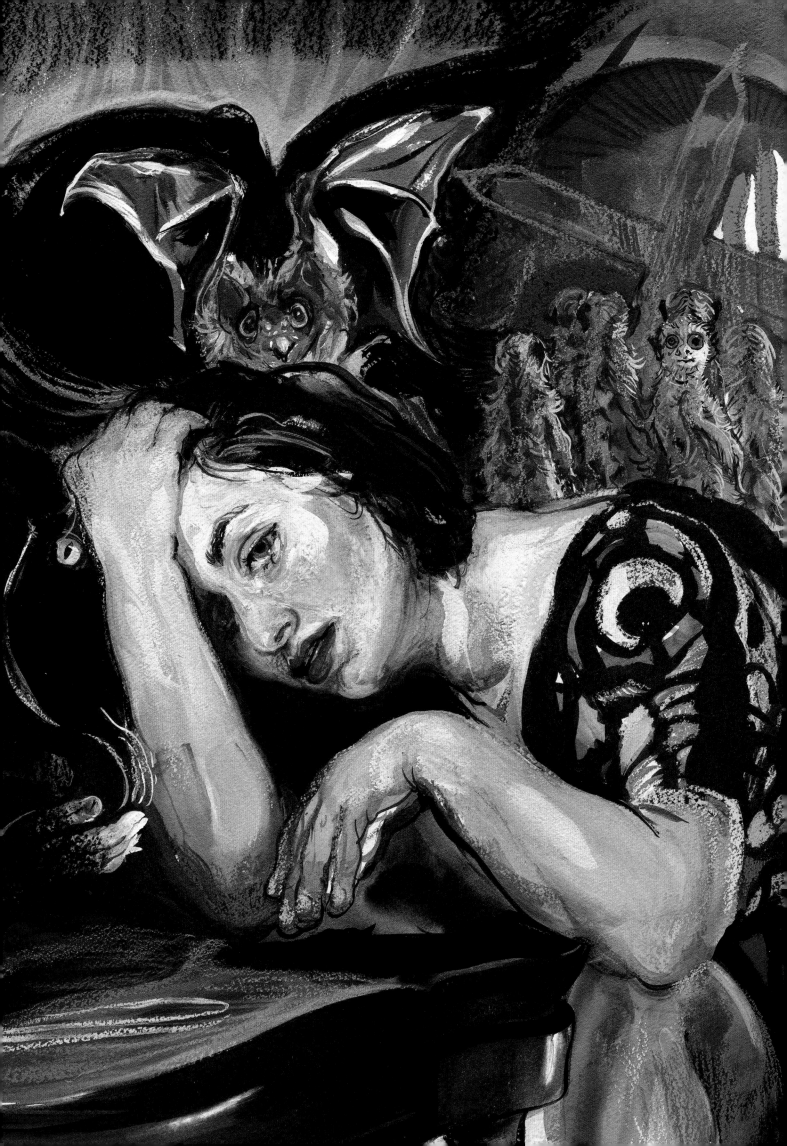

equinox. At last, the fateful night, in which old Liese had promised to afford comfort and help, had come, and Veronica, long used to thoughts of nocturnal wandering, was full of courage and hope. She rushed through the solitary streets, heedless of the storm that was howling in the air and pouring thick raindrops in her face.

The clock at the Church of the Cross struck eleven with a dull droning clang, as Veronica, quite wet, reached old Liese's home.

"Are you here, dear? Wait, love. Wait, love!" cried a voice from above. And within seconds, the crone stood at the door with a basket and her cat. "We will go, then, and do what is necessary and appropriate, and this night we shall also benefit from the weather, which favors our work."

Upon saying this, the crone seized the shivering Veronica with her cold hand and gave her the heavy basket to carry, while she herself produced a little cauldron, a trivet, and a spade. By the time they reached the open field, the rain had ceased, but the storm had become louder, howling in a thousand tones and flitting through the air. A horrible lament, strong enough to pierce hearts, could be heard from the black clouds, which rolled themselves together in rapid flight and veiled everything in thick darkness. But the crone stepped briskly forward, crying in a shrill harsh voice: "Light! Light the way, my boy! Light!"

Then blue lightning quivered and sputtered before them, and Veronica perceived that it was the cat emitting sparks and leaping forward to illuminate the way, while his doleful, ghastly screams were heard in the momentary pauses of the storm. Her heart almost failed. It was as if ice-cold talons were clutching her soul, but she made a strong effort, collected herself, and pressed closer to the crone. "We must accomplish everything now," she said, "come what may!"

"Right, right, my little daughter!" replied the crone. "Be steady, like a good girl, and I'll give you something nice with Anselmus to boot."

At last, the crone paused and said: "Here is the place!"

Then she dug a hole in the ground, shook coals into it, put the trivet over them, and placed the cauldron on top. While doing this, she made strange gestures, while the cat kept circling around her. Sparks sputtered from his tail and then formed a ring of fire. The coals began to burn, and at last blue flames rose up around the cauldron. Veronica was ordered to take off her coat and veil and kneel down beside the crone, who seized her hands and pressed them hard,

glaring with her fiery eyes at the maiden. Before long, the strange materials—flowers, metals, herbs, beasts, it was difficult to determine—that the crone had taken from her basket and thrown into the cauldron, began to seethe and foam. The crone let go of Veronica, then clutched an iron ladle and plunged it into the glowing mass, which she began to stir. Meanwhile, she commanded Veronica to concentrate and look steadily into the cauldron and fix her thoughts on Anselmus. Now the crone threw fresh ingredients, glittering pieces of metal, a lock of hair that Veronica had cut from her head, and a little ring into the pot. The old woman howled in dread, yelling through the gloom, and the cat, in quick, incessant motion, whimpered and whined.

I wish very much, gentle reader, that on this twenty-third of September, you had been on the road to Dresden. That when night sank down upon you, the people at the last staging post had tried to keep you there. That the friendly innkeeper had pointed out to you that the storm and the rain were too bitter, and moreover, for all sorts of uncanny reasons, it was not safe to travel in the dark on the night of the equinox, but that you had paid no attention to him, thinking to yourself: "I will give the coachman a silver coin as a tip, and so, at latest, by one o'clock I shall reach Dresden. There in the Golden Angel or the Helmet or the city of Naumburg a good supper and a soft bed await me."

And now, as you ride toward Dresden through the dark, you suddenly observe in the distance a very strange, flickering light. When you come nearer, you can distinguish a ring of fire, and in its center, beside a pot, out of which a thick vapor is mounting with quivering red flashes and sparks, two very different forms are seated. Your path leads straight through the fire, but the horses snort, and stamp, and rear. The coachman curses and prays and doesn't spare his whip. However, the horses will not stir from the spot. Without thinking, you leap out of the stagecoach and rush toward the fire.

And now, you clearly see a beautiful girl, obviously of gentle birth, who is kneeling by the cauldron in a thin white nightdress. The storm has loosened her braids, and her long chestnut-brown hair is floating freely in the wind. Her sweet face can be distinguished in the dazzling light from the flame flickering from beneath the metal stand, but you perceive the horror that has poured over her like an icy stream. Her face is frozen and pale as death, and you can tell

from her eyebrows and her mouth, vainly opened, for the shriek of anguish cannot find its way from her compressed bosom, that she is overwhelmed by an unnamable torment and horror. She holds her small hands, spasmodically pressed together, high in the dark air, as if she were calling and praying for her guardian angel to deliver her from the monsters of the pit, which, in obedience to this potent spell, are to appear at any moment! There she kneels, motionless like a marble figure. Then you see opposite her a long, shriveled, copper-yellow crone with a sharp hawk nose and glistening cat eyes. Skinny naked arms stick out from the black cloak draped round her as she stirs the hell broth, and she laughs and cries with a creaking voice through the raging, bellowing storm.

I can well believe that disturbing feelings may arise in you, even though you may not be acquainted with such feelings of fear and dread as those pictured by Rembrandt or Breughel taking place in actual life. Indeed, the hairs of your head might have stood on end in horror. But your eye could not turn away from the gentle girl entangled in these infernal doings, and the electric stroke that quivered through all your nerves and kindled in you with the speed of lightning the courageous thought of defying the wondrous powers of the ring of fire. At this thought, your horror disappeared, for the thought itself came into being from your feelings of horror, as their product. Your heart felt as if you yourself were one of those guardian angels to whom the maiden, frightened almost to death, was praying, as if you must instantly whip out your pocket pistol and without further ceremony blow the hag's brains out.

But while you were thinking of this incident most vividly, you cried aloud, "Holla!" or "What's the matter here?" or "What's going on there?" The coachman blew a bombastic blast on his horn; the witch ladled about in her brew, and in a trice, everything vanished in thick smoke. Whether you would have found the girl, for whom you were groping in the darkness with the most heartfelt longing, I cannot say. But you surely would have destroyed the witch's spell and undone the magic circle into which Veronica had thoughtlessly entered. Alas! Neither you, kind reader, nor any other person either drove or walked this way, on the twenty-third of September, in the tempestuous night favoring witches; and Veronica had to sit near the cauldron in deadly terror, until the work was nearly finished. She heard, indeed, the howling and raging around her. All sorts of hateful voices bellowed and bleated, and yelled and hummed, but she did

not open her eyes, for she felt that the sight of the abominations and the horrors with which she was encircled might drive her into incurable destructive madness. The hag had ceased to stir the pot. Its smoke grew fainter and fainter, and at last, nothing but a light flame was burning in the bottom. Then she cried:

"Veronica, my child! My darling! Look at the bottom there! What do you see? What do you see?"

Veronica could not answer. Yet, it seemed as if all sorts of perplexing shapes were dancing and whirling in the cauldron, and suddenly, with a friendly look and stretching out his hand to her, the student Anselmus rose from the bottom of the vessel. Immediately, she cried aloud: "It's Anselmus! It's Anselmus!"

All at once, the crone turned the lever at the bottom of the cauldron, and glowing metal rushed forth, hissing and bubbling into a little mold that she had placed beside it. The hag now jumped up, shrieked, and danced about with wild horrific gestures: "It's done! It's done! Thanks, my pretty boy. Did you watch? Pooh, pooh, he is coming! Bite him to death! Bite him to death!"

But then a strong flapping could be heard in the air. It was as if a huge eagle were descending and striking around him with its pinions. At the same time, a terrifying voice thundered.

"Hey, hey, vermin! It is over! It is over with you!"

The crone collapsed with bitter howling, and Veronica fainted. When she regained consciousness, it was broad daylight. She was lying in her bed, and Frances was standing in front of her with a cup of steaming tea and saying to her: "Tell me, sister, what in all the world is the matter with you? I've been standing here for an hour, and you have been lying senseless, as if in a fever, and moaning and whimpering so that we were frightened to death. Father has not gone to his class this morning because of you. He will be here shortly with the doctor."

Veronica took some tea in silence, and while she was drinking it, the horrid images of the night rose vividly before her eyes. "So, it was all nothing but a wild dream that tortured me?" she thought to herself. "Yet, last night, I surely went to that old woman, and it was the twenty-third of September, too? Well, I must have been very sick last night and imagined all this. Nothing has made me sick except my perpetual thinking of Anselmus and the strange old woman who pretended to be Liese, but really wasn't and only made a fool of me with that story."

The Golden Pot

51

Frances, who had left the room, returned with Veronica's coat in her hand. It was all wet.

"Look, sister," she said, "what a sight your coat is! The storm last night blew open the shutters and upset the chair where your coat was hanging, and the rain came in and soaked it."

This revelation disturbed Victoria very much, for she now saw it wasn't a dream that had tormented her, but she had really been with the witch. Anguish and horror took hold of her at the thought, and a frosty fever quivered through her body. As she put on her dressing gown, she felt spasmodic shuddering and something hard pressing on her breast. She grabbed it with her hand, and it seemed like a medallion. As soon as Frances went away with the coat, she pulled the object out; it turned out to be a little, round, brightly polished metallic mirror.

"This is a present from the woman!" she cried eagerly; and it was as if fiery beams were shooting from the mirror and penetrating into her innermost soul with a serene warmth. The frosty fever was gone, and an intense feeling of contentment and delight streamed through her whole body. She couldn't help but remember Anselmus, and as she turned her thoughts more and more intensely on him, he suddenly smiled at her in a friendly fashion from the mirror, like a living miniature portrait. Before long, she felt as if it was no longer an image that she saw, but Anselmus himself, alive and in person. He was sitting in a stately chamber with the strangest furniture and diligently writing. Veronica was about to step forward, to pat his shoulder, and say to him: "My dear Anselmus, look around you, it is me!" But she couldn't do this, for it was as if a stream of fire encircled him. And yet, when she looked more closely, this stream was nothing but large books with gilded pages. Finally, Veronica successfully caught Anselmus's eye, and it seemed as if he needed to think about who she was as he gazed at her. But at last, he smiled and said: "Ah! Is it you, dear Mademoiselle Paulmann? But why do you keep taking the form of a little snake every now and then?"

At these strange words, Veronica could not help but laugh aloud, and this caused her to wake from a deep dream, and she quickly concealed the little mirror, for the door opened, and Rector Paulmann entered the room with Doctor Eckstein. Immediately, the doctor went to her bedside and felt Veronica's pulse for a long time. Then he cried out: "Ey! Ey!" Without saying a word, he wrote a prescription. Then he felt her pulse again and cried out: "Ey! Ey!" Finally, he mumbled, looked at his patient, and left the room. Unfortunately, these disclo-

sures of Doctor Eckstein did not enable Rector Paulmann to understand clearly what it was that ailed Veronica.

Eighth Vigil

The library of palm trees. The fortunes of an unhappy Salamander. How the black feather caressed a beet, and how Registrar Heerbrand got very drunk.

Anselmus had now worked several days with Archivist Lindhorst, and these working hours were for him the happiest of his life, for he was still surrounded by lovely tones and by Serpentina's encouraging voice. Indeed, he was filled and overflowed by joy, which often rose to great ecstasy. Every difficulty and trifle of his meager existence had vanished from his mind, and in the new life, which had arisen like the sun in serene splendor, he comprehended all the wonders of a higher world, which before had simultaneously filled him with astonishment and dread. His copying proceeded rapidly and easily, for he felt more and more as if he were writing characters long known to him; and he scarcely needed to cast his eye on the manuscript, while copying it all with the greatest exactitude.

With the exception of dinner, Archivist Lindhorst seldom made his appearance, and this always occurred precisely at the moment when Anselmus had finished the last letter of some manuscript. Then the archivist would hand him another and immediately leave him without uttering a word, after having first stirred the ink with a little black rod and changed the old pens for new, sharp-pointed ones. One day, when Anselmus climbed the stairs as usual, he found, at the stroke of twelve, the door through which he usually entered was locked. Then Archivist Lindhorst came forward from the other side, clothed in his strange flowery dressing gown covered with bizarre figures.

"Today, I want you to come this way, my good Anselmus," he cried. "We must go to the chamber where the masters of Bhagavad Gita are waiting for us."

Right after announcing this, the archivist walked along the corridor and led Anselmus through the same chambers and halls as he had done at the first visit. Anselmus again felt astonished at the marvelous beauty of the garden, but he now perceived that many of the strange flowers hanging on the dark bushes were in truth insects gleaming with lordly colors, flying up and down with their little wings, as they danced and whirled in clusters, caressing one another with their antennae. On the other hand, the rose-and-blue birds turned into beau-

The Golden Pot

53

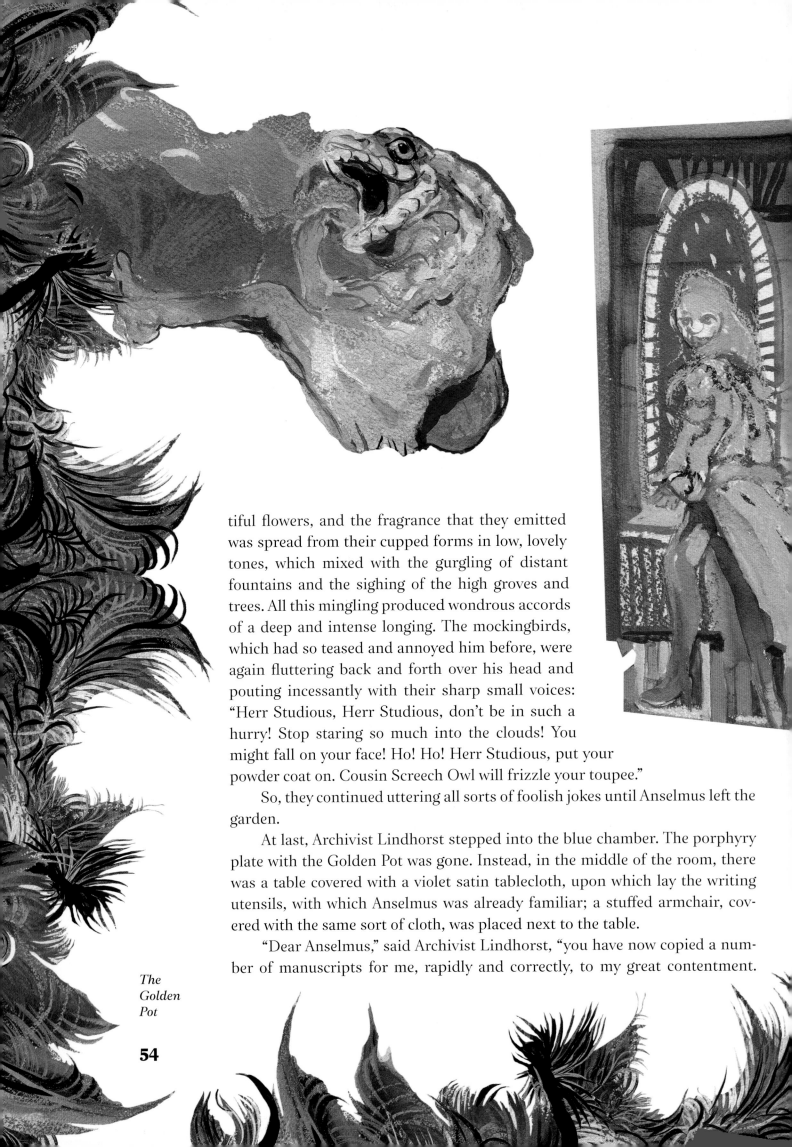

tiful flowers, and the fragrance that they emitted was spread from their cupped forms in low, lovely tones, which mixed with the gurgling of distant fountains and the sighing of the high groves and trees. All this mingling produced wondrous accords of a deep and intense longing. The mockingbirds, which had so teased and annoyed him before, were again fluttering back and forth over his head and pouting incessantly with their sharp small voices: "Herr Studious, Herr Studious, don't be in such a hurry! Stop staring so much into the clouds! You might fall on your face! Ho! Ho! Herr Studious, put your powder coat on. Cousin Screech Owl will frizzle your toupee."

So, they continued uttering all sorts of foolish jokes until Anselmus left the garden.

At last, Archivist Lindhorst stepped into the blue chamber. The porphyry plate with the Golden Pot was gone. Instead, in the middle of the room, there was a table covered with a violet satin tablecloth, upon which lay the writing utensils, with which Anselmus was already familiar; a stuffed armchair, covered with the same sort of cloth, was placed next to the table.

"Dear Anselmus," said Archivist Lindhorst, "you have now copied a number of manuscripts for me, rapidly and correctly, to my great contentment.

The Golden Pot

54

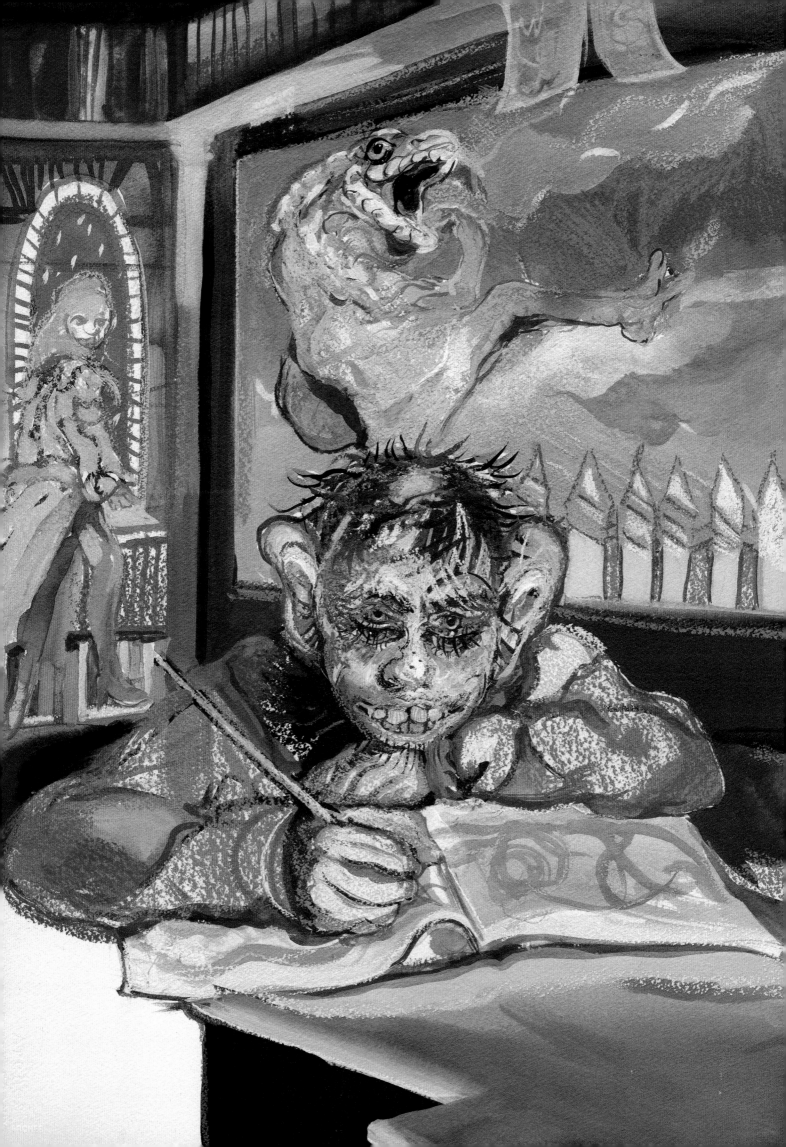

Indeed, you have gained my confidence. But the hardest is still ahead, and that is the transcribing or rather painting of certain works, written in peculiar characters. I keep them in this room, and they can only be copied in this spot. You will, therefore, in the future, work here. But I must urge you to exercise the utmost care and attention, for if you make one false stroke, or let a blot fall on the original, your life will become a life of misery. Heaven forbid!"

Anselmus noticed some little emerald green leaves protruding from the branches of the palm trees, and when the archivist detached one, Anselmus saw that the leaf was, in truth, a roll of parchment, which the archivist unfurled and spread out before the student on the table. Anselmus was astounded by the strange, intertwined characters; and as he looked over the many points, dots, strokes, dashes, and twirls in the manuscript, he almost lost hope of ever copying it and fell silent and into deep thought.

"Don't mope, young man!" cried the archivist. "If you continue to have faith and believe in true love, Serpentina will help you."

His voice rang and sounded like metal. As Anselmus looked up in utter terror, Archivist Lindhorst was standing before him in the royal form that he had assumed in the library during the first visit. Anselmus felt now that he had to show his reverence by kneeling, but the archivist stepped up to the trunk of a palm tree, embraced it, and began climbing. Soon he vanished high above in the emerald green leaves. Anselmus perceived that the Prince of the Spirits had been speaking with him, and he had now gone to his study, perhaps to confer with the rays, which some of the planets had sent as envoys, to send back word about what was to happen with Anselmus and Serpentina.

"In addition, it may be," he further thought, "that the archivist is expecting news from the springs of the Nile, or that some magician from Lapland is paying him a visit. So, I had better get to work and be diligent." And with this, he began studying the foreign characters on the parchment.

The strange music of the garden sounded above him and surrounded him with lovely sweet odors—the mockingbirds, too, for he still heard giggling and twittering, but couldn't distinguish their words, a thing that greatly pleased him. At times, it was as if the leaves of the palm trees were rustling, and as if the clear crystal tones, which Anselmus on that fateful Ascension Day had heard under the elder tree, were beaming and flitting through the room. Wonderfully

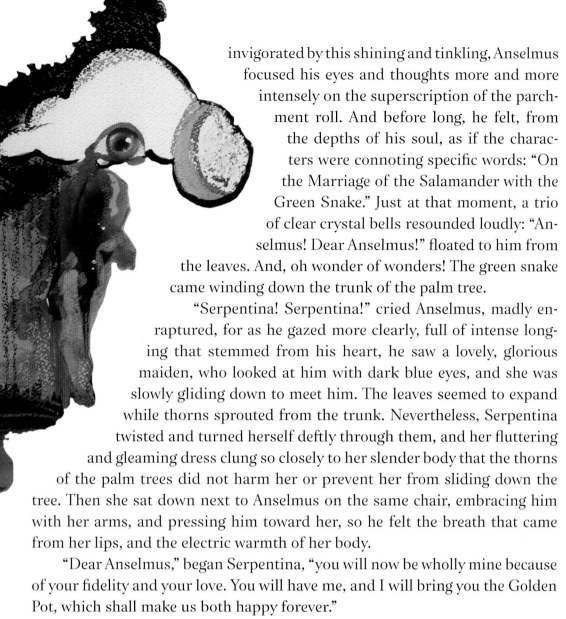

invigorated by this shining and tinkling, Anselmus focused his eyes and thoughts more and more intensely on the superscription of the parchment roll. And before long, he felt, from the depths of his soul, as if the characters were connoting specific words: "On the Marriage of the Salamander with the Green Snake." Just at that moment, a trio of clear crystal bells resounded loudly: "Anselmus! Dear Anselmus!" floated to him from the leaves. And, oh wonder of wonders! The green snake came winding down the trunk of the palm tree.

"Serpentina! Serpentina!" cried Anselmus, madly enraptured, for as he gazed more clearly, full of intense longing that stemmed from his heart, he saw a lovely, glorious maiden, who looked at him with dark blue eyes, and she was slowly gliding down to meet him. The leaves seemed to expand while thorns sprouted from the trunk. Nevertheless, Serpentina twisted and turned herself deftly through them, and her fluttering and gleaming dress clung so closely to her slender body that the thorns of the palm trees did not harm her or prevent her from sliding down the tree. Then she sat down next to Anselmus on the same chair, embracing him with her arms, and pressing him toward her, so he felt the breath that came from her lips, and the electric warmth of her body.

"Dear Anselmus," began Serpentina, "you will now be wholly mine because of your fidelity and your love. You will have me, and I will bring you the Golden Pot, which shall make us both happy forever."

"Oh, kind and lovely Serpentina!" Anselmus replied. "If you belong to me and I belong to you, why should I care for anything else? If you are mine, I shall joyfully discard all the wonderful mysteries that have haunted me since the moment I first saw you."

"I know," Serpentina stated, "all the strange and wondrous things that my father often creates merely as a whim and to satisfy his humor. And I know that because of this, you are alarmed and distrust him, but now, I hope, all this will stop, for I have come to tell you, dear Anselmus, from the bottom of my heart, everything, including the smallest detail, that you need to know to understand my father, and also so that you can understand quite clearly how matters stand between him and me."

Anselmus felt as if he were being fully grasped by this gentle, lovely form and as though he could only move and live with her. Even if it were just the beating of her pulse that throbbed through his nerves, he listened to each one

The Golden Pot

57

of her words until it sounded in his innermost heart like a burning ray that kindled the rapture of heaven in him. He had put his arm around that daintier than dainty waist. But the glistening cloth of her robe was so smooth and slippery that it seemed to him as if she could, at any moment, wind herself from his arms and glide away. He trembled at the thought.

"Ah, do not leave me, gentlest Serpentina!" he cried. "You are my life."

"Ah, Anselmus, I won't leave," said Serpentina, "until I have told you everything that, in your love for me, you can comprehend. So, know then, dearest, that my father has sprung from the wondrous race of the Salamanders, and that I owe my existence to his love for the green snake. In primeval times, in the fairyland called Atlantis, the strong Prince Phosphorus, also known as Prince of the Spirits, was the supreme ruler, and the Salamanders and other spirits of the elements, were pledged by oath to follow him. Once upon a time, a Salamander whom he loved above all others—it was my father—happened to be walking in the royal garden, which Phosphorus's mother had designed in the most magnificent fashion with all her best talents; and the Salamander heard a tall lily singing in low tones: 'Close your little eyelids until my beloved, the morning wind, wakes you.' He walked closer, and when the lily was touched by his glowing breath, she opened her leaves, and he saw the lily's daughter, the green snake, lying asleep in the hollow of the flower.

"Then the Salamander was inflamed with intense love for the fair snake, and he carried her away from the lily, whose fragrance in nameless lamentation vainly called for her beloved daughter throughout the garden. Indeed, the Salamander had stolen her, brought her to the palace of Phosphorus, and implored him: 'Please wed me to my beloved, for I want to be with her forever.'

"'Madman, do you know what you are asking?' replied the Prince of the Spirits. 'You must know that the lily was once my mistress and shared the reign with me, but the spark that I cast into her threatened to annihilate the fair lily; and only my victory over the black dragon, whom the earth spirits now hold in chains, maintains her so that her leaves can continue to be strong enough to enclose this spark and preserve it within them. But if you embrace the green snake, your fire will consume her body, and a new being will rapidly arise from her and soar away.'

"The Salamander did not heed the warning of the Prince of the Spirits.

Filled with ardent love, he folded the green snake in his arms, and she crumbled into ashes. Then a winged being, born from her ashes, soared away through the sky. Instantly, the Salamander was driven mad and desperate, and he ran through the garden and laid waste to it with fire and flames and continued to destroy it in his wild fury until its fairest flowers and blossoms were blackened and scathed and their lamentation filled the air.

"The indignant Prince of the Spirits became extremely angry, and in his fury, he grabbed the Salamander and said: 'Your fire has burned out; your flames are extinguished; your rays darkened. You are now to sink down to the Spirits of the Earth. Let them mock and jeer you, and keep you captive until the elements of fire shall again kindle and radiate from the earth with you as a new being.'

"The poor Salamander collapsed from exhaustion, but now the testy old Spirit of the Earth, who was Phosphorus's gardener, came forth and said: 'Master, who has greater reason to complain about the Salamander than I? Haven't all the fair flowers, which he has burnt, been decorated by my gayest metal? Haven't I stoutly nursed and tended them and spent many a fair hue on their leaves? And yet, I must pity the poor Salamander, for it was nothing but love, in which you, oh Master, have often been entangled, that drove him to despair and made him devastate the garden. So, I beg of you to rescind this harsh punishment.'

"'His fire is extinguished for the present,' said the Prince of the Spirits, 'but in the hapless time, when the language of nature will no longer be intelligible to degenerate men, when the elemental spirits confined to their regions will speak to men only in faint and distant sounds, when men will be estranged from the harmonious circle and only an infinite longing alone will bring him obscure news of the wondrous realm, which he once inhabited while belief and love still dwelled in his soul, the fire of the Salamander will again kindle, but he will arise only to the level of humankind and must adapt himself to their wretched life and endure its privations. Yet, not only shall the remembrance of his first condition continue with him, but he will again rise into the sacred harmony of all nature. He will understand its wonders, and the power of his fellow spirits will stand at his behest. Then, too, he will find the green snake in a lily bush, and the fruit of his marriage with her will be three daughters, which, to humans, will appear in the form of their mother. In the spring, they will hang in the dark elder tree and sing with their lovely crystal voices. And then if, in

that needy and wretched age of inward obduracy, a youth hears and understands their song, and if one of the little snakes gazes at him with her kind eyes and the gaze awakens in him an awareness of the distant wondrous land, to which, having thrown away the burden of the common cares he can courageously soar, and if, due to his love of the snake, a belief in the wonders of nature and in his own existence amid these wonders arises, then the snake will be his. But this will not occur until three youths of this sort have been found and married to the three daughters. Only then, will the Salamander be able to cast his heavy burden away and return to his brothers.'

"'Permit me, master,' said the Spirit of the Earth, 'I intend to give these three daughters a present that may glorify their lives with the husbands they find. Let each of them receive from me a flowerpot made of the fairest metal I have. Then I will polish it with rays borrowed from the diamond. In its glitter, our kingdom of wonders, as it now exists in the harmony of universal nature, will be mirrored in glorious, dazzling reflection; and from its interior, on the day of marriage, a fire lily, whose eternal blossoms shall encircle the youth who is found worthy, will spring forth with sweet wafting odors. Soon, too, he will learn its speech, and will understand the wonders of our kingdom and dwell with his beloved in Atlantis itself.'

"You must have realized by now, dear Anselmus, that the Salamander, about whom I have been speaking, is none other than my father. In spite of his higher nature, he was forced to subject himself to the paltriest contradictions of common life; and hence, he often resorts to sarcastic humor, which annoys many people. He has often told me that the spiritual character that Prince Phosphorus required as a condition of marriage for me and my sisters now has a name that has only much too frequently been abused. They call it a 'childlike poetic spirit,' and it is often found in young people, due to their high simplicity and lack of worldly manners. Consequently, they are mocked by the common mob. Ah, dear Anselmus! Beneath the elder tree, you understood my song and my gaze. You love the green snake and believe in me. Indeed, you will be mine forever! The fair lily will bloom forth from the Golden Pot; and we shall dwell together, blissfully and blessed, in Atlantis!

"Yet, I cannot conceal from you that the black dragon escaped the Salamanders in a deadly battle with the Salamanders and Spirits of the Earth. He managed to fly off quickly through the air. Indeed, Phosphorus has once again imprisoned him, but hostile spirits sprung from the black quills that rained down on the ground during the struggle, and they have continued to act against the Salamanders and Spirits of the Earth. That vicious old woman who

hates you, dear Anselmus, is, as my father knows full well, seeking to possess the Golden Pot. That woman owes her existence to the love of a black quill (plucked in battle from the dragon's wing) for a certain beet beside which it dropped. She knows her origin and her power; for, in the moans and convulsions of the captive dragon, the secrets of many a wondrous constellation are revealed to her; and she uses every means and effort to work from the outward and seen to the inward and unseen; while my father, with the beams that shoot forth from the spirit of the Salamander, resists and subdues her. She collects all the baneful principles that lurk in deadly herbs and poisonous beasts, mixes them under favorable constellations, uses wicked spells to call up many an evil sprite to overwhelm the soul of man with fear and trembling, and subjects men to the power of those demons, produced from the dragon in battle. Beware of that old woman, dear Anselmus! She hates you because your childlike, pious character has annihilated many of her wicked charms. Keep true, true to me. Soon you will reach your goal!"

"Oh, my Serpentina! My own Serpentina!" cried Anselmus. "How could I leave you? How could I not love you forever!"

With a burning kiss on his lips, Anselmus awoke as if from a profound dream. Serpentina had vanished. Six o'clock was striking, and his heart felt heavy because he had not copied a single letter that day. Full of anxiety, and dreading a scolding from the archivist, he looked at the sheet, and—oh, wonder of wonders! The copying of the marvelous manuscript was finished, and when he examined the characters more closely, he realized that he had written nothing but Serpentina's story of her father, the favorite of Prince Phosphorus in Atlantis, the land of marvels. And now, Archivist Lindhorst entered in his light gray coat with hat and staff. He looked at the parchment on which Anselmus had been writing, took a large pinch of snuff, and said with a smile: "Just as I thought! Well, Anselmus, here is your silver coin for your hard work. We will now go to the Linke Tavern. Please follow me!"

The archivist walked rapidly through the garden, which was very noisy due to the singing, whistling, and talking. Consequently, Anselmus could hardly hear himself talk, and he thanked heaven when he found himself on the street. They had scarcely gone twenty paces, when they met Registrar Heerbrand, who joined them in a friendly way. At the gate, they filled their pipes, which they carried with them. Registrar Heerbrand complained that he had left his tinderbox at home, and could not light his pipe.

"If you need a light," cried Archivist Lindhorst angrily, "I have enough fire to spare!"

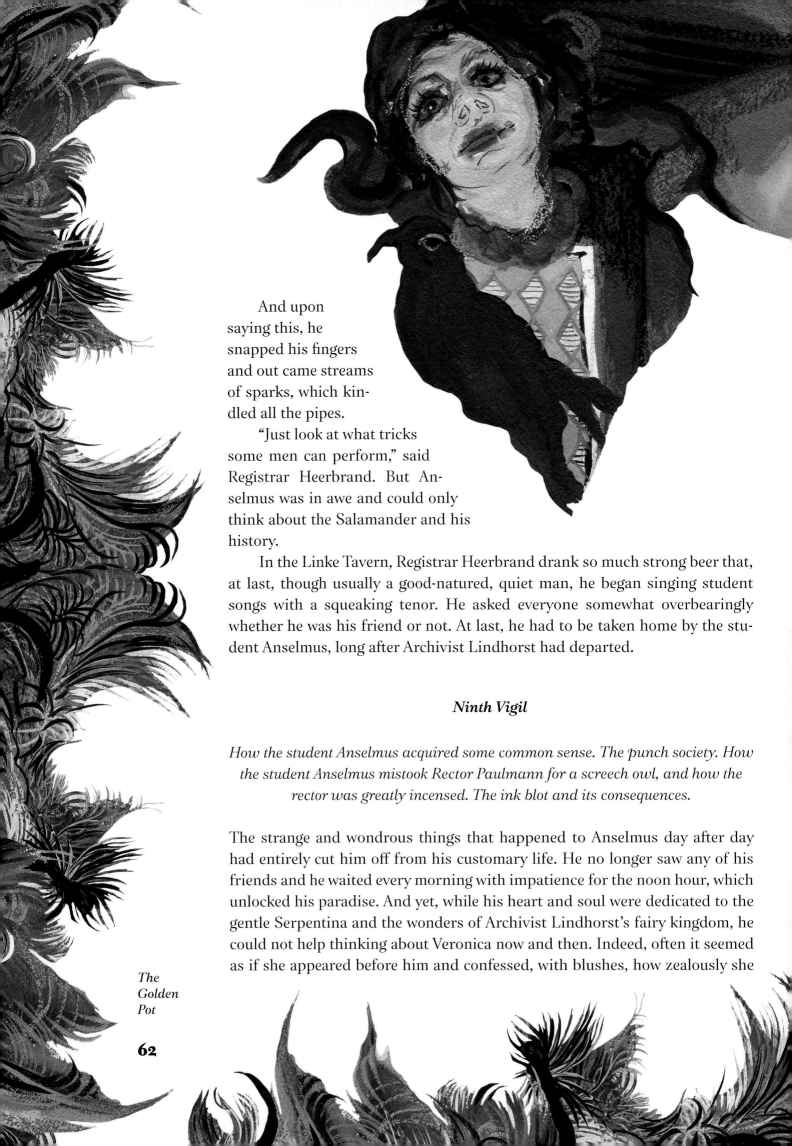

And upon saying this, he snapped his fingers and out came streams of sparks, which kindled all the pipes.

"Just look at what tricks some men can perform," said Registrar Heerbrand. But Anselmus was in awe and could only think about the Salamander and his history.

In the Linke Tavern, Registrar Heerbrand drank so much strong beer that, at last, though usually a good-natured, quiet man, he began singing student songs with a squeaking tenor. He asked everyone somewhat overbearingly whether he was his friend or not. At last, he had to be taken home by the student Anselmus, long after Archivist Lindhorst had departed.

Ninth Vigil

How the student Anselmus acquired some common sense. The punch society. How the student Anselmus mistook Rector Paulmann for a screech owl, and how the rector was greatly incensed. The ink blot and its consequences.

The strange and wondrous things that happened to Anselmus day after day had entirely cut him off from his customary life. He no longer saw any of his friends and he waited every morning with impatience for the noon hour, which unlocked his paradise. And yet, while his heart and soul were dedicated to the gentle Serpentina and the wonders of Archivist Lindhorst's fairy kingdom, he could not help thinking about Veronica now and then. Indeed, often it seemed as if she appeared before him and confessed, with blushes, how zealously she

The Golden Pot

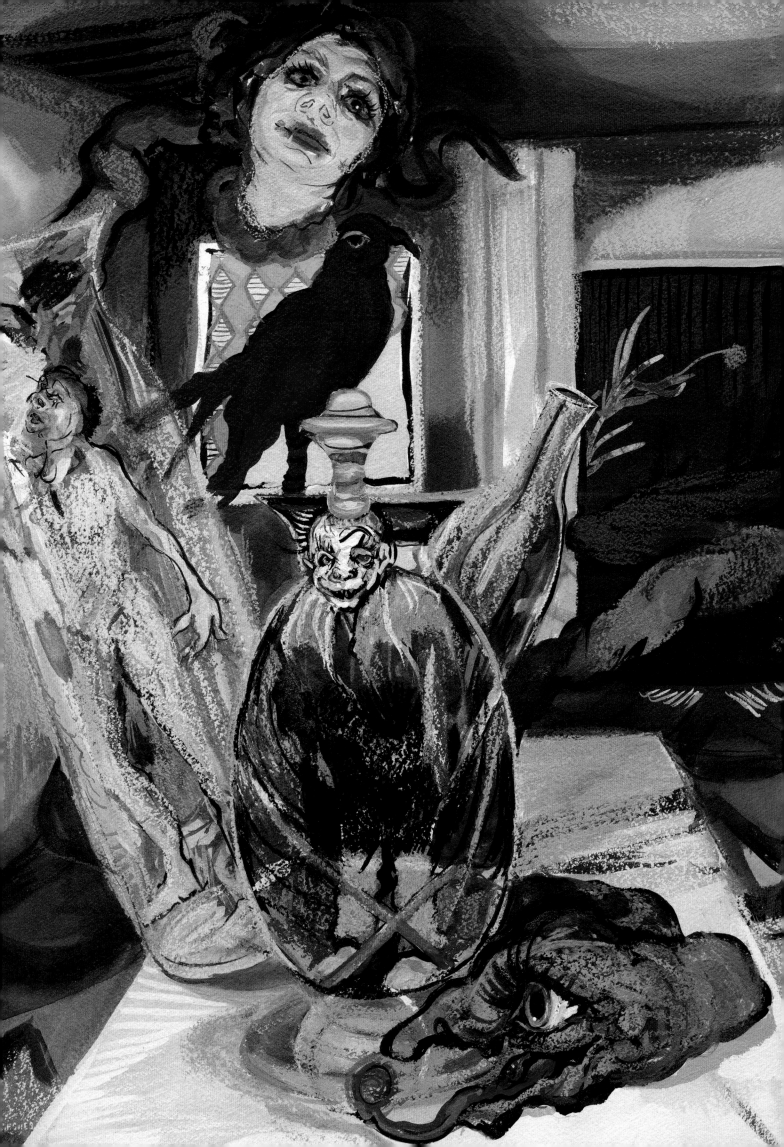

loved him, and how much she longed to rescue him from the hallucinations that were mocking and toying with him. At times, he felt as if a foreign power suddenly intruded in his life and drew him irresistibly to the forgotten Veronica, as if he were obliged to follow her wherever she desired to go. Indeed, it seemed as if he were linked to her by ties that would not break. The very night after Serpentina had appeared to him in the form of a lovely maiden, and after the wondrous secret of the Salamander's nuptials with the green snake had been disclosed, Veronica appeared more vividly than ever in his mind. Indeed, it was not until he awoke that he became clearly aware that he had only been dreaming, for he had felt certain that Veronica was actually beside him, complaining with an expression of sorrow, piercing his innermost soul, and questioning why he was sacrificing her deep, true love for fantastic visions. She insisted that his mind was generating these visions into being, and that they would finally prove his ruin. Veronica was lovelier than he had ever seen her, and he was incapable of driving her from his thoughts. Consequently, torn by his puzzled mind and contradictory feelings, he decided to take an early morning walk to gain clarity.

A mysterious force led him to Pirna Gate, and he was just turning onto a cross street, when Rector Paulmann cried out: "Hey there! Anselmus! My friend! My friend! Where in heaven's name have you been keeping yourself? We never see you at all. Do you know, Veronica has been longing very much to join you again in a duet? So, come along with me. You were just on time to call on me at any rate."

Although Anselmus hesitated, he had no choice but to tag along with the rector. On entering the house, they were met by Veronica, attired with such great care and charm that Rector Paulmann was amazed and asked her: "Why are you so decked out, my dear Mamsell? Were you expecting visitors? Well, here I bring you the student Anselmus."

As Anselmus, politely and elegantly, kissed Veronica's hand, he felt a small, soft pressure that shot like a stream of fire throughout his body. Veronica was very cheerful and graceful. When Paulmann left them for his study, she used all kinds of tricks to make Anselmus feel at ease, so much so that he finally forgot his bashfulness and chased the playful girl around the room. But here again, the demon of awkwardness got the best of him, and he knocked over a table, causing Veronica's pretty little sewing box to fall to the floor. When Anselmus picked it up, the lid flew open, and a little round metallic mirror glistened and

invited him to gaze at it with peculiar delight. Meanwhile, Veronica slid softly up to him, laid her hand on his arm, and pressing close to him, looked over his shoulder into the mirror. Now Anselmus felt as if a battle were beginning in his soul, with thoughts and images flashing in and out—Archivist Lindhorst, Serpentina, the green snake. Finally, the tumult abated, and all this chaos shifted and turned into clear consciousness. He was now certain that he had always only thought of Veronica alone. Indeed, he believed that the form that had appeared to him yesterday in the blue chamber had been none other than Veronica, and that the wild legend about the Salamander's marriage with the green snake had merely been written down by him from the manuscript, but had nothing to do with him. He wondered greatly about all his dreams and ascribed them to both the heated state of mind into which Veronica's love had brought him, as well as his working with Archivist Lindhorst, in whose rooms there were so many strange and intoxicating odors. He could not help laughing heartily at the mad whim of falling in love with a little green snake and mistaking a well-fed privy archivist for a Salamander.

"Yes, yes! It is Veronica!" he cried aloud, and, on turning his head around, he looked right into Veronica's blue eyes, beaming with love. Then a faint soft "Ahhh!" escaped her lips, which at that moment were burning on his.

"Oh, happy man that I am!" sighed the enraptured Anselmus. "What I dreamed last night is now coming true today!"

"But will you really marry me, then, when you become a privy councilor?" Veronica asked.

"That I will do," replied Anselmus, and just then the door creaked. It was Rector Paulmann, who entered with the words: "Now, dear Anselmus, I will not let you go today. You must put up with a bad dinner. Afterward, Veronica will make us delightful coffee, which we shall drink with Registrar Heerbrand, who has promised to join us."

"Ah, Rector!" Anselmus answered. "I'm sorry but I must go to Archivist Lindhorst's and do some copying."

"Look here, my friend!" said Rector Paulmann, holding up his watch, which pointed to half-past twelve.

Anselmus saw clearly that he was much too late to do some copying for Archivist Lindhorst. So, he complied with the rector's wishes all the more readily, so he might now hope to look at Veronica the entire day, obtain many a stolen

The Golden Pot

65

glance, and a little squeeze of the hand. Perhaps he might even succeed in stealing a kiss. Indeed, Anselmus's desires now increased, and he felt more and more contented. Moreover, he convinced himself that he would soon do away with all his hallucinations and fantasies, which really might have made a sheer idiot of him.

Registrar Heerbrand came after dinner and once coffee was over and dusk had arrived, the registrar puckered his face and cheerfully rubbed his hands, indicating that he had something with him, which, if mixed by Veronica's hands and, given the appropriate form, might be pleasant to them all on this October evening.

"Please tell us without any more ado what his wondrous substance is that you are carrying with you, my good friend!" cried Rector Paulmann.

Then Registrar Heerbrand stuck his hand into his deep pocket and gradually pulled out a bottle of Sri Lankan arrack, two lemons, and a bag of sugar. Before half an hour had passed, a bowl of delicious punch was steaming on Paulmann's table. Veronica drank to their health with a sip of the liquor, and before long there was plenty of gay, good-natured chat among the friends. When the spirit of the drink mounted in Anselmus's head, he began seeing all the images of those wondrous things, which he had experienced, flashing in front of him. He saw the archivist in his damask dressing gown, which glittered like phosphorus. He saw the azure room and the golden palm trees. It now seemed to him as if he still had to believe in Serpentina. There was a fermentation, a conflicting tumult in his soul. Veronica handed him a glass of punch, and in taking it, he gently touched her hand. "Serpentina! Veronica!" he sighed to himself.

Then Anselmus sank into deep dreams, until Registrar Heerbrand cried aloud: "A strange old gentleman! Nobody can fathom him, for he is what he is, this Archivist Lindhorst. Well, long life to him! Clink your glass, Anselmus!"

Anselmus was surprised, and, as he touched glasses with Registrar Heerbrand, he said: "All this is due, my respected registrar, to Archivist Lindhorst's condition. In reality, he is a Salamander, who in his fury had destroyed Prince Phosphorus's garden because the green snake had flown away from him."

"What?" inquired Rector Paulmann.

"Yes," continued the student Anselmus, "and for this reason he is now forced to be a royal archivist and to keep house here in Dresden with his three daughters, who are nothing more than little gold-green snakes who bask in el-

der bushes and sing seductive songs to lure young men away like the sirens have done."

"Anselmus! Oh, my good Anselmus!" cried Rector Paulmann. "Have you gone out of your mind? Is your brain cracked? In heaven's name, what is all this monstrous stuff that you are babbling?"

"He is right," interrupted Registrar Heerbrand. "That fellow, our friend the archivist, is a cursed Salamander who can light fires when he snaps his fingers. Moreover, he can burn holes in your coat like a red-hot tinder. Ay, ay, you are most definitely right, my good fellow. And anyone who doubts you is no friend of mine!"

With these words, the registrar struck the table with his fist until the glasses tinkled again.

"Registrar! Are you raving mad?" cried the enraged rector. "Oh, Anselmus! What weird things are you saying again?"

"Ah, Rector!" replied the student. "You, too, are nothing but a screech owl who dresses in wigs!"

"What? You think I'm a screech owl, a hairdresser?" cried the rector, full of indignation. "Sir, you are mad, born mad!"

"But the crone will get the better of him . . ." Registrar Heerbrand cried.

"Yes, the crone is extraordinarily powerful," interrupted Anselmus. "Though she is of very humble origins, for her father was nothing but a ragged wing feather, and her mother a dirty beet. But most of her power comes from all sorts of baneful creatures, such as poisonous vermin that she keeps around her."

"Everything you've said is horrid slander," cried Veronica, with eyes glowing in anger. "Old Liese is a wise woman, and the black cat is not a malicious creature, but her first cousin, a polished young gentleman with elegant manners."

"Can he eat salamanders without burning his whiskers, and dying like a snuffed candle?" Registrar Heerbrand asked in a loud voice.

"No! No!" shouted the student Anselmus. "That he can never do in this world, and the green snake loves me, for I have looked into Serpentina's eyes."

"The cat will scratch them out," Veronica cried.

"Salamander, Salamander will defeat them all, all," Rector Paulmann exploded in uncontrollable fury. "But am I in a madhouse? Am I mad myself? What foolish nonsense am I spurting? Yes, I am mad, too! Oh, so mad, too!"

Upon saying this, Rector Paulmann jumped up, tore the wig from his head,

and threw it against the ceiling. The battered locks whizzed and became entangled. Then powder rained down all over the room. Meanwhile, Anselmus and Registrar Heerbrand grabbed hold of the punch bowl and the glasses, and with shouts and screams, they threw them against the ceiling, and the pieces of glass fell, jingling and tingling all over the floor.

"Long live the Salamander! Down with the crone! Smash the metal mirror! Scratch the cat's eyes out! Bird, little bird, from the air! Hooray for the Salamander!" The three men shrieked, shouted, and bellowed like utter maniacs. Frances ran out of the room, weeping, but Veronica stayed, whimpering in pain and sorrow on the sofa.

At this moment, the door opened, and suddenly everything became quiet. A little man in a small gray cloak entered the room. His face had a singular air of gravity, with the round, hooked nose. He was wearing a huge pair of spectacles, and his nose distinguished itself from all noses ever seen. In addition, he wore a strange wig, more like a feather cap than a wig.

"Many good evenings to you all!" the funny little man croaked, as if he had a hoarse throat. "Is the student Anselmus among you gentlemen? I bring the fondest regards from Archivist Lindhorst. Today he waited in vain for the student Anselmus. So, tomorrow he begs most respectfully that the student Anselmus not miss his appointment."

And with this, he left the room, then they all saw clearly that the grave tiny man was, in fact, a gray parrot. Rector Paulmann and Registrar Heerbrand exploded with laughter, which resounded through the room, while Veronica moaned and whimpered as if torn by sorrow. As for Anselmus, the madness of inner terror was tantalizing him, and without knowing what he was doing, he ran out the door and onto the street. Instinctively, he reached his house and ran up to his room in the garret. Before long, Veronica arrived and asked him with a peaceful and friendly manner why he had frightened her when he was so tipsy during the party and warned him to be on his guard against figments of the imagination while working at Archivist Lindhorst's home.

"Goodnight, goodnight, my beloved friend!" Veronica whispered in a low voice and breathed a kiss on his lips. He stretched out his arms to embrace her, but the dreamy shape had vanished, and he awoke cheerful and refreshed. He could not but laugh heartily at the effects of the punch, but in thinking of Veronica, he detected a most delightful feeling.

The Golden Pot

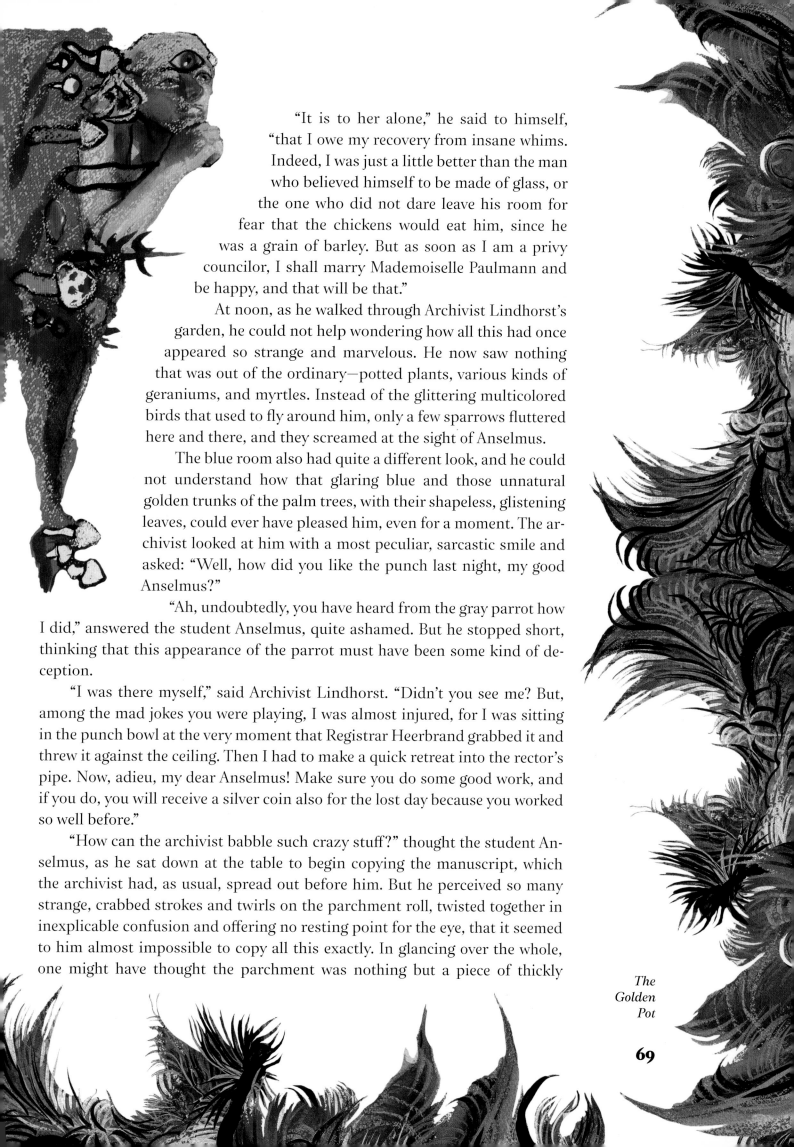

"It is to her alone," he said to himself, "that I owe my recovery from insane whims. Indeed, I was just a little better than the man who believed himself to be made of glass, or the one who did not dare leave his room for fear that the chickens would eat him, since he was a grain of barley. But as soon as I am a privy councilor, I shall marry Mademoiselle Paulmann and be happy, and that will be that."

At noon, as he walked through Archivist Lindhorst's garden, he could not help wondering how all this had once appeared so strange and marvelous. He now saw nothing that was out of the ordinary—potted plants, various kinds of geraniums, and myrtles. Instead of the glittering multicolored birds that used to fly around him, only a few sparrows fluttered here and there, and they screamed at the sight of Anselmus.

The blue room also had quite a different look, and he could not understand how that glaring blue and those unnatural golden trunks of the palm trees, with their shapeless, glistening leaves, could ever have pleased him, even for a moment. The archivist looked at him with a most peculiar, sarcastic smile and asked: "Well, how did you like the punch last night, my good Anselmus?"

"Ah, undoubtedly, you have heard from the gray parrot how I did," answered the student Anselmus, quite ashamed. But he stopped short, thinking that this appearance of the parrot must have been some kind of deception.

"I was there myself," said Archivist Lindhorst. "Didn't you see me? But, among the mad jokes you were playing, I was almost injured, for I was sitting in the punch bowl at the very moment that Registrar Heerbrand grabbed it and threw it against the ceiling. Then I had to make a quick retreat into the rector's pipe. Now, adieu, my dear Anselmus! Make sure you do some good work, and if you do, you will receive a silver coin also for the lost day because you worked so well before."

"How can the archivist babble such crazy stuff?" thought the student Anselmus, as he sat down at the table to begin copying the manuscript, which the archivist had, as usual, spread out before him. But he perceived so many strange, crabbed strokes and twirls on the parchment roll, twisted together in inexplicable confusion and offering no resting point for the eye, that it seemed to him almost impossible to copy all this exactly. In glancing over the whole, one might have thought the parchment was nothing but a piece of thickly

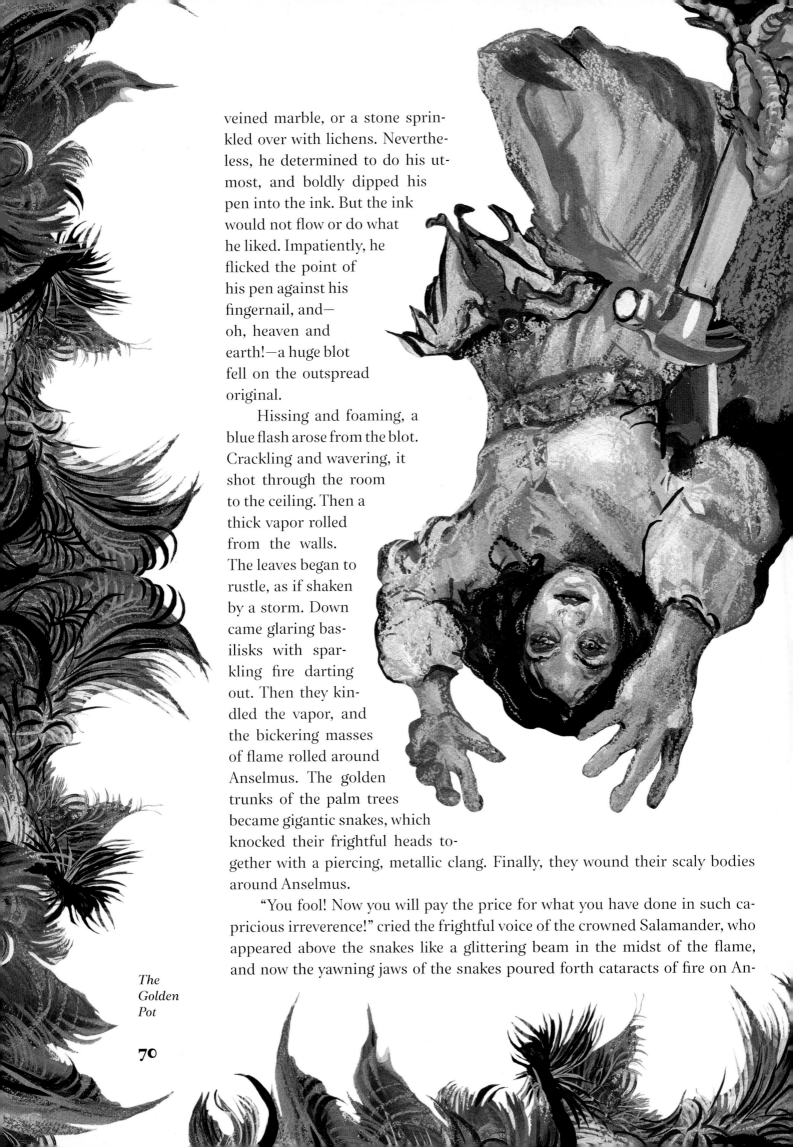

veined marble, or a stone sprinkled over with lichens. Nevertheless, he determined to do his utmost, and boldly dipped his pen into the ink. But the ink would not flow or do what he liked. Impatiently, he flicked the point of his pen against his fingernail, and— oh, heaven and earth!—a huge blot fell on the outspread original.

Hissing and foaming, a blue flash arose from the blot. Crackling and wavering, it shot through the room to the ceiling. Then a thick vapor rolled from the walls. The leaves began to rustle, as if shaken by a storm. Down came glaring basilisks with sparkling fire darting out. Then they kindled the vapor, and the bickering masses of flame rolled around Anselmus. The golden trunks of the palm trees became gigantic snakes, which knocked their frightful heads together with a piercing, metallic clang. Finally, they wound their scaly bodies around Anselmus.

"You fool! Now you will pay the price for what you have done in such capricious irreverence!" cried the frightful voice of the crowned Salamander, who appeared above the snakes like a glittering beam in the midst of the flame, and now the yawning jaws of the snakes poured forth cataracts of fire on An-

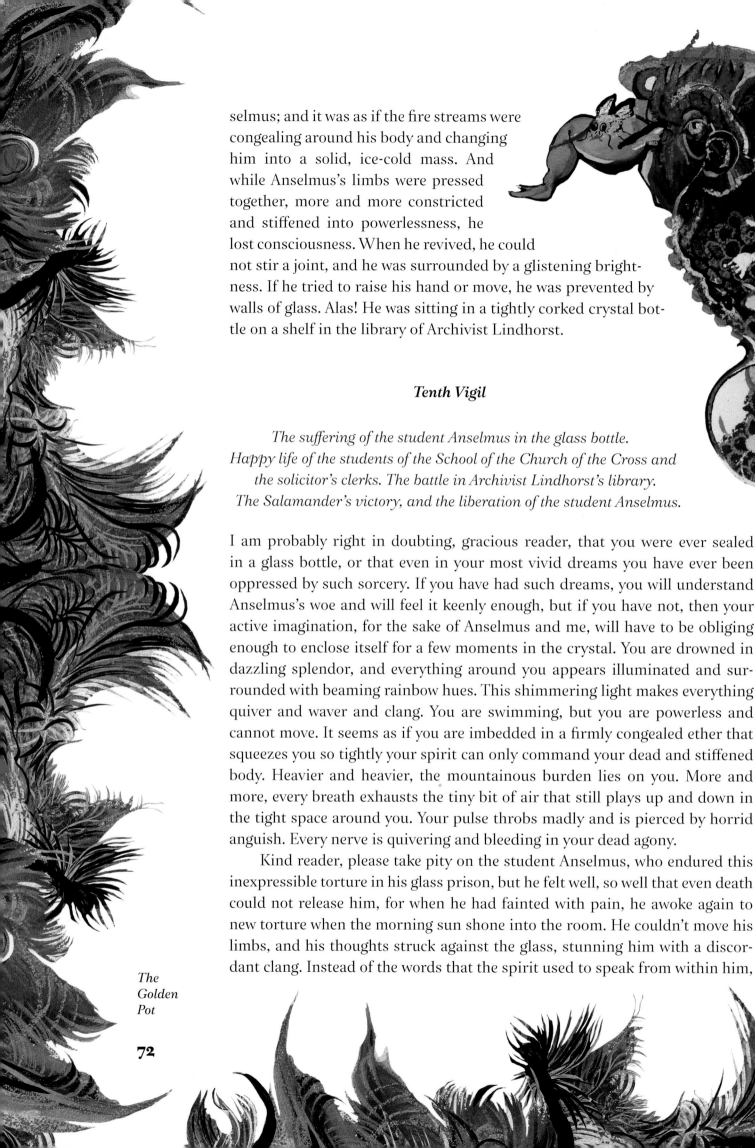

selmus; and it was as if the fire streams were congealing around his body and changing him into a solid, ice-cold mass. And while Anselmus's limbs were pressed together, more and more constricted and stiffened into powerlessness, he lost consciousness. When he revived, he could not stir a joint, and he was surrounded by a glistening brightness. If he tried to raise his hand or move, he was prevented by walls of glass. Alas! He was sitting in a tightly corked crystal bottle on a shelf in the library of Archivist Lindhorst.

Tenth Vigil

The suffering of the student Anselmus in the glass bottle.
Happy life of the students of the School of the Church of the Cross and
the solicitor's clerks. The battle in Archivist Lindhorst's library.
The Salamander's victory, and the liberation of the student Anselmus.

I am probably right in doubting, gracious reader, that you were ever sealed in a glass bottle, or that even in your most vivid dreams you have ever been oppressed by such sorcery. If you have had such dreams, you will understand Anselmus's woe and will feel it keenly enough, but if you have not, then your active imagination, for the sake of Anselmus and me, will have to be obliging enough to enclose itself for a few moments in the crystal. You are drowned in dazzling splendor, and everything around you appears illuminated and surrounded with beaming rainbow hues. This shimmering light makes everything quiver and waver and clang. You are swimming, but you are powerless and cannot move. It seems as if you are imbedded in a firmly congealed ether that squeezes you so tightly your spirit can only command your dead and stiffened body. Heavier and heavier, the mountainous burden lies on you. More and more, every breath exhausts the tiny bit of air that still plays up and down in the tight space around you. Your pulse throbs madly and is pierced by horrid anguish. Every nerve is quivering and bleeding in your dead agony.

Kind reader, please take pity on the student Anselmus, who endured this inexpressible torture in his glass prison, but he felt well, so well that even death could not release him, for when he had fainted with pain, he awoke again to new torture when the morning sun shone into the room. He couldn't move his limbs, and his thoughts struck against the glass, stunning him with a discordant clang. Instead of the words that the spirit used to speak from within him,

The
Golden
Pot

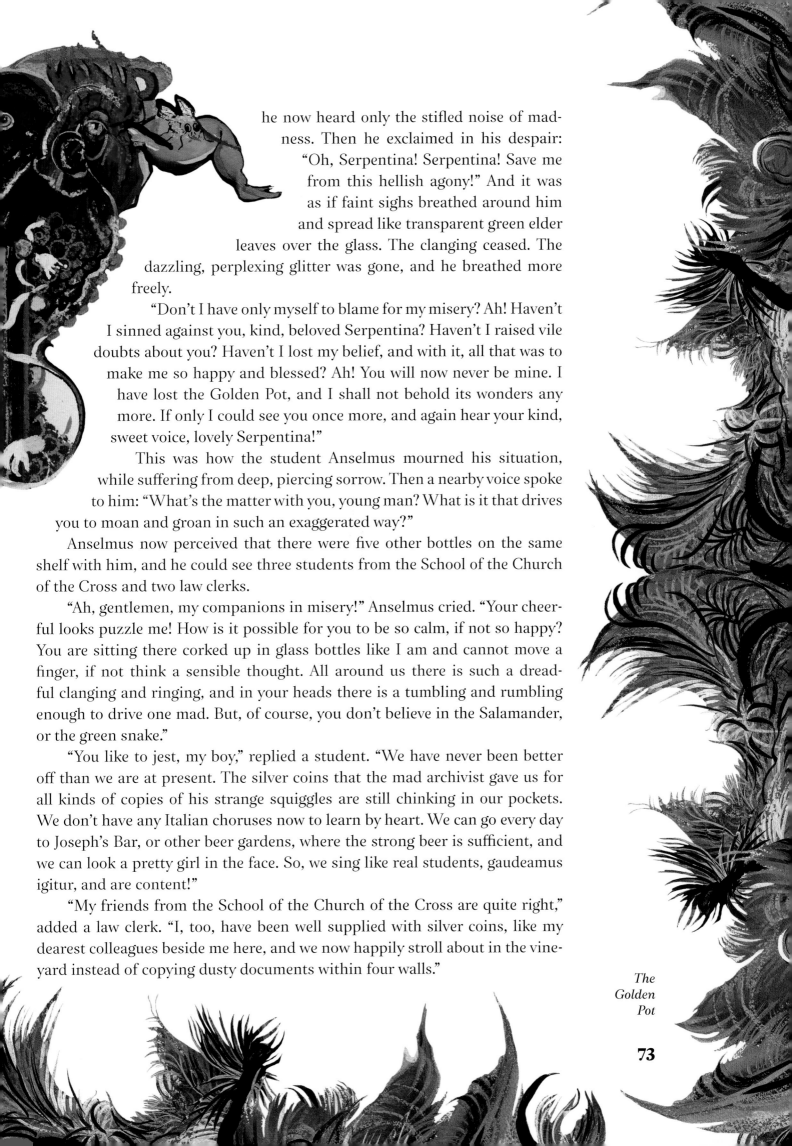

he now heard only the stifled noise of madness. Then he exclaimed in his despair: "Oh, Serpentina! Serpentina! Save me from this hellish agony!" And it was as if faint sighs breathed around him and spread like transparent green elder leaves over the glass. The clanging ceased. The dazzling, perplexing glitter was gone, and he breathed more freely.

"Don't I have only myself to blame for my misery? Ah! Haven't I sinned against you, kind, beloved Serpentina? Haven't I raised vile doubts about you? Haven't I lost my belief, and with it, all that was to make me so happy and blessed? Ah! You will now never be mine. I have lost the Golden Pot, and I shall not behold its wonders any more. If only I could see you once more, and again hear your kind, sweet voice, lovely Serpentina!"

This was how the student Anselmus mourned his situation, while suffering from deep, piercing sorrow. Then a nearby voice spoke to him: "What's the matter with you, young man? What is it that drives you to moan and groan in such an exaggerated way?"

Anselmus now perceived that there were five other bottles on the same shelf with him, and he could see three students from the School of the Church of the Cross and two law clerks.

"Ah, gentlemen, my companions in misery!" Anselmus cried. "Your cheerful looks puzzle me! How is it possible for you to be so calm, if not so happy? You are sitting there corked up in glass bottles like I am and cannot move a finger, if not think a sensible thought. All around us there is such a dreadful clanging and ringing, and in your heads there is a tumbling and rumbling enough to drive one mad. But, of course, you don't believe in the Salamander, or the green snake."

"You like to jest, my boy," replied a student. "We have never been better off than we are at present. The silver coins that the mad archivist gave us for all kinds of copies of his strange squiggles are still chinking in our pockets. We don't have any Italian choruses now to learn by heart. We can go every day to Joseph's Bar, or other beer gardens, where the strong beer is sufficient, and we can look a pretty girl in the face. So, we sing like real students, gaudeamus igitur, and are content!"

"My friends from the School of the Church of the Cross are quite right," added a law clerk. "I, too, have been well supplied with silver coins, like my dearest colleagues beside me here, and we now happily stroll about in the vineyard instead of copying dusty documents within four walls."

The Golden Pot

"But, my good and worthy sirs," Anselmus responded. "Don't you realize that you are all corked up in glass bottles and cannot move about, much less go strolling in gardens?"

Here the students from the School of the Church of the Cross and the law clerks exploded in laughter and cried out: "You are crazy, sir! You imagine that you are sitting in a glass bottle while, all the time, you are standing on the Elbe Bridge and looking right down into the water. Let us go on our way!"

"Oh, my lord!" Anselmus sighed. "They have never encountered kind Serpentina. They don't know what real freedom is in life, nor what love and belief signify. That's why they don't grasp that their folly, and their closed-mindedness prevents them from feeling the oppression of the imprisonment into which the Salamander has cast them. But I, unlucky student that I am, must perish in want and woe, if she, whom I so intensely love, does not rescue me!"

All of a sudden, Serpentina's voice could be heard radiating through the room: "Anselmus! Believe, love, hope!"

Every tone beamed into Anselmus's prison, and the crystal yielded to his pressure and expanded, until the chest of the captive could move and heave. Now, the torment of his situation became less and less, and he saw clearly that Serpentina still loved him, and that she alone rendered his confinement tolerable. He did not concern himself anymore about his inane companions and their misfortunes. Now, he directed all his thoughts to the gentle Serpentina. Suddenly, however, a dull, repulsive, croaking murmur arose on the other side. Before long, he could observe that it came from an old coffeepot with a half-broken lid standing opposite him on a little shelf. As he looked at it more narrowly, the ugly features of a wrinkled old woman gradually unfolded themselves, and in a few moments the apple woman of the Black Gate stood before him.

She grinned, laughed at him, and cried, with screeching voice: "Ho, ho, my pretty boy! You are lying in limbo now! You've ended up in a crystal bottle! Didn't I tell you long ago that this would happen to you?"

"Mock and jeer at me, you cursed witch!" said Anselmus. "You are to blame for it all, but the Salamander will catch you, you vile beet!"

"Ho, ho!" replied the crone. "Don't be so pretentious, my fine copyist! You have squashed my little sons, and you have scarred my nose. But I still love

you, you knave, for once you were a pretty fellow, and my little daughter likes you, too. Out of the crystal you will never get unless I help you. I cannot climb up there, but my friend the rat, who lives close behind you, will eat the shelf in two. Then you will plunge down, and I shall catch you in my apron so that your nose doesn't get broken or your fine, sleek face doesn't get injured at all. Then I will carry you to Mamsell Veronica, and you will marry her when you become a privy councilor."

"Leave me alone, you devil's brood!" Anselmus shouted in fury. "It was you alone and your hellish art that made me commit the sin I must now expiate. But I shall bear it all patiently. Only here can I be encircled by Serpentina's love and consolation. Listen to me, you hag, and despair! I defy your power. I love Serpentina and none but her. I shall not become a privy councilor. I shall not look at Veronica, for thanks to you, she is enticing me to evil. If the green snake cannot be mine, I shall die in sorrow and longing. Get away from me, you filthy buzzard!"

The crone laughed until the chamber rang: "Sit and die then," she cried. "But now it is time to get to work, for I have other matters to deal with here."

All of a sudden, she threw off her black cloak and stood there in hideous nakedness. Then she ran around in circles, and large folios came tumbling down to her. Immediately, she tore pages of parchment and rapidly patched them together in artful combination. After sticking them on her body, she was soon dressed in a strange, multicolored armor. Spitting fire, the black cat darted out of the ink glass, which was standing on the table, and it ran, mewing, toward the crone, who shrieked in loud triumph. Then she vanished with the cat through the door.

Anselmus observed that she went toward the blue room. And immediately, he heard a hissing and storming in the distance. The birds in the garden were crying. The parrot creaked out: "Help! Help! Thieves! Thieves!"

Just then, the crone returned and leapt into the room, carrying the Golden Pot on her arm, and with hideous gestures, she waved it wildly through the air, shrieking: "Hoorah! Hoorah! My little son! Kill the green snake! Attack, my son! Attack!"

Anselmus thought he heard a deep moaning. Yes, it was Serpentina's voice. Then horror and despair seized him, and with all his strength, he ran against

The
Golden
Pot

75

the wall and pounded the glass vigorously, as if every nerve and artery were bursting. Finally, he smashed the crystal. A piercing clang went through the room, and the archivist in his bright damask dressing gown was standing in the door.

"Hey, hey! You vermin! Don't try to cast a spell! Witch work won't work! Get over here!" the archivist shouted.

Then the black hair of the crone rose up in tufts. Her red eyes glazed with infernal fire, and clenching together the peaked fangs of her abominable jaws, she hissed: "Get him! Get him!" And she laughed and neighed in scorn and mockery. Then she pressed the Golden Pot firmly to her bosom and threw handfuls of glittering soil at the archivist, but as it touched the dressing gown, the earth changed into flowers, which rained down on the ground. Then the lilies of the dressing gown flickered in flames, and the archivist caught these lilies, blazing in sparkling fire, and threw them at the witch. She howled with agony, but as she jumped into the air and shook her armor of parchment, the lilies were extinguished and fell down into ashes.

"Get your prey, you beast!" the crone shrieked. The black cat flew through the air and jumped over the archivist's head toward the door, but the gray parrot flew out, caught him by the nape with his crooked bill, and held the cat until fiery red blood gushed down over his neck. Then Serpentina's voice cried: "Saved! Saved!"

Foaming with rage and desperation, the crone now attacked the archivist and dropped the Golden Pot behind her. Holding her long fingernails as claws, she tried to clutch the archivist by the throat, but he quickly pulled off his dressing gown and hurled it at her. Then, hissing, sputtering, and bursting, blue flames shot from the parchment pages, and the crone rolled around, howling in agony and attempting to get fresh earth from the flowerpot and fresh parchment pages from the book so that she might stifle the blazing flames. Whenever any dirt or pages fell down on her, the flames went out. But the archivist managed to send furious, fiery beams, which continually hit the crone.

"Hey, hey! Attack again!" roared the archivist. "Victory to the Salamander!"

Suddenly, a hundred flashes of lightning whirled forth in fiery circles around the shrieking crone, while the cat and parrot kept whizzing and buzzing in their furious battle. At last, the parrot smashed the cat to the ground

with his strong wing, and while using his talons to firmly hold his adversary, who in deadly agony uttered horrid meows and howls, he pecked out his glowing eyes with his sharp beak, and burning froth spouted from them. Then thick vapor streamed up from the spot where the crone, who had been hurled to the ground, was lying under the dressing gown. Her howling and terrifying cry of lamentation died away in the remote distance. The smoke, which had spread all over the region with a piercing stench, cleared away; and the archivist picked up his dressing gown. Under it lay an ugly beet.

"My worthy Herr Archivist, let me offer you the vanquished foe," the parrot said, holding out a black hair in his beak to Archivist Lindhorst.

"Well done, my dear friend," replied the archivist. "Here lies my vanquished foe, too. Be so good now as to manage what remains. This very day you shall have six coconuts as sweet treats, and a new pair of spectacles as well, for I see the cat has villainously broken the lenses of these old ones."

"Yours to command forever, most honored friend and patron!" answered the parrot, much delighted. Then he took the withered beet in his bill and flew out through the window, which Archivist Lindhorst had opened for him.

The archivist now lifted the Golden Pot and cried with a loud voice, "Serpentina! Serpentina!"

As Anselmus rejoiced in the defeat of the vile witch, who had sought to destroy him, he cast his eyes on the archivist. Once again, he recognized the majestic form of the Prince of the Spirits, who was looking up to him with indescribable dignity and grace.

"Anselmus," said the Prince of the Spirits, "your loss of faith was not your fault. Rather, it was a hostile and destructive principle that endeavored to destroy you by penetrating your heart and dividing you against yourself. However, you have kept the faith. Be free and happy."

A bright flash of lightning soared through Anselmus's heart and raised his spirit. The splendid trio of the crystal bells sounded stronger and louder than he had ever heard before. His nerves and fibers trembled, while the melodious tones rang through the room and swelled higher and higher. The glass that had enclosed Anselmus broke, and he rushed into the arms of his dear and gentle Serpentina.

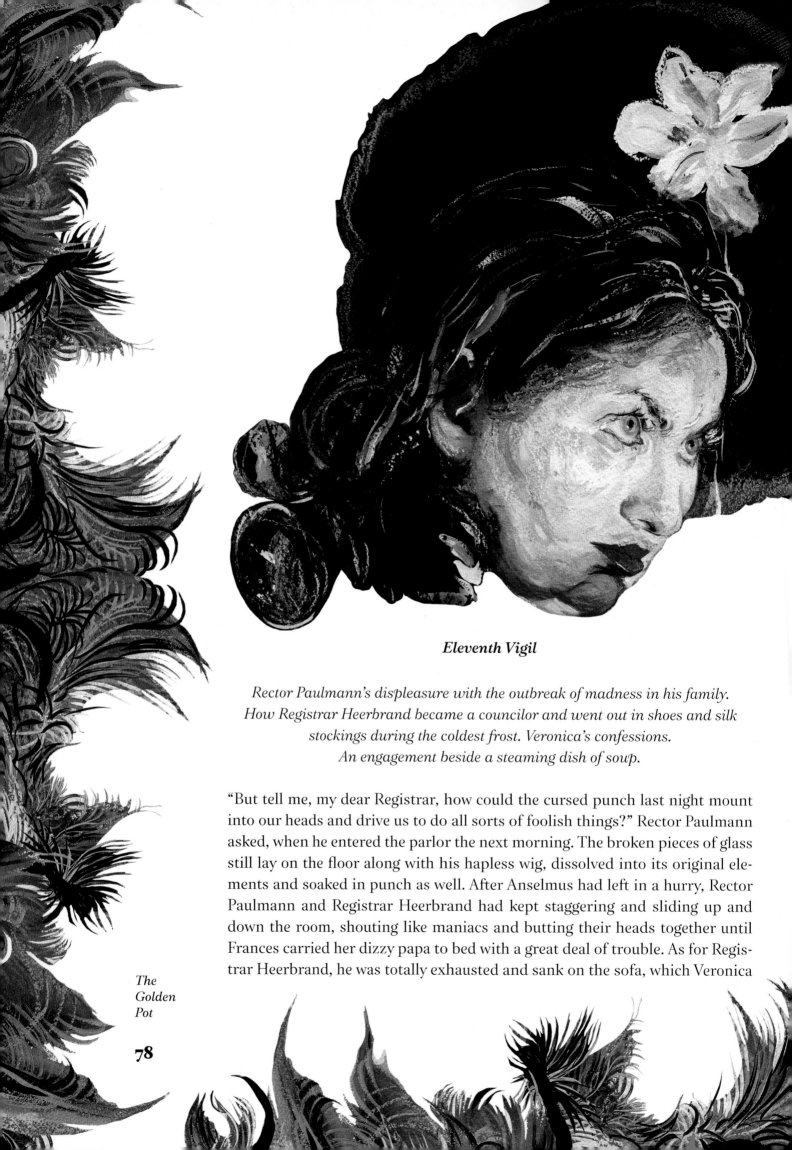

Eleventh Vigil

Rector Paulmann's displeasure with the outbreak of madness in his family.
How Registrar Heerbrand became a councilor and went out in shoes and silk
stockings during the coldest frost. Veronica's confessions.
An engagement beside a steaming dish of soup.

"But tell me, my dear Registrar, how could the cursed punch last night mount into our heads and drive us to do all sorts of foolish things?" Rector Paulmann asked, when he entered the parlor the next morning. The broken pieces of glass still lay on the floor along with his hapless wig, dissolved into its original elements and soaked in punch as well. After Anselmus had left in a hurry, Rector Paulmann and Registrar Heerbrand had kept staggering and sliding up and down the room, shouting like maniacs and butting their heads together until Frances carried her dizzy papa to bed with a great deal of trouble. As for Registrar Heerbrand, he was totally exhausted and sank on the sofa, which Veronica

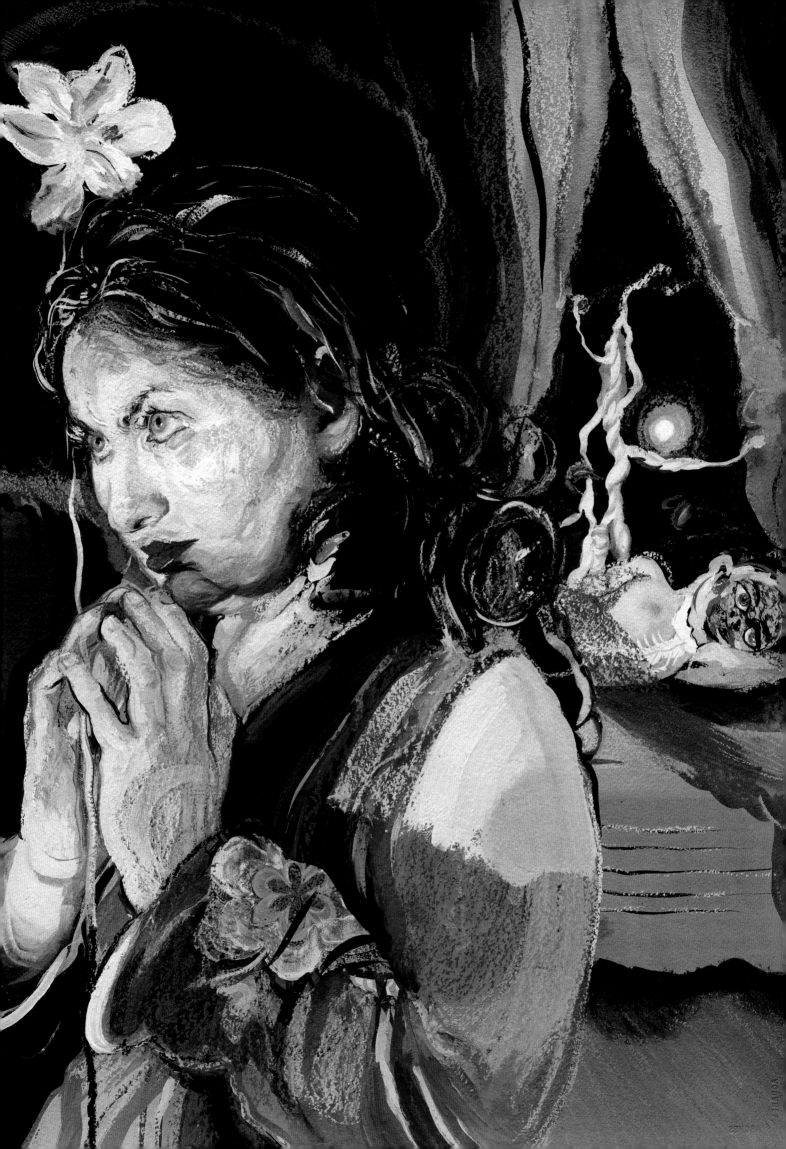

had abandoned, taking refuge in her bedroom. Registrar Heerbrand had his blue handkerchief tied around his head, and he looked quite pale and melancholy.

"Ah, worthy Rector," he moaned, "it was not the punch, which Mamsell Veronica most admirably brewed. No! I believe that cursed student was simply to blame for all the mischief. Haven't you noticed that he hasn't been in his right mind for some time? And are you not aware that madness is infectious? One fool makes twenty; pardon me, it is an old proverb. Especially when you have drunk a glass or two, you fall into madness quite readily, then involuntarily you join in the mad games and play along and imitate the crackbrained maniac, who started everything. Would you believe it, Rector? I am still giddy when I think of that gray parrot!"

"Gray fiddlestick!" interrupted the rector. "It was nothing but Archivist Lindhorst's little old amanuensis, who had thrown a gray cloak over himself and was looking for the student Anselmus."

"It may well be," answered Registrar Heerbrand, "but I must confess, I am quite down. Throughout the night there was such a piping organ music."

"That was me," said the rector. "I snore loudly."

"Well, maybe," answered the registrar, "but, Rector, Rector! I had good reason last night to provide some good cheer among us, but that the student Anselmus spoiled it all! You do not know, oh, Rector!"

And with this, Registrar Heerbrand jumped to his feet, plucked the cloth from his head, embraced the rector, pressed his hand warmly, and again cried in quite a heartbreaking tone: "Oh, Rector, Rector!" Then, snatching his hat and staff, he rushed out of the house.

"This Anselmus will not cross my threshold again," said Rector Paulmann. "I see clearly that his moping madness robs the best gentlemen of their senses. The registrar has now gone overboard, too. Until now, I have kept myself safe, but the devil, who knocked hard on our door last night, may get in at last and taunt me with his tricks. So, off with you, Satan! Off with you, Anselmus!"

Veronica, who had just entered the room, had grown quite pensive. She didn't speak much, only smiled now and then very oddly, and she seemed to wish to be left alone.

"She, too, has Anselmus in her head," said the rector, "but it is good that he doesn't show himself here. I know he fears me, this Anselmus, and so he will never dare to come here."

The Golden Pot

Rector Paulmann spoke these concluding words aloud. Then the tears rushed into Veronica's eyes, and she sobbed: "Ah! How do you think Anselmus can manage to come anyway? He has been corked up in the glass bottle for a long time."

"What? What?" cried Rector Paulmann. "Ah, heavens above! My heaven, she is talking nonsense like the registrar. Soon she will have a great fit! Ah, you abominable, thrice-cursed Anselmus!"

He ran out of the house and straight to Doctor Eckstein, who smiled and again said: "Well, well!"

This time, however, he prescribed nothing. Instead, he added the following words to the few he had uttered, and as he walked away, he said: "Nerves! It will all pass. Get some fresh air. Take walks and amuse yourself. Take in the theater, see *Sunday's Child* or *The Sisters from Prague*. It will all pass by itself."

"I have seldom seen the doctor so eloquent," thought Rector Paulmann. "Really talkative, I must confess!"

Several days and weeks and months passed. Anselmus had vanished, and Registrar Heerbrand did not appear either—that is, not until the fourth of February, when, in a fashionable new coat made of the finest cloth, in shoes and silk stockings, notwithstanding the strong frost, and with a large nosegay of fresh flowers in his hand, the registrar entered the parlor of Rector Paulmann precisely at noon. The rector was surprised to see his friend so well dressed. With a solemn air, Registrar Heerbrand approached Rector Paulmann, embraced him elegantly and then said: "Now at last, on the saint's day of your beloved and most honored Mamsell Veronica, I will tell you candidly something about what has long been disturbing my heart. That evening, that unfortunate evening, when I put the ingredients of our noxious punch in my pocket, I intended to deliver some good news and to celebrate the happy day in convivial pleasure. I had just learned that I was to be made privy councilor, and I now have the patent, *cum nomine et sigillo Principis,* in my pocket."

"Ah, wonderful! Herr Registrar—that is, I should say, Herr Privy Councilor Heerbrand," stammered the rector.

"But it is you, most honored Rector," continued the new privy councilor, "it is you alone who can complete my happiness. For a long time, I have secretly loved your daughter, Mamsell Veronica, and I can boast of many a kind look that she has given me, evidently showing that she would not reject me, if I pro-

posed to her. In a word, honored Rector, I, Privy Councilor Heerbrand, do now request the hand of your most lovely Mamsell Veronica, to whom I, if you have nothing against it, shall propose shortly, and if she accepts, I would like to lead her to the altar as soon as possible."

Rector Paulmann, who was totally astonished, clapped his hands repeatedly and cried: "Well, well, well, Herr Registrar, that is, Herr Privy Councilor, I meant to say, who would have guessed? So, if Veronica does really love you, I, for my part, cannot object. Perhaps, her present melancholy is nothing but concealed love for you, most honored Privy Councilor! You know how deceptive young women can be!"

Just at this moment, Veronica entered, pale and agitated, as she now habitually looked. Then Privy Councilor Heerbrand approached her, mentioned her saint's day in a neat speech, and handed her the fragrant bouquet, along with a little packet. When she opened it, a pair of glittering earrings sparkled at her. Immediately she blushed, and her cheeks turned red. Then her eyes sparkled in joy, and she cried: "Oh, heaven! These are the very earrings that I took such pleasure in wearing a few weeks ago."

"How can this be, dearest Mamsell?" interrupted Privy Councilor Heerbrand, somewhat alarmed and hurt. "I just bought them not an hour ago on Castle Lane for cash!"

But Veronica paid no attention to him. Instead, she went and stood before the mirror to witness the effect of the earrings, which she had already attached to her pretty little ears. Rector Paulmann disclosed to her with a serious face and solemn tone that his friend Heerbrand had asked for her hand in marriage. Veronica gazed at the privy councilor with a searching look and said: "I have long known that you wished to marry me. Well, so be it! I promise you my heart and hand, but I must now unfold to you, to both of you, I mean, my father and my bridegroom, that there is something heavily weighing on my heart, yes, even now, though the soup, which I see Frances is just putting on the table, may get cold."

Without waiting for the rector's or the privy councilor's reply, though the words were visibly hovering on the lips of both, Veronica continued: "You may believe me, Father. I loved Anselmus from my heart, and when Registrar Heerbrand, who has now become a privy councilor himself, assured us that Anselmus might possibly rise that high, I resolved that he, and no other, should be my husband. But then it seemed as if hostile alien creatures tried to snatch him away from me. I had recourse to old Liese, who was once my nurse, but is

now a wise woman and a great enchant-
ress. She promised to help me and deliver
Anselmus wholly into my hands. We went at
midnight during the equinox to the crossing of the
roads, where she conjured certain hellish spirits, and
with the help of the black cat, we manufactured a little
metallic mirror, in which I just had to look at and focus on
Anselmus in order to rule his heart and mind. But now I
sincerely repent having done all this, and here I now ab-
jure all satanic arts. The Salamander has conquered old
Liese. I know this because I heard her shrieks, but I could
not help. As soon as the parrot had eaten the beet, my me-
tallic mirror broke in two with a piercing clang."

Veronica took out both pieces of the mirror and a lock of
hair from her sewing box and handed them to Privy Councilor
Heerbrand. Then she proceeded to talk some more: "Here, take the fragments
of the mirror, dear Privy Councilor. At twelve o'clock midnight, throw them off
the Elbe Bridge, from the place where the cross stands; the stream is not fro-
zen there. But you are to wear the lock of hair on your faithful bosom. I hereby
abjure all magic and sincerely wish Anselmus joy and good fortune, since he
is now wedded to the green snake, who is much prettier and richer than I am.
Dear Privy Councilor, I shall love and honor you as a true and faithful wife."

"Oh, Lord! Oh, Lord!" Rector Paulmann cried, full of sorrow. "She is
crazy! Yes, she is crazy! She can never become Madame Privy Councilor! She
is cracked in the head!"

"Not in the least," Privy Councilor Heerbrand interrupted. "I know well
that Mamsell Veronica has had some fondness for the brute Anselmus, and it
may be that, in some fit of passion, she turned to the wise woman, who, as I
perceive, can be none other than old Frau Rauerin, who lives outside the Lake
Gate and tells fortunes from cards and coffee grounds. Nor can it be denied
that there are secret arts, which exert their influence on men, but much too
negatively. We read of such in the ancients, and doubtless there are still some
practices like this. But as to what Mamsell Veronica is pleased to say—about
the victory of the Salamander, and the marriage of Anselmus with the green
snake—this, in reality, I take for nothing but a poetic allegory, a sort of song, in
which she sings her entire farewell to the student."

"Take it for what you will, my dear Privy Councilor," cried Veronica. "Per-
haps for a very stupid dream."

"That I shall not do," replied Privy Councilor Heerbrand, "for I know full
well that Anselmus himself is controlled by secret powers that torment him
and drive him to play all sorts of mischievous pranks."

*The
Golden
Pot*

Rector Paulmann could stand it no longer and shouted: "Stop! For the love of heaven, stop! Are we somehow menaced by that cursed punch again, or has Anselmus's madness come over us, too? Herr Privy Councilor, what nonsense are you talking about? I must assume, of course, that it is love that deadens your brain. This will soon change when you are finally married. Otherwise, I would be apprehensive that you, too, have fallen into some kind of madness, most honored Herr Privy Councilor. Then what would happen to the future progeny of the family, if they were to inherit the madness of their parents? But now, I give my paternal blessing to this happy union and permit you as bride and bridegroom to exchange kisses."

This immediately took place; and thus, before the soup had grown cold, a formal engagement was concluded. In a few weeks, Privy Councilor Heerbrand's wife was very content, for she had earlier imagined sitting on the balcony of a fine house in the Neumarkt and looking down with a smile at the beautiful people who passed by and turned their glasses up to her, and saying: "She is a heavenly woman, the Privy Councilor Heerbrand's elegant wife."

Twelfth Vigil

News from the country estate where Anselmus took up residence
after he became Archivist Lindhorst's son-in-law
and how he was living life there with Serpentina.

Conclusion

You can imagine how deeply I felt for the happiness of the student Anselmus, who was now wedded to his gentle Serpentina! He had departed for the mysterious and wondrous realm that he recognized as the home for which his heart, despite strange premonitions, had always yearned. But it was in vain for me, kind reader, despite all my endeavors, to put these feelings into words and to write about all those magnificent splendors surrounding Anselmus. Reluctantly, I could not but acknowledge the feebleness of my every expression. I felt

myself enthralled amid the petty tedium of everyday life. I was sickened and tormented, and I glided about like a dreamer. In brief, I suffered from the same condition that Anselmus had endured in the Fourth Vigil, which I endeavored to describe for you. It grieved me greatly when I glanced over the Eleventh Vigil, which is now finished, and I thought I would never be permitted to insert the Twelfth, the keystone of the entire book. In the evening, when I sat down, with pen in hand, to complete the work, it was as if mischievous spirits (they might be relations, perhaps first cousins of the slain witch) held a polished and glistening mirror before me, in which I beheld my own, mean self: melancholy, drawn, and pale, somewhat like Registrar Heerbrand after his bout with the punch. Then I threw down my pen and went quickly to bed so that I might see the happy Anselmus and the fair Serpentina at least in my dreams. All this lasted for several days and nights, when, at last, quite unexpectedly, I received a note from Archivist Lindhorst, in which he wrote to me as follows:

Respected Sir, it is well known to me that you have written eleven vigils about the unique fortunes of my fine son-in-law Anselmus, former student, now poet, and are at present storming your brains so that in the Twelfth and Last Vigil you may recount something of his happy life in Atlantis, where he now lives with my daughter on the pleasant estate that I own in that country. Now, notwithstanding, I must regret that my own peculiar nature has been disclosed to the reading public, and this may cause me difficulties in my office as privy archivist. Indeed, it may expose me to a thousand inconveniences in the collegium and even give rise to the question: How far can a Salamander go and justly take an oath as a servant of the state with binding consequences? And how far, on the whole, may important affairs be entrusted to him, since, according to Gabalis and Swedenborg, the spirits of the elements are not to be trusted at all?

As a result, my best friends must now avoid my embrace, because they fear if I suddenly become angry, I might cast a flash or two and singe their hair curls and Sunday frocks. Despite all this, it is still my purpose to assist you in the completion of your work, since much good—of me and of my dear married daughter (I wish my other two daughters were also off my hands!)—has been said.

If you are going to write your Twelfth Vigil, please come down your cursed five flights of stairs, leave your garret, and pay me a visit. In the blue palm tree room, which you already know, you will find adequate writing materials. And you can then, in a few words, specify to your readers what you have seen. This is a better plan for you than any long-winded description of a life that you know only by hearsay.

With esteem,

Your obedient servant,

The Salamander Lindhorst,
P. T. Royal Archivist

This somewhat rough, yet, on the whole, friendly, note from Archivist Lindhorst gave me great pleasure. It seemed clear enough, indeed, that the particular manner in which the fortunes of his son-in-law had been revealed to me—and which I, bound to silence, must conceal even from you, gracious reader—was well known to this peculiar old gentleman. Yet, he had not taken offence, as I might have expected. In fact, he was offering me a helping hand in the completion of my work, and from this I might justly conclude that, in the end, he was not averse to having his marvelous existence in the world of spirits thus divulged through the press.

"It may be," thought I, "that he himself expects from this encounter that he might perhaps manage to get his two other daughters married in the near future. Who knows, but a spark might fall on this or that young man's chest and kindle a longing for the green snake, whom he might seek and find on Ascension Day under the elder tree? Of course, he will be forewarned by Anselmus's misery when he was enclosed in the glass bottle, and he will be doubly, if not trebly, on his guard against all doubt and unbelief."

Precisely at eleven o'clock, I extinguished my study lamp and went to visit Archivist Lindhorst, who was already waiting for me in the lobby.

"Are you there, my worthy friend? Well, this is what I like! You have not mistaken my good intentions. Follow me!"

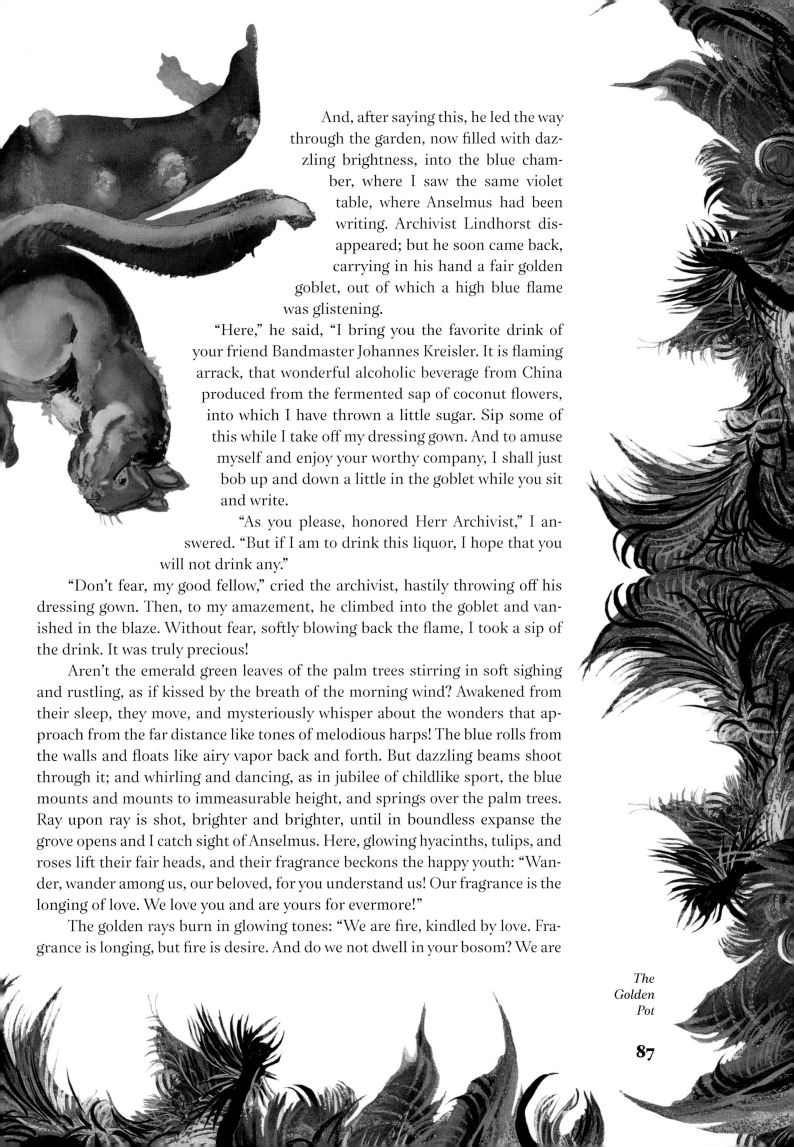

And, after saying this, he led the way through the garden, now filled with dazzling brightness, into the blue chamber, where I saw the same violet table, where Anselmus had been writing. Archivist Lindhorst disappeared; but he soon came back, carrying in his hand a fair golden goblet, out of which a high blue flame was glistening.

"Here," he said, "I bring you the favorite drink of your friend Bandmaster Johannes Kreisler. It is flaming arrack, that wonderful alcoholic beverage from China produced from the fermented sap of coconut flowers, into which I have thrown a little sugar. Sip some of this while I take off my dressing gown. And to amuse myself and enjoy your worthy company, I shall just bob up and down a little in the goblet while you sit and write.

"As you please, honored Herr Archivist," I answered. "But if I am to drink this liquor, I hope that you will not drink any."

"Don't fear, my good fellow," cried the archivist, hastily throwing off his dressing gown. Then, to my amazement, he climbed into the goblet and vanished in the blaze. Without fear, softly blowing back the flame, I took a sip of the drink. It was truly precious!

Aren't the emerald green leaves of the palm trees stirring in soft sighing and rustling, as if kissed by the breath of the morning wind? Awakened from their sleep, they move, and mysteriously whisper about the wonders that approach from the far distance like tones of melodious harps! The blue rolls from the walls and floats like airy vapor back and forth. But dazzling beams shoot through it; and whirling and dancing, as in jubilee of childlike sport, the blue mounts and mounts to immeasurable height, and springs over the palm trees. Ray upon ray is shot, brighter and brighter, until in boundless expanse the grove opens and I catch sight of Anselmus. Here, glowing hyacinths, tulips, and roses lift their fair heads, and their fragrance beckons the happy youth: "Wander, wander among us, our beloved, for you understand us! Our fragrance is the longing of love. We love you and are yours for evermore!"

The golden rays burn in glowing tones: "We are fire, kindled by love. Fragrance is longing, but fire is desire. And do we not dwell in your bosom? We are

yours!" The dark bushes, the high trees, rustle and resound: "Come to us, beloved, happy one! Fire is desire, but hope is our cool shadow. Lovingly, we rustle around your head, for you understand us, because love dwells in your heart!"

The brooks and fountains murmur and patter: "Loved one, do not walk so quickly by us! Look into our crystal! Your image dwells in us, and we preserve it with love, for you have understood us." In the triumphal choir, bright birds are singing: "Hear us! Hear us! We are joy, we are delight, the rapture of love!"

But, anxiously, Anselmus turns his eyes to the glorious temple, which rises behind him in the distance. The fair pillars seem to be trees, and the capitals and friezes acanthus leaves, which in wondrous wreaths and figures form splendid decorations. Anselmus walks to the temple. He views, with inward delight, the variegated marble, the steps with their strange veins of moss.

"Ah, no!" he cries in ecstasy. "She is not far from me now. She is near!"

Then Serpentina exits the temple in the fullness of her beauty and grace. She carries the Golden Pot, from which a bright lily has sprung. The nameless rapture of infinite longing glows in her meek eyes. Then she looks at Anselmus and says: "Oh, dearest, the lily has opened her blossom. What we longed for is fulfilled. Is there a happiness to equal ours?"

Anselmus embraces her with the tenderness of warmest ardor. The lily burns in flaming rays over his head. The trees and bushes move louder and clearer and gladder. The birds and shining insects dance in the waves of the sweet odors. There is a gay, bright, rejoicing tumult—in the air, in the water, in the earth—that is holding the festival of love! Now sparkling streaks rush, gleaming over all the bushes. Diamonds look from the ground like shining eyes. Strange vapors are brought here on whirring wings. They are the spirits of the elements, who do homage to the lily and proclaim the happiness of Anselmus. Then Anselmus raises his head, as if surrounded with glistening glory. Is it appearance? Are they words? Is it song? The sound can be heard.

"Serpentina! Belief in you, and my love of you has unfolded to my soul the innermost spirit of nature! You have brought me the lily, which sprang from gold, from the primeval force of the world, before Phosphorus had kindled

the spark of thought. This lily is knowledge of the sacred harmony of all beings, and in this I live in the realm of the highest bliss and blessedness forevermore. Yes, I have perceived what is highest. I must indeed love you forever. Oh, Serpentina! Never shall the golden blossoms of the lily grow pale, for, like belief and love, this knowledge is eternal."

For the vision, in which I now behold Anselmus bodily on his estate in Atlantis, I stand indebted to the arts of the Salamander, and it was fortunate that when everything had melted into air, I found a paper lying on the violet table with the foregoing statement concerning this matter, written fairly and distinctly by my own hand. But now I felt pierced and lacerated by a sudden attack of anguish and said:

"Oh, happy Anselmus, who has cast away the burden of everyday life, who in the love of kind Serpentina flies with bold wings, and who now lives in rapture and joy on your estate in Atlantis! While I, unfortunate as I am, must soon, that is, in a few moments, leave this fair hall, which itself is far from an estate in Atlantis, and again be transplanted to my garret, where, enthralled by the pettiness of existence, my heart and my sight are so obscured by a thousand ills, as though by a thick fog so that I doubt if I shall ever behold the lily."

Then Archivist Lindhorst patted me gently on the shoulder and said: "Softly, softly, my honored friend! Do not complain so much! Weren't you just now in Atlantis? And don't you have at least a pretty little farm there as the poetical property of your mind? And is the happiness of Anselmus anything else but life in poetry? Can anything else but poetry reveal the sacred harmony of all beings as the deepest secret of nature?"

The Sandman

Nathaniel to Lothar

CERTAINLY, YOU MUST all be very upset that I haven't written for such a long, long time. Mother is probably angry, and Clara may believe that I'm living like a king and have completely forgotten my sweet angel, whose image is deeply engraved in my heart and mind. But this is not the case. In fact, I think about all of you all the time, and the friendly image of my sweet little Clara continues to shine in my dreams, smiling upon me with her bright eyes, as she used to do when we were all together. So, you see, how could I have possibly written to you in the distracted state of mind that has bothered me and disturbed my every thought?

A horrible thing has happened to me. Dark forebodings of a cruel fate threaten and tower over me like dark clouds, and

not a single friendly ray of sun can penetrate my misery. So, now, I'll tell you what has happened. I must do this! I don't have a choice. I must share this with you, but the mere thought of it sets me to laughing like a madman. Ah, my dear Lothar, how shall I begin? How is it possible to relate what happened to me a few days ago, something that has had a fatal impact on my life? If you were here, you could see for yourself, but, as it is, you will certainly take me for a crazy fellow who walks around seeing ghosts. To be brief, this terrible occurrence, the dreadful encounter that I am vainly trying to avoid, is nothing more than the following:

Some days ago, namely on the thirtieth of October at twelve o'clock noon, a dealer in barometers entered my room and offered me his wares. I bought nothing and threatened to throw him down the stairs. Consequently, he left of his own accord.

I am sure you will assume that this incident could only have meaning if you know something about the profound and intertwined experiences in my life and that the dealer touched something that has had a very negative effect on me. This is the way it really is, and so I am gathering together all my strength to write to you calmly and patiently about my early childhood so that your keen mind will be able to visualize everything in clear images. While I am writing this, I can hear you laugh and Clara say: "This is nothing but childish nonsense!" Well, please do it! Laugh at me as much as you want and make fun of me! But, oh my God in heaven, my hair stands on end, and it is as if I seem to be begging you to laugh at me just like Franz Moor did in Schiller's play, *The Robbers*. But let me now return to the heart of the matter.

My brothers and sisters and I saw our father very little during the day, with the exception of lunch. He must have been busily absorbed by his work. After dinner, which was served according to the old custom at seven o'clock, we all went with my mother into my father's study and seated ourselves at the round table, where he would smoke and drink his large glass of beer. Often, he told us wonderful stories and grew so enthusiastic that his pipe continually went out. Consequently, I had to light it again with a match, which I enjoyed very much. Often, too, he would give us picture books and would sit in his armchair, silent and thoughtful, puffing out such thick clouds of smoke that we all seemed to be swimming in a fog. On such evenings as these, my mother was very sad, and as soon as the clock struck nine, she would say: "Now, children, to bed—to bed! The Sandman is coming. I can see him already!"

The Sandman

And, indeed, on each occasion I used to hear someone with a heavy, slow step come thumping up the stairs. That had to be the Sandman. Once, when I felt the thudding and thumping of footsteps to be especially frightening, I asked my mother, who was taking us to our room, "Mamma! Who is this evil Sandman? Why does he always drive us away from Papa? What does he look like?"

"There is no such thing as the Sandman, my dear child," my mother replied. "When I say the Sandman is coming, I only mean that you're all sleepy and can't keep your eyes open. It's as if someone had sprinkled sand into your eyes."

My mother's answer never satisfied me. On the contrary, in my childish mind I began thinking clearly and came to the conclusion that my mother only denied the Sandman's existence so that we would not be frightened of him. For sure, I always heard him coming up the stairs. Soon I became very curious to learn more about this Sandman and his connection to all of us children. So, at last, I asked the old woman who looked after my youngest sister what sort of a man he was, this Sandman.

"Well, well, my little one," she replied, "don't you know yet? He's a wicked man who comes to children when they won't go to bed. Then he throws a handful of sand into their eyes, causing them to bleed and become delirious. As soon as that happens, he puts their eyes into a bag and carries them to the crescent moon to feed his own children, who sit in a nest up there. They have crooked beaks, like the owls, so that they can peck the eyes of naughty human children."

Gradually, I began to paint a frightful picture of the brutal Sandman in my mind so that whenever I heard the noise on the stairs in the evening, I trembled with anxiety and horror, and my mother, who tried to calm me, could get nothing out of me except tears and a stuttering cry. "The Sandman! The Sandman!" I then ran into the bedroom, where I spent the whole night terrified by the apparition of the Sandman. Actually, I had already grown old enough to realize that the old woman's tale about him and the nest of children in the crescent moon could not really be true. Nevertheless, the Sandman remained a fearful, terrifying ghost, and I was gripped with horror one time when I heard him not only climb the stairs, but violently force open my father's door to enter his study. There was a period when he stayed away for a long time, but then his visits became more frequent. All this lasted for years, but I could never get used to the uncanny spook, and my image of him did not become any fainter. In fact, his dealings with my father increasingly occupied my imagination. Even

The Sandman

93

so, I could not conquer the shyness and fear I felt to ask my father about the strange Sandman. Over the years, my desire to investigate the case of the extraordinary Sandman and to see him grew and grew. He ignited my interest and set me on the marvelous and adventurous life track that had already been implanted in my mind as a child. I liked nothing more than to hear or read chilling stories about goblins, witches, and imps. But the Sandman was the most prominent and horrible of all, and I spent a good deal of my time drawing him with chalk or charcoal on the tables, cupboards, and walls. When I turned ten years old, my mother moved me from the evening nursery into a tiny room situated in a hall that was near my father's room. Nevertheless, when the clock struck nine and we could hear the feet of the unknown man on the stairs, we had to quickly leave our father's study. I could then hear how he entered my father's room. Moreover, I could also detect a thin vapor that had a strange and particular odor, which spread throughout the house. As my curiosity about the Sandman grew, so did my courage, and I decided to make his acquaintance some way or the other. I often crept from my room into the hallway after my mother had passed by my room, but I could never discover anything, because the Sandman always entered my father's room before I could reach the place where I could catch sight of him. Finally, driven by an irresistible impulse, I decided to hide myself in my father's room and await the Sandman. So, one evening, when I noticed from my father's silence and my mother's sadness that the Sandman was about to arrive, I pretended to be extremely sleepy, and I left the room before nine o'clock and hid myself in a corner close to the door. Soon I heard the house door creak, and suddenly there were heavy, slow, threatening steps on the stairs. My mother hurried out of the room with the rest of the children, while I very quietly opened the door to my father's room. As usual, he was sitting stiff and silent with his back to the door and did not notice me. So, I quickly dashed

The Sandman

94

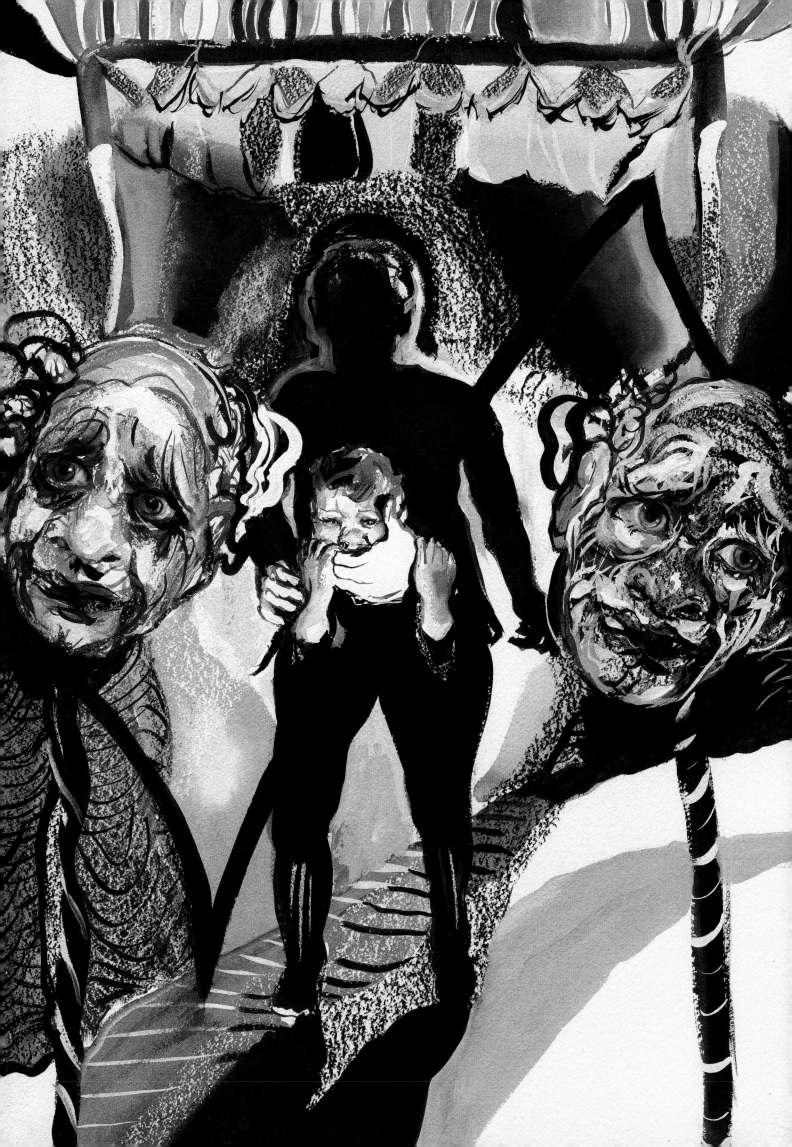

into the room and hid behind the curtain that covered an open cupboard close to the door in which my father's clothes were hanging. Closer and closer came the rumbling steps, and outside I heard a strange coughing, scraping, and droning. I felt my heart pounding with anxious expectation. Then I heard a sharp step close, very close, to the door. Suddenly, there was a heavy knock on the door, and it opened with a rattling noise. Now, I gathered together all my courage and carefully peeped from my hiding place. There he was! The Sandman was standing before my father in the middle of the room, while the bright lights of the candles exposed his face. The Sandman, the dreadful Sandman, was the old lawyer Coppelius, who sometimes ate lunch with us. However, even the most hideous figure could not have terrified me more than this very same man, Coppelius.

Just imagine a large, broad-shouldered man with a thick, deformed head, a yellow-brown face, and bushy gray eyebrows, beneath which a pair of green cat eyes sparkled with the most penetrating luster, and a large nose curved over his upper lip. His crooked mouth often twisted itself into a malicious laugh. Then a couple of dark red spots became visible on his cheeks, and a strange hissing sound could be heard through his gritted teeth. Coppelius always appeared in an old-fashioned, tailored ash-gray coat with a jacket and pants of the same color, while his stockings were black, and his shoes were adorned with agate buckles. His little wig hardly covered the top of his head, while his curls stood high above his large, red ears, and a wide bagwig jutted stiffly from his neck so that the silver clasp that fastened his folded cravat could be clearly seen. His entire figure was completely hideous and repulsive, but most disgusting to us children were his gnarled, hairy fists, so we would never eat anything that his hands had touched. Indeed, he had noticed this, and consequently, under some pretext or other, he enjoyed touching a tiny piece of cake or some sweet that our kind mother had secretly placed on our plates. He did this just for the pleasure of seeing us turn away with tears in our eyes, in disgust and horror. He acted in the same manner on holidays when our father would give us a little glass of sweet wine. Then he would quickly put his hand over it, and sometimes even raise the glass to his blue lips, laughing quite devilishly, while we could only express our indignation by silent sobs. He called us "little beasts" all the time, and whenever he was present, we did not dare utter a sound, but we did curse the ugly, hostile man who deliberately and intentionally marred our slightest pleasures. Our mother also seemed to hate the repulsive Coppelius as much as we did. Indeed, as soon as he appeared, her liveliness and her open and cheerful nature changed into

The Sandman

a sad and gloomy mood. Meanwhile, our father behaved as though Coppelius were some superior being whose bad manners were to be tolerated, and we were to maintain a good mood, no matter what he did. For example, he needed only to give the slightest indication that he wanted something to eat, and his favorite dishes were cooked, and the choicest wines were served.

When I finally came face-to-face with Coppelius, my soul was so perturbed by his gruesome and horrific manners that I felt nobody but this man could be the Sandman. In this case, however, the Sandman was no longer the bogeyman of the old woman's tale who filled the nest in the crescent moon with children's eyes. No, he was a detestable and eerie fiend, who brought with him eternal grief, misery, and destruction wherever he went, whether it was in the present or future. I was under his spell.

Realizing the danger of being discovered and that I might be severely punished, I remained with my head peeping through the curtain. Meanwhile, my father greeted Coppelius with great solemnity.

"Time to start our work!" this abominable man cried in a harsh and purring voice, as he flung off his coat. In response, my father silently and gloomily discarded his dressing gown. Then both put on long, black overalls. I don't recall where they had gotten them. My father opened the wing of what I had always thought to be a wall cupboard. But I now realized it was not a cupboard, but rather a dark cave in which there was a little fireplace. When Coppelius entered, a blue flame began to cackle on the hearth. There were all kinds of strange tools lying on the ground. My God! When my old father stooped down to the fire, he looked like some other man. He seemed to have been overcome by a horrible pain that changed his mild features into those of a repulsive, diabolical figure. In fact, he looked just like Coppelius, who was brandishing red-hot tongs, which he used to take glowing masses out of the thick smoke, then hammering these masses. It seemed to me that there were human faces lying around without any eyes. Instead, there were hideous, deep, black holes.

"Eyes here! Eyes here!" Coppelius cried, with a muffled, menacing voice.

Struck dumb with terror, I screamed wildly, fell from my hiding place, and landed on the floor. Now Coppelius grabbed hold of me, and as he snarled, he bleated: "Little beast! Little beast!" Then he dragged me and flung me on the hearth, where the fire began to singe my hair.

"Now we have eyes—enough eyes—a pretty pair of children's eyes," Coppelius whispered, as he took some red-hot grains out of the flame with his bare hands. He intended to sprinkle them in my eyes, but my father raised his hands high and pleaded: "Master, master, let my Nathaniel keep his eyes! I beg you!"

The Sandman

Coppelius laughed with a shrill voice and replied, "Well, let the boy keep his eyes so that he can contribute to the world's quota! But now let's examine the mechanism of his hands and feet!"

Then he seized me so roughly that my joints cracked, and after he screwed off my hands and feet, he put them back on again, one after the other.

"There's something wrong here," he mumbled. "But now it's as good as ever. The old man has learned how to do it!" Coppelius hissed and lisped.

Yet, everything around me turned dark and gloomy. Suddenly, I felt a sharp pain shoot through my bones and nerves, and I lost consciousness. There was nothing more to feel. Later, a gentle warm breath glided over my face. It was as if I had awakened from the sleep of death. My mother had been stooping over me.

"Is the Sandman still here?" I stammered.

"No, no, my dear child, he left long ago. He won't hurt you!" my mother replied, kissing me and happy to have regained her darling son.

Forgive me for tiring you, my dear friend Lothar. Why go into such lengthy details when I have so much more to tell? Enough! In short, I had been discovered eavesdropping and then was maltreated by Coppelius. My anxiety and fear coupled together, engendering delirium and fever, and causing me to lay in bed sick for several weeks.

"Is the Sandman still here?"

These were the first words that indicated I was healthy again—a sign that my recovery and salvation had begun. Now I have only to tell you about this exceedingly frightful moment in my childhood, then you will be convinced that it is not due to my blurry vision that everything seems colorless to me. Indeed, you will learn that a dark fatality has hung over my life. Actually, it is really a gloomy veil of clouds that I perhaps can only tear apart when I die.

Coppelius disappeared, and people said that he had left town. A good year passed, and we resumed sitting as we used to do at the round table. One night, my father was very cheerful and began telling us entertaining stories about his travels when he was a young man. Then, when the clock struck nine, we heard the door to the house squeak, followed by slow steps, heavy as lead, causing the stairs to rumble.

"It's Coppelius," my mother said, as she turned pale.

"Yes," my father agreed, in a faint, broken voice.

Tears flooded my mother's eyes, and she uttered, "No, no, must it be so?"

"He is coming for the last time. I promise you!" my father replied. "Now take the children and go! Go straight to bed. Good night!"

I felt as if I had been turned into a cold, heavy stone. I couldn't breathe. My mother grabbed my arm, but I couldn't move or be moved.

"Come, Nathaniel. Come now!" my mother cried, and I let her lead me to my room.

"Be quiet. Just be quiet and go to sleep," my mother commanded. However, I was tortured by indescribable internal anxiety and restlessness and could not close my eyes. The despicable and hateful Coppelius stood before me with fiery eyes, laughing with a smirk. Try as I might I could not get rid of his image. It must have been midnight when I heard a frightful noise, like a gunshot. The entire house shook. There was a rattling and a rustling outside my door, then the house door slammed shut.

"It's Coppelius!" I screamed, as I jumped out of bed in terror. Then there was a shriek that sounded like blazing and inconsolable grief. So, I dashed to my father's room. The door was open, and I was confronted by suffocating smoke.

"Ah, my master! My master!" the servant woman screamed.

On the floor of the smoking hearth lay my father. He was clearly dead, and his face was burned, blackened, and hideously distorted. My sisters were gathered around him, howling and bawling, and my mother, who had fainted, lay next to him.

"Coppelius, you cursed devil, you have murdered my father!" I screamed and went out of my mind.

Two days later, my father was laid in his coffin, and his features were again as mild and gentle as they had been when he was alive. My soul was comforted by the thought that his compact with the satanic Coppelius did not plunge him into eternal perdition. The explosion had wakened the neighbors. The incident had become the talk of the town and had reached the ears of the magistrate, who wished to charge Coppelius with a crime. He had, however, vanished without leaving a trace. If I tell you, my dear friend, that the barometer dealer was the accursed Coppelius himself, I hope you will not blame me for regarding all this as a hostile phenomenon and the omen of some dire calamity. He was dressed differently, but the figure and features of Coppelius are too deeply imprinted on my mind for an error in this respect to be possible. Moreover, Coppelius had not even changed his name. I am told that he calls himself a Piedmontese optician and goes by the name Giuseppe Coppola. I am determined to

The Sandman

deal with him and to avenge my father's death, no matter what might happen. Please, tell my mother nothing about the hideous monster's appearance. Remember me to my dear sweet Clara, to whom I will write when I feel calmer. Farewell.

Clara to Nathaniel

Though it's true that you have not written to me for a long time, I, nevertheless, believe that I am still on your mind and thoughts. Clearly, you were thinking about me very intensely when you mistakenly sent the letter intended for my brother Lothar to me instead. I joyfully opened the letter and did not realize my error until I came to the words, "Ah, my dear friend Lothar." Now, I shouldn't have read any further and should have handed the letter to my brother. Although you have often teased me, in your childish way, of having such a calm, levelheaded female disposition that, even if the house were about to collapse, I would smooth down a wrong crease in the window curtain in a most ladylike manner before I escaped the catastrophe. So, I can hardly tell you how your letter shocked me. I could barely breathe. Everything flickered before my eyes. Ah, my dear Nathaniel, how could such an awful thing happen in your life? To be separated from you, never to see you again—this thought penetrated my breast like a burning dagger. I read and read! Your description of the hideous Coppelius is terrifying. This was the first time that I learned about your good old father and how he died such a violent and gruesome death. When I returned the letter to my brother Lothar, he tried to calm me, but he didn't succeed. The fatal barometer dealer Giuseppe Coppola followed me at every step, and I am almost ashamed to confess that he disturbed my health and usually peaceful sleep with all sorts of eerie nightmares. Yet, the next day, I was able to arrange and deal with things for the better. Please do not be angry with me, dearest one, if Lothar tells you that, in spite of your strange premonition that Coppelius will in some way harm you, I am in the same cheerful and uninhibited mood as ever. This is not the case, but I must honestly confess that, in my opinion, all the horrid and terrible things of which you speak occurred merely in your own mind and have little to do with the actual, real world. Old Coppelius may have been repulsive, but his hatred of children was what really caused the abhorrence you children felt toward him. Naturally, in your mind as a child, the frightful Sandman in the old wives' tale was associated with old Coppelius. Why, even if you had not believed in the Sandman, Coppelius would still have seemed to you a fiend, especially dangerous to children.

The Sandman

The sinister business that he conducted at night with your father was nothing more than secret alchemical experiments. All this distressed your mother very much, and she could not have been satisfied with your father because a good deal of money was being wasted, and your father's mind was possessed by a false and deceptive desire to attain greater wisdom. This led him to become alienated from his family. Certainly, due to his carelessness, your father brought about his own death, and Coppelius was not guilty of this.

I must tell you that yesterday I asked our neighbor, an experienced pharmacist, whether such chemical experiments can cause sudden and fatal explosions. Well, he said, "certainly," and, in his own customary way, he told me in great detail and at great length how such explosions can be caused. While doing this, he mentioned such a number of strange-sounding names that I have forgotten them. Now, I know that you will be indignant about your Clara, and you'll say that her cold disposition is impervious to the slightest ray of the wondrous, which often embraces people with invisible arms. She only sees the colorful surface of the world and is delighted like a silly child by some glittering golden fruit that contains a deadly poison within it.

Ah! My dear Nathaniel, can't you see that even in open, cheerful, uninhibited, and carefree minds there is a suspicion of some dread power that endeavors to destroy us in our own selves? Please forgive me, if I, a simpleminded maiden, venture in any way to indicate what I think about such an internal struggle. In the end, I won't find the right words, of course, and you'll laugh at me, not because my thoughts are foolish, but because I express them in such an awkward manner.

If there is a dark and hostile power that lays a treacherous thread within us, holds us tightly, and draws us along the path of peril and ruin, a path that we would not have taken—if I say there is such a power, then it must form itself inside and out of ourselves. Indeed, it must become identical with ourselves. Only under this condition can we believe in it and grant it the room it requires to accomplish its secret work. Now, if we have a mind that is sufficiently firm, sufficiently strengthened by the joys of life, and if our mind can always recognize this strange enemy as such and calmly follows its own path of inclination and calling, then the dark power will fail in its attempt to gain a form that would be a reflection of ourselves. Lothar adds that if we willingly surrender ourselves to the dark powers, they are known often to impress on our minds any strange, unfamiliar shape that the external world has thrown in our way. Consequently, we ourselves kindle the spirit that we, in our strange delusion, believe to be speaking to us. It is the phantom of our own selves, whose close

The Sandman

relationship with and effect on our minds casts us into hell or sends us into heaven.

You see, dear Nathaniel, how freely Lothar and I are in giving our opinion on the subject of the dark powers. Indeed, this subject is a complicated one, as you can judge by my difficulties in writing down its most important features. I don't quite understand Lothar's last word. I can only surmise what he means, and yet, I feel his words are all very true. So, please get the despicable lawyer and barometer dealer, Giuseppe Coppola, out of your mind. You must convince yourself that these strange fears have no power over you, and that only a belief in their hostile influence can make them hostile in reality. If the trauma in your mind did not speak on every line of your letter, if your situation did not give me the deepest pain, I could joke about the lawyer Sandman and the barometer dealer Coppelius. Cheer up! Yes, cheer up! I have decided to play the part of your guardian spirit. If the ugly Coppola seeks to annoy you in your dreams, I'll scare him away with loud laughter. I am not afraid of him at all—or of his disgusting hands. I won't let him, neither as lawyer nor as Sandman, ruin my sweets and biscuits or my eyes.

Forever yours, my dear Nathaniel

Nathaniel to Lothar

I am truly sorry that Clara opened the letter intended for you and read it. This was all due to my distracted state of mind. She has written me a profound and philosophical letter, in which she proves in great detail that Coppelius and Coppola only exist in my own mind and are phantoms of myself that will dissipate as soon as I recognize them as such. Indeed, it is difficult to believe that her mind, which often shines from such bright, smiling, and naive eyes, with all the charms of a sweet dream, could analyze and make my complex prob-

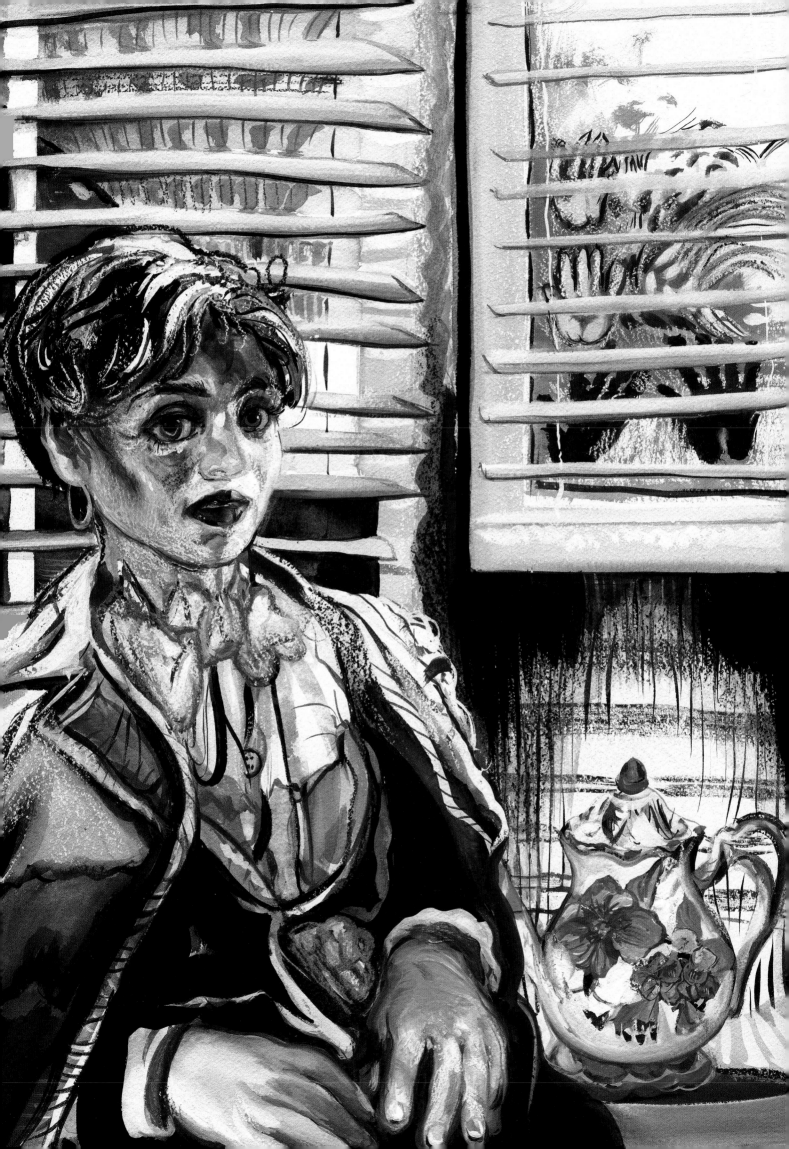

lems comprehensible. She refers to you, and I know you have been talking about me. Clearly, you have read her logical conclusions, which demonstrate how she sifted carefully though all the details of my situation. So, let's not talk about this anymore, please!

By the way, it is quite certain that the barometer dealer, Giuseppe Coppola, is not the lawyer Coppelius. I have been attending the lectures of a recently arrived professor of physics. His name is the same as that of the famous natural philosopher of physics, Spallanzani, and he is of Italian origin. He has known Coppola for many years, and moreover, it is clear from his accent that he is really a Piedmontese. Coppelius was a German, but I don't think he was an honest one.

I must say that I am not relieved or calm, and though you and Clara may consider me a gloomy visionary, I cannot get rid of the impression that the cursed face of Coppelius has made upon me. I am glad Coppola has left town—so Spallanzani says. This professor is an extraordinary oddball. He is a small, round man with high cheekbones, a sharp nose, pouting lips, and tiny, piercing eyes. However, you will get a better idea of him than from this description if you look at the portrait of Cagliostro, drawn by Chodowiecki in one of the Berlin calendars. Spallanzani looks exactly like that.

Recently, I went up the stairs to his room and saw that the curtain, which is generally drawn completely over a glass door, left a little opening on one side. Somehow, my curiosity got the better of me and I was compelled to look through the tiny gap in the curtain, and there I saw a very tall, slender lady, extremely well proportioned and most splendidly attired, who sat in the room by a little table, upon which she had laid her arms with her hands folded together. She sat opposite the door so I could see her entire angelic face. She did not seem to see me, however, and indeed, there was something dull about her eyes, as if, I might almost say, she had no power of sight. It appeared to me that she was sleeping with her eyes open. This made me very uncomfortable, and consequently, I crept away and entered a nearby lecture hall.

Later, I learned that the figure I had seen was Spallanzani's daughter, Olympia, whom he keeps locked up in a strange and brutal manner, so nobody can approach her.

The fact of the matter is that there may be something wrong with her. Perhaps, she is imbecilic, or something of the kind. But why should I write you

all this? I could have told you all this, much better and in more detail, in person. Indeed, you know I shall be with you in two weeks, for I must see my dear, sweet angelic Clara again. By then I shall have overcome my bad mood, though I must confess that it has been a struggle for me ever since I received Clara's sensible, but annoying, letter. Therefore, I'm not writing to her today.

A thousand greetings, etcetera.

Your true friend, Nathaniel

There can be nothing stranger and more wondrous than the fateful story of my poor friend, the young student Nathaniel, which I, gracious reader, shall undertake to tell you. Have you ever known something that has completely filled your heart, mind, and thoughts—to the exclusion of everything else? Have you ever experienced a burning fermentation within you, such that your blood seethed like a molten glow through your veins, sending a higher color to your cheeks? Have your eyes ever become weird, as if they sought something in an empty space that was invisible to others? Have you ever felt your spoken words turn into dark sighs? If so, I am sure your friends asked you, "What's wrong? What's the matter?"

In response, you may have endeavored to draw the picture in your mind, in all its glowing colors, in all its light and shade, and you may have tried to find just the right words to begin. It must have seemed that you should express in the very first sentence all those wonderful, glorious, horrible, comical, and frightful events, so your listeners would be stunned as if hit by an electric shock. However, every word, everything that speech is capable of, seemed to you colorless, cold, and dead. So, you hunted and hunted, stuttered and stammered, and the sober questions that your friends asked blew like icy wind upon your internal fire, until the fire was almost extinguished.

On the other hand, if you had first drawn an outline of the internal picture with a few daring strokes, like a bold painter, you might have easily painted the layers of color brighter and brighter, and the living throng of various shapes would have carried your friends away with it. Then they would have seen themselves, like you did in the picture that your mind had generated.

Now I must confess to you, dear reader, that no one has actually asked me to write the story of young Nathaniel, but you know well enough that I belong to the strange clan of authors, who, if they have anything such as I have

The Sandman

105

just described on their minds, feel as if everyone who comes near them, and the entire world besides, insistently demands: "What is it then? Please tell it to me, my dear friend." Consequently, I felt immensely driven to tell you something about the disastrous life of Nathaniel. The miraculousness and strangeness of his life filled my entire soul, and for this very reason, my dear reader, I had to make you just as inclined to tolerate the uncanny, which is no small matter. Indeed, I struggled to begin telling Nathaniel's story in a manner as significant, original, and gripping as possible. "Once upon a time," the beautiful beginning of every tale, was too sober. "In the provincial town of S__ lived" was somewhat better, since it at least allowed for a long story. Or should I jump right in, in medias res, with "'Go to hell!' cried the student Nathaniel, with rage and horror in the ferocious look of his eyes. When the barometer dealer Giuseppe Coppola . . . ?" Actually, I had already written this down when, however, I noticed that I could detect something comical in the wild look of the student Nathaniel, whereas the story is not funny at all. I could not find any kind of approach that reflected in the least the colorful images of the internal picture. Therefore, I decided not to begin at all. So, gentle reader, take the three letters that my friend Lothar was good enough to give me as the frame of the picture that I shall endeavor to provide with more colorful images as I proceed with my narrative.

Perhaps, like a good portrait painter, I might succeed in capturing the features of the people in my story, so you will find them familiar even without having personally met them and feel as if you had often seen the person in the flesh with your own eyes. Maybe, dear reader, you will then believe that nothing is stranger and more fantastic than actual life, which the poet can only catch in the reflection of a dimly finished mirror. To give you all the information you will need for a start, I shall supplement these letters with the news that, shortly after the death of Nathaniel's father, Clara and Lothar, the children of a distant relative who had also died and left them orphans, were taken by Nathaniel's mother into her own home. Clara and Nathaniel formed a strong attachment to each other, and since no one in the world had any objection, they were engaged just before Nathaniel left the town to pursue his studies in G__. And so, there he was, according to his last letter, attending the lectures of the celebrated professor of physics, Spallanzani.

Now that you know this, I could self-assuredly proceed with my story, but right now Clara's picture stands so plainly before me that I cannot look away.

The Sandman

106

This was always the case when she gazed at me with one of her lovely smiles. Clara could not, by any means, be considered beautiful, and this was the opinion of all those experts of beauty. Architects, nevertheless, praised the exact symmetry of her stature, and painters considered her neck, shoulders, and bosom almost too chastely formed, but then they all fell in love with her wondrous hair and coloring, comparing her to the Magdalene in Battoni's picture in Dresden. One of them, a most fantastical and unusual fellow, compared Clara's eyes to a lake near Ruysdael, in which the pure blue of a cloudless sky, the wood and flowery field, the whole cheerful life of the rich landscape, are reflected. Poets and composers went still further. "What lake? What mirror!" they exclaimed.

"Is it possible to look at this woman without wondrous, heavenly music flowing back toward us from her glances, which penetrate our innermost souls so that everything in us is wakened and stirred? If we don't sing well then, there is not much in us, as we learn from the delicate smile that plays on Clara's lips when we presume to provide her with something intended to pass for a song, although it is only a confused jumble of notes."

So, it was. Clara had the vivid imagination of a cheerful, uninhibited child; a deep, tender, feminine disposition; an acute, clever understanding. Misty dreamers did not have a chance with her. Though she did not talk—talking would have been altogether repugnant to her silent nature—her bright glance and firm, ironic smile would say to them: "Good friends, do you think that I shall take your fleeting, shadowy images for real shapes imbued with life and motion?" On this account, Clara was criticized by many as cold, unfeeling, and prosaic; while others, who understood life to its clear depths, greatly loved the acute, childlike young woman. Of course, none more than Nathaniel, whose perception in art and science was clear and strong. Clara was devoted to her lover with all her heart, and when he parted from her, it was the first time that clouds darkened her life. Therefore, it was with great joy that she rushed into his arms when, as he had promised in his last letter to Lothar, he returned to his hometown and entered his mother's room! Everything happened as Nathaniel thought it would. Just as soon as he saw Clara, he stopped thinking about the lawyer Coppelius and Clara's sensible letter. All his bad feelings disappeared.

However, Nathaniel was quite right when he wrote in his letter to his friend Lothar that the figure of the repulsive barometer dealer, Coppola, had a most negative effect on his life. Even in the first days at home, everyone felt that Nathaniel had undergone a complete change in his whole being. He sank into

The Sandman

107

a gloomy reverie and behaved in a strange manner that he had never shown before. Everything, his whole life, had become to him a dream and a premonition. Indeed, he often spoke about how people deceived themselves, thinking they were free, while really they were controlled by dark powers. Moreover, he claimed that it was futile to resist. Man must patiently resign himself to his fate. He even went so far as to say that it is foolish to think that we do anything in art and science according to our own independent will, for the very inspiration that enables us to produce anything does not proceed from within ourselves, but is the effect of an external, higher principle.

Even though all this mysticism was highly repugnant to the sensible Clara, it seemed fruitless to her to contradict Nathaniel. Only when Nathaniel demonstrated that Coppelius was the evil principle which had seized hold of him while he was listening behind the curtain, and that this disgusting man would, in some horrible manner, disturb the happiness of their lives, did Clara grow very serious and say: "Yes, Nathaniel, you are right. Coppelius is an evil and hostile principle. He can trigger horrible things through a diabolical power that enters into our lives, but only if you will not banish him from your mind and thoughts. As long as you believe in him, he will really exist and exert his influence. He will only have power over you if you believe in him."

Incensed that Clara did not admit the devil's existence other than in his mind, Nathaniel would start talking about the mystical doctrine of devils and the powers of evil. But Clara would get frustrated and bring up some other matters, to Nathaniel's annoyance. He thought that such profound secrets could not be understood by cold, unreceptive minds, without being aware that he counted Clara among these secondary people. Therefore, he constantly endeavored to initiate her into the mysteries of mysticism.

In the morning, when Clara was getting breakfast ready, he stood near her and read her all sorts of mystical books, until she cried: "But, dear Nathaniel, suppose I scold you for being the evil principle that has a negative effect on my coffee? If, to please you, I drop everything and look at your eyes while you read, my coffee will overflow into the fire, and neither of us will get any breakfast."

Nathaniel slammed the book shut and ran to his room in great displeasure. At one time, he had a remarkable gift for creating graceful, lively tales, which he wrote down, and to which Clara listened with the greatest delight. However, now Clara found his stories gloomy, incomprehensible, and formless, but she refused to say so out of compassion. Meanwhile, he plainly felt how lit-

tle she was interested in his works. Indeed, nothing was more unbearable for Clara than tediousness. Her looks and words revealed just how bored and drowsy she became when Nathaniel read his stories. To be sure, they were very tedious.

Nathaniel was frustrated by Clara's cold, prosaic disposition, and it grew even more because Clara could not overcome her dislike of his dark, sinister mysticism. Consequently, they became more and more estranged from one another, without either becoming aware of this change. Coppelius's ugly figure, as Nathaniel himself was compelled to confess, was growing dimmer in his imagination, and it became difficult to portray him in stories with sufficient color when he was to appear as the dreadful bogeyman of evil. Finally, Nathaniel reached the point of writing a poem in which he evoked his dark foreboding, revealing how Coppelius would destroy his happiness. He depicted himself and Clara as united by true love, but often threatened by a black hand that intruded into their lives, seizing some new joy just as it was emerging. In the end, Clara and Nathaniel are portrayed standing at the altar, when the hideous Coppelius appears and touches Clara's lovely eyes, which spring into Nathaniel's heart like bleeding sparks, scorching and burning, then Coppelius catches Nathaniel and flings him into a flaming, fiery circle that flies around with the swiftness of a storm, carrying him along with it, amid its roaring. The thunder is like that of a hurricane when it fiercely lashes foaming waves, which rise up, like black giants with white heads, for a furious battle. But through the wild tumult, Nathaniel hears Clara's voice: "Can't you see me then? Coppelius has deceived you. Those, indeed, were not my eyes that burned in your breast. On the contrary, they were glowing drops of your own heart's blood. I still have my eyes. Just look at them!"

Nathaniel reflects: "That is Clara, and I am hers forever!"

Then it seems to him as though this thought has powerfully entered into the fiery circle, which is standing silent while the noise fades into the dark abyss. Nathaniel looks into Clara's eyes, and from her eyes death looks kindly upon him.

While Nathaniel composed this poem, he was very calm and collected. In fact, he polished and improved every line, and since he had committed himself to the demands of rhyme and meter, he did not rest till everything was correct and melodious. When he finally finished and began reading the poem aloud to himself, he became terrified. "Whose horrible voice is that?" he cried out. Soon, however, after he had read more, the entire book seemed to be very successful, and he felt that it might ignite Clara's cold temperament, although he did not clearly

The
Sandman

109

grasp why he should ignite her interest, nor what purpose it would serve to torment her with frightful pictures threatening a horrible fate, destructive to their love.

Soon after finishing the poem, Nathaniel was sitting with Clara in his mother's little garden. Clara was very cheerful because Nathaniel had not plagued her with his dreams and forebodings during the three days in which he had been writing his poem. He was even talking cheerfully, as in the old days, about pleasant matters, which caused Clara to remark: "Now, for the first time, I have you again! Don't you see that we have driven the ugly Coppelius away?"

At that moment, it occurred to Nathaniel that he had the poem in his pocket, and that he had intended to read it to Clara. So, he pulled the pages out and began reading, while Clara, expecting something tedious as usual, resigned herself and quietly began to knit. But as dark clouds rose from the pages and became blacker and blacker, she let the stocking fall and stared right into his eyes. But he was carried away by his poem and could not stop reading. His cheeks turned deep red, lit by an internal fire, and tears flowed from his eyes. At last, after he had finished, he groaned in a state of utter exhaustion and grabbed hold of Clara's hand. Then he sighed as if he had dissolved into hopeless misery: "Oh, Clara! Clara!"

The Sandman

110

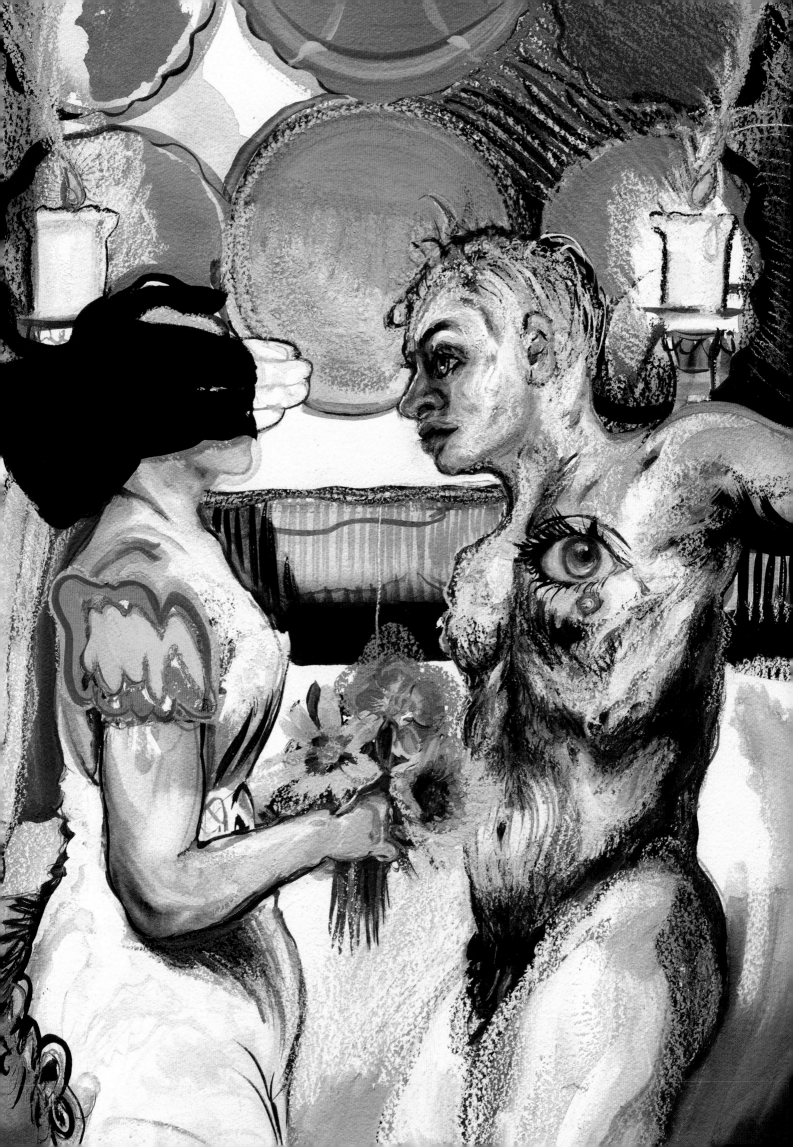

Clara pressed him gently to her bosom and said softly, but very slowly and sincerely: "Nathaniel, dearest Nathaniel, please throw that mad, senseless, insane fairy tale into the fire!"

Upon hearing this, Nathaniel was enraged. He jumped from his chair and pushed Clara away from him. "Oh, you lifeless, damned automaton!"

After saying this, he ran off, while Clara, who was deeply offended, shed bitter tears, and sobbed aloud: "Ah, he has never loved me! He doesn't understand me!"

Just then, Lothar entered the arbor, and Clara told him all about what had happened. Since he loved his sister with all his might, every word of her reproach fell like a spark of fire in his heart so that the discontent he had felt for a long time about the dreamer Nathaniel now exploded into a wild rage. He immediately left the arbor and went to Nathaniel's room, where he used hard words to reproach him for his senseless behavior toward his beloved sister. In response, the infuriated Nathaniel exchanged words in the same style. Called a fantastical, mad fool, he responded by calling Lothar a miserable, commonplace bore. A duel was inevitable. So, according to the local student custom, they agreed to fight with sharp rapiers on the far side of the garden the following morning.

Silently and gloomily, they went their separate ways. Clara had overheard the violent dispute, and when she saw the fencing master bring the rapiers at dawn, she guessed what was about to happen. When Lothar and Nathaniel reached the place in the garden where the duel was to take place, they somberly flung off their coats. Bloodthirsty and with the lust of battle flaming in their eyes, they were about to begin the duel when Clara rushed through the garden door, crying aloud between her sobs: "You wild, horrible men! Strike me down before you attack each other. Tell me, how would I be able to live if my lover murders my brother, or my brother murders my lover?"

Lothar lowered his weapon and looked silently at the ground, while Nathaniel felt his heart torn by the most poignant sorrow. His love for the beautiful Clara was recovered, revived from his earlier, happier days. Then he dropped his weapon and threw himself at Clara's feet.

"Can you forgive me, the love of my life, my beloved Clara? Can you forgive me, my dear brother Lothar?"

Lothar was moved by Nathaniel's deep suffering, and the three friends were reconciled. They embraced one another as a thousand tears flowed, and vowed eternal love and fidelity. Nathaniel felt as though a heavy burden, which had weighed on him, had been lifted. Indeed, it was as if he had resisted the

The Sandman

dark power that had oppressed him and thus had saved his whole being, which had been threatened with annihilation.

Nathaniel spent three more blissful days with his dear friends and then went to G__, where he intended to study one more year before returning to his hometown. Nathaniel kept his mother from knowing anything pertaining to Coppelius—because he knew she couldn't think of him without dread, and especially because she considered him responsible for her husband's death, as did Nathaniel.

When Nathaniel arrived in G__, he went to the house where he had rented a room and saw that the building had burned to the ground and only the bare walls stood amid the ashes. Although the fire had broken out in the laboratory of the pharmacist, who lived on the ground floor, and had destroyed the house from top to bottom, some courageous and brave friends had succeeded in entering Nathaniel's room on the upper story in time to save his books, manuscripts, and instruments. They carried all that they could save to another house, where they reserved a room that Nathaniel inhabited as soon as he arrived in G__. Nathaniel did not think it at all strange that he was now living in a room opposite Professor Spallanzani's office. Neither did it appear odd when he noticed that his window looked straight across the street into the room where Olympia often sat alone. In fact, he could clearly recognize her figure, although the features of her face were indistinct and muddled. After a while, he realized that Olympia often remained for hours in the position in which he had first seen her some time ago through the glass door, sitting idly at the little table, and that she was clearly watching him with a steadfast gaze. He had to admit to himself that he had never in his life seen a young woman with such a lovely stature. However, since Clara was in his heart, he was not moved by her beauty when he looked at the stiff and rigid Olympia. To be sure, he gazed at the beautiful statue from time to time when he was studying at his desk. But that was all.

Once he settled down, he began writing a letter to Clara, when he heard a light tap at the door. Nathaniel responded and invited the person who knocked into his room. But, then, he was surprised to see the repulsive face of Coppola. His heart trembled, but, when he recalled what Spallanzani had told him about his compatriot Coppola and also the firm promise he had made to Clara with respect to the Sandman Coppelius, he felt ashamed of his childish fear. Consequently, he collected himself with all his might and said, as softly as possible: "I don't want a barometer, my good friend. Please leave my room."

The Sandman

113

Despite Nathaniel's request, Coppola did not budge. His wide mouth opened and responded with a hideous laugh. His beady eyes flashed and sparkled beneath their long, gray lashes: "Eh, eh, no barometer? No barometer?" he said in a hoarse voice. "I have pretty eyes, too! Pretty eyes!"

"Madman!" the horrified Nathaniel screamed. "How can you have eyes? Eyes. Eyes."

But Coppola had already put his barometer aside and dug his hand into his wide coat pocket, from which he drew lorgnettes and spectacles, which he placed on a table.

"Now, now, spectacles on the nose. Those are my eyes—pretty eyes!" he muttered as he pulled out more and more spectacles, until the entire table began to glitter and sparkle in the most extraordinary manner. A thousand eyes stared and quivered with their gaze fixed on Nathaniel. Yet, he could not look away from the table where Coppola kept laying down more and more spectacles. Meanwhile, Coppola's flaming eyes leapt more and more wildly and shot their blood-red rays into Nathaniel's heart, causing great confusion. At last, overwhelmed by this insane terror, he screamed: "Stop, stop, you're horrifying me!"

Then he grabbed Coppola by the arm, but this maniacal man was searching his pockets to pull out even more spectacles, even though the whole table was already covered with them. Coppola managed to break away from Nathaniel and, with a repulsive, hoarse laugh, muttered: "Ah, nothing for you—but here are pretty glasses!"

While he was laughing, Coppola gathered together all the spectacles and packed them away. Then he drew a number of large and small telescopes from the breast pocket of his coat. As soon as the spectacles were gone, Nathaniel felt more at ease. Thinking of Clara, he realized that the hideous phantom was nothing but the creation of his own imagination and that this Coppola was actually an honest optician and could not possibly be the accursed double of Coppelius. Moreover, there was nothing strange about the telescopes that Coppola had placed on the table, at least nothing as eerie as the spectacles. Therefore, to set matters right, Nathaniel decided to buy a telescope. So, he picked up a little, very neatly constructed, pocket telescope and looked through the window to test it. To his surprise, he had never in his life experienced a telescope that brought objects so pure, sharp, and clear before his eyes. Not realizing what he was doing, he looked into Spallanzani's room. Olympia was sitting as usual by the little table with her arms on top of it and her hands folded. For the first time, Nathaniel could see Olympia's beautifully formed face. However, her eyes seemed strangely rigid and dead. As he looked more and more clearly through

The Sandman

the telescope, it appeared as if moist moonbeams were rising in Olympia's eyes. Indeed, it was as if the power of eyesight was being kindled for the first time. Now her glances flashed and were more and more lively. Nathaniel leaned against the window and seemed to be spellbound as he observed the beautiful, heavenly Olympia. Then a cough and scratching noise woke him, as if he had been dreaming. Coppola was standing behind him.

"*Tre zecchini*—three ducats!" he said.

Nathaniel had quite forgotten the optician, and quickly paid what he owed.

"Isn't it so . . . a beautiful telescope . . . beautiful telescope?" asked Coppola in his hoarse, repulsive voice and with a malicious smile.

"Yes . . . yes," Nathaniel replied peevishly. "Goodbye, my friend."

Coppola left the room, but not without casting many strange glances at Nathaniel, who heard him laugh on the stairs. "Ah," Nathaniel said to himself, "he is laughing at me because I have undoubtedly paid him too much for this little telescope." While he softly uttered these words, it seemed as if a horribly deep sigh could be heard erupting in the room, as if someone was dying, and it momentarily took his breath away. Then he realized that it was he who had sighed.

"Clara is right," he said to himself, "in calling me a crude visionary of some kind, but it is pure madness. . . . No, it is more than madness that the foolish thought of having paid Coppola too much for the telescope still bothers me and makes me so strangely anxious. I don't understand the cause of all this."

Now he sat down to finish his letter to Clara, but a glance through the window convinced him that Olympia was still sitting there, and as if driven by an irresistible power, he jumped up, grabbed hold of the telescope, and could not tear himself away from the seductive sight of Olympia—until his friend Sigismund arrived and went with him to Professor Spallanzani's lecture.

In the meantime, the curtain was drawn tightly in the fatal room, and he could no longer see Olympia. Nor could he the next day or the day after, even though he hardly ever left his window and constantly tried to see her through Coppola's telescope. On the third day, the window was completely covered, and in utter despair and driven by a longing and burning desire, he ran outside and made his way to the town gate. Olympia's figure hovered in the air before him. Then she stepped out of the bushes and gazed at him with large, beaming eyes. Clara's image had completely vanished from his mind. He thought only of Olympia and complained aloud in a murmuring voice: "Ah, you glorious, sublime star of my

The Sandman

love, have
you only
arisen to
vanish imme-
diately and
leave me in the
dark, hopeless
night?"

When Na-
thaniel headed back
to his room, he be-
came aware of many
workers bustling in Spallanzani's dwelling. The doors were wide open, and all
sorts of tools were being carried inside. The windows on the first floor were car-
ried out. The maids were sweeping and dusting with large brooms. Carpenters
and upholsterers were knocking and hammering inside the rooms. Nathaniel
was completely astonished and remained standing in the street. His friend Si-
gismund came up to him, laughing, and said: "Now, what do you say to our old
Spallanzani?"

Nathaniel assured him that he could say nothing because he knew nothing
about the professor. On the contrary, he was somewhat astonished and watched
the strange proceedings in a house that tended to be quiet and gloomy. He then
learned from Sigismund that Spallanzani intended to organize a grand party
the following day—a concert and ball—and that half the university was invited.
In addition, people had heard that Spallanzani, who had anxiously kept his
daughter far from the sight of human eyes, would now let her appear for the
first time.

*The
Sandman*

116

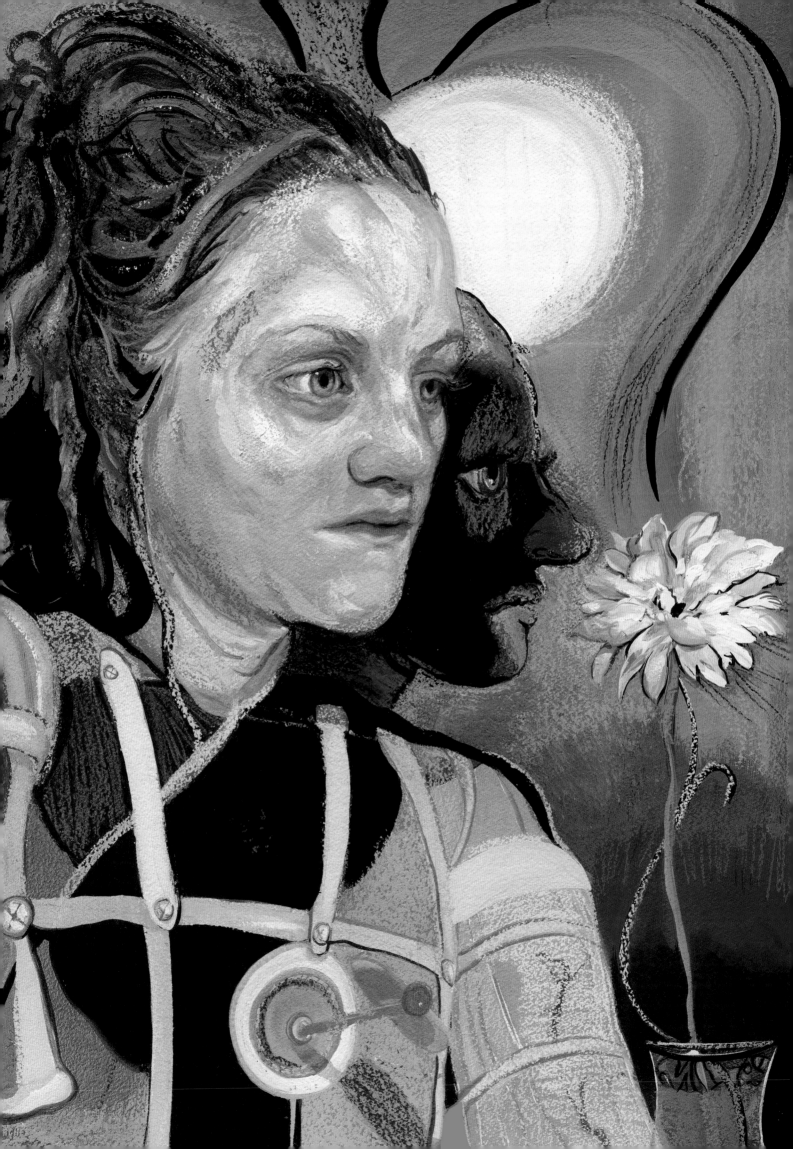

When he returned to his room, Nathaniel found an invitation. With his heart beating rapidly, he went to the professor's house at the appointed hour, and saw coaches already arriving and lights shining in the decorated rooms. The visitors were numerous and radiant. Olympia appeared sumptuous and dressed with great taste. Her beautifully shaped face and figure aroused general admiration. The somewhat strange arch of her back and the wasplike thinness of her waist seemed to be produced by too-tight lacing. There was something measured and stiff in the way she held herself and walked, and this struck many as unpleasant, but it was attributed to the constraint produced by the large company of people. Soon the concert began. Olympia played the harpsicord with great dexterity and sang a virtuoso piece with a voice like the sound of a glass bell, clear and almost piercing. Nathaniel was completely enraptured. He stood in the back row and could not perfectly recognize Olympia's features in the dazzling light. Therefore, without drawing attention to himself, he took out Coppola's telescope and looked at the beautiful Olympia. Ah! Then he saw how she gazed at him with great longing and how every note of her song clearly sprang from the loving glance, which ignited his inner desire and yearning. Her artful roulades seemed to Nathaniel to be the exultation of a mind transformed by love, and when, at last, after the cadence, the long trill blared through the room, he felt as if he had been suddenly seized by burning arms. He could no longer restrain himself and had to shout with pain and rapture, "Olympia!"

Everyone turned and looked at him, and many laughed. The church organist made a grimmer face than usual and simply said: "Well, now!"

The concert had concluded, and the ball began. "To dance with her—with her!" That was the sum of all Nathaniel's desires, wishes, and striving. But how could he summon the courage to ask her, the queen of the ball? And yet! Nathaniel did not know how it happened. No sooner had the dancing begun than he was standing close to Olympia, who had not yet been invited to dance. Hardly able to stammer a few words, he seized her hand, which was as cold as ice. He felt a horrible, deadly chill running through his body. He stared into her eyes, which beamed back full of love and desire, and at the same time it seemed her pulse began to beat and her life's blood began to flow into her cold hand. All this caused Nathaniel's soul to reap the joy of love in exaltation. Now he embraced the beautiful Olympia, and they flew through the dance. He thought his dancing was usually correct with regard to timing and step. However, the

The Sandman

118

peculiar, steady rhythm with which Olympia moved, often causing him to miss a step, soon revealed that his timing was quite defective. However, he refused to dance with any other lady and would have murdered anyone who approached Olympia to ask her for a dance. But this happened only twice, and to his astonishment, Olympia remained seated until the next dance, when he lost no time in asking her to rise again. Had Nathaniel been able to see any other object aside from the beautiful Olympia, all sorts of quarrels and arguments would have been inevitable. Indeed, in every corner of the ballroom, a quiet, scarcely suppressed laughter arose among the young people, and this laughter was clearly directed toward Olympia, whom they followed with curious glances. It was difficult to know why this was. Nathaniel had become overheated through dancing and drinking a great deal of wine, and he had abandoned all reserve. He sat next to Olympia, with her hand in his, and he enthusiastically talked about his love for Olympia in words that nobody understood, neither he nor Olympia. Yet, perhaps she did, for she gazed unmovably straight into his eyes and sighed several times. "Ah . . . ah . . . ah!"

Upon hearing this, Nathaniel cried out: "Oh, glorious, heavenly lady! My sun ray from the promised land of love, all my being is reflected in your deep soul!" In fact, he uttered even more stuff like that. But Olympia merely went on sighing, "Ah . . . ah!"

Occasionally, Professor Spallanzani walked past the happy pair and smiled at them with a look of strange content. Although Nathaniel felt he was in quite another world, it seemed suddenly as though Professor Spallanzani's face was growing considerably grimmer. Then, when Nathaniel looked around, he perceived, to his great horror, that the last two candles in the empty room had burned down to their sockets and were just going out. The music and dancing had stopped long ago.

"We must part! Must part!" Nathaniel cried in wild despair.

After he kissed Olympia's hand, he bent toward her mouth, where his glowing lips were met by lips cold as ice! It was just like the time before when he had touched her cold hand. Once again, he felt himself overcome by horror, and he recalled the legend of the dead bride. However, Olympia squeezed him, and her lips seemed to spring to life at his kiss. Professor Spallanzani walked slowly through the empty hall. His steps produced a hollow echo, and flickering shadows swirled around his figure, which had a fearful, spectral appearance.

"Do you love me? Do you love me, Olympia? Only one word! Do you love

The Sandman

119

me?" Nathaniel whispered and waited for an answer. However, as Olympia rose, she only sighed, "Ah . . . ah!"

"Yes, my sweet, glorious, and beautiful star of love," Nathaniel exclaimed. "You have risen above me and will shine forever and open my innermost soul!"

"Ah . . . ah!" responded Olympia as she departed.

Nathaniel followed her until they both stood before Professor Spallanzani.

"You have had a very animated conversation with my daughter," he said, smiling. "Now, now, my dear Nathaniel, if you have pleasure talking with a shy and silly young woman, your visits will be welcome."

So, Nathaniel departed with an entire heaven beaming in his heart. The next day, Spallanzani's party was the favorite topic of conversation in the town. Even though the professor had made every effort to appear as splendid as possible, the gossips found all sorts of incongruities and strange things to talk about. They were particularly critical of the dumb, stiff Olympia. In spite of her beauty, they considered her to be completely stupid, and they were delighted to surmise that her stupidity was the reason Spallanzani had kept her concealed so long. Of course, when Nathaniel heard this, it made him wince and become angry. Nevertheless, he kept quiet and thought it was not worth his while to convince these people that their own stupidity was what prevented them from recognizing Olympia's profound and noble mind.

One day, Sigismund asked him, "Be kind enough, my friend, and tell me how a sensible fellow like you could possibly lose your head over the wax face of that wooden doll up there?"

Nathaniel was just about to explode in response, but he collected himself and replied: "Tell me, Sigismund, how is it that Olympia's heavenly charms could escape your active and intelligent eyes, which generally perceive things so clearly? For that very reason, thank our good fortune that you are not my rival. Otherwise, one of us would have had to fall bleeding in duel."

Sigismund clearly understood his friend's condition. So, observing that it was impossible to argue about the affairs of love, he skillfully turned the conversation to another subject. Then he added: "Nevertheless, it is strange that many of us think much the same way about Olympia. Please don't take this the wrong way, my friend. She appears peculiarly stiff and soulless. It's true that her body is well proportioned, as is her face. She might pass for beautiful if her

The Sandman

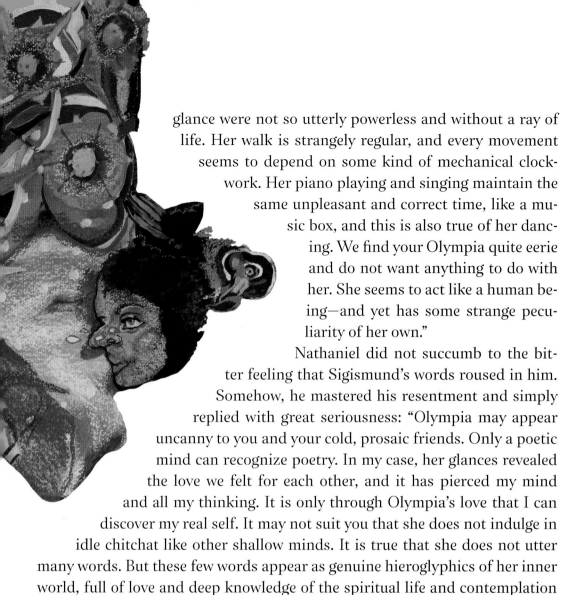

glance were not so utterly powerless and without a ray of life. Her walk is strangely regular, and every movement seems to depend on some kind of mechanical clock-work. Her piano playing and singing maintain the same unpleasant and correct time, like a music box, and this is also true of her dancing. We find your Olympia quite eerie and do not want anything to do with her. She seems to act like a human being—and yet has some strange peculiarity of her own."

Nathaniel did not succumb to the bitter feeling that Sigismund's words roused in him. Somehow, he mastered his resentment and simply replied with great seriousness: "Olympia may appear uncanny to you and your cold, prosaic friends. Only a poetic mind can recognize poetry. In my case, her glances revealed the love we felt for each other, and it has pierced my mind and all my thinking. It is only through Olympia's love that I can discover my real self. It may not suit you that she does not indulge in idle chitchat like other shallow minds. It is true that she does not utter many words. But these few words appear as genuine hieroglyphics of her inner world, full of love and deep knowledge of the spiritual life and contemplation of the eternal beyond. But you have no sense for all of this, and my words are wasted on you!"

"May God protect you, my friend," Sigismund said very softly, almost sorrowfully. "But you seem to be on some kind of evil path. You may depend on me if everything—no, no, I don't want to say anything more!"

All of a sudden, Nathaniel realized that the unimaginative Sigismund meant well toward him, and therefore he warmly shook hands with him.

Nathaniel had totally forgotten the very existence of Clara, whom he had once loved. Moreover, his mother, Lothar, and his other friends had all vanished from his memory. He lived only for Olympia, with whom he sat for hours every day, uttering strange, fantastical stuff about his love, about the sympathy that glowed to life, and about the affinity of souls. Meanwhile, Olympia listened with great devotion. At one point, Nathaniel took out everything that he had ever written from the bottom of his desk—poems, fantasies, visions, romances, tales. This stock of his writing was increased daily by all sorts of extravagant sonnets, stanzas, and canzones, and he tirelessly read them all to Olympia, for hours on end. Never had he encountered such a marvelous listener. She neither embroidered nor knitted; she never looked out the window; she did

The Sandman

121

not feed favorite birds; she played with
neither a lapdog nor a pet cat; she
did not twist a slip of paper or any-
thing else in her hand; she did not
have to suppress a yawn by a gen-
tle, forced cough. In short, she sat
for hours, looking straight into her
lover's eyes, without stirring, and
her glance became more and more
lively and animated. Only when
Nathaniel rose at last and kissed
her hand and her lips did she say,
"Ah, ah!" to which she added:
"Good night, dearest."

"Oh glorious, deep mind!"
cried Nathaniel when he
reached his own room.
"You, you alone, dear
one, fully understand me."

He trembled with de-
light when he thought about the won-
derful harmony that was revealed more
and more every day between his own mind
and that of Olympia. Indeed, it seemed to him as if Olympia
spoke about him and his poetic talent out of the depths of his own
mind—as if her voice had actually sounded from within himself. That
must indeed have been the case, for Olympia never uttered any words
whatsoever beyond those that had already been recorded.

Even when Nathaniel, in clear and sober moments, as for instance upon
waking in the morning, remembered Olympia's utter passivity and her painful
lack of words, he merely said: "What do words mean? Words! Her heavenly
glance speaks more than any language here on earth. Can a child of heaven
adapt herself to the narrow confines of miserable mundane necessity?"

Professor Spallanzani seemed delighted by the relationship between his
daughter and Nathaniel. Indeed, he gave the most unequivocal signs of ap-
proval to Nathaniel, and when the student ventured at last to hint at a union
with Olympia in the future, Spallanzani's whole face smiled, and he stated that
he would leave his daughter a free choice in the matter.

Encouraged by these words, and with burning passion in his heart, Na-
thaniel decided to implore Olympia on the very next day to say directly and in
plain words what her kind glance had told him long ago—namely, that she loved

*The
Sandman*

122

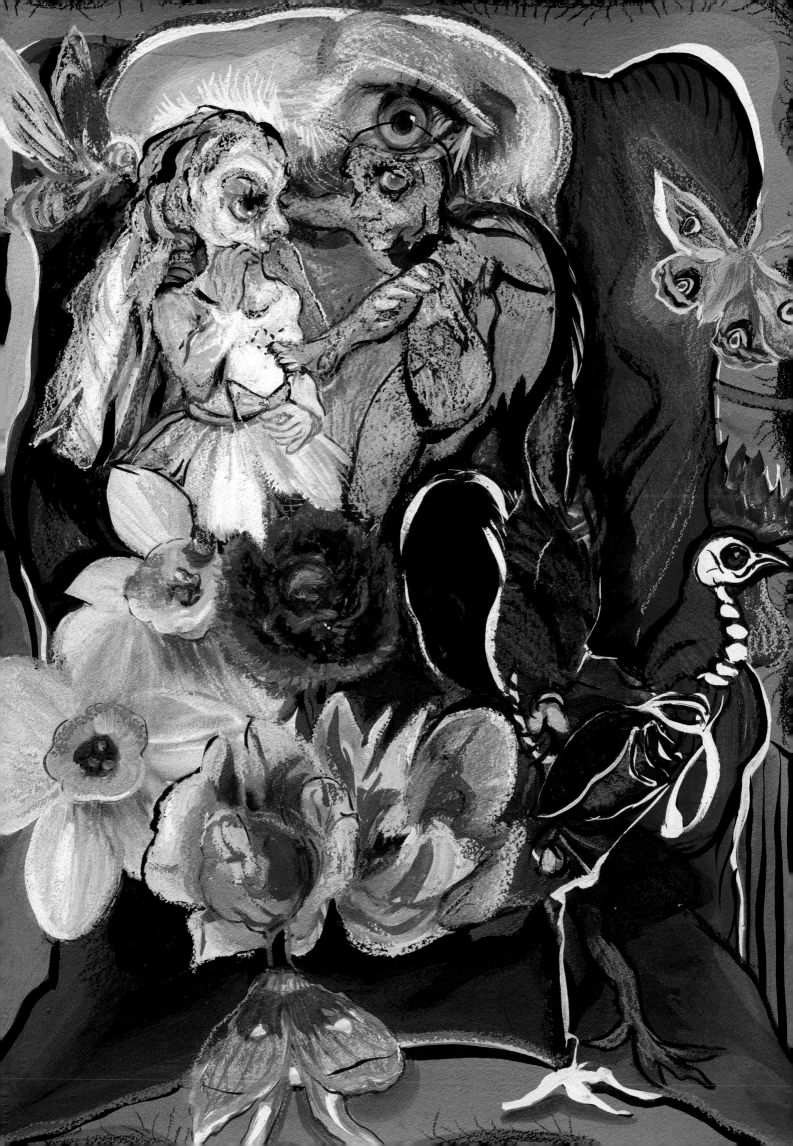

him. He looked for the ring that his mother had given him at parting. He wanted to give it to Olympia as a symbol of his devotion and of his life, which budded forth and bloomed with her alone.

During his search for his mother's ring, Nathaniel came across Clara's and Lothar's letters, but he flung them aside indifferently. Once he found the ring, he pocketed it and rushed over to Olympia. But on the steps, in the hall, he heard a strange noise that seemed to come from Spallanzani's room. There was a stamping, a clattering, a pushing, and a banging against the door, mingled with curses and oaths.

"Let go, you infamous scoundrel!—I've risked body and soul on this!—Ha, ha, ha!—That's not what we bet on!—It was me! I was the one who made the eyes!—I made the clockwork!—Stupid blockhead, you and your clockwork!—You simpleminded watchmaker!—Off with you!—You devil!—Stop!—Pipemaker!—Infernal beast!—Stop!—Get out!—Let go!"

These words were uttered by the voices of Spallanzani and the hideous Coppelius. They were raging and furious. Overcome by the most unspeakable anguish, Nathaniel rushed into the room. The professor was holding a female figure firmly by the shoulders, while the Italian Coppola grabbed it by the feet, and there they were tugging and pulling, this way and that. Both were desperately trying to gain possession of it with the utmost fury. When Nathaniel recognized that Olympia was the figure over which they were fighting, he collided with them in horror. With his anger flaring, Nathaniel was about to rescue his beloved from these infuriated men, but Coppola suddenly whirled around and, with the strength of a giant, wrenched the figure from the professor's hands. Then, in a tremendous blow, he hit the professor with the figure, sending him reeling and tumbling backward over the table, where vials, retorts, bottles, and glass cylinders were standing. All these were dashed to a thousand slivers. Now Coppola flung the figure across his shoulders, and with a frightful burst of shrill laughter, he dashed down the stairs so fast that the figure's feet, which dangled in the most hideous manner, rattled with a wooden sound on every step.

Nathaniel stood paralyzed, for he saw that Olympia's waxen, deathly pale face had no eyes, but black holes instead. She was, indeed, a lifeless doll. Spallanzani was writhing on the floor. Pieces of glass had cut his head, chest, and

The Sandman

124

arms, and blood was spurting as if from many fountains. But he soon gathered together all his strength.

"After him! After him! What are you waiting for? Coppelius, Coppelius has robbed me of my best automaton—a work of twenty years. Body and soul risked upon it. The clockwork, the speech, the walk—mine; the eyes, stolen from you. The damned thief! After him! Fetch Olympia! There you see the eyes!"

Just then, Nathaniel saw a pair of eyes lying on the ground, staring at him. But Spallanzani quickly picked them up with his unwounded hand and threw them at Nathaniel. When they landed on his breast, madness seized Nathaniel in its red-hot claws and tore apart his very soul, destroying his mind and thoughts.

"Wow! Wow! Wow! Circle of fire! Fire! Spin round, circle! Merrily, merrily! Ho, wooden doll—spin around, pretty doll!" Nathaniel screamed and leaped upon the professor, clutching his throat. He would have strangled him if the noise had not attracted a crowd. Consequently, some people rushed inside and forced Nathaniel to let go, thus saving the professor, whose wounds were immediately dressed. Sigismund, strong as he was, was not able to master the mad Nathaniel, who kept crying out in a frightening voice: "Spin around, wooden doll!" and waving clenched fists. At last, the combined force of many people succeeded in overcoming him, flinging him to the ground, and tying him with rope. His words merged into one hideous roar, like that of a brute, and in this insane condition he was taken to the madhouse.

Before I proceed to tell you, gentle reader, what else happened to the unfortunate Nathaniel, I can inform you, if you are interested, that the skillful optician and automaton-maker Spallanzani recovered completely from his wounds. However, he was obliged to leave the university because Nathaniel's story had created a sensation, and it was universally considered a most unpardonable experiment to smuggle a wooden doll, disguised as a live person, into respectable tea parties. Here it is important to know that Olympia had been quite a success at tea parties. The lawyers called it a most subtle deception, inasmuch as Spallanzani had planned it so artfully, and not a single soul—with the exception of a few cunning students—had detected it. Of course, now there are many wiseacres who claim to have observed various facts that had appeared suspicious to them. Nothing remarkable was revealed in this way. Would it strike anyone as terribly suspicious, for instance, that, according to the testimony of an elegant

The Sandman

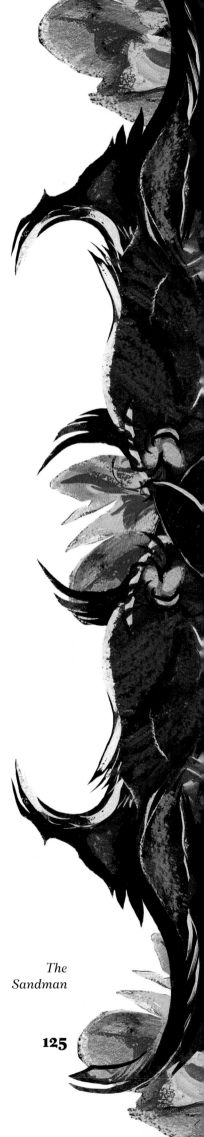

member of one tea party, Olympia had, contrary to all norms, sneezed more often than she had yawned? Actually, this fashionable person remarked that the sneeze was the sound of the concealed clockwork winding itself up. Moreover, it had creaked audibly. And so on. The professor of poetry and eloquence took a pinch of snuff, clapped the lid of his box shut, cleared his throat, and said solemnly: "Ladies and gentlemen, haven't you noticed where the crux of the matter lies? It is all an allegory—a sustained metaphor—you understand me. A word to the wise is sufficient!"

But many distinguished men were not satisfied with this. In fact, the story of the automaton had planted deep roots into their minds, and an awful mistrust of human figures in general had begun to spread all over the town. Many men wanted to be convinced that the women they loved were not wooden dolls and requested the ladies to sing and dance a little, embroider and knit, and play with their lapdogs, while listening to readings, and so forth. Moreover, the women were not merely to listen, but also sometimes to talk in such a manner that demanded actual thought and feeling. Indeed, the bond of love became firmer and more charming. However, other couples broke their engagements. "One cannot really answer for this," said some. At tea parties, yawning prevailed to an incredible extent, and there was no sneezing at all, so suspicion might be avoided. Spallanzani, as already stated, was obliged to decamp, to escape a criminal prosecution for fraudulently introducing an automaton into human society. Coppola had also vanished.

Nathaniel awakened as if he had had a difficult, frightful dream. When he opened his eyes, he felt an indescribable sensation of pleasure flowing through him with heavenly warmth. He was in bed in his own room, in his father's house. Clara was stooping over him, and Lothar and his mother were standing nearby.

"At last, at last, beloved Nathaniel, you have recovered from your difficult sickness. Now you are mine again!" Clara said from the very depth of her soul and embraced Nathaniel in her arms. It was with mingled sorrow and delight that bright tears streamed from his eyes, as he answered with a deep sigh: "My . . . my Clara!"

Sigismund, who had faithfully remained with his friend in his hour of need, now entered. Nathaniel stretched out his hand to him.

"And you, faithful friend, you never abandoned me!"

Every trace of Nathaniel's madness had vanished, and he soon gained

strength under the care of his mother, his beloved Clara, and his friends. Good fortune also had visited the house, for a miserly old uncle of whom nothing had been expected had died, leaving their mother an estate in a pleasant spot near the town along with considerable property. Nathaniel decided to go there with Clara (whom he now intended to marry), his mother, and Lothar. He had grown milder and more docile than ever before, and now, for the first time, he understood Clara's heavenly pure and glorious mind. No one gave the slightest hint or reminded him of the past. It was only when Sigismund was about to depart that Nathaniel said: "My God, Sigismund! I certainly did some stupid things, but a good angel led me onto the path of light just at the right moment! Ah, that was Clara!"

Sigismund did not let him carry on the conversation further, fearing that grievous recollections might explode in all their lurid light. It was about this time that the four fortunate friends thought of going to the estate. It was noon, and they were walking in the streets of the city, where they had bought many different things. The high steeple of the town hall was already casting its gigantic shadow over the marketplace. "Oh," said Clara, "let's climb it once more and gaze at the distant mountains!"

No sooner said than done. Nathaniel and Clara both climbed the steps, while Nathaniel's mother returned home with the servant, and Lothar, who was not inclined to clamber up so many stairs, decided to remain below. The two lovers stood arm-in-arm on the highest gallery of the tower, and looked down upon the misty forests, behind which the blue mountains rose like a gigantic city.

"Look there at that curious little gray bush," said Clara. "It actually looks as if it were striding toward us."

Nathaniel mechanically put his hand into his breast pocket, where he found Coppola's telescope and pointed it to one side. Clara was in the way of the telescope. His pulse and veins leapt convulsively. Pale as death, he stared at Clara. Soon streams of fire flashed and glared from his rolling eyes. He roared horribly, like a hunted beast. Then he jumped high into the air, and punctuating his words with horrible laughter, shrieked in a piercing tone: "Spin around, wooden doll! Spin around!"

Then he grabbed Clara with immense force and tried to hurl her from the steeple. However, with the desperate strength of one struggling against death, she grabbed hold of the railing. Fortunately, Lothar heard the madman's raging

The Sandman

127

and Clara's shriek of agony. Fearful forebodings darted through his mind as he ran up the stairs of the steeple. The door to the second flight was locked. Clara's shrieks became louder and still louder. Frantic with rage and anxiety, he threw himself against the door, which finally burst open. Clara's voice was becoming weaker and weaker. "Help! Help! Save me!"

Her words and voice seemed to die in the air.

"She's gone! Murdered by that madman!" cried Lothar.

The door of the gallery was also closed, but despair gave him a giant's strength, and he tore it off its hinges. God in heaven! Nathaniel was dangling Clara over a railing, and she was hanging in the air over the gallery. With only one hand, she still held onto the iron railing. Quick as lightning, Lothar grabbed hold of his sister and pulled her back to safety, striking the madman in the face with his clenched fist, so he reeled and let his prey go. Now Lothar was able to run down the steps of the steeple with his fainting sister in his arms. Indeed, he had saved her.

Nathaniel continued raging in the gallery. Leaping high in the air, he yelled: "Circle of fire, spin around! Spin around!"

People gathered together at the sound of his wild shrieks. Among them was the lawyer Coppelius, who stood out prominently because of his large stature. He had just arrived in the town and had proceeded straight to the marketplace. Some people wanted to climb up and restrain the madman, but Coppelius only laughed, saying, "Ha, ha. Just wait—he will soon come down of his own accord," and he looked up like the rest.

Nathaniel suddenly stood very still, as if petrified. Then, as soon as he caught sight of Coppelius, he stooped down and yelled, "Ah, pretty eyes. Pretty eyes!"

Then, suddenly he sprang over the railing.

While Nathaniel lay on the stone pavement, his head shattered, Coppelius disappeared into the crowd. Many years later, it is said that Clara was seen in a remote region, sitting hand in hand with a friendly man before a country house, while two lively boys played in front of them. From this, it may be inferred that she at last found a quiet, domestic happiness that suited her serene and cheerful nature, a happiness that the completely torn and crazed Nathaniel would never have been able to provide.

The Sandman

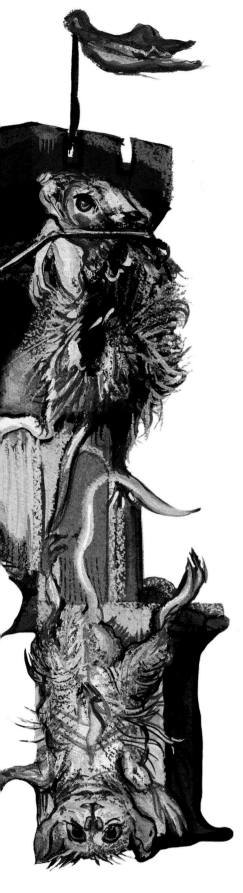

The Nutcracker and the Mouse King

Christmas Eve

ON THE TWENTY-FOURTH of December, the children of Medical Officer Stahlbaum were told they were not allowed to enter the small parlor, or even the adjacent ceremonial room. So, Fritz and Marie sat huddled together in a corner of the back parlor, and when evening twilight fell, they began to feel terribly uneasy, for no candles had been set out, as was generally the case on Christmas Eve. Fritz whispered secretly and mysteriously confided to his younger sister (who had just turned seven) that, ever since the morning, he had been hearing some hammering, along with rustling and murmuring, which went on all day inside the forbidden rooms. Furthermore, a short time ago, a small, dark man had tiptoed across the vestibule with a big box under

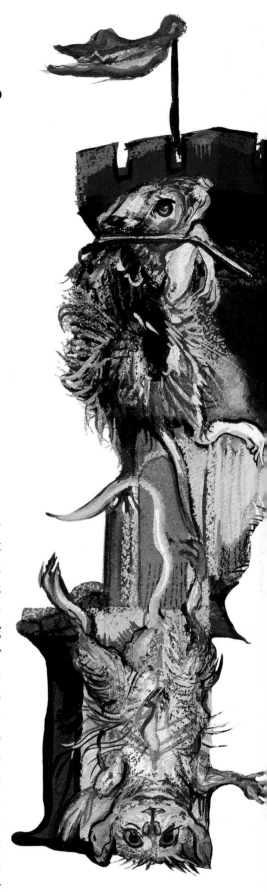

129

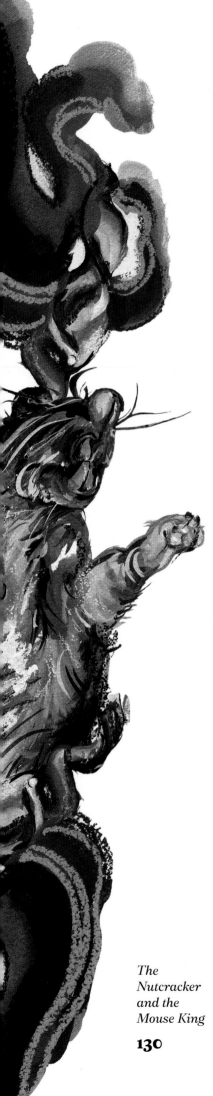

his arm. Meanwhile, Fritz revealed to Marie that he knew this man was none other than Godfather Drosselmeier. Upon hearing this, Marie joyfully clapped her hands and exclaimed: "Oh! I wonder what nice things he's made for us this time!"

Supreme Court Justice Drosselmeier was anything but handsome. He was short and thin, with many wrinkles on his face, and he wore a big black patch over his right eye. In addition, since he was almost bald, he wore a fine white wig made of glass on his head, a very beautiful work of art. Indeed, their godfather was a very talented man. He even knew and understood everything about clocks and watches and could make them himself. So, whenever one of the beautiful clocks in Dr. Stahlbaum's house broke down and couldn't keep the time, Godfather Drosselmeier would arrive, take off his glass wig and his little yellow coat, put on a blue apron, and proceed to stick sharp, pointed instruments into the inside of the clock in a way that made little Marie quite sad to witness. However, all this didn't really hurt the poor clock, which, on the contrary, would come to life again and begin to whirr, sing, and strike as cheerfully as ever, much to everyone's delight.

Whenever Drosselmeier visited the Stahlbaums, he always carried something delightful in his pockets for the children. One time, it was a little man, who would roll his eyes and bow in a comic fashion. Other times, Godfather Drosselmeier brought a box with a little bird that would hop out of the box, or do something else of the kind. But for Christmas he always succeeded in creating a special artistic work that involved a strenuous and exhausting effort on his part. For this reason, the children's parents always removed the artwork with great care and stored it in a safe place.

"Oh! I wonder what Godfather Drosselmeier has made for us this time!" Marie remarked.

Meanwhile, Fritz had already decided that their godfather's present would surely be a great castle with a fortress where all sorts of handsome soldiers would be drilling and marching about. Then other soldiers would come and attack the fortress, causing the soldiers inside to fire away at them with cannons as quickly as possible, and everything would bang and thunder.

"No, no," Marie said. "Godfather Drosselmeier once told me about a beautiful garden with a great lake in it and beautiful swans swimming about with marvelous gold collars and lovely singing music. And then a lovely little girl

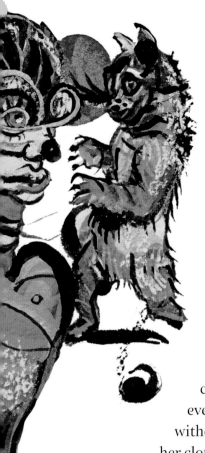

comes down through the garden to the lake and entices the swans with marzipan."

"Swans don't eat marzipan!" Fritz interrupted rather rudely. "And Godfather Drosselmeier can't build an entire garden. After all, we're not allowed to keep any of the toys he makes. Whatever he brings is always taken away from us. So, I like the things Papa and Mamma give us much better. We can keep them for ourselves and can do what we like with them."

The children went on discussing what Drosselmeier might have in store for them this time, and Marie called Fritz's attention to the fact that Miss Gertrude (her largest doll) appeared to be failing a good deal as time had passed. She was now more clumsy and awkward than ever, tumbling onto the floor every two or three minutes, something that did not occur without leaving very ugly marks on her face. Consequently, her clothes could not be properly cleaned. Scolding was of no use. Moreover, her mother had laughed at her for being so pleased with Miss Gertrude's new little parasol.

As for Fritz, he remarked that he needed a good fox in his small zoological collection, and that his army lacked a cavalry, as his father was well aware. The children knew that their parents had bought all sorts of lovely and beautiful things and had got them ready for them. They also knew that the Christ Child took special care for their wants at Christmas, and he shone upon them with the pious and friendly eyes of a child. Moreover, they were convinced that every Christmas gift would give them a marvelous pleasure, as if it had been chosen and touched by beneficial hands.

The children kept whispering about the expected gifts, and they were reminded of this pleasure by their older sister, Louise. And they added that it was now also the Holy Christ, who, through the hands of their dear parents, always brought them real joy and pleasure. Indeed, He knew that a lot better than did the children themselves who didn't have to nurture all sorts of hopes and wishes. Rather, they had to wait and be still before they opened their Christmas presents.

Little Marie sat and grew pensive, while Fritz murmured quietly to himself: "All the same, I'd like to have a fox and some hussars!"

It was now quite dark, and Fritz and Marie sat close together. They did not dare utter another syllable. They felt as if some fluttering, invisible wings were gently touching them, even though they were far away, while they also heard

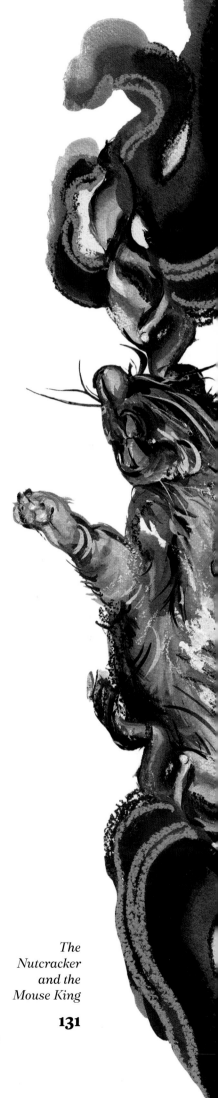

The Nutcracker and the Mouse King

131

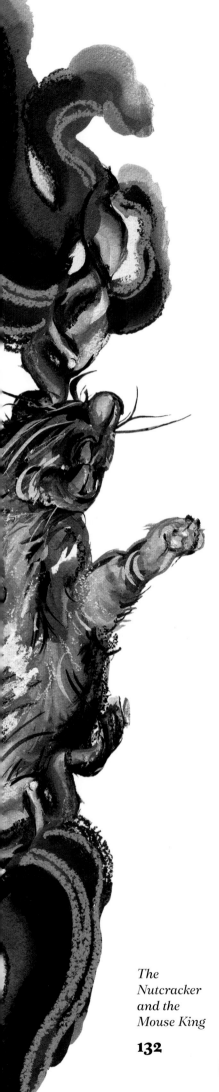

some beautiful sounds of music. Then a bright gleam of light passed quickly and grazed the wall, and the children knew that the Christ Child had flown away on shiny wings to other happy children. Then they heard a silvery bell chiming: "Cling-a-ling! Cling-a-ling!"

All at once, the doors flew open, and a brilliant light came streaming from the parlor. The children were petrified and stood rooted where they were. "Oh! Oh!" they cried out, and suddenly, Papa and Mamma came and took their hands.

"Come now, my sweet things. Come and see what the blessed Christ Child has brought you."

The Christmas Presents

I would now like to appeal to you, kind reader or listener—Fritz, Heidi, Gabby, Theodore, Ernest, or whatever your name may be—and I beg you to recall vividly your last Christmas table, glorious and splendidly set with its various attractive Christmas presents. Then, perhaps you will be able to form some idea of the manner in which the two children stood speechless with glowing eyes focused on all the beautiful things. Please picture how, after a little while, Marie sighed and cried out, "Oh, how lovely! How lovely!" while Fritz jumped up and down several times. The children had certainly been very, very good and well behaved the entire year and were thus rewarded more than amply. Never had so many beautiful and delightful things been provided for them. The great Christmas tree on the table carried many silver and gold apples, and all its branches were decorated with buds and blossoms, consisting of sugar almonds, candy, and other delicious things to eat. Perhaps the most striking thing about this miraculous tree, however, was the fact that hundreds of little lights glittered on all the spreading branches like stars, inviting the children to pluck its flowers and fruit. Also, all around and on every side of the tree, everything shone and twinkled in the loveliest manner. Oh, how many gorgeous things there were! Who, oh who, could describe them all?

Marie gazed at the most fascinating dolls, all kinds of toys, and the prettiest little silk dress with many tinted ribbons. It was hung on a long branch in such a way that she could admire it on all its sides, which she accordingly did, crying out several times, "Oh! How lovely! What a lovely, darling little dress! And I suppose, I do believe, I shall really be allowed to put it on!"

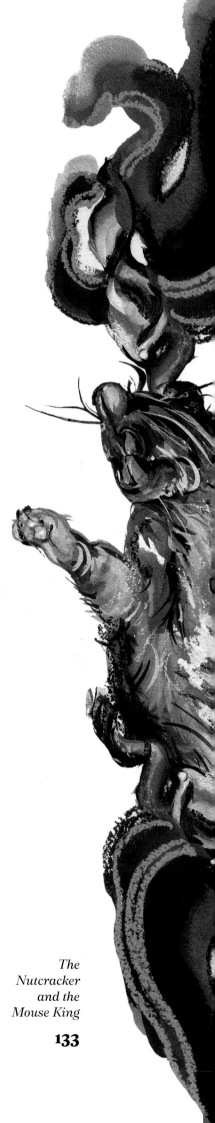

In the meantime, Fritz found his new hobbyhorse—on the table of all places—and he immediately began testing to see if it could gallop. Then, after he dismounted, he stated that the horse seemed to be a bit wild. But, no matter, he felt sure he would soon be able to tame and train the horse. Then, he set to work and inspected his new squadron of hussars, admirably dressed in red and gold uniforms and with real silver swords. They were all seated on white horses that you would have thought were made of pure silver.

Soon after, when the children had calmed down a little, they started to pounce on the beautiful picture books that were open so that you could see all sorts of the most beautiful flowers and a variety of people—to say nothing of lovely children playing. All of the characters were depicted as if they were really alive and could speak. Suddenly, the bell rang again to announce Godfather Drosselmeier's Christmas present, which was on another table against the wall and was concealed by a curtain. When this curtain was removed, the children were mesmerized by what they saw.

A majestic castle, with numerous shiny windows and golden towers, stood on a green lawn with bright, colorful flowers. Inside, bells chimed, doors and windows opened, and you could see very tiny, but beautiful, ladies and gentlemen with plumed hats and long robes down to their heels. They were walking up and down in the castle's rooms. In the central hall, which seemed all in a blaze, there were numerous little candles burning on silver chandeliers. The boys were dressed in little, short doublets and were dancing to the chimes of the bells. A gentleman in an emerald cape often came to a window, briefly beckoned to the onlookers, then disappeared inside again. He looked just like Godfather Drosselmeier himself, but was scarcely taller than their father's thumb and came now and then to the castle door and then went inside again.

Fritz propped his elbows on the table and leaned over to look more closely at the beautiful castle and the people walking about and dancing. Then he said: "Godfather Drosselmeier, let me go into your castle for a little while."

However, Drosselmeier answered that this was not possible. And he was right, for it was silly of Fritz to want to go into a castle that, together with the golden towers and all, was not as tall as he himself. And Fritz soon realized that this was the case.

After a short time, since the ladies and gentlemen kept strolling in about the same fashion, the children dancing, and the man in the emerald cape looking out at the same window, Godfather Drosselmeier came into the room.

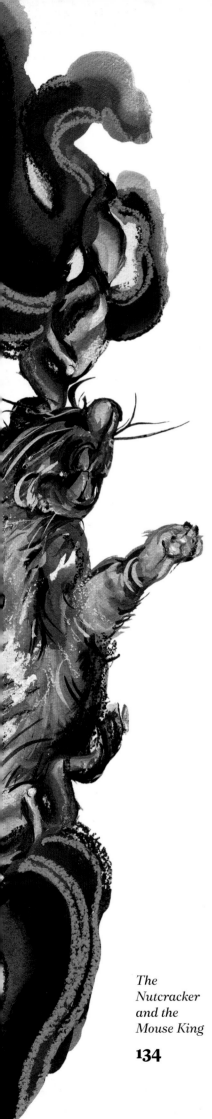

Fritz became impatient and cried out: "Godfather Drosselmeier, please come out at that other door."

"That can't be done, dear Fritz," Drosselmeier answered.

"Well," Fritz continued, "make that green man who looks out so often walk about with the others."

"And that can't be done, either," his godfather said once more.

"Then make the children come down," Fritz insisted. "I want to inspect them more closely."

"You can't. Stop being so silly. Nothing of this kind can be done," cried Drosselmeier, who was now somewhat annoyed. "The machinery is set to work as it's doing now, and it can't be altered, you know."

"Oh, really!" Fritz complained. "It can't be done, huh? Very well, then, godfather. If your little creatures in the castle must always do the same thing, they're not worth much, and I don't have a high opinion of them! No, give me my hussars. They've got to maneuver backward and forward, just as I want them to, and they're not locked up in a house!"

After saying this, Fritz ran back to the Christmas table and set his squadron of silver horses trotting here and there to his heart's content. They reared and charged and slashed right and left. Marie had also slipped away quietly, for she was bored by the promenading and dancing of the figurines in the castle.

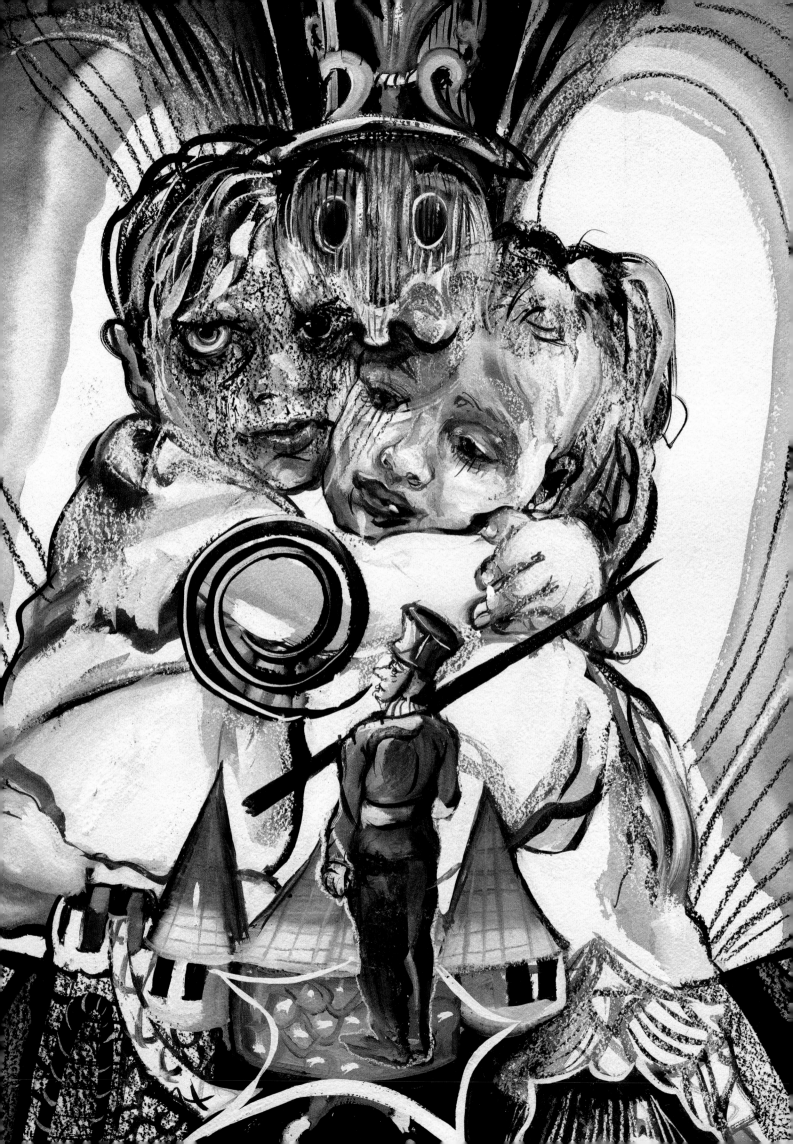

Since she was kind and gentle, Marie did not like to show how discontent she was, as her brother did.

Drosselmeier was somewhat annoyed by their behavior and said to their parents: "Clearly, such artistic work is not for children, who don't understand it. I might as well put my castle back in its box again."

But their mother came to the rescue and asked Drosselmeier to show her the complex machinery which moved the figures. So, he took all the pieces apart and then put them together again. In the process, he calmed down and became cheerful. Then, he gave the children all sorts of delicious men and women, with golden faces, hands, and legs, made of gingerbread. To be sure, they were delighted by these tiny gifts.

Meanwhile, their mother asked the elder sister, Louise, to try on a lovely frock, which was one of her presents, and she looked beautiful in it. However, when Marie was asked to put on her dress, she asked whether she could just look at it for a while, and her mother was glad to comply.

The Protégé

Actually, there was a reason why Marie did not want to leave the Christmas table, where the Christmas presents were displayed; this was because she had noticed something there that she had not observed at first. It was a splendid little man, who revealed himself after Fritz's hussars had paraded and taken over a ground to the right at some distance from the tree. He was standing there quiet and unobtrusive, as if waiting patiently until it was his turn to be noticed. And to be honest, his stature was somewhat odd and unusual. His body was rather too tall and stout for his legs, which were short and skinny. Moreover, his head was much too large for his body. However, the oddity of this figure was atoned for by the elegance of his clothing, which showed him to be a person of taste and breeding. He had on a very attractive violet hussar's jacket with many white knobs and braidings. His pants were a perfect fit for his thin legs, and he wore the loveliest little boots ever seen—even on a hussar officer. It was funny, certainly, that, dressed in this style as he was, he had on a little, rather absurd, short cloak on his shoulders that looked almost as if it were made of wood. Finally, he sported a miner's cap. But Marie remembered that Godfather Drosselmeier often appeared in a terribly ugly morning jacket and wore a frightful looking cap on his head. Yet, he was a very dear godfather. As Marie kept looking at this little man, with whom she had quite fallen in love at

first sight, she was more and more convinced that he had a sweet nature and disposition. His bulging light green eyes, which, perhaps, stuck a little more prominently out of his head than was quite desirable, radiated with kindness and benevolence. In addition, one of his most handsome features was that his chin was covered by a well-groomed beard of white cotton, and this drew attention to the sweet smile that his bright red lips always displayed.

"Oh, Father, dear!" cried Marie at last. "Whose gift is that lovely little man beside the tree?"

"Well," came the answer, "that little fellow is going to do plenty of good service for all of you. He's going to crack nuts for you, and he is to belong to you, Louise, and Fritz."

Upon saying this, her father picked up the nutcracker from the table. Then he lifted the end of his wooden cloak, and the little man opened his mouth wider and wider, displaying two rows of very sharp, white teeth. Next, her father told Marie to put a nut into the little man's mouth and—"crack!"—he bit it in two so that the shells split and Marie got the kernel. Now her father explained to everyone in the room that this charming little man belonged to the Nutcracker family and was practicing the profession of his ancestors.

"And," said her father, "since friend Nutcracker seems to have made such an impression on you, Marie, he will be placed under your special care and protection. However, you must remember that Louise and Fritz are to have the same right to his services as you."

Marie took Nutcracker into her arms at once and had him crack some more nuts, but she picked out all the smallest so that he might not have to open his mouth so terribly wide, because that was not good for him. Then Louise came, and he had to crack some nuts for her, too. "Crack!" He seemed very glad to perform this task, for he kept on smiling most courteously. Meanwhile, Fritz became a bit tired after so much riding and drilling, and so he joined his sisters. Once at the table, he roared with laughter at the funny little fellow. Since Fritz wanted his share of the nuts, Nutcracker was passed from hand to hand and continually had to snap his mouth open and shut. Fritz gave him all the biggest and hardest nuts he could find, but all at once, there was a "Crack! Crack!" and three teeth fell out of Nutcracker's mouth and his lower jaw became loose and wobbly.

"Oh! My poor darling Nutcracker!" Marie cried and took him away from Fritz.

"What a bumbling stupid guy he is!" Fritz exclaimed. "He calls himself a nutcracker and can't even bite decently. In fact, he doesn't seem to know much

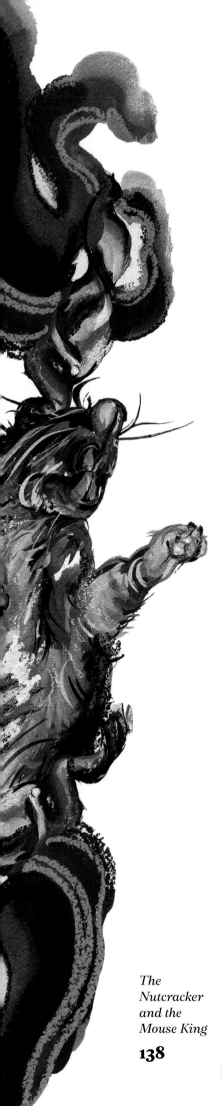

about his business. Hand him over to me, Marie! I'll keep him biting nuts until he loses all the rest of his teeth as well as his jaw in the bargain. He's just plain good-for-nothing!"

"No, no," Marie replied in tears. "I won't let you have my darling Nutcracker. Look at how he's staring at me so mournfully and showing me his poor, sore mouth. You're nothing but a hard-hearted creature! You beat your horses, and you've had one of your soldiers shot!"

"Those things must be done," said Fritz. "And you don't understand much about such matters. Anyway, Nutcracker is as much mine as he is yours. So, hand him over!"

Marie began weeping bitter tears, and she quickly wrapped up the wounded Nutcracker in her pocket handkerchief. Meanwhile, their parents came with Drosselmeier and took Fritz's side, to Marie's great regret. However, her father said, "I put Nutcracker under Marie's special protection, and since just now he seems to have need of her care, she is to have full control of him, and nobody else has anything to say in the matter. And I'm surprised that Fritz should expect further service from a man wounded in the execution of his duty. As a good soldier, he ought to know better than that."

Fritz was ashamed and decided not to concern himself any further about nuts or nutcrackers. So, he moved to the other side of the table, where his hussars had established the necessary outposts and gone to their quarters for the night

As for Marie, she began searching for Nutcracker's lost teeth, and she took a pretty, white ribbon from her dress and tied it around his chin. Then she wrapped the poor little fellow, who was looking very pale and frightened, in her handkerchief, more tenderly and carefully than before. Afterward, she held him like a child in her arms and rocked him as she looked at the picture books. Though it was not usually the case, she grew quite angry with Godfather Drosselmeier because he laughed so much and kept asking how she could make such a fuss over an ugly little fellow like that. Yet, the odd and peculiar likeness to Drosselmeier himself had struck her when she first saw Nutcracker, and it occurred to her once more.

"Who knows, Godfather," she said seriously, "if you were to be dressed up the same way as my darling Nutcracker and had on the same shining boots, you might be as handsome as he is?"

Marie did not understand why her mother and father laughed so heartily,

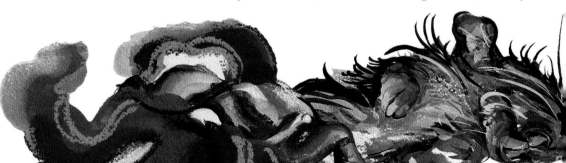

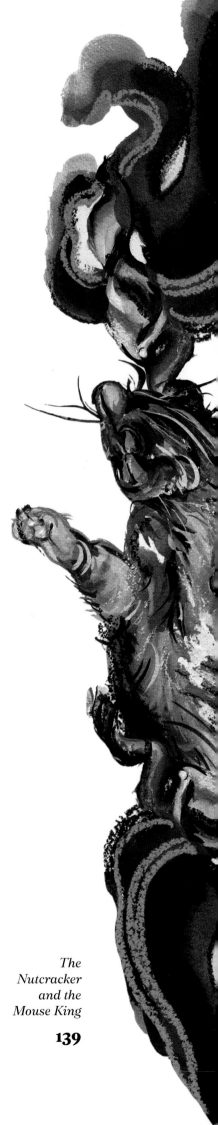

why Supreme Court Justice Drosselmeier's nose got so red, or why he didn't join so much in the laughter as before. Probably there was some special reason for these things.

Miraculous Events

It is important to know that in the sitting room, on the left-hand side as you enter, and against the wall, stands a tall, glass-fronted cupboard in which all the children's Christmas presents are put away every year. Louise, the elder sister, was still quite little when her father had this cupboard built by a very skillful cupboard maker, who had inserted transparent panes of glass and made the whole cupboard so splendid that everything inside it looked almost more glistening and lovely than when you were actually holding it yourself. Godfather Drosselmeier's works of art were stored on the upper shelves, which were beyond the reach of Fritz and Marie. Immediately under them there was a shelf for the picture books. Fritz and Marie were allowed to do what they liked with the two lower shelves, but usually Marie reserved the lowest one for all her dolls, as their place of honor, while Fritz used the shelf above this as barracks for his troops.

On that particular evening, Fritz had quartered his hussars on the upper shelf, while Marie had put Miss Gertrude in a corner and established a new doll in the appointed place with all the appropriate furniture and had tea and cakes with her. This shelf was splendidly furnished, everything in first-rate condition and in good and admirable style, as I have already said, and I don't know if you, my gentle reader, are fortunate to have the same kind of room for your dolls, with a beautifully flowered sofa, a number of the most charming little chairs, a nice little tea table, and, above all, a beautiful little white bed, where your lovely darling dolls go to sleep? All this was in a corner of the shelf, where the walls in this part had beautiful little pictures hanging on them. And you may well imagine that, on such a delightful shelf as this one, the new doll, whose name, as Marie had discovered, was Miss Clara, thought herself comfortably settled and remarkably well-off.

Now it was getting very late. Indeed, midnight was approaching before the children could tear themselves away from all these Yuletide pleasures, and Godfather Drosselmeier had long since gone home. The children remained riveted in front of the glass-fronted cupboard, although their mother reminded them several times that it was long after bedtime.

The Nutcracker and the Mouse King

139

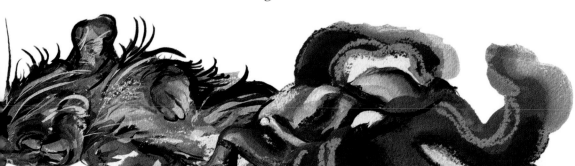

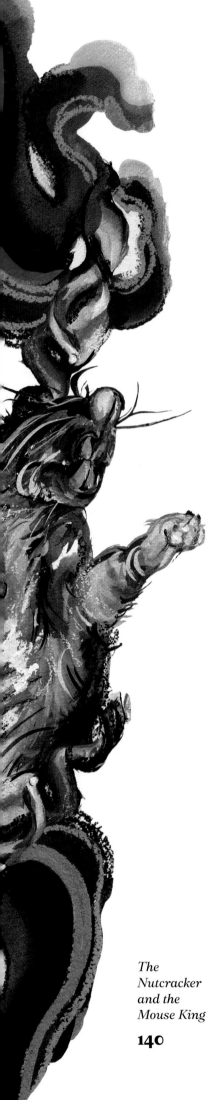

"Yes," Fritz said, "I know well enough that these poor fellows [meaning his hussars] are tired and awfully anxious to turn in for the night. But as long as I'm here, not a man dares to nod his head."

Upon saying that, Fritz went off to bed, while Marie earnestly begged to stay a little longer, saying she still had a number of things to do, and she promised that as soon as she had taken care of them, she would go to bed at once. Marie was a very good and sensible child, and, therefore, her mother allowed her to remain for a little longer with her toys, but in case she became too occupied with her new doll and the other playthings so as to forget to put out the candles that were lit all round on the walls, she herself put them all out, leaving merely the lamp that hung from the ceiling to project a soft and pleasant light.

"Come to bed soon, Marie, otherwise you'll never get up at the right time in the morning," her mother warned as she went to her own bedroom.

As soon as Marie was alone, she quickly went to do what she desired most and didn't want to do in her mother's presence, though she scarcely knew why she didn't like to do these things in her mother's presence. She had been holding Nutcracker wrapped in the handkerchief carefully in her arms all this time, and she now laid him gently down on the table, unrolled the handkerchief, and examined his wounds. Nutcracker was very pale, but at the same time, he was smiling with so much melancholy and gratitude that he touched her heart very much. Indeed, she felt great sympathy for him.

"Oh, my darling little Nutcracker!" she said very softly. "Please don't be angry with me because my brother Fritz has hurt you so. He didn't mean it, you know. He's become somewhat overbearing and hardened with all his sol-

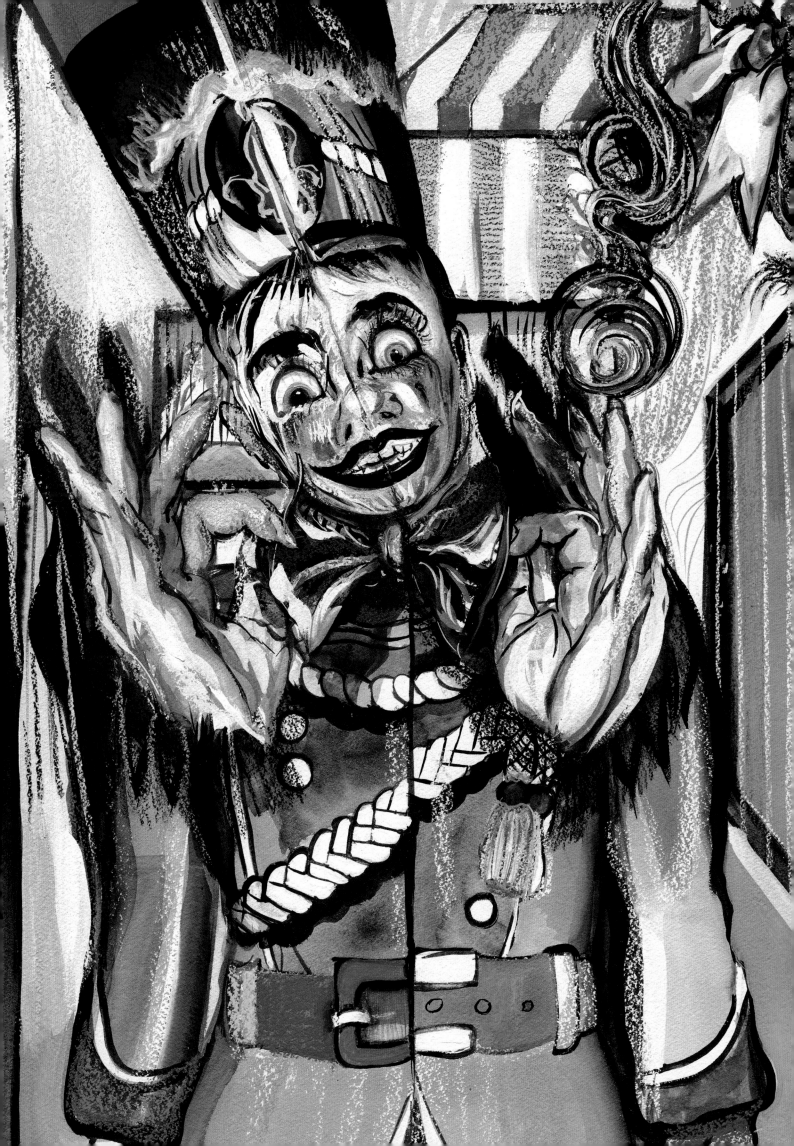

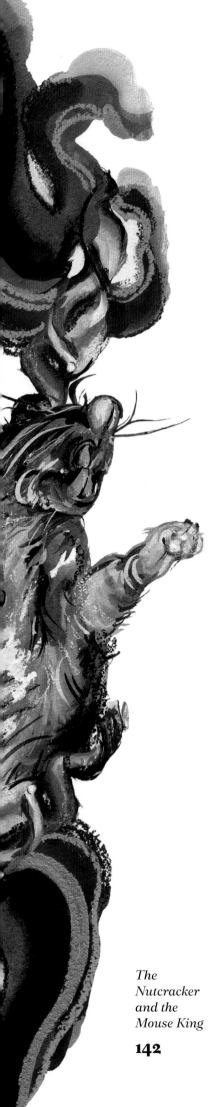

diering, but he's a nice, good boy. I can assure you, and I'll take the greatest care of you now and nurse you until you're quite better and happy again. I'll make sure that your teeth are restored, and that your shoulder is set right. Godfather Drosselmeier will see to this because he knows how to do such things."

Marie could not finish what she was going to say because at the mention of Godfather Drosselmeier's name, Nutcracker made the most horrible and ugly face. Sharp green darts shot out of his eyes. This was only for an instant, however, and just as Marie seemed to become afraid, she found that she was looking at the very same kind face with the sympathetic smile she had seen before. Moreover, she realized that it was nothing but some draft of air making the lamp flicker, which seemed to have produced the change in Nutcracker.

"Well!" she said. "I certainly am a foolish girl to be so easily frightened and think that a wooden doll could make faces at me! But I'm really too fond of Nutcracker because he's so funny and so kind and nice. That's why I must take great care of him and nurse him until he's quite well."

Upon saying this, she took him in her arms again and approached the cupboard. Kneeling down beside it, she said to her new doll: "I'm going to ask a favor of you, Miss Clara. I'd appreciate it very much if you would give up your bed for this poor, sick, wounded Nutcracker and make yourself as comfortable as you can on the sofa here. Remember that you're very well and strong yourself, or you wouldn't have such fat, rosy cheeks, and that there are very few dolls who have such a comfortable sofa as the one you have to lie upon."

Dressed stunningly in her Christmas outfit, Miss Clara looked very grand and disdainful and didn't utter a single word in response.

"Very well," said Marie, "why should I make such a fuss and stand on ceremony?"

She took the bed and moved it forward, placed Nutcracker carefully and tenderly down on it, and wrapped another pretty ribbon, taken from her own dress, around his hurt shoulder. Then she drew the bedspread up to his nose.

"Well, you certainly won't stay with that nasty Miss Clara," she said and moved the bed with Nutcracker in it to the upper shelf so that he was placed near the village in which Fritz's hussars had their camp. Then she closed the

cupboard and began to head for her room to go to bed, when—now listen, children!—she heard a low, soft rustling and rattling, and a sort of whispering all around her, in all directions, from all corners of the room, behind the stove, under the chairs, behind the cupboards. The clock on the wall went "ticktock, ticktock," louder and louder, but couldn't strike. Clearly, it was some kind of warning. Marie looked at the clock and saw that the big, gilded owl that was on the top had lowered its wings so that they covered the entire clock. Then it stretched its head with the crooked beak a long way forward. And the warning kept growing louder and louder with distinct words: "Clock, tick, tock, clock, tick, tock!" It was a cautious "warning." Mouse King has a fine ear. "Prr-prr. Only sing, poom-poom, sing the olden song of doom! Prr-prr, poom-poom. Bells chime and ring the fated time!" And then came "Poom! Poom!" quite hoarsely, uttered twelve times.

Marie grew terribly frightened and was about to rush away as fast as she could when she noticed that Godfather Drosselmeier was sitting up on the top of the clock instead of the owl, and his yellow coattails were hanging down on both sides, like wings. Marie pulled herself together and exclaimed in a loud voice of anguish: "Godfather! Godfather! What are you doing up there? Come down and don't frighten me, you naughty, nasty Godfather!"

But now a sort of wild giggling and squeaking burst out everywhere, and soon there was a sound of running and trotting, as if thousands of little feet behind the walls, and thousands of little lights began to flicker between the chinks of the woodwork. But they were not lights. No! No! They were little glittering eyes, and Marie became aware that there were mice everywhere, and they were peeping and squeezing themselves out through every chink and hole in the walls. Soon they were trotting and galloping in all directions over the room. Indeed, the mice continued to increase and form themselves into regular troops and squadrons in good order, just as Fritz's soldiers did when they prepared themselves for a battle.

Since Marie was not afraid of mice, like many children are, she couldn't help being amused by this, and she was about to shed any sign of terror when suddenly she heard a sharp and terrible piping noise, which made the blood in her veins curdle. Ah! What do you think she saw then?

Well, truly, kind reader, I know that your heart is in the right place, just as much as my wise and courageous friend Field Marshal Fritz Stahlbaum's is, but if you had seen what now appeared before Marie's eyes, you would have run for your life! In fact, I even think that you would have jumped into your bed and drawn the blankets farther over your head than necessity demanded.

But poor Marie did not have it in her power to do any such thing because right at her feet, as if propelled by some subterranean power, sand and lime and broken stone came bursting up, then the heads of seven mice, each with a shining crown and hissing and piping in a most horrible way, rose through the floor. Quickly, the mouse's body, which had those seven crowned heads attached to it, forced its way up through the floor, and this enormous creature shouted with its seven heads to the assembled multitude of mice. It squealed loudly to them with all the seven mouths in full chorus, then the entire army set itself in motion and trotted right up to the cupboard. In fact, they went directly up to Marie, who was standing beside it. Her heart had been beating with so much fright that she had thought it might jump out of her breast and that she would die. But now it seemed to her as if the blood in her veins stood still. Half fainting, she leaned backward, then there was a "klirr, klirr, purr," and the glass pane of the cupboard, which she had broken with her elbow, fell in pieces to the floor.

For a moment, Marie felt a sharp, stinging pain in her arm, and yet, this seemed to make her heart lighter. Then she heard no more of the squeaking and piping. Everything was quiet, and though she didn't dare to look, she thought the noise of the glass breaking had frightened the mice back to their holes.

But the commotion was not over.

Right behind Marie, strange sounds seemed to be coming from the cupboard, and she could detect strange voices saying: "Wake up! Out to the fight, out to the fight! Wake up! This is the night!"

Then harmonic bells began ringing sweetly.

"Oh! Those are bells from my glockenspiel," cried Marie, who went to the cupboard and looked inside. She saw a bright light in the cupboard, and everything busily in motion there. Dolls and little figures of various kinds were all running about together and fighting with their little arms. At this point, Nutcracker rose from his bed, took off his pajamas, and sprung with both feet onto the floor of the shelf, crying out at the top of his lungs: "Crack, crack, crack! Stupid mousey pack! All their skulls we shall crack! Mousey pack, crick and crack, stupid pack!"

And with this, he drew his little sword, waved it in the air, and cried: "Rise up, my trusty vassals, brothers and friends! Are you ready to stand by me in this great battle?"

Immediately, three scaramouches, one pantaloon, four chimney sweeps, two zither players, and one drummer cried eagerly: "Yes, your highness! We are loyal, and we shall stand by you and fight for you, to victory or death!"

And they followed Nutcracker, who, in the excitement of the moment, had dared to jump to the bottom shelf. Now his comrades could not exactly jump after him, for they were wearing heavy clothes made of cloth and silk. However, there was not much in their insides except cotton and sawdust so that they plunged down to the shelf like little wool sacks. As for poor Nutcracker, he would certainly have broken his arms and legs—because it was nearly two feet from where he had stood to the shelf below, and his body was as fragile as if it had been made of elm wood. Yes, Nutcracker would have broken his arms and legs if Miss Clara had not woken up on her sofa at the moment of his jump and caught the hero with his drawn sword in her tender arms.

"Oh! You dear, good Clara!" cried Marie. "How I underestimated you! I believe you would certainly have been quite willing to let dear Nutcracker have your bed."

But Miss Clara was now worried, and as she pressed the young hero gently to her silken breast, she cried out: "Oh, my lord! Do not endanger your life in this ferocious battle, sick and wounded as you are. Look at how your trusty followers—the pantaloon, chimney sweeps, zither players, and drummer—have already gathered and the coat-of-arms men on my shelf here are in action and preparing for the fray! Please consider, then, oh my lord, to rest in these arms of mine and watch your victory from the safety of my plumed hat."

So spoke Miss Clara. But Nutcracker was impatient and kicked so much with his legs that Miss Clara was obliged to put him down on the shelf in a hurry. Then he immediately knelt down gracefully on one knee and whispered as follows: "Oh, my lady, I shall always be thankful for the kind protection and aid that you have afforded me. All this dedication will be present in my heart, in battle, and in victory!"

After saying this, Miss Clara bowed so deeply that she was able to take hold of him by his arms and gently pulled him up. Then she quickly loosened her girdle, which was covered by many spangles. She would have placed them on his shoulders. But the little man stepped back, laid his hand upon his heart,

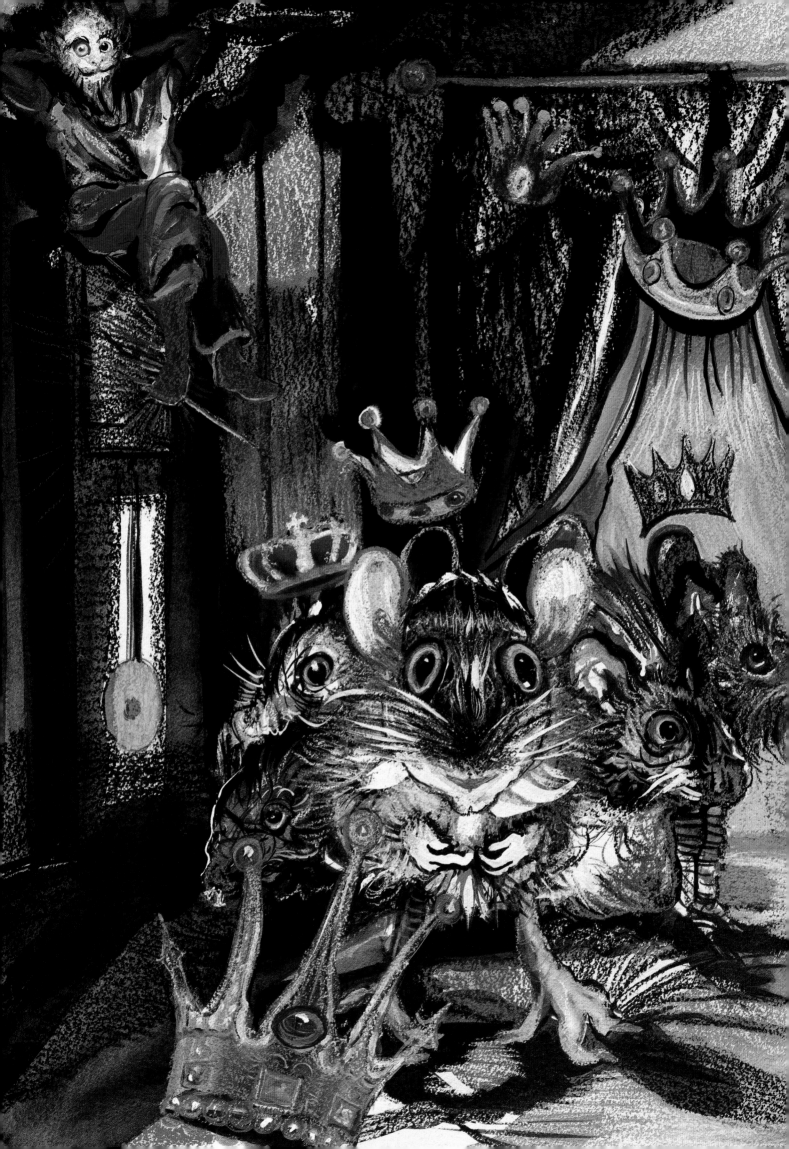

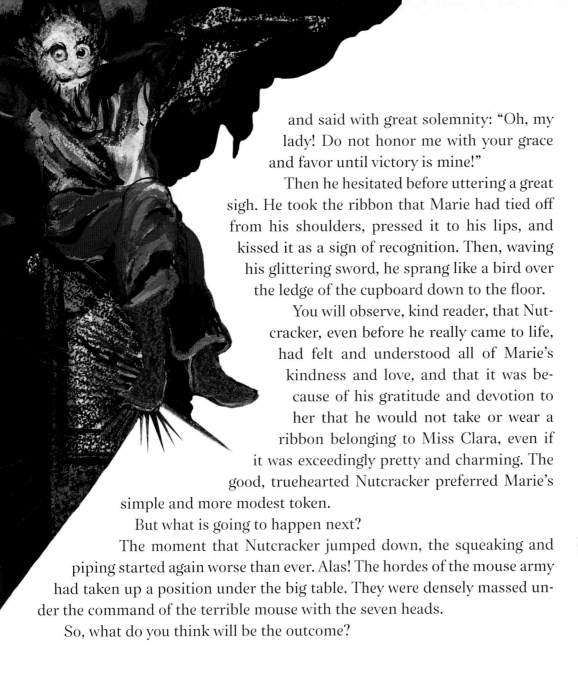

and said with great solemnity: "Oh, my lady! Do not honor me with your grace and favor until victory is mine!"

Then he hesitated before uttering a great sigh. He took the ribbon that Marie had tied off from his shoulders, pressed it to his lips, and kissed it as a sign of recognition. Then, waving his glittering sword, he sprang like a bird over the ledge of the cupboard down to the floor.

You will observe, kind reader, that Nutcracker, even before he really came to life, had felt and understood all of Marie's kindness and love, and that it was because of his gratitude and devotion to her that he would not take or wear a ribbon belonging to Miss Clara, even if it was exceedingly pretty and charming. The good, truehearted Nutcracker preferred Marie's simple and more modest token.

But what is going to happen next?

The moment that Nutcracker jumped down, the squeaking and piping started again worse than ever. Alas! The hordes of the mouse army had taken up a position under the big table. They were densely massed under the command of the terrible mouse with the seven heads.

So, what do you think will be the outcome?

The Battle

"Let us march to your beat, my loyal drummer!" Nutcracker yelled very loudly, and immediately the drummer began to roll his drum in the most splendid style so that the glass windows of the cupboard rattled. Then, a cracking and a clattering could be heard inside the cupboard, and Marie saw all the lids of the boxes in which Fritz's army had been quartered burst open, and the soldiers appeared and jumped down to the bottom shelf, where they formed special squads. Nutcracker ran up and down inspecting the ranks and speaking words of encouragement.

"There's not a dog of a trumpeter taking the trouble to sound a call!" he cried furiously. Then he turned to Pantaloon, who was looking decidedly pale and wobbling his long chin a good deal. Nutcracker was very solemn and, turning to the army, said, "I know how brave and experienced you are, General!

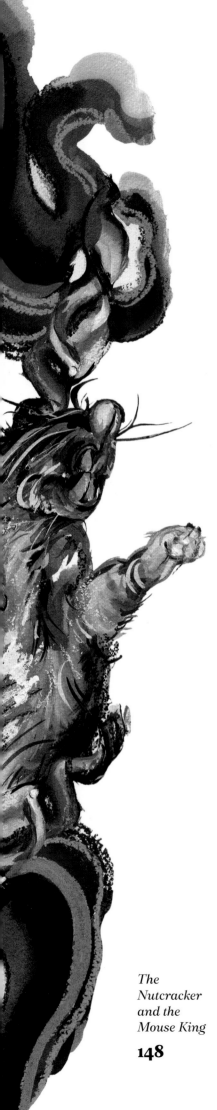

A rapid comprehension of the situation and immediate use of the present moment is essential. I entrust you with the command of the cavalry and artillery. You can do without a horse, since your own legs are long and you can gallop on them whenever necessary. Now start the battle!"

Pantaloon put his long, lean fingers to his mouth and whistled with such a piercing sound that his forces responded as if a hundred little trumpets had been cheerfully blowing. Then in the cupboard a tramping and a neighing could be heard from the dragoons and cuirassiers, but above all, the new glittering hussars could be seen marching out and then coming to a halt up on the floor. They then marched past Nutcracker in regiments, with bands playing followed by the formation of lines up at right angles to the line of the march. As this was happening, Fritz's artillery came rattling up and formed a front in advance of the cavalry. Then it went "boom-boom!" and Marie watched the sugar plums damaging the thickly massed mouse battalions, which were powdered quite white by them and put to shame. But a battery of heavy cannons that had taken up a strong position on the mother's footstool did the greatest damage. "Boom, boom, boom!" The cannons kept up a murderous shelling of gingerbread nuts into the enemy's ranks, mowing the mice down in great numbers. The enemy, however, was not completely checked. The mice had even taken over some cannons when there came a "prr-prr-prr!"

Marie could scarcely see what was happening because of the smoke and dust, but this much is certain: All the soldiers fought with the utmost bravery and determination, and for a long time it was doubtful which side would gain the day. The mice kept on sending fresh squadrons that advanced to the scene of action. Their little silver balls, the size of pills, which they shot with great precision, had an effect even inside the glass-fronted cupboard. Miss Clara and Miss Gertrude ran up and down in utter despair, wringing their hands and loudly lamenting:

"Must I, the very loveliest doll in the entire world, perish miserably in the very flower of my youth?" cried Miss Clara.

"Oh, was it for this," wept Miss Gertrude, "that I took such pains to con-

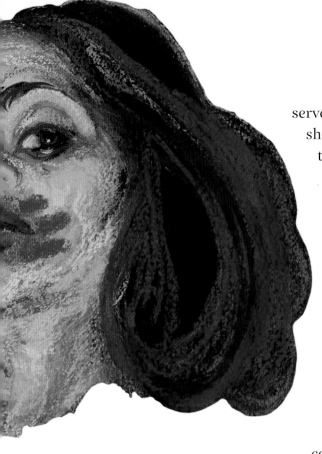

serve myself all these years? Must I be shot here in my own drawing room after all?"

They fell into each other's arms and howled so terribly that you could hear them above the din of the battle. Oh, my gentle readers, you have no idea of the noise that went on now. It sounded like: "prr-prr-poof, piff—pudd—boom—boom—tatatata—boom, boom, boom!" It was all confused and chaotic, and Mouse King and the mice squeaked, squealed, and screamed. Then Nutcracker's powerful voice could be heard shouting commands and issuing important orders. He could be seen striding among his battalions in the thick of the fire.

Pantaloon had made several of the most brilliant cavalry charges and covered himself with glory, while Fritz's hussars were subjected to the heavy fire of the mice, who shot disgusting, smelly bullets and caused horrid stains on their red tunics. All this made the hussars hesitate and hang back for a time. Pantaloon ordered them to swing to the left, and in the excitement of the moment, he led his dragoons and cuirassiers in a somewhat analogous movement. That is to say, they brought up the right shoulder, swung to the left, and marched home to their quarters. This had the effect of bringing the battery of artillery on the footstool into imminent danger, and it was not long before a large body of exceedingly ugly mice began such a tremendous assault on this position that the entire footstool, along with the guns and gunners, fell into the enemy's hands. Nutcracker seemed very disconcerted and ordered his right wing to commence a retreat. A soldier of your experience, my dear Fritz, knows well that such a move is almost tantamount to a regular retreat, and I'm sure you grieve with me already because all this threatened the army of Marie's beloved little Nutcracker.

But turn your glance in the other direction and look at Nutcracker's left wing, forces where all is going well, and you will see that there is still much hope for the commander in chief and his cause. During the hottest part of the engagement, masses of mouse cavalry had quietly emerged from under the chest of drawers and had subsequently advanced on the left wing of Nutcracker's forces, uttering loud and horrible squeaks. But what a reception they encoun-

tered! Very slowly, as the nature of the terrain necessitated (for the ledge at the bottom of the cupboard had to be passed), the regiment bearing the coat of arms and commanded by two Chinese emperors, advanced and formed *en carré plaine*. These fine, brilliantly uniformed troops, consisting of gardeners, Tyroleans, Tunguses, barbers, harlequins, cupids, lions, tigers, unicorns, apes, and monkeys, fought with the utmost courage, coolness, and endurance. This battalion of the elite would have wrested the victory from the enemy had not one of the cavalry captains, who rushed forward in a rash and foolhardy manner, attacked one of the Chinese emperors and bit off his head. As he fell, this Chinese emperor knocked over and smothered a couple of Tunguses and a unicorn, creating a gap through which the enemy charged, resulting in the whole battalion being bitten to death. However, the enemy gained little advantage by doing this because, as soon as one of the mouse soldiers bit one of these brave adversaries to death, he found that there was a small piece of printed paper sticking in his throat. So, he died in a flash. Still, this did not help Nutcracker's army very much. Once Nutcracker's forces began a retrograde movement and went on retreating farther and farther, they suffered greater and greater losses. Consequently, the unfortunate Nutcracker found himself driven back close to the front of the cupboard with a very small squad.

"Bring up the reserves! Pantaloon! Scaramouch! Drummer! Where the devil have you been?" shouted Nutcracker, who was still reckoning with reinforcements from the cupboard. And, in fact, a small contingent of brown gingerbread men and women advanced with golden faces, hats, and helmets, but they fought so clumsily that they never hit any of the enemy and soon would have knocked off the cap of their commander in chief, Nutcracker himself. And the enemy chasseurs bit their legs off, so they tumbled, killing several of Nutcracker's comrades in arms in the bargain.

Nutcracker was now hard-pressed and hemmed in by the enemy. In a position of extreme peril, he tried to jump to the bottom ledge of the cupboard, but his legs were not long enough. Miss Clara and Miss Gertrude had fainted, so they could not give him any assistance. Hussars and dragoons came charging by him, and he shouted in wild despair: "A horse! A horse! My kingdom for a horse!"

At this moment, two of the enemy's riflemen seized him by his wooden

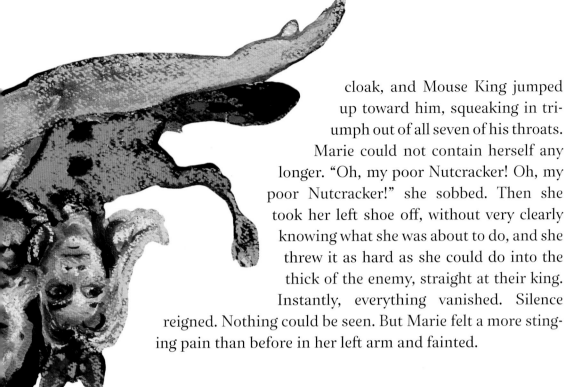

cloak, and Mouse King jumped up toward him, squeaking in triumph out of all seven of his throats. Marie could not contain herself any longer. "Oh, my poor Nutcracker! Oh, my poor Nutcracker!" she sobbed. Then she took her left shoe off, without very clearly knowing what she was about to do, and she threw it as hard as she could do into the thick of the enemy, straight at their king. Instantly, everything vanished. Silence reigned. Nothing could be seen. But Marie felt a more stinging pain than before in her left arm and fainted.

The Illness

When Marie awoke from a deathlike sleep, she was lying in her little bed, and the sun was shining brightly through the icy window, covered with frost flowers. There was a strange gentleman sitting beside her, whom she soon recognized as Dr. Wendelstern, who whispered, "She's awake."

Then her mother came and scrutinized her anxiously.

"Oh, dear Mother!" Marie said. "Have all those horrid mice gone away, and is Nutcracker safe?"

"Don't talk such nonsense, Marie," her mother answered. "What have the mice to do with Nutcracker? You're a very naughty girl and have caused us all a great deal of anxiety. Do you see what happens to children when they don't do as they're told! You were playing with your toys so late last night that you fell asleep. I don't know whether or not some mouse jumped out and frightened you, though there are generally no mice here. At any rate, you broke a pane of the glass-fronted cupboard with your elbow and cut your arm so badly that Dr. Wendelstern, who has just removed a number of glass fragments from your arm, thinks that, if it had been only a little higher up, you might have had a stiff arm for life, or even have bled to death. Thank heaven I awoke at midnight and found you lying unconscious in front of the cupboard, bleeding frightfully, with a number of Fritz's lead soldiers scattered around you. Other toys were shattered, the coats of arms and gingerbread men. Nutcracker was lying on your bleeding arm with your left shoe not far away."

"Oh, Mother, Mother!" Marie was now excited. "These are the remains of the tremendous battle between the toys and the mice, and what frightened me so terribly was that the mice were going to take Nutcracker prisoner. He

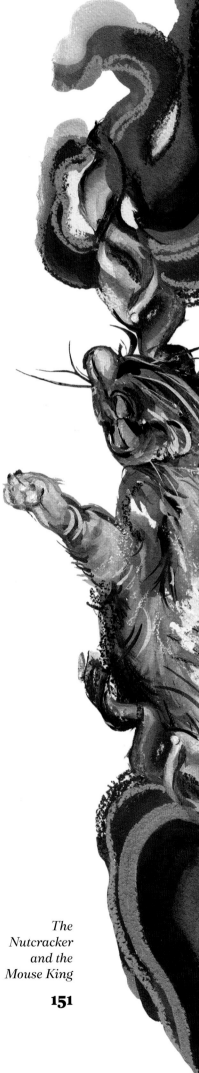

The Nutcracker and the Mouse King

151

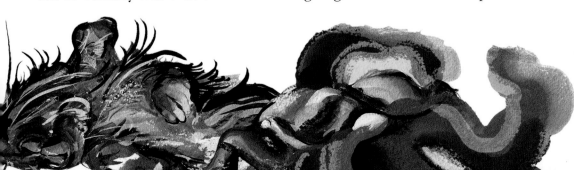

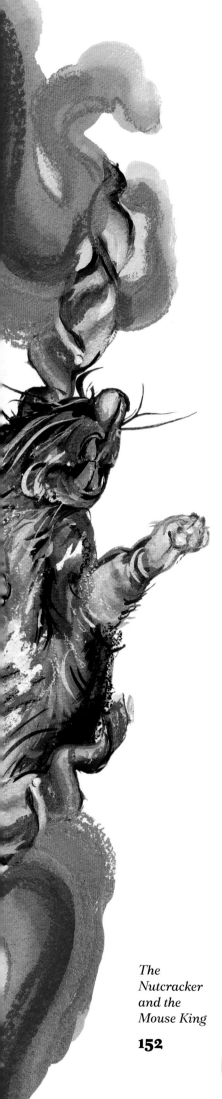

was the commander in chief of the toy army. Then I threw my shoe at the mice, and after that, I don't know anything more about what happened."

Dr. Wendelstern winked at her mother, who said very gently to Marie, "Never mind, dear. Calm down. The mice have all gone away, and Nutcracker is in the cupboard, quite safe and sound."

At this point in the conversation, Marie's father entered and had a long talk with Dr. Wendelstern, who had taken Marie's pulse, and she heard them talking about something like a fever caused by her wound. Indeed, Marie had to stay in bed and take medicine for some days, although she didn't feel at all ill, with the exception of her arm, which was rather stiff and painful. She knew that Nutcracker had survived the battle, and she seemed to remember, as if in a dream, that he had said quite distinctly in a very melancholy tone: "Marie, my dearest lady, I am most deeply indebted to you. But it is in your power to do even more for me."

She thought and thought what this could possibly be, but it was in vain. She couldn't figure it out. She wasn't able to play, on account of her arm, and when she tried to read, or look at the picture books, everything turned hazy before her eyes so that she was obliged to stop. Consequently, the days seemed very long to her, and she could scarcely wait until dusk, when her mother would come and sit at her bedside, where she would read and tell her all sorts of nice stories. Her mother had just finished telling her the story of Prince Fakardin, when the door opened, and in came Godfather Drosselmeier. "I've come to see with my own eyes how Marie's getting on," he said.

When Marie saw Godfather Drosselmeier in his little yellow coat, she immediately recalled the scene of the night when Nutcracker lost the battle with the mice, and it came back so vividly to her that she couldn't help crying out: "Oh, Godfather Drosselmeier, how nasty you were! I saw you quite well when

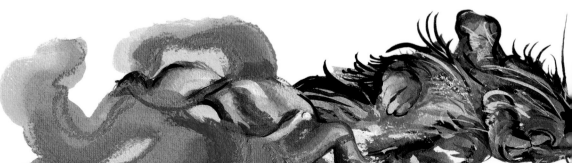

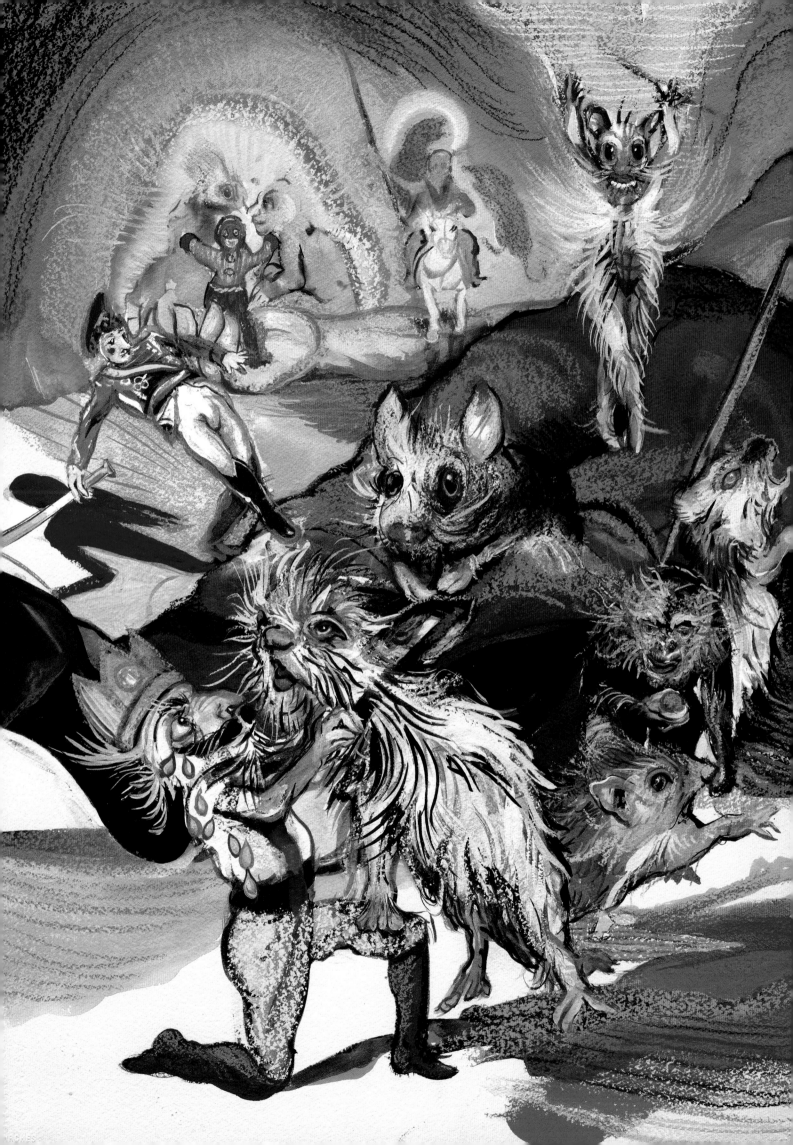

you were sitting on the clock, covering it with your wings to prevent it from striking and frightening the mice. I heard what you shouted at Mouse King! Why didn't you help Nutcracker? Why didn't you help me, you nasty Godfather! It's nobody's fault but yours that I'm lying here with a bad arm."

Her mother was very alarmed and asked what she meant. But Drosselmeier began making bizarre faces and, in a snarling, monotone voice that was a sort of chant, said: "Pendulum had to rattle dazzle, couldn't tick, never a click; all the clicking, stopped their ticking, no more clicking. Loud blast. Dollies! Don't let your heads hang so low! Hink and hank, and honk and hank. Dolls and girls. Don't let your heads hang so low. Cling and ring! The battle's over. Nutcracker's safe and sound. Here comes the owl who carries away the mice's king. Pik-pak and pik and pik-pook. Clocks hum and then a boom . . . grr-grr pendulums must click again . . . tick tack, grr and brr, prr and purr."

Marie was terrified and stared with wide eyes at Grandfather Drosselmeier because he looked quite different and was much more horrid than usual. He jerked his right arm backward and forward as if he were some kind of marionette. In addition, she was growing terribly frightened, while Fritz laughed heartily and cried out: "Why, Godfather, you are so funny! You're just like my old jumping jack, which I threw away last month."

But her mother looked very grave and said, "This is most extraordinary behavior, Mr. Drosselmeier? What do you think you are doing?"

"My goodness," Drosselmeier laughed. "Have you never heard my sweet rhyme, which I call 'The Watchmaker's Ditty'? I always sing it to little patients like Marie."

Then he quickly sat down beside Marie's bed and said to her, "Don't be angry with me just because I didn't gouge all of Mouse King's fourteen eyes. I couldn't exactly manage that. However, to make up for it, here's something that I know will please you greatly."

He reached into one of his pockets, and slowly, slowly produced Nutcracker, whose teeth he had firmly inserted again and whose broken jaw he had straightened. As soon as Marie saw this, she shouted for joy, and her mother laughed and said, "Now you can see for yourself how nice Godfather Drosselmeier has been to Nutcracker."

"But you must admit, Marie," her godfather said, "that Nutcracker is far from being what you might call a handsome fellow. You can't say he has a pretty

face. If you like, I'll tell you how this ugliness came into his family and has been handed down from one generation to another. But, tell me, have you ever heard the story about Princess Pirlipat, the witch Mouseyrink, and the clever clockmaker?"

"I say, Godfather Drosselmeier," Fritz interrupted, "You've put Nutcracker's teeth in again all right, and his jaw isn't as wobbly as it was, but what's happened to his sword? Why haven't you given him a sword?"

"Oh," cried the irritated Drosselmeier, "must you always be bothering me and finding fault with something or other, my boy! What do I care about Nutcracker's sword? I've fixed his mouth and chin. So, he must look for a sword by himself."

"Yes, yes," said Fritz. "Of course, he must, if he's the right sort of fellow."

"So, tell me, Marie," Drosselmeier continued, "whether you know the story of Princess Pirlipat?"

"Oh, no," answered Marie. "Tell it to me. Please do tell it to me!"

"I hope it won't be as strange and gruesome as your stories generally are," said her mother.

"Oh, no. Nothing of the kind," said Drosselmeier. "On the contrary, it's quite a funny story that I have the honor of telling this time."

"Tell us! Please go on and tell us!" cried the children.

And Drosselmeier began his tale as follows.

The Tale of the Hard Nut

Pirlipat's mother was a king's wife, so that, of course, she was a queen, and as soon as Pirlipat herself was born, she became a princess by birth. The king was overjoyed by the birth of his beautiful little daughter, and, as she lay in her cradle, he danced around and around upon one leg, crying again and again, "Hurray, hurray! Hip, hip, hurray! Has anybody ever seen a baby more beautiful than my little Pirlipat?"

And all the ministers of state, and the generals, presidents, and officers of the staff danced around on one leg, following the king, and cried as loud as they could: "No, no, never!"

Indeed, there was no denying that a lovelier baby than Princess Pirlipat had never been born, ever since the world began. Her little face looked as if it

were woven out of the most delicate white and rose-colored silk flakes. Her eyes were sparkling blue, and her hair consisted of little curls like threads of gold. Moreover, she had come into the world with two rows of little pearly teeth, and two hours after her birth, she used them to bite the Lord High Chancellor's fingers when he was making a careful examination of her features, causing him to cry "For heaven's sake!" quite loud. However, there are people who assert that he used the expression "Oh, Lord," and opinions are still considerably divided on this point even today.

In any event, Pirlipat really did bite the chancellor's fingers, and the people of this kingdom learned, with much gratification, that both intelligence and discrimination dwelt within her angelic little body.

Everyone was joyful and happy, as I have said, except for the queen, who was very anxious and uneasy. Nobody could tell why. One remarkable indication of her anxiety was that she had Pirlipat's cradle carefully guarded. Not only were there always bodyguards at the doors of the nursery, but two head nurses were close to the cradle, and six additional nurses were posted all around the room at night. And what seemed rather a funny thing, which nobody could understand, was that each of these six nurses always had to have a cat in her lap and keep stroking it all night long so that the cat would never stop purring.

Now, it is impossible that you, my reader, would know the reason for all these precautions, but I do, and I shall proceed to tell you.

Once upon a time, many great kings and grand princes gathered at the court of Pirlipat's father, and numerous tournaments, plays, and dances were held on a great scale. To show that he had no lack of gold and silver, the king made up his mind to dip his hand into the royal revenues for once and launch these events, regardless of expense. He did this, after having previously ascertained privately from the state's master chef that the court astronomer had indicated it was a propitious hour for pork. So, he decided to arrange a grand sausage and dessert banquet. He jumped into a state carriage and personally invited all the kings and princes for a spoonful of soup merely so that he might enjoy their astonishment at the magnificence of the food and entertainment. Then he said to the queen, very graciously, "My darling, you know exactly how I like my sausages and desserts."

The queen quite understood that this meant she was to undertake the im-

portant duty of making the sausages and desserts herself, which was a thing she had done on one or two previous occasions. So, the supreme treasurer was ordered to deliver the large golden sausage kettle and the silver casseroles to the kitchen. A great fire of sandalwood was kindled, and the queen put on her damask kitchen apron. Soon the most delicious aroma of broth arose steaming out of the kettle. This sweet smell penetrated the council chamber, and the king could not control himself.

"Excuse me for a few minutes, gentlemen," he cried and rushed to the kitchen, where he embraced the queen and stirred the soup in the kettle a little with his golden scepter, then returned to the council chamber in a calmer condition. The important moment had now arrived when the bacon had to be cut up into little square pieces and browned on silver spits. The ladies-in-waiting retired because the queen thought it important to perform this task alone, out of love and duty to her royal consort. But when the bacon began to brown, a soft little voice began whispering: "Give me some of that, sister! I want some of it, too. I am a queen just like you yourself. So, give me some."

The queen knew quite well who was speaking. It was Dame Mouseyrink, who had been living in the palace for many years. She claimed she was related to the royal family, and that she herself was queen of the realm of Mousolia and lived with a considerable retinue of her own under the kitchen hearth. The queen was a kindhearted, benevolent woman, and, although she didn't exactly care to recognize Dame Mouseyrink as a sister and a queen, she was willing at this festive occasion to spare some of the tidbits. So, she said, "Come out, then, Dame Mouseyrink. Of course, you can enjoy my bacon at any event."

So, Dame Mouseyrink came running out as fast as she could, held up her pretty little paws, and took piece after piece of the bacon that the queen held out for her. But then all Dame Mouseyrink's uncles, cousins, and aunts came jumping out, too, joined by her seven sons, who were terrible sponges and do-nothings. They all began eating the bacon, and the queen was too frightened to fend them off. Fortunately, the royal controller's wife came to her rescue and drove these intrusive visitors away, but very little of the bacon was left, according to the court mathematician's assessment. He had been called in to manage the damage, and so he skillfully distributed the leftover bacon among the sausages.

The Nutcracker and the Mouse King

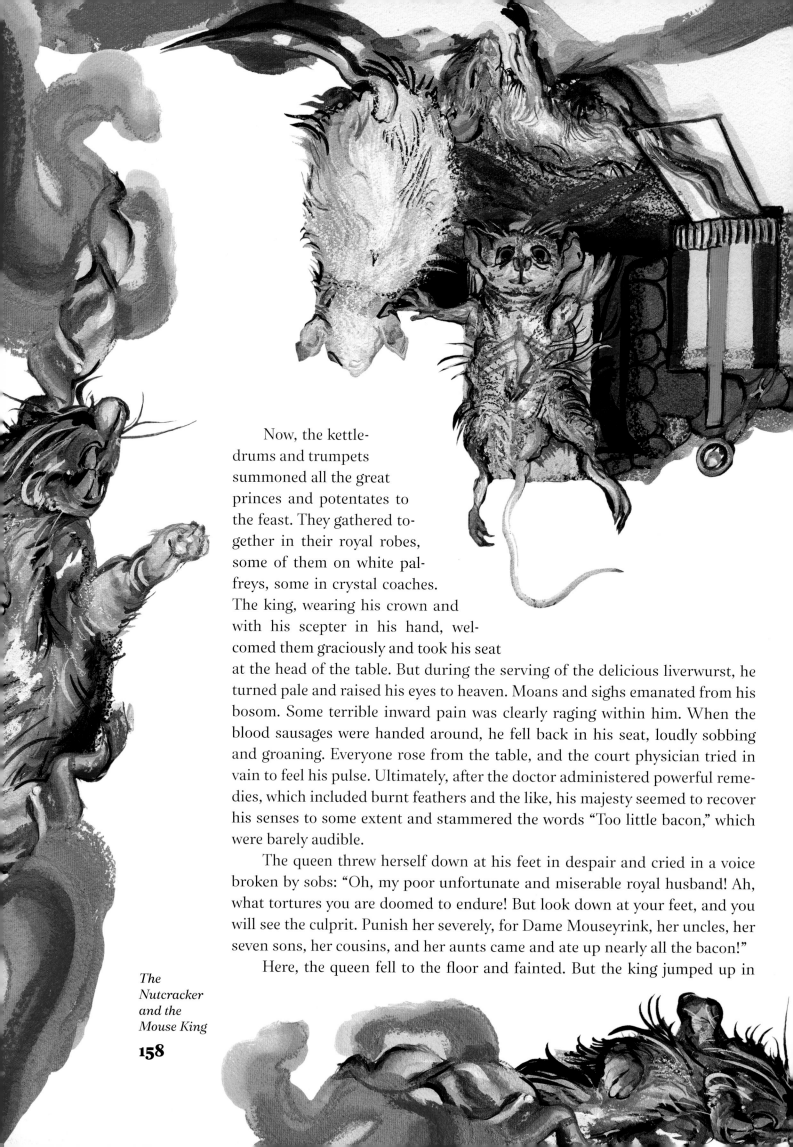

Now, the kettledrums and trumpets summoned all the great princes and potentates to the feast. They gathered together in their royal robes, some of them on white palfreys, some in crystal coaches. The king, wearing his crown and with his scepter in his hand, welcomed them graciously and took his seat at the head of the table. But during the serving of the delicious liverwurst, he turned pale and raised his eyes to heaven. Moans and sighs emanated from his bosom. Some terrible inward pain was clearly raging within him. When the blood sausages were handed around, he fell back in his seat, loudly sobbing and groaning. Everyone rose from the table, and the court physician tried in vain to feel his pulse. Ultimately, after the doctor administered powerful remedies, which included burnt feathers and the like, his majesty seemed to recover his senses to some extent and stammered the words "Too little bacon," which were barely audible.

The queen threw herself down at his feet in despair and cried in a voice broken by sobs: "Oh, my poor unfortunate and miserable royal husband! Ah, what tortures you are doomed to endure! But look down at your feet, and you will see the culprit. Punish her severely, for Dame Mouseyrink, her uncles, her seven sons, her cousins, and her aunts came and ate up nearly all the bacon!"

Here, the queen fell to the floor and fainted. But the king jumped up in

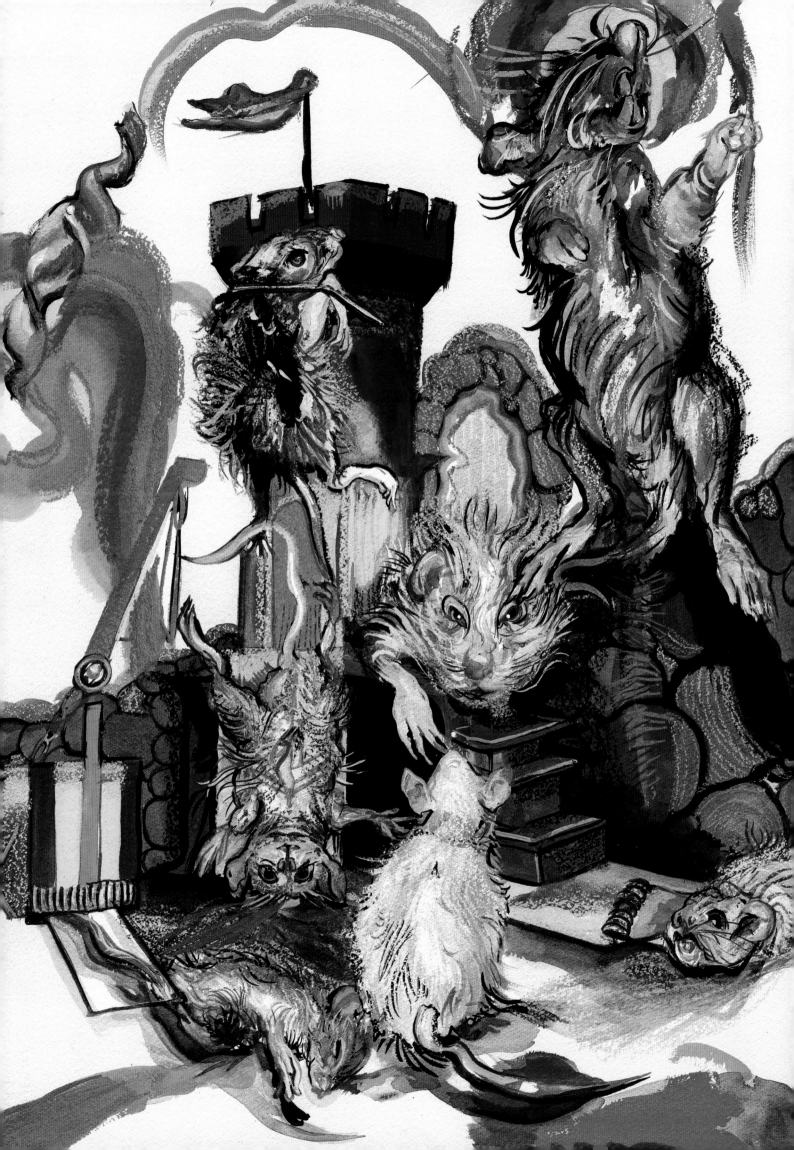

fury and cried in a terrible voice: "Royal Controller's Wife, how did this happen?"

The controller's wife reported all she knew, and the king resolved to take revenge on Dame Mouseyrink and her family for eating up practically all the bacon, which ought to have been in the sausages. The privy council was summoned, and it was decided that Dame Mouseyrink should be tried for her life and all her property confiscated. But since his majesty believed that she might go on consuming the bacon, which was his special delicacy, the entire matter was referred to the court clockmaker, whose name was the same as mine—Christian Elias Drosselmeier—and he sought to expel Dame Mouseyrink and all her relations from the palace forever by means of a certain politically shrewd procedure. He invented ingenious tiny devices into which pieces of bacon were inserted, and he placed these devices all over Dame Mouseyrink's dwelling. Now, she herself was much too smart and knowledgeable not to see through Drosselmeier's artifice. Yet, her relations ignored all her warnings. Enticed by the fragrance of the bacon, all seven of her sons and a great many of her uncles, cousins, and aunts walked into Drosselmeier's little devices and were immediately trapped and taken prisoners, after which they met with a shameful death in the kitchen.

Dame Mouseyrink left this scene of horror with a small following. Rage and despair filled her breast. The royal court rejoiced greatly, but the queen was very anxious because she knew Dame Mouseyrink's character and knew well that she would never allow the death of her sons and other relatives to go unavenged. And, in fact, one day when the queen was cooking a fricassee for the king, a dish that was one of his favorites, Dame Mouseyrink suddenly made her appearance and said: "My sons and my uncles, my cousins and my aunts are now no longer with us. Take good care, lady! Otherwise, the queen of the mice may bite your little princess in two! Take care!"

Upon saying this, Dame Mouseyrink vanished and was seen no more. But the queen was so frightened that she dropped the fricassee into the fire. So, this was the second time Dame Mouseyrink managed to spoil one of the king's favorite dishes, and this made him very angry.

*

"But this is enough for Marie and Fritz tonight. I'll finish the story tomorrow."

Marie had ideas of her own about this story and begged Godfather Drosselmeier to go on with it. But he would not let himself be persuaded. Instead,

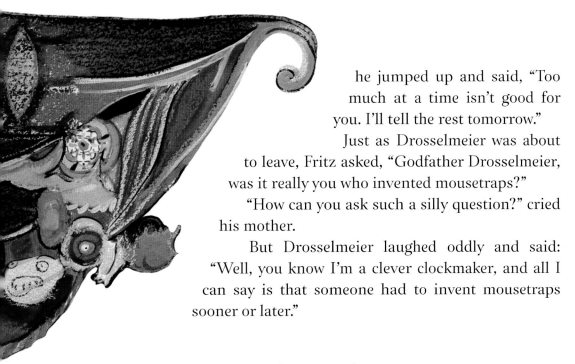

he jumped up and said, "Too much at a time isn't good for you. I'll tell the rest tomorrow."

Just as Drosselmeier was about to leave, Fritz asked, "Godfather Drosselmeier, was it really you who invented mousetraps?"

"How can you ask such a silly question?" cried his mother.

But Drosselmeier laughed oddly and said: "Well, you know I'm a clever clockmaker, and all I can say is that someone had to invent mousetraps sooner or later."

Continuation of the Tale of the Hard Nut

"And now you know, children," Drosselmeier continued the next evening, "why the queen took such precautions about her little Pirlipat: she was always afraid and anxious that Dame Mouseyrink might return and carry out her threat of biting the princess to death." Drosselmeier's ingenious traps were of no avail against the clever, crafty Dame Mouseyrink, and nobody except the court astronomer, who was also state astrologer and reader of the stars, knew that the family of Tomcat Purr had the power to keep her at bay. This was the reason why each of the nurses was obliged to keep one of the sons of that family on her lap, and each of the sons was given the honorary rank and title of privy councilor of legation. Their onerous duty was made less irksome by the nurses, who rubbed their backs.

One night, just after midnight, one of the chief nurses who was stationed close to the cradle woke suddenly from a profound sleep. Everyone was fast asleep. Not a purr to be heard. There was only sleep, deathlike silence so that the clock ticking in the wainscot sounded quite loud. So, you can imagine the feelings of the principal nurse when she saw, close beside her, a great, hideous mouse standing on its hind legs with its horrid head lying on the princess's face! She leapt into the air with a scream of terror. Everybody awoke, but then Dame Mouseyrink (for she was the great, hideous mouse in Pirlipat's cradle) ran quickly away into the corner of the room. The privy councilors of legation dashed after her, but they were too late. Dame Mouseyrink was squeezing through a chink in the floor. The noise woke Pirlipat, who began howling.

"Heaven be thanked that she is still alive!" cried all the nurses, but, to their horror, when they looked at Pirlipat they saw that the beautiful, delicate little baby had turned into a creature with an enormous, bloated head perched on

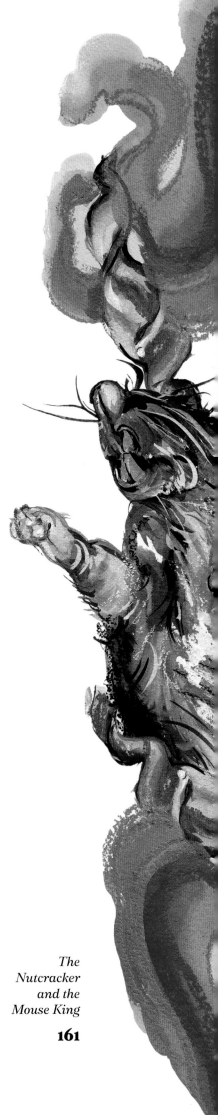

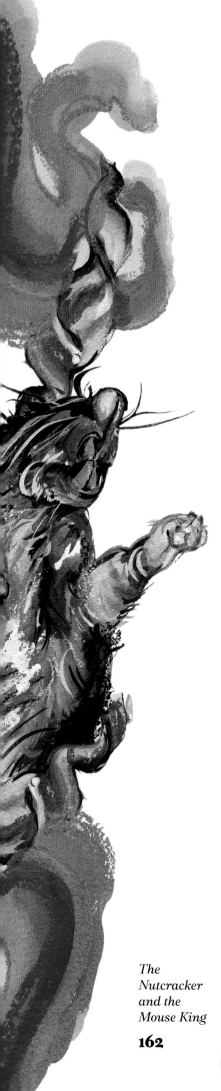

a diminutive, crumpled body. The small blue eyes had turned into gawking green eyes, and the little lips stretched from one ear across to the other.

Of course, the queen nearly died of weeping and grieving, and all the walls of the king's study had to be padded, because he kept on banging his head against them and crying: "Oh, wretched king that I am! Oh, wretched king that I am!"

Of course, he should have realized that it would have been much better to have eaten his sausages with no bacon in them at all, and to have allowed Dame Mouseyrink and her folk to remain under the hearthstone. But Pirlipat's father had not thought of that. Instead, he placed all the blame on the court clockmaker, Christian Elias Drosselmeier of Nürnberg. Consequently, he issued a strict order that said Drosselmeier had four weeks to restore Princess Pirlipat to her pristine condition, or at least indicate an unmistakable and reliable process that might cure the princess, otherwise Drosselmeier would suffer a shameful death by the axe of the royal executioner.

Drosselmeier was somewhat alarmed, but he had confidence in his art and in his luck. So, he proceeded to operate on the princess, which seemed to him to be the most expedient thing to do. He took Princess Pirlipat apart very carefully, screwed off her hands and her feet, and examined her interior structure. Unfortunately, he found that the larger she grew, the more deformed she became, so he wasn't able to find a solution. Consequently, he carefully put her together again and sat down in a melancholy mood beside her cradle, which he wasn't allowed to leave. Indeed, he was in a deep depression. The fourth week arrived. And on Wednesday of the fourth week, when the king entered his eyes were glistening with anger. All at once, he made threatening gestures with his scepter and cried: "Christian Elias Drosselmeier, restore the princess, or prepare for death."

Drosselmeier began to weep bitter tears while the little princess cracked nuts, an occupation that seemed to afford her quiet satisfaction. For the first time, Drosselmeier noticed Pirlipat's remarkable appetite for nuts, and that she had actually been born with teeth. In fact, he remembered that, after her transformation, she had immediately begun to cry and continued crying until, by chance, she picked up a nut. Then she immediately cracked it, ate the kernel,

and quieted down. From that time onward, her nurses found that nothing would soothe her except cracking nuts.

"Oh, holy instinct of nature! Eternal, wondrous, inscrutable Interdependence of Things!" Drosselmeier was greatly relieved. "You have revealed the secret door. I shall knock, and the door will open!"

He immediately begged for an interview with the court astronomer and, though closely guarded, he was conducted to him. They embraced with many tears, for they were great friends. Without wasting a second, they entered a private room, where they examined numerous books about the treatment of sympathies, antipathies, and other daunting subjects.

When it turned night, the court astronomer consulted the stars, and with the assistance of Drosselmeier, himself adept in astrology, explored the princess's horoscope. This was an exceedingly difficult operation, for the lines kept getting more and more entangled and confused. But at last— oh what joy!—they saw clearly that all the princess had to do to break the malicious spell that made her so hideous and to regain her former beauty was eat the sweet kernel of a crackatuk nut. Now this nut had a shell so hard that even if you fired a forty-eight-pound cannon at it, nothing would happen to the nut. Moreover, this nut must be cracked in the princess's presence by the teeth of a man whose beard had never known a razor and who had never worn boots. This man had to hand the kernel to her with his eyes closed, and he was not allowed to open them until he had taken seven steps backward without a tumble.

Drosselmeier and the astronomer had been working on this problem uninterruptedly for three days and three nights. On Saturday, the king was sitting at dinner, when Drosselmeier, who was to be executed on Sunday morning, burst joyfully into the room to announce that he had discovered what had to be done to restore Princess Pirlipat to her pristine beauty. So, the king embraced him with rapture and promised him a diamond sword, four decorations, and two Sunday suits.

"I want you to start work immediately after dinner!" the monarch commanded, then added kindly, "Take care, dear Drosselmeier, that the young, unshaven gentleman without boots will already have the crackatuk nut in his hand and is ready, and be sure that he doesn't touch any liquor beforehand,

so he won't trip when he takes his seven backward steps, like a crab. He can get as drunk as a lord afterward, if he likes."

Drosselmeier was dismayed by the king's words and stammered in reply, not without trembling and hesitation, that, though the remedy had been discovered, both the crackatuk nut and the young gentleman who was to crack it hadn't yet been found, and that it was somewhat doubtful whether they ever would be found.

Greatly incensed by this reply, the king whirled his scepter around his crowned head and shouted in the voice of a lion, "Very well, then you will be beheaded!"

However, it was exceedingly fortunate for the wretched Drosselmeier that the king had thoroughly enjoyed his dinner that day, and was consequently in a good mood and disposed to listen to the sensible advice that the queen, who felt very sorry for Drosselmeier, did not hesitate to give him. Drosselmeier took heart and maintained that he really had fulfilled the conditions required to save his life by discovering the necessary steps that they had to take.

However, the king replied that this was a lame excuse and nonsense. Then, after two or three glasses of potent alcohol, he ordered Drosselmeier and the astronomer to start off immediately and not return without a crackatuk nut in their pocket. The queen sought to help them and suggested that the man who was to crack the nut might be contacted by means of advertisements in the local and foreign newspapers and gazettes.

At this point, Godfather Drosselmeier stopped and promised to finish his story the following evening.

Conclusion of the Tale of the Hard Nut

The next evening, as soon as the candles were brought out, Godfather Drosselmeier arrived and went on with his story as follows:

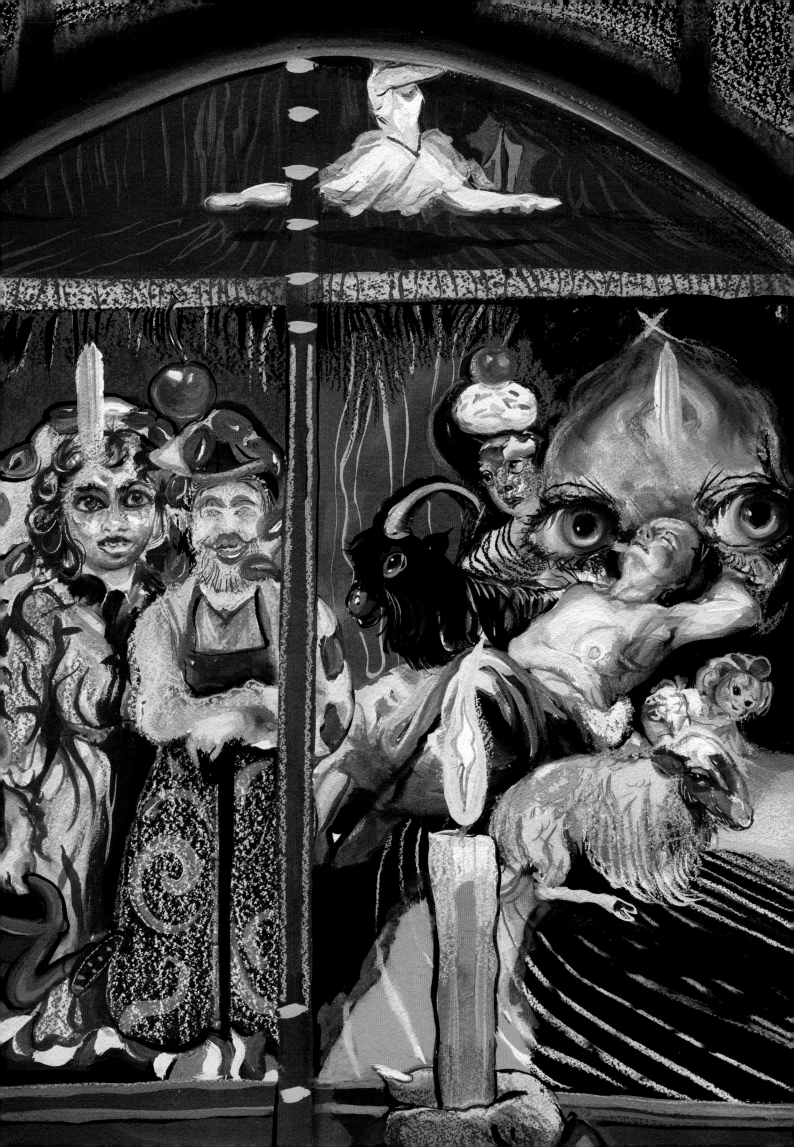

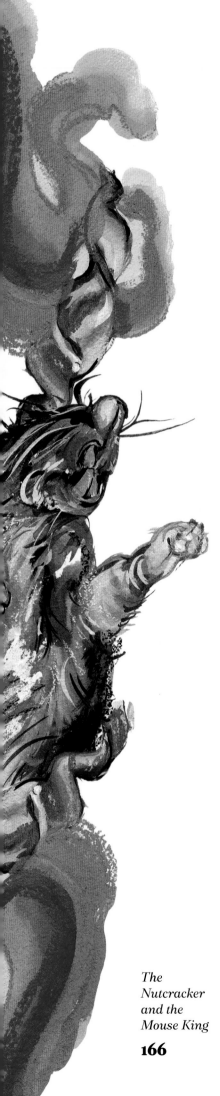

Drosselmeier and the court astronomer traveled for fifteen long years without finding the slightest trace of the crackatuk nut. I could go on for more than four weeks telling you which countries they had visited and what extraordinary things they had seen. However, I shall not do so. Instead, I'll merely mention that the discouraged Drosselmeier gradually began to feel a most powerful longing to see his dear hometown of Nürnberg once again. And he was moved strongly by this longing one day when he happened to be smoking a pipe of special tobacco with his friend in the middle of a large forest in Asia, and he cried: "Oh, Nürnberg! Nürnberg, my dear hometown! He who has not known you, place of renown, though he may have traveled far and wide, and seen great cities like London, Paris, and Petrovaradin does not know what it is to be happy and must still his longing heart and languish for you. Oh, Nürnberg, exquisite city, where the houses have windows both upstairs and down!"

As Drosselmeier lamented with great sadness, the astronomer, who was gripped by compassion and sympathy, began to weep and howl so terribly that he could be heard all over Asia. But he gathered himself together, wiped the tears from his eyes, and said: "My dear colleague, why should we sit and weep and howl here? Why not go to Nürnberg? Does it matter where and how we search for this horrible crackatuk nut?"

"That's true," Drosselmeier replied, feeling consoled.

Immediately, they both stood up, knocked the tobacco out of their pipes, and started traveling straight for Nürnberg without stopping. Indeed, they left the forest in the middle of Asia and did not end their journey until they came to Nürnberg. As soon as they arrived there, Drosselmeier went straight to his cousin Christoph Zacharias Drosselmeier, a toy and doll maker, varnisher, and gilder, whom he had not seen for a great many years. Once there, he told him the complete tale of Princess Pirlipat, Dame Mouseyrink, and the cracka-tuk nut. As he did this, his cousin clapped his hands repeatedly and cried in amazement: "Dear me, cousin, these things are really wonderful—very wonder-ful, indeed!"

Drosselmeier also told him about some of the adventures he had expe-rienced on his long journey: how he had spent two years at the court of King of Dates; how Prince of Almonds had expelled him with ignominy from his

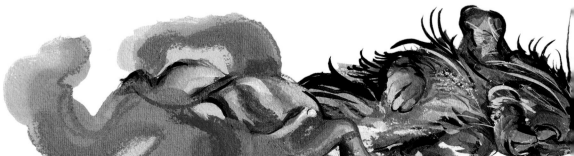

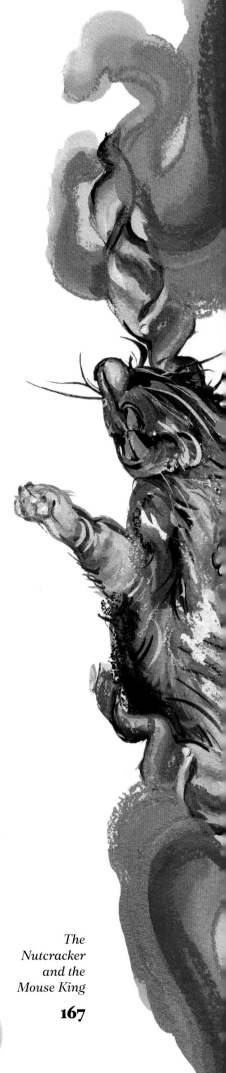

territory; how he had applied for help in vain to the Society of Natural History at Squirreltown. In short, how he had been utterly unsuccessful everywhere and was not able to discover the faintest trace of the crackatuk nut.

During this brief sketch of their travels, Christoph Zacharias frequently snapped his fingers, twisted himself around on one foot, clicked his tongue, and finally shouted: "Oh, my! Goodbye! I can't believe my ears!"

Finally, he threw his hat and wig into the air, hugged Drosselmeier warmly, and cried: "Cousin, cousin, you're a lucky man! A lucky man you are. Either I am mistaken, or I must tell you, I myself possess the crackatuk nut!"

He immediately produced a little cardboard box from which he took a medium-sized, gilded nut and said: "Look at this!"

After showing the nut to his cousin, he declared: "I must tell you all about this nut. Several years ago, during Christmas, a stranger came here with a sack of nuts that he offered for sale. Right in front of my shop he had a quarrel and put the sack down to better defend himself from the local nut sellers, who attacked him because they were against an outsider hawking his nuts. Just then, a heavily loaded wagon drove over the sack, and all the nuts were crushed except one. Right after this, the stranger smiled oddly and offered to sell me this nut for a twenty-penny piece from the year 1796. This struck me as wonderful, for I had just found such a coin in my pocket. So, I bought the nut, and I gilded it, though I didn't know why I took the trouble, or paid so much for it."

All questions as to whether this gilded nut really was the long-sought-after crackatuk nut were dispelled when the court astronomer carefully scraped away the gilding and found the word *crackatuk* engraved on the shell in Chinese characters.

As you may imagine, the travelers were thrilled, and the cousin was even happier, for Drosselmeier assured him that he was a made man and was certain to receive a good pension, and all the gold he desired for the rest of his life for gilding the nut for nothing.

Later that evening, Drosselmeier and the astronomer had both put on their nightcaps and were going to go to bed when the astronomer said: "I must tell you, dear colleague, one piece of good fortune never comes alone. I feel

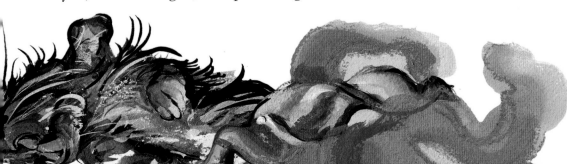

convinced that we've not only found the nut, but also the young man who is to crack it and hand the kernel to the princess in the bargain. I mean none other than your cousin's son, and I don't intend to close an eye this night until I've read that youngster's horoscope."

Upon saying this, he took off his night-cap and immediately set to work to consult the stars. The cousin's son was a nice-looking, well-groomed young fellow who had never been shaved and had never worn boots. True, he had been a jumping jack for a Christmas or two in his earlier days, but there was scarcely any trace of this about him now. Last Christmas, he had appeared in a beautiful red coat with gold trimmings, a sword by his side, his hat under his arm, and a fine wig with a pigtail. Now, he stood glowing in his father's shop, a handsome and attractive young man, and very gallant, for he occupied himself by cracking nuts for the young ladies, who called him "the handsome nutcracker."

The next morning, the astronomer embraced Drosselmeier with great emotion and shouted: "This is the very man! We have him! We've found him! Now, there are two things, my dear colleague, that we must keep carefully in mind. First, for this precious nephew of yours, we must create and braid a sub-stantial pigtail, which will be connected with his lower jaw in such a way that it is able to pull. And next, when we return to the royal residence, we must care-fully conceal the fact that we have brought the young man with us who will bite open the crakatuk nut. He is to make his appearance only after we arrive. I have read in the horoscope that two or three others have taken a bite unsuccessfully, and so the king has promised that the man who cracks the nut and restores Pirlipat's beauty will wed the princess and become the successor to the crown."

The doll-maker cousin was immensely delighted by the idea of his son marrying Princess Pirlipat and becoming a prince and king. So, he placed him fully under the charge of the envoys to do what they liked with him. The pigtail that Drosselmeier attached to him proved to be a powerful and efficient instru-ment, and the young man demonstrated this by cracking the hardest of peach pits with the utmost ease.

Now Drosselmeier and the astronomer sent word to the royal residence about the discovery of the crackatuk nut, and the necessary notices and news were at once published in the newspapers. By the time our travelers appeared, several young gentlemen, including princes, had also arrived, having suffi-

cient confidence in their teeth to try to disenchant the princess. The ambassadors were horrified when they saw poor Pirlipat again. Her diminutive body, with tiny hands and feet, was not big enough to support her great, shapeless head. Her hideous face was made more repulsive by a white, cotton-like beard, which had grown around her mouth and chin. Everything had turned out as the court astronomer had predicted in the horoscope. One bumbler after another bit his teeth and his jaws in agony over the nut, without doing the slightest good for the princess. And then, when the candidate was carried out, unconscious, by the dentists who were purposefully in attendance, he would sigh: "Ah! That was a hard nut to crack!"

Now, soon after the anguished king had promised his daughter and kingdom as reward for whomever might disenchant the princess, the charming, gentle young Drosselmeier made his appearance and begged to be allowed to make an attempt. None of the previous candidates had pleased the princess so much. She pressed her little hands to her heart and sighed: "Ah, I hope it will be this young man who cracks the nut and becomes my husband."

After he had politely saluted the king, the queen, and the Princess Pirlipat, Drosselmeier took the crackatuk nut from the hands of the clerk of the closet, put it between his teeth, made a strong effort with his head, and "crack—crack!" the shell was shattered into a number of pieces. Now he neatly cleared the kernel from the pieces of husk that were sticking to it, and making a bow, he presented it courteously to the princess, after which he closed his eyes and began his backward steps. The princess swallowed the kernel, and—oh, wonder of wonders—the monstrosity vanished, and in its place stood a magnificently beautiful lady with a face that seemed woven of delicate lily, white and rose-colored silk, sparkling blue eyes, and hair in little curls like threads of gold.

Trumpets and kettledrums resounded, joined by the loud rejoicings of the populace. The king and his entire court danced around on one leg, as they had done at Pirlipat's birth, and the queen, who had fallen into a fainting fit from joy and delight, needed to be treated with eau de cologne. All this tremendous tumult interfered a good deal with young Drosselmeier's self-confidence, for he still had to take his seven backward steps. But he collected himself as best he could and was just about to stretch out his right foot to make his seventh step when up came Dame Mouseyrink through the floor, making a horrible squealing and

The Nutcracker and the Mouse King

169

squeaking so that Drosselmeier, as he was putting his foot down, stepped on her, stumbled, and almost fell.

Oh, misery! In one second, he was transformed just as the princess had been. His body shriveled, and he could scarcely support the great, shapeless head with enormous, bulging eyes and wide, gaping mouth. In the place where his pigtail had been, there was now a scanty wooden cloak hanging down and destroying the control of the jaw.

The clockmaker and the astronomer were dismayed and terrified, but they saw that Dame Mouseyrink was wallowing in her gore on the floor. Her wickedness had not escaped punishment, for young Drosselmeier had squashed her throat with the sharp point of his shoe so that she was mortally wounded and dying. As Dame Mouseyrink lay in agony, she squeaked and squealed in a lamentable way and cried: "Oh, crackatuk, you nut so hard! Oh, fate, which none may disregard! Hee-hee, pee-pee, woe's me, I cry! Though I must die. But, brave young Nutcracker, I see you must soon follow after me. My sweet young son with sevenfold crown will soon bring Master Cracker down. His mother's death he will repay! So, Nutcracker, beware that day! Oh, life most sweet, I feebly cry and leave you now, for I must die. Squeak!"

With this cry, Dame Mouseyrink dropped dead, and her body was carried out by the court oven heater. In the meantime, nobody was concerned about young Drosselmeier. But the princess reminded the king of his promise, and he immediately ordered the young hero to be conducted to his presence. Yet, when the poor wretch came forward in his transformed condition, the princess put both her hands to her face and cried: "Oh, please take away that horrid Nutcracker!"

Now Lord Chamberlain immediately seized Nutcracker by his little shoulders and shoved him out the door. The king was furious that they had tried to dupe him and have him take a nutcracker as a son-in-law. Indeed, he placed all the blame on the clockmaker and the astronomer. As a consequence, he ordered them both to be banished from the court forever. The horoscope that the

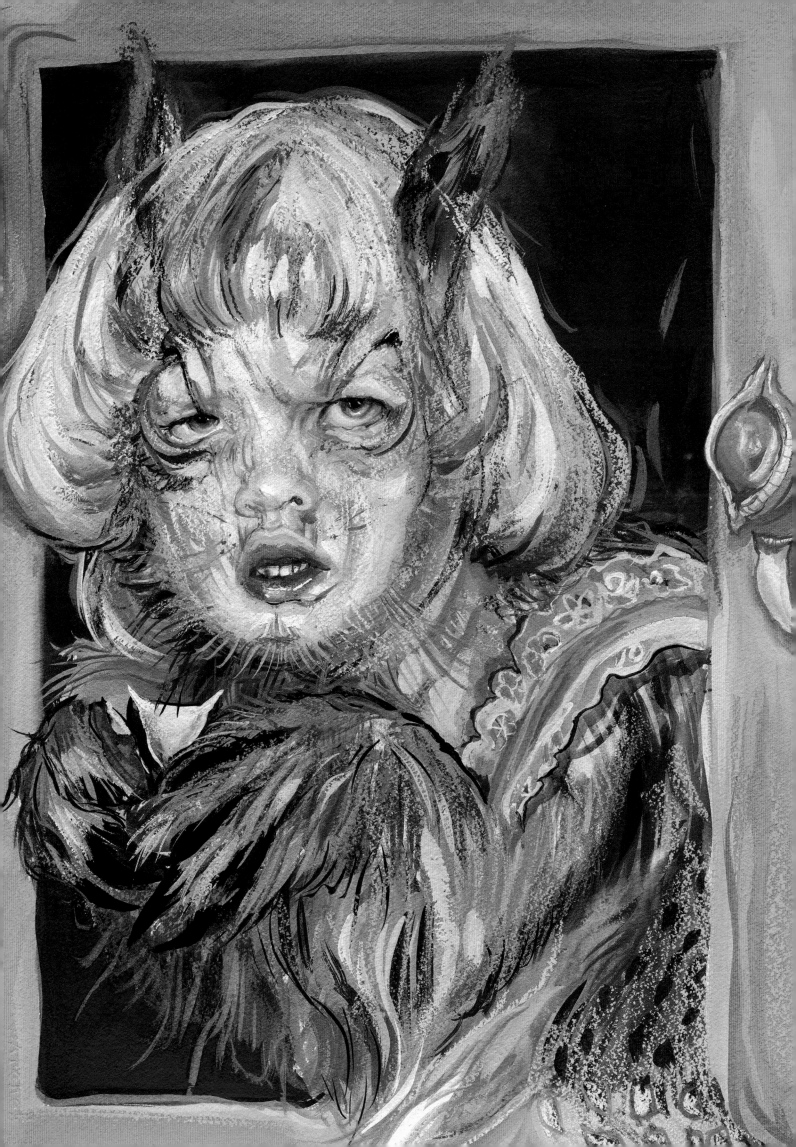

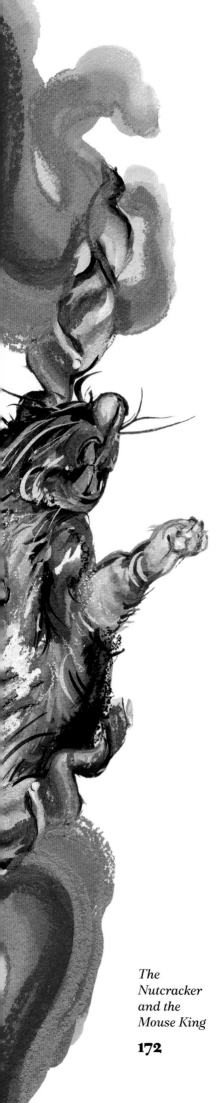

astronomer had consulted in Nürnberg had said nothing about this, but that didn't prevent him from consulting the stars anew, and they told him that young Drosselmeier would conduct himself so admirably in his new condition that he would still become a prince and a king despite his deformation. In addition, they indicated that his deformity would disappear after the son of Dame Mouseyrink, the seven-headed king of the mice (to whom she had given birth after the death of her original seven sons), should perish by his hand, and a lady would fall in love with him notwithstanding his deformity.

<p style="text-align:center">*</p>

That is the story of the hard nut, children, and now you know why people so often use the expression "that was a hard nut to crack," and why nutcrackers are so ugly. Upon saying this, Godfather Drosselmeier finished his tale.

Marie thought Princess Pirlipat was a nasty, ungrateful thing. On the other hand, Fritz was of the opinion that if Nutcracker had wanted to be a decent guy, he would have made short work of Mouse King soon after and would have regained his good looks.

Uncle and Nephew

If any of my respected readers or listeners has ever been cut by glass, they will know what an exceedingly nasty thing it is, and how long it takes to heal. So, Marie was obliged to stay in bed a whole week because she felt terribly dizzy whenever she tried to stand up, but finally she was quite well again and able to jump around the room. Everything in the glass-fronted cupboard looked very fine indeed—all the new and shiny things, trees and flowers and houses, toys of every kind. Above all, Marie found her dear Nutcracker again, smiling at her on the second shelf with his teeth all sound and fixed in the right spots. However, whenever she fondly looked at her favorite, it suddenly occurred to her that Godfather Drosselmeier's entire story had been about Nutcracker and his family feud with Dame Mouseyrink and her people. Marie now knew that her Nutcracker was none other than young Mr. Drosselmeier of Nürnberg, Godfather Drosselmeier's delightful nephew, who was unfortunately under the spell

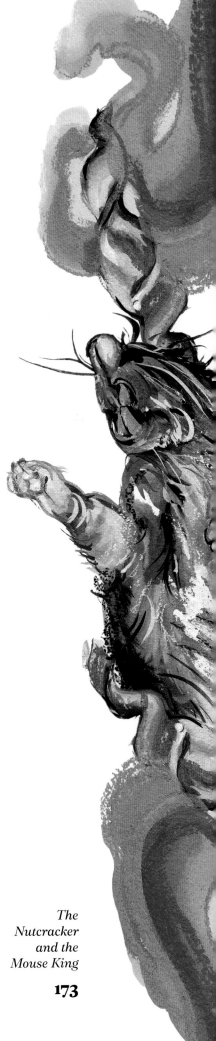

of Dame Mouseyrink. As the story was being told, Marie did not doubt for a moment that the clever clockmaker at Princess Pirlipat's father's court was Godfather Drosselmeier himself.

"But why didn't your uncle help you? Why didn't he help you?" Marie asked sorrowfully, for she felt more and more clearly that in the battle, which she had witnessed, the question in dispute had been no less a matter than Nutcracker's crown and kingdom. Weren't all the other toys his subjects? And wasn't it clear from the astronomer's prophecy he would truly become the rightful king of Toyland?

While the clever Marie was contemplating all these things, she kept expecting Nutcracker and his vassals to give some indication of being alive, and that they would move about as she looked at them. This, however, was by no means the case. Everything in the cupboard remained quite still. Marie thought this was due to Dame Mouseyrink's spells and those of her seven-headed son, which were still effective.

"But," she said, "though you're not able to move, or speak, dear Mr. Drosselmeier, I know you understand me, and how I wish you all the best. You may always depend on my assistance when you require it. In any event, I will ask your uncle, with all his great skill and talents, to help you whenever there may be an opportunity."

Nutcracker remained still and quiet. But Marie felt as if a gentle sigh flowed through the glass-fronted cupboard, making its panes ring in a wonderful, though all-but-imperceptible, manner, while something like a little chime and voice seemed to sing: "Little Marie, fine angel be! I shall be yours for all eternity!"

Although a cold shiver ran through her body, she also felt some pleasure. Dusk had arrived, and Marie's father entered with Godfather Drosselmeier. Soon Louise set the tea table, and the family took their places around it and began talking about the most pleasant and cheerful sorts of things. Marie took her little stool and silently sat down at her godfather's feet. When everybody happened to stop talking, Marie looked straight into her godfather's face with her great blue eyes and said, "I know now, Godfather, that my nutcracker is your nephew, young Mr. Drosselmeier from Nürnberg. The prophecy has come true, and he is a king and a prince, just as your friend the astronomer said he would be. But you know as well as I do that he is at war with Dame Mousey-

The Nutcracker and the Mouse King

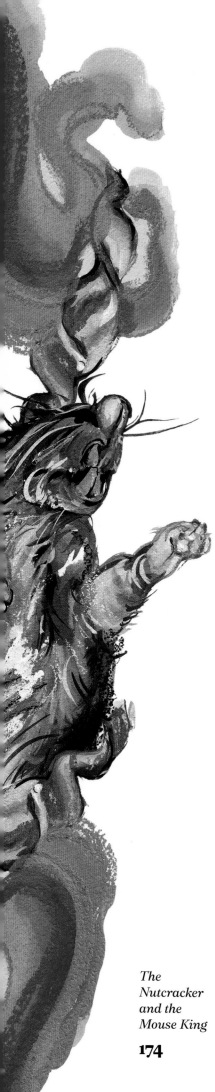

rink's son, the horrid king of the mice. Why don't you help him?"

Marie told the entire story of the battle, just as she had witnessed it, and was frequently interrupted by the loud laughter of her mother and sister, but Fritz and Drosselmeier listened quite seriously.

"Just where did the child get her head filled with such nonsense?" her father cried.

"Don't you see?" her mother replied. "She has such a lively imagination. I'm sure she dreamt it all when she was feverish from her wound."

"It is all nonsense," cried Fritz, "and it isn't true! My red hussars are not such cowards as she said they were. If they were, do you suppose I would command them?"

But Godfather Drosselmeier smiled strangely and took little Marie on his knee and spoke to her more gently than he had ever done before.

"You have been given more imagination, dear Marie, than have I, or the others. Actually, you were born a princess, like Pirlipat, and reign in a bright, beautiful country. Nevertheless, you will suffer a great deal if you intend to befriend poor, deformed Nutcracker. Indeed, Mouse King lies in wait for him at every turn. But I cannot help him! It's you, and only you, who can do that. So, be faithful and true."

Neither Marie nor any of the others knew what Godfather Drosselmeier meant by these words. In fact, they struck Dr. Stahlbaum as being so odd that he felt Drosselmeier's pulse and said, "You seem to have a serious case of cerebral congestion, my dear sir. Let me just write a little prescription to help you."

But Marie's mother shook her head thoughtfully and said, "I have a strong idea about what Mr. Drosselmeier means, though I can't exactly put it into words."

Victory

A short time later, Marie was wakened one moonlit night by a curious noise that came from one of the corners of her room. It was as though small stones were being thrown and rolled to and fro. In between, there was a horrid squealing and squeaking.

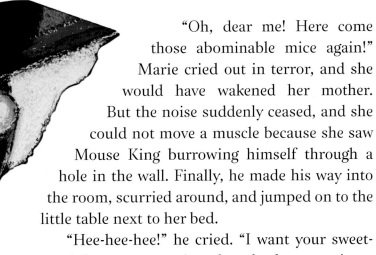

"Oh, dear me! Here come those abominable mice again!" Marie cried out in terror, and she would have wakened her mother. But the noise suddenly ceased, and she could not move a muscle because she saw Mouse King burrowing himself through a hole in the wall. Finally, he made his way into the room, scurried around, and jumped on to the little table next to her bed.

"Hee-hee-hee!" he cried. "I want your sweetmeats! Give me your gingerbread cakes, marzipan, and sugar sticks! Don't dare argue with me! If you don't do what I say, I'll chew up Nutcracker! See if I don't! Hee-hee!"

As he spit out these terrible words, he gnashed and crunched his teeth in a frightening way, then ran off again through the hole in the wall.

All this frightened Marie so much that she was quite pale in the morning, and so upset that she could scarcely utter a word. Indeed, she felt compelled a hundred times to tell her mother or her sister, or at least her brother, all about what had happened. But she thought: "Of course, none of them would believe me. They would only laugh at me."

Marie quickly realized that, to save Nutcracker, she would have to relinquish all her sweets to Mouse King. So, the next evening, she laid out all she had at the bottom of the cupboard.

"I just can't make out where the mice are coming from in the sitting room," her mother said. "This is something quite new. There never were any there before. Just look, Marie, they've eaten up all your sweets."

And so it was. The epicure Mouse King did not find the marzipan altogether to his taste, but he had gnawed all around the edges, so what was left of it had to be thrown into the trash bin. Marie didn't care much about losing her sweets. She was just delighted to think that she had saved Nutcracker. But what were her feelings when, the next night, the squeaking and whistling came again close to one of her ears. Mouse King was there, with the glaring of his eyes and the whistling between his teeth even worse than the night before.

"Give me your sugar toys and dolls!" he cried. "You'd better give them to me, or else I'll chew Nutcracker into dust!" Then the gruesome mouse was gone again.

The next morning, Marie was quite depressed when she went to examine the cupboard. She had as beautiful a collection of sugar toys as any little girl

The Nutcracker and the Mouse King

175

could boast about. Not only did she have a charming little shepherd and shepherdess looking after a flock of milk-white sheep, with a nice dog jumping about them, but also two postmen with letters in their hands and four couples of handsomely dressed young gentlemen with the most beautifully dressed young ladies swinging on Russian swings. Then there were two or three dancers, and behind them, Farmer Feldkümmel with the Maid of Orleans. Marie didn't much care about them, but back in the corner there was a little baby with rosy-red cheeks, and this was Marie's darling. Suddenly, tears came to her eyes.

"Ah!" she cried, turning to Nutcracker. "I really will do all I can to help you, but it's very hard."

Nutcracker gazed at her with such a distressed look that she decided to sacrifice everything, for she pictured Mouse King with his seven mouths all wide open, ready to swallow the poor young fellow, and she could not bear abandoning him. So, that night she placed all her sugar figures in front of the cupboard, as she had done with the sweetmeats the night before. She kissed the shepherd, the shepherdess, and the lambs. Finally, she brought her most beloved, the little red-cheeked baby, from its corner, but she did put it a little farther back than the rest, while Farmer Feldkümmel with the Maid of Orleans had to stand in the front rank.

"This is really going from bad to worse," said Marie's mother the next morning. "Some nasty mouse or other must have made a hole in the glass-

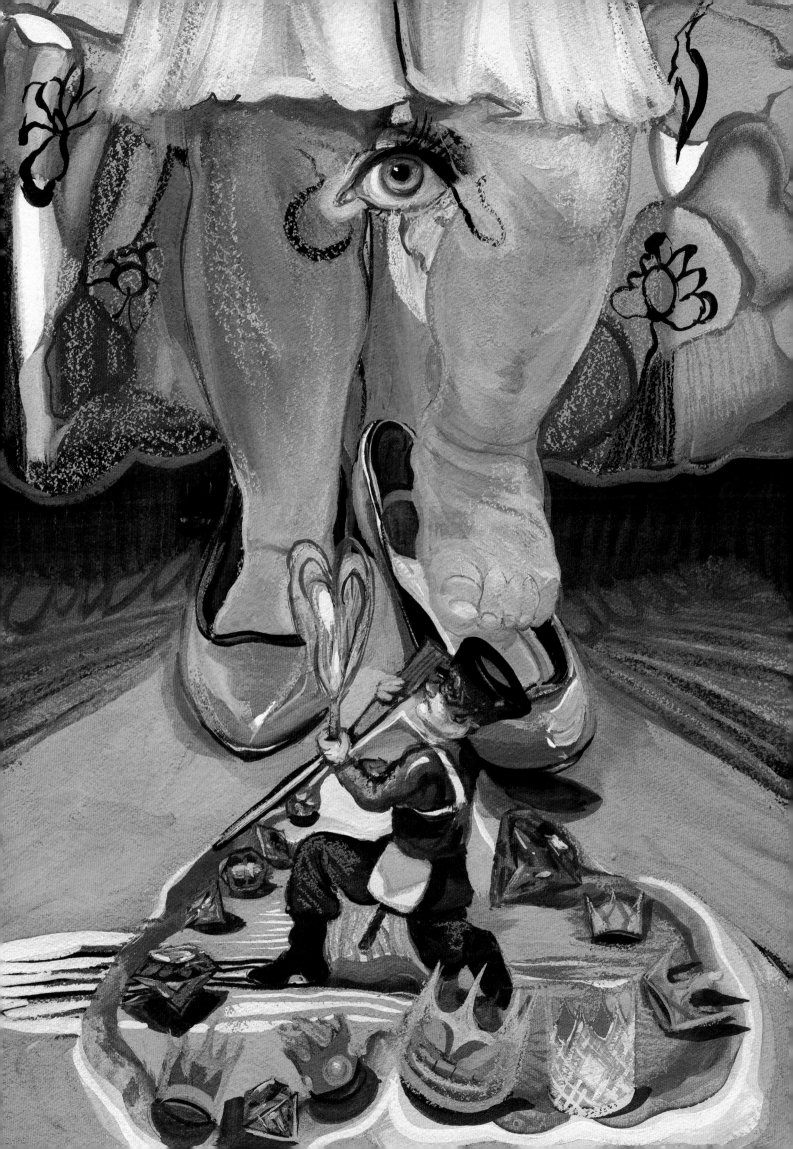

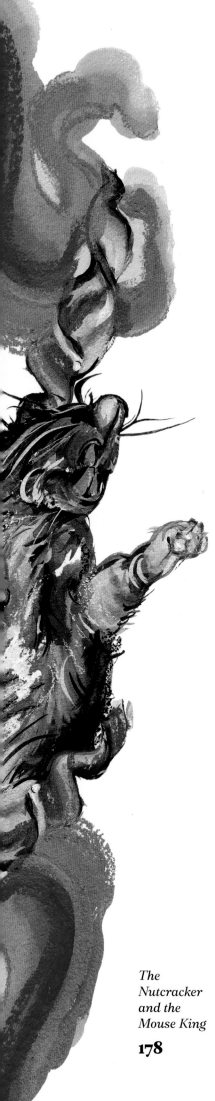

fronted cupboard, for poor Marie's sugar figures have all been eaten and gnawed."

Now Marie really could not keep back her tears. But she was soon able to smile again because she thought, "What does it matter? Nutcracker is safe."

In the evening, Marie's mother was telling her father and Godfather Drosselmeier about the mischief that some mouse was doing in the children's cupboard, and her father said: "It's a regular nuisance! What a pity it is that we can't get rid of it. This mouse is destroying all the poor child's things."

Fritz intervened and remarked: "The baker downstairs has a shrewd gray cat. I'll go and fetch him. I'm sure he'll soon put an end to it and bite the mouse's head off, whether it's Dame Mouseyrink herself, or her son, Mouse King."

"Oh, yes!" said his mother, laughing. "But the cat will jump upon the chairs and tables, knock down the cups and glasses, and do some other mischief besides."

"No, no!" answered Fritz. "The baker's cat is a very clever fellow. I wish I could walk along the edge of the roof, as he does."

"Please, let's not have a nasty cat in the house during the night," said Louise, who hated cats.

"Fritz is quite right though," their mother said. "We need to set a trap. Don't we have such a thing in the house?"

"Godfather Drosselmeier is the man to call for this task," said Fritz. "After all, he was the man who invented traps, you know."

Everybody laughed. And when their mother said they did not own such a thing, Drosselmeier said he had plenty, and he actually sent a very fine one to them that very day. Now the godfather's tale about the hard nut came to life again for Marie and Fritz. When the cook was roasting the bacon and listening to the marvels of the godfather's tale, Marie shivered and shuddered and called out to her: "Ah, take care, Queen! Remember Dame Mouseyrink and her people."

But Fritz drew his sword and cried, "Let them come if they dare! I'll give them a lesson or two!"

But everything around the hearth remained quiet and calm. As Drosselmeier was fixing the browned bacon on a fine thread and setting the trap gently down in the glass-fronted cupboard, Fritz cried: "Now, Godfather Clock-

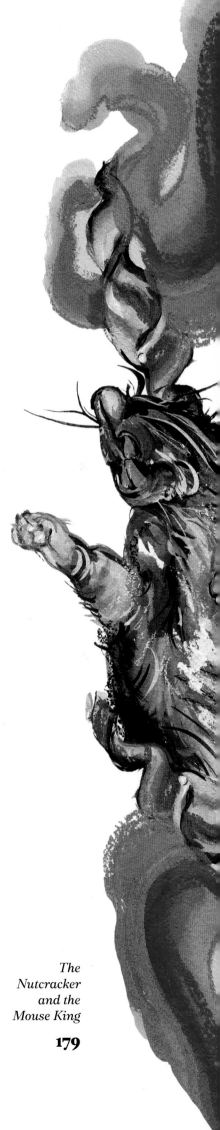

maker, be careful that Mouse King doesn't play some trick on you!"

"Ah, how terrible things were for Marie that night! Something ice cold went dribbling down her arm, and something rough and nasty laid itself on her cheek and squealed and squeaked in her ear. Horrible Mouse King came and sat on her shoulder, shot blood-red foam out of all seven of his mouths, and, munching and grinding his teeth, hissed into Marie's ear: "Hiss, hiss! Keep away—don't go in there—beware of that house—don't you be caught by a mouse—death to the mouse—hand over your picture books—none of your angry looks! Give me your dresses—also your laces—or, if you don't, I won't leave you—I won't—Nutcracker I'll bite—drag him out of your sight—his last hour is near—so tremble for fear! Hee-hee, pee-pee, queak, queak!"

Marie was overwhelmed by anxiety and sorrow and was looking quite pale and upset when her mother said to her the next morning: "This horrid mouse hasn't been caught yet. But never mind, dear, we'll catch the nasty thing! Never fear. If the traps don't do it, Fritz will fetch the gray cat."

As soon as Marie was alone, she went up to the glass-fronted cupboard and said to Nutcracker in a voice broken by sobs: "Oh, my dear, good Mr. Drosselmeier, what can I do for you, poor, unfortunate girl that I am. Even if I give that horrid Mouse King all my picture books and my new dress, which the Child Christ gave to me at Christmas, he's sure to go on asking for more. Soon I won't have anything left, and he'll want to eat me, instead of you! Oh, poor thing that I am! What shall I do? What shall I do?"

As she was crying and grieving, she noticed that a great spot of blood remained on Nutcracker's neck from the eventful night of the battle. Ever since Marie had learned that he was really young Mr. Drosselmeier, her godfather's nephew, she had given up carrying him in her arms, and stopped hugging and kissing him. Indeed, she felt somewhat sensitive and timid about touching him at all. But now she took him down carefully from his shelf and began to wipe off this blood spot with her handkerchief. Suddenly, she found that Nutcracker was growing warmer and warmer in her hand and beginning to move! Therefore, she put him back into the cupboard as fast as she could. His mouth began to wobble, and he began to whisper with great difficulty.

"Ah, dearest Miss Stahlbaum, most precious of friends! How deeply I am

The Nutcracker and the Mouse King

179

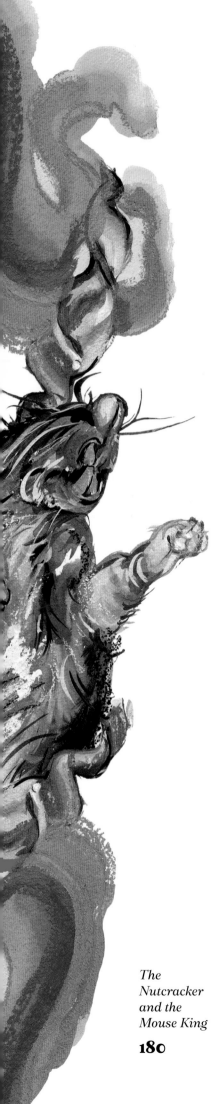

indebted to you for everything! But please don't sacrifice any of your picture books or pretty dresses for me. Just get me a sword! A sword is what I want. If you get me that, I'll manage the rest, though he may . . ."

Here, Nutcracker's speech died away, and his eyes, which had been expressing the most sympathetic grief, now turned melancholy and lifeless again. However, Marie felt no fear. Rather, she jumped for joy now that she knew how to help Nutcracker without further painful sacrifices. But where on earth was she to get hold of a sword for him? She decided to consult Fritz, and that evening, when their father and mother had gone out, and the children were sitting beside the glass-fronted cupboard, Marie told him what had happened between her and Nutcracker and Mouse King. In particular, she explained to him what it would take to rescue Nutcracker. Yet, the thing that constantly occupied Fritz's mind was Marie's statement about the poor conduct of his red hussars in the great battle. He asked her once more, most seriously, to verify if it really was the truth, and after she repeated her statement on her word of honor, he went to the glass-fronted cupboard to give a grand speech to his hussars, and as a punishment for their bad behavior, he solemnly took the plumes, one by one, out of their caps and banned them from playing the march of the hussars of the guard for one year. After he had berated his soldiers, he turned to Marie and said: "As far as the sword is concerned, I certainly can assist Nutcracker. Yesterday, I placed an old colonel of the cuirassiers on retirement with a pension. So, he has no further need for his saber, which is sharp."

Now this colonel had settled down with his pension in the back corner of the third shelf of the cupboard. Fritz immediately fetched him from there and took off his saber, still a bright and handsome silver weapon, and hung it on Nutcracker.

The following night, Marie was so anxious that she couldn't sleep. About midnight, she thought she heard a strange stirring and noise in the sitting room. Then, there was a rustling and a clanging, and all at once came a shrill squeak. "Mouse King! Mouse King!" she cried and jumped out of bed filled with terror. Then, everything was silent. Soon there was a gentle tapping at the door of her room and a soft voice could be heard: "Please do not worry about opening your door, dearest Miss Stahlbaum! Do not be alarmed in the slightest. I have some good and happy news for you."

It was Drosselmeier's voice, that is, young Drosselmeier's voice. So, she

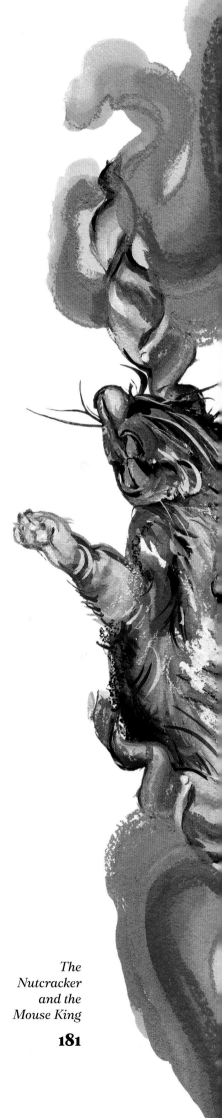

threw on her dressing gown and opened the door as quickly as possible, and there stood Nutcracker with his sword, all covered with blood, in his right hand, and a little wax candle in his left hand. As soon as he saw Marie, he knelt down on one knee and said: "It was you, and only you, dearest lady, who inspired me with chivalrous courage and steeled me with knightly strength to do battle with the insolent rogue who dared insult you. Treacherous Mouse King has been vanquished and lies in his own gory blood. Therefore, I beg you, my lovely lady, to accept these tokens of victory from the hand of he who will be your true and faithful knight until death."

Upon saying this, Nutcracker took the seven crowns of Mouse King, which he had arranged on his left arm, and handed them to Marie, who gladly received them.

Then Nutcracker stood up and continued as follows: "Oh, my dearest and beloved Miss Stahlbaum, if you would only deign to take the trouble to follow me for a few steps, I can show you glorious and beautiful things from the supreme moment when I overcame my eternal foe! Please do come with me, dearest lady! Do come!"

The Kingdom of Dolls

I am quite convinced, children, that none of you would have hesitated for a moment to accompany the kind Nutcracker, who had always shown himself to be such a fine and worthy person. As for Marie, she was all the more disposed to go with him because she believed his gratitude to be true and was sure that he would keep his word and show her all sorts of beautiful things. Therefore, she said: "I shall go with you, dear Mr. Drosselmeier, but it can't be very far, and I can't stay very long because, you know, I didn't get much sleep last night."

"Then we shall take the shortest route," Nutcracker responded, "although it is, perhaps, the most difficult."

So, he took the lead, followed by Marie, and walked until he stopped before the big old wardrobe. Marie was surprised, and wondered why. Though the doors were generally closed, they were now wide open, so Marie could see her father's traveling cloak of fox fur hanging in the front. Nutcracker climbed deftly up the edges and trimmings of the cloak to get hold of the big tassel

that was fastened at the back by a thick cord. He gave this tassel a tug and a pretty, little ladder made of cedar wood dropped quickly through one of the arm holes of the cloak.

"Now, Miss Stahlbaum, please climb that ladder, if you will be so kind," Nutcracker said.

Marie did so, but as soon as she managed to get through the arm hole and began looking out at the neck, a dazzling light came streaming toward her, and she found herself standing on a lovely fragrant meadow from which millions of sparks were streaming upward, like beautiful sparkling gems.

"This is Candy Meadow," Nutcracker said. "But now we'll pass through that gate there."

Marie looked up and saw a beautiful gateway on the meadow only a few steps away. It seemed to be made of white and brown marble, but when she came closer, she saw it was made of baked sugar almonds and raisins, which, as Nutcracker explained when they were going through it, was the reason it was called "Almond and Raisin Gate." A gallery, apparently made of barley sugar, ran around the upper part of the gate, and in this gallery six monkeys dressed in red doublets were playing on brass instruments in the most delightful manner. Indeed, Marie was overwhelmed by the realization that what appeared to be a beautiful, variegated pavement was actually a mosaic of lozenges of all colors. Soon the sweetest fragrances came streaming from little beautiful forests on both sides of the grove. There was such a glittering and sparkling from within the dark foliage that one could discern gold and silver fruits hanging on various tinted stems, and these stems and branches were ornamented and dressed up with ribbons and bunches of flowers, like brides and bridegrooms and festive

The Nutcracker and the Mouse King

182

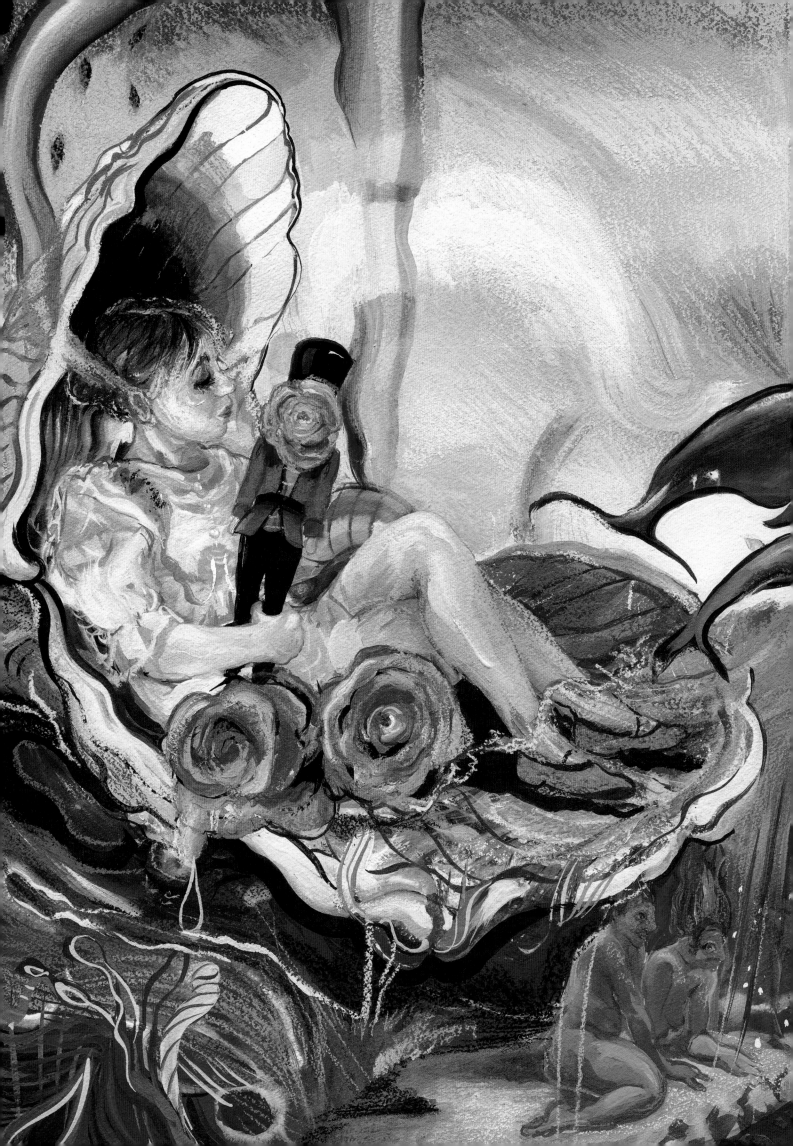

wedding guests. When the citrus fragrance billowed as if on the wings of gentle zephyrs, there was a humming among the leaves and branches, and the gold leaves and tinsel rustled and tinkled like beautiful music, causing the sparkling lights to dance.

"Oh, how charming this is!" cried the enraptured Marie.

"This is Christmas Forest, dearest Miss Stahlbaum," Nutcracker explained.

"Ah!" said Marie. "If I could only stay here for some time! Oh, it is so lovely!"

Nutcracker clapped his hands, and immediately a number of little shepherds, shepherdesses, hunters, and huntresses appeared. They were so white and delicate that you would have thought they were made of pure sugar. Marie had not noticed them before, even though they had been walking around in the forest. They brought a beautiful gold reclining chair and placed a white satin cushion in it. Then they politely invited Marie to take a seat. As soon as she did, the shepherds and shepherdesses danced a pretty ballet, while the hunters and huntresses played music on their horns. Then they all disappeared into the thickets.

"I must apologize for the poor style in which this dance was performed, dearest Miss Stahlbaum," said Nutcracker. "The dancers belong to our marionette troupe and can only do the same thing over and over again. There are also good reasons why the hunters were so feeble in their blowing. The sugar basket is hanging too low and at nose level. Next time it will be better. But shouldn't we now move on?"

"Oh, believe me, it was all very delightful. I enjoyed it immensely!" said Marie, as she stood up and followed Nutcracker, who was leading the way. Next, they walked along a gentle rippling brook, which seemed to be producing magnificent odors that permeated the forest.

"This is Orange Brook," Nutcracker said. "It has a lovely, sweet scent, but it is nothing like Lemonade River, a beautiful broad river, which empties into Almond Milk Sea, as this one also does."

Indeed, Marie soon heard a loud splashing and rushing, then caught sight of Lemonade River, which rolled along in swelling, yellowish waves between banks covered with an herbage and underwood that shone like green carbun-

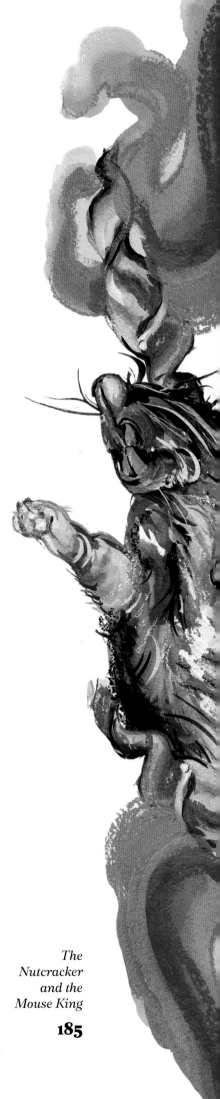

cles. A remarkable freshness that emanated from this fine river cooled Marie's heart and breast. Nearby, a dark yellow stream crept sluggishly along, emitting a most delicious odor. On its banks sat numerous pretty children, fishing for fat little fish, which they ate as soon as they caught them. When she came closer, Marie saw that these fish looked very much like hazelnuts. A short distance farther a nice little village stood on the banks of this river. The houses of this village, the church, the parsonage, and the barns were all dark brown with golden roofs, and many of the walls looked as if they were plastered over with lemon peels and shelled almonds.

"That is Gingerbread Home on the Honey River," Nutcracker said. "It is famous for the good looks of its inhabitants, but they are very grumpy people because they suffer so much from toothaches. So, we won't go there for the time being."

Just then, Marie caught sight of a little town where the houses were painted in all sorts of colors, quite transparent, and exceedingly pretty. Nutcracker went on toward this town, and Marie heard joyful sounds and an uproar and saw some thousands of little folk unloading a number of wagons that were standing in the marketplace. It looked like they were unloading packages of colored paper and chocolate bars.

"This is Bonbonville," Nutcracker related. "An ambassador has just arrived from Paperland and the King of Chocolate. These poor Bonbonville people have been terribly threatened lately by Admiral Mosquito's forces. This is why they are covering their houses with their gifts from Paperland and constructing fortifications with the fine pieces of workmanship that King of Chocolate has sent them. But, oh! Dear Miss Stahlbaum, we are not going to restrict ourselves just to touring the small towns and villages of this country. Let us be off to the capital. To the capital!"

Now Nutcracker rushed onward, and Marie followed him with great expectation. Soon she smelled a beautiful rosy fragrance that suffused everything with a soft, shimmering splendor. She saw that this was the reflection in rosy-red shining water that went splashing and rushing away in front of them in wavelets of roseate silver. And the loveliest swans, white as silver and with gold collars, floated on this delightful water, which kept getting wider and wider like a great lake. As if vying with each other, the swans were singing the most

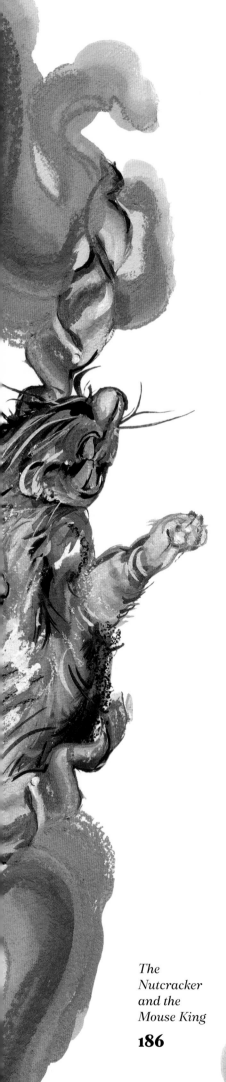

beautiful songs, and little fish, glittering like diamonds, danced up and down in the rosy ripples.

"Oh!" Marie cried in great delight. "This must be the lake that Godfather Drosselmeier was once going to make for me, and I was to be the girl who played with the swans."

Suddenly, Nutcracker smirked in a way that Marie had never seen him do before and said, "My uncle could never make a thing like this. You would be much more likely to do it yourself. But don't let us bother about that. Instead, let's cross Lake Rosa and head to the capital."

The Capital

Nutcracker clapped his little hands again, and the waves of Lake Rosa began to rush louder and louder and splash higher and higher. Marie became aware of a boat approaching from the distance. It was made wholly of glittering precious stones of every color and drawn by two dolphins covered with gold. When the boat landed, twelve strong little natives with headdresses and doublets made of hummingbird feathers woven together jumped out and gently carried first Marie and then Nutcracker into the boat, which immediately began to move along and over the lake on its own accord. Oh! How beautiful it was to see Marie sailing over the water in the shell-shaped boat with fragrant roses and the rosy waves splashing all around her. The two golden dolphins lifted their nostrils and sent streams of crystal high into the air, and as the flakes fell down in glittering rainbows, she could hear two delicate, silvery voices singing: "Who is sailing over the rosy sea? Fairy is she. Bim-bim-bee—swim-swim-swans—tra-la-la—golden birds; tra-trah, rosy waves, wake you, and sing, sparkle and ring, sprinkle and clink—this is the fairy we long to see—coming at last to us over the sea. Rosy waves dash—bright dolphins play—merrily, merrily—can't you see?"

Nutcracker and Marie suddenly heard strange voices that seemed to be floating both in the water and in the air. However, Marie paid no attention to them, and instead went on looking into the gentle and fragrant rosy waves and was somewhat astonished when a pretty girl's face smiled back at her.

"Oh! Look at Princess Pirlipat!" Marie cried. "She's clapping her hands with joy and smiling at me so charmingly down there! Do look at her, Mr. Drosselmeier!"

However, Nutcracker sighed almost sorrowfully and said: "That's not Princess Pirlipat, dearest Miss Stahlbaum. It is only yourself, always your own lovely face smiling from the rosy waves."

Upon hearing this, Marie quickly drew her head back, closed her eyes as tightly as she could, and was terribly ashamed. But just then, the twelve little natives lifted her out of the boat and set her ashore. Then, she found herself in a small thicket, almost more beautiful than Christmas Forest. Everything glittered and sparkled, and the fruit on the trees was extraordinarily delicious and beautiful. Not only did the fruit have a great variety of colors, but they were quite pungent.

"Ah!" said Nutcracker. "Here we are in Jelly Grove, and over there you can see the capital."

How shall I begin describing all the wonderful and exotic sights that Marie now saw? How can I give you an idea of the splendor and magnificence of the city that lay stretched out before her on a flowery plain? Not only did the walls and towers shine in the brightest and most gorgeous colors in the world, but the shapes and appearances of the buildings were like nothing to be seen on earth. Instead of roofs, the houses sported beautiful crowns, and the towers were decorated with splendid gilding, sculpted and carved into exquisite, intricate designs. As they passed through the gateway, which looked as if it were made entirely of macaroons and sugared fruits, silver soldiers presented arms, and a little man in a brocaded robe embraced Nutcracker and cried: "Welcome, dearest prince! Welcome to Sweet Jamburg!"

Marie was not a little surprised to see such a grand personage address young Drosselmeier as a prince. But then, she heard numerous delicate voices rejoicing with boisterous greetings and talking. Indeed, there was such a laughing and chattering and such a singing and playing that she couldn't pay attention to anything else. Immediately, she asked Drosselmeier what was the meaning of it all.

"Oh, it is nothing uncommon, dearest Miss Stahlbaum," he answered. "Sweet Jamburg is a large, populous city, full of mirth and entertainment. This

is only the usual thing that happens here every day. But, please, let us keep walking."

After they had walked a few paces more, they reached the great marketplace, which offered an astonishing view. All the surrounding houses were made of sweets, and a lofty cake covered with sugar towered above the galleries. There was an obelisk surrounded by fountains spouting lemonade and other delicious drinks high into the air. The basins that ran alongside the pathways were full of creams, which could have been spooned out right away.

But loveliest of all were the thousands of delightful little people, who formed crowds, shouting, laughing, playing, and singing. In short, they were producing all that merry uproar that Marie had heard from the distance. There were beautifully dressed ladies and gentlemen—Greeks and Armenians, Tyrolese and Jews, officers and soldiers, clergymen, shepherds, and clowns. In short, people of every conceivable kind in the world were celebrating. The tumult grew louder in one of the corners. The people streamed all over the place, for the Great Mogul happened to be passing through there in his litter, attended by ninety-three grandees of the realm and seven hundred servants. Just at the same time, the Fishermen's Guild, about five hundred strong, happened to be holding a festival at the opposite corner of the marketplace, and it was rather an unfortunate coincidence that the Grand Turk decided then and there to go out for a ride and cross the square with three thousand janissaries. And, as if this were not enough, the grand procession of the opera "The Interrupted Sacrificial Feast," came along at the same time, marching up toward the obelisk

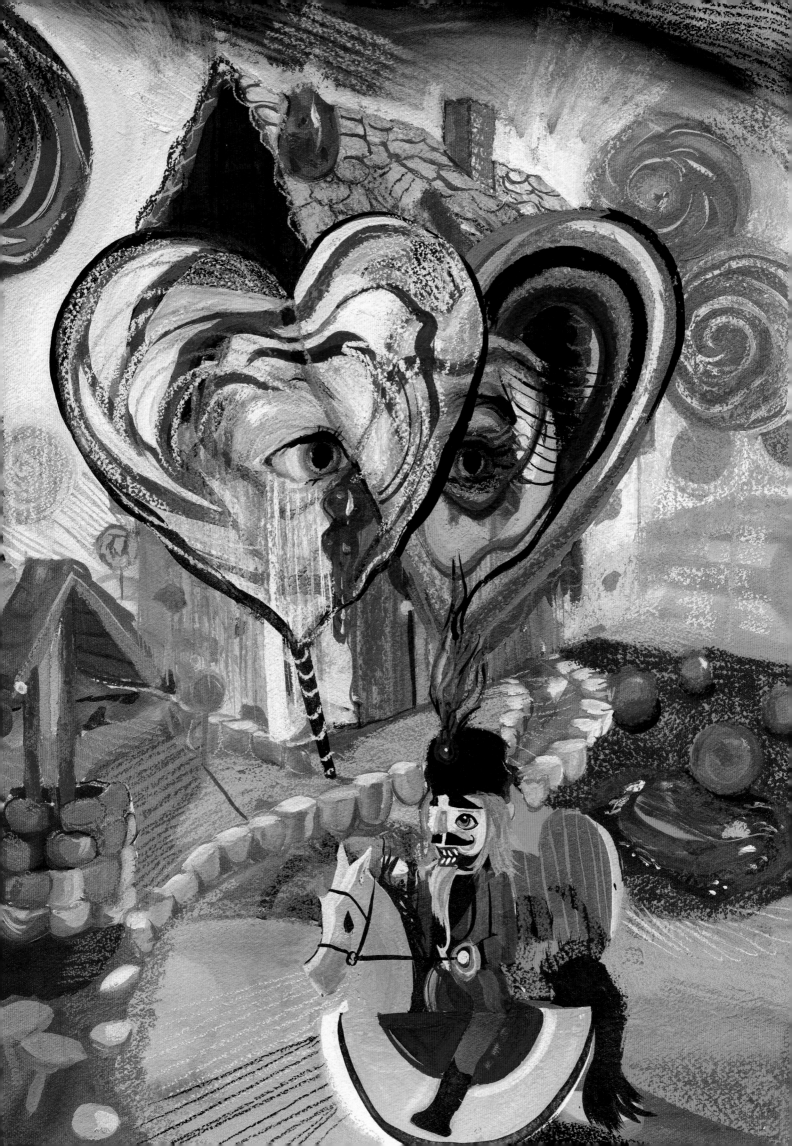

with a full orchestra playing, and the chorus singing: "Hail! All hail to the glorious sun!"

So, there was a pushing and a shoving, a screaming and a squeaking, and soon grieving voices arose and cries of pain, for one of the fishermen had knocked a Brahman's head off in the crowd, and the Great Mogul had been very nearly run over by a clown. The noise grew wilder and wilder. The people who had been shoving one another soon came to fisticuffs. Then the man in the brocade robe, who had welcomed Nutcracker as prince at the gate, climbed up to the top of the obelisk, rang a booming bell three times, and yelled: "Chef! Chef! Chef!"

The tumult subsided. The people tried to save themselves as quickly as they could, and, after the entangled processions had been untangled, the dirt was brushed off the Great Mogul and the Brahman's head was stuck on again. Then, the merry celebration resumed just the same as before.

"Tell me why that gentleman yelled 'Chef,' Mr. Drosselmeier. Please, Mr. Drosselmeier."

"Ah! Dearest Miss Stahlbaum," Nutcracker said, "in this kingdom *chef* means a certain unknown and very terrible power, which, it is believed, can treat people just as it wants to do. It represents fate, or destiny, which governs these happy little people, and they stand in such awe and terror of it that the mere mention of its name quells the wildest tumult in a second, as the mayor has just shown. Everyone stops thinking about earthly matters, pokes in the ribs, concussions, or the like. Everyone retires within himself and asks: 'What is man? What is his ultimate destiny?'"

Marie could not stop herself from displaying admiration and utmost astonishment, as she now found herself suddenly standing before a rose red, glistening castle with a hundred beautiful towers. Here and there at intervals upon its walls were rich bouquets of violets, narcissus, tulips, and carnations, whose dark, glowing colors heightened the dazzling whiteness of rose-colored walls. The great dome of the central building, as well as the pyramidal roofs of the towers, were all covered with thousands of sparkling gold and silver stars.

"Aha!" Nutcracker declared. "We've finally made it to Marzipan Castle!"

Marie was completely absorbed in viewing this magical palace, but it did not escape her that the roof of one of the huge towers was missing, and that little

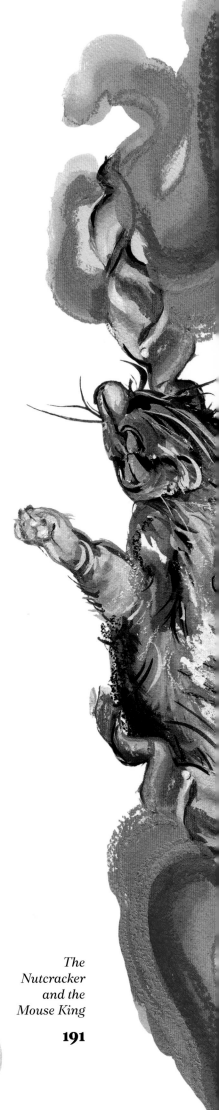

men, who were up on a scaffold made of cinnamon sticks, were busy putting it on again. But before she had time to ask Nutcracker about this, he said: "A short time ago, this beautiful castle was threatened by tremendous destruction, if not devastation. Sweettooth, the giant, happened to be passing by one day, and he bit off the top of that tower there and was beginning to gnaw at the great dome. But the people of Jamburg brought him a whole section of the town along with a considerable slice of Comfit Grove as a tribute. After he devoured these gifts, he went on his way."

Nutcracker had told this brief story while beautiful music could be heard. Out came twelve little pages holding clove stems, like torches, with their little hands. Each of their heads was a pearl. Their bodies were emeralds and rubies, and their feet were beautifully designed in pure gold. After them came four ladies about the size of Marie's Miss Clara, but so gloriously and brilliantly dressed that Marie saw in a moment they could be nothing but princesses of royal blood. They embraced Nutcracker most tenderly, shed happy tears, and exclaimed: "Oh, dearest prince! Beloved brother!"

Nutcracker seemed to be deeply touched. He wiped away the tears that flowed thick and fast, then he took Marie by the hand and said with great pathos and solemnity: "This is Miss Marie Stahlbaum, daughter of a most worthy medical councilor, and the protector of my life. If she had not thrown her slipper just in the nick of time, and if she had not obtained the pensioned colonel's sword, I would be lying in my cold grave at this moment, bitten to death by the accursed Mouse King. So, I ask you to tell me candidly, can Princess Pirlipat, though she may be a princess, compare for a moment with Miss Stahlbaum in beauty, in goodness, in virtues of every kind? My own answer is emphatically, No!"

In response, all the ladies shouted: "No!" And, with sobs and tears, they hugged Marie's neck and cried: "Oh, noble savior of our beloved royal brother! Excellent Miss Stahlbaum!"

They now conducted Marie and Nutcracker into the castle to a hall whose walls were composed of sparkling crystal. But what delighted Marie most of all was the furniture. There were the most darling little chairs, bureaus, writing tables, dressers, and secretaries, standing about everywhere, all made of ce-

The Nutcracker and the Mouse King

191

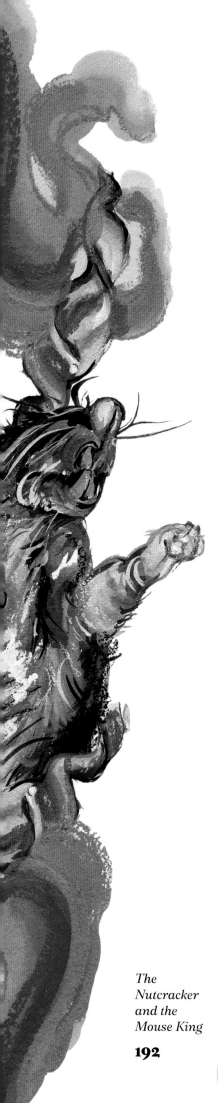

dar or brazilwood and covered with golden flowers. The princesses made Marie and Nutcracker sit down and said they would prepare a banquet. So, they fetched a huge number of little cups, dishes made of the finest Japanese porcelain, spoons, knives and forks, graters and stew pans, and other kitchen utensils made of gold and silver. Then they brought the most delightful fruits and sweets that Marie had ever seen in her life, and they began to squeeze the fruit in the daintiest way with their little hands. After doing this, they grated the spices and rubbed down the sugar almonds. In short, they worked so skillfully that Marie could see how accomplished they were in kitchen matters. What a magnificent banquet this was going to be!

Knowing her own skill in cooking and baking, Marie wished with all her heart that she might be allowed to help the princesses and play a role in the preparations for the banquet. Just then, as if she had read Marie's wishes, the prettiest of Nutcracker's sisters handed her a little gold mortar and pestle.

"Sweet friend," she said, "dear preserver of my brother, would you mind just pounding a little of this sugar candy?"

As Marie pounded with the pestle, which she did with the utmost enjoyment, her pounding produced a sound like a lovely song. In the meantime, Nutcracker relayed in great detail everything that had happened during the terrible battle between his forces and Mouse King's army. In particular, he revealed how he had received the worst of it due to the poor behavior of his troops, and how the horrible Mouse King had all but bitten him to death, so Marie had to sacrifice a number of the subjects who were in her service. During all this, it seemed to Marie that what Nutcracker was saying—and even the sound of her own pestle—kept growing more and more faint and hazy. Soon she saw a silver mistiness rising up like clouds in which the princesses, the pages, Nutcracker, and she herself were floating. Then a curious singing, buzzing, and humming began, which seemed to die away in the distance. Finally, Marie felt herself rising up—up—up, as if on waves, constantly rising and swelling higher and higher, higher and higher, higher and higher.

The Nutcracker and the Mouse King

Conclusion

All of a sudden, "bam! bam!" resounded, and Marie fell down from some immeasurable height with a crash and a tumble! Once she opened her eyes, she realized she was lying in her own bed, and it was broad daylight. Her mother was standing at her bedside and commented: "Well, what a sleepy head you are! Breakfast has been ready for quite a while!"

Of course, dear readers, you know what happened. Marie had seen and been amazed by all the wonderful things she experienced in Jamburg. Confounded and amazed, she had fallen asleep at last in Marzipan Castle. Then the Moors or the pages, perhaps even the princesses themselves, had carried her home and put her to bed.

"Oh, Mamma, dear Mamma," Marie exclaimed. "What a number of places young Mr. Drosselmeier has shown me during the night, and what beautiful things I have seen!"

And she gave a very detailed account of everything she experienced just as I have done. As her mother listened, she looked at her in astonishment, and after she had finished, she said: "You have had a long, beautiful dream, Marie, but now you must put it all out of your head."

Marie firmly maintained that she had not been dreaming at all. So, her mother took her to the glass-fronted cupboard, lifted Nutcracker from his usual position on the third shelf, and said: "You silly girl, how can you believe that this wooden figure can come to life and walk about?"

"Ah, Mamma," answered Marie, "I know perfectly well that Nutcracker is Godfather's nephew from Nürnberg."

Upon hearing this reply, her father and mother both burst out into laughter.

"It's all very well for you to laugh at poor Nutcracker, Pappa," Marie responded, almost weeping, "but he spoke very highly of you. When we arrived at Marzipan Castle, and Nutcracker introduced me to his sisters, all beautiful princesses, he said you were a most worthy medical councilor."

The laughter grew louder, and Louise and Fritz joined in the fun. Then Marie ran into the next room, took Mouse King's seven crowns from her little box, and handed them to her mother, saying: "Look here, dear Mother. These

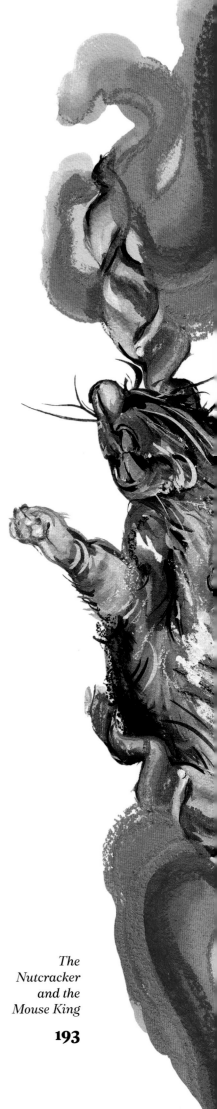

are Mouse King's seven crowns, which young Mr. Drosselmeier gave me last night as a proof that he had defeated our mortal enemy!"

Her mother gazed in amazement at the little crowns, which were made of some brilliant, wholly unknown, metal and designed more beautifully than any human hands could have done. Likewise, Dr. Stahlbaum could not stop gazing at them with admiration and astonishment, and both Marie's father and mother urged Marie most earnestly to tell them where she really had obtained them. But she could only repeat what she had said before. And when her father scolded her and accused her of lying, she began to weep bitter tears and said: "Oh, dear me! I'm only telling you the truth, poor unfortunate girl that I am!"

Just at this moment, the door flew open, and Godfather Drosselmeier entered. "Hello! Hello! What's all this? My little Marie crying!? What's all this about?"

Then, Dr. Stahlbaum immediately informed him about everything that had happened and showed him the gold crowns. As soon as Drosselmeier looked at them, however, he cried out: "Stuff and nonsense! Stuff and nonsense! These are the crowns I used to wear on my watch chain. I gave them as a present to Marie on her second birthday. Do you mean to tell me you don't remember?"

None of them did remember anything of the kind. But seeing that her father and mother's faces were friendlier, Marie ran up to her godfather and said: "You know all about this, Godfather! Please tell them and let them know from your own lips that my Nutcracker is your nephew, young Mr. Drosselmeier from Nürnberg, and that it was he who gave me the crowns."

But Drosselmeier made a very angry face and muttered: "Stupid stuff and nonsense!"

Quickly but gently, Marie's father pulled her in front of him and spoke very earnestly: "Now, just look here, Marie, let there be an end to all this foolish trash and absurd nonsense for once and for all! I'm not going to allow any more of it, and if ever I hear you say again that this idiotic, deformed Nutcracker is your godfather's nephew, I shall throw not only Nutcracker, but all your other toys and dolls—Miss Clara included—out of the window!"

Now, of course, poor Marie did not dare utter another word about all the wonderful adventures she had had. You may well suppose that it was impossi-

ble for anyone who had experienced all that she had to ever forget it. And I regret to say that even Fritz himself turned his back on his sister at once whenever she wanted to talk to him about the wondrous realm in which she had been so happy. Indeed, he is said to have frequently murmured "Stupid goose!" between his teeth, though I do not think at all that this was compatible with his kind heart. But this much, however, is certain. He no longer believed what his sister said, and he now formally recanted at a public display of his soldiers what he had said to his red hussars, and in place of the plumes he had taken away from them, he gave them much taller and finer ones of goose quills and allowed them to play the march of the hussars of the guard as they had done before.

Marie did not dare say anything more about her adventures. But the memories of that fairy realm were unforgettable, and the lovely music of that delightful happy country still rang sweetly in her ears. Whenever she allowed her thoughts to dwell on all those glorious days, she would envision them again, and so it came about that, instead of playing as she used to do, she sat quietly and meditatively absorbed within herself. Everybody found fault with her for being such a little dreamer. This is the name that they called her.

Now, it happened one day that Godfather Drosselmeier was repairing one of the clocks in the house, and Marie was sitting next to the glass-fronted cupboard, immersed in her dreams and gazing at Nutcracker. All at once, she blurted out: "Ah, dear Mr. Drosselmeier, if you really were alive, I wouldn't be like Princess Pirlipat and despise you because you had to give up being a nice handsome gentleman for my sake!"

"Stupid stuff and nonsense!" cried Godfather Drosselmeier.

But, as he spoke, there was a tremendous bang and shock so that Marie fainted and fell from her chair. When she regained consciousness, her mother was busily caring for her and said: "How could you tumble out of your chair that way, a big girl like you? Godfather Drosselmeier's nephew has just arrived from Nürnberg. See if you can behave!"

Marie looked up. Her godfather was wearing his yellow coat and his glass wig and was smiling. He was in his best mood, and was holding a small but very handsome young gentleman by his hand. His little face was rosy red, and

he was wearing a beautiful red coat trimmed with gold lace, white silk stockings and shoes, and a lovely bouquet of flowers in his shirt frill. He was nicely groomed and powdered and had a magnificent queue hanging down his back. The little sword at his side seemed to be made entirely of glistening jewels that sparkled, while the little hat under his arm was woven of flocks of silk. He gave proof of his fine manners by bringing a quantity of the most delightful toys for Marie. Many were the very same figures that Mouse King had devoured. Moreover, he brought a beautiful saber for Fritz and cracked nuts at the table for the whole party. Indeed, the very hardest nut could not withstand him. He placed them in his mouth with his left hand, tugged at his pigtail with his right, and "crack!" they fell in pieces.

Marie grew red as a rose at the sight of this charming young gentleman, and she grew redder still when, after dinner, young Drosselmeier asked her to go with him to the glass-fronted cupboard in the sitting room.

"Play nicely together, children," said Godfather Drosselmeier. "I don't mind your playing now that my clocks are all in order."

But as soon as young Drosselmeier was alone with Marie, he went down on one knee and said, "Ah! My most dearly beloved Miss Stahlbaum! You see at your feet the fortunate Drosselmeier, whose life you saved here on this very spot. You were kind enough to say, plainly and unmistakably, in so many words, that you would not have despised me, as Princess Pirlipat did, if I had been turned into an ugly creature for your sake. Immediately, I stopped being a contemptible Nutcracker and resumed my previous form, with good looks.

"Ah! Most exquisite lady! Bless me with your precious hand. Share with me my crown and kingdom and reign with me in Marzipan Castle, for I am now king of this country."

Marie raised him and said gently: "Dear Mr. Drosselmeier, you are a kind and handsome gentleman, and since you reign over a delightful country of charming, funny, and handsome people, I accept your hand."

And so they were then formally betrothed. And when a year and a day had come and gone, they say he came and took her away in a golden coach, drawn by silver horses. At their marriage, twenty-two thousand of the most beautiful dolls and figurines, all glittering in pearls and diamonds, danced away the night, and to this day Marie is the queen of a realm where all kinds of sparkling Christmas forests and transparent marzipan castles, and all the most wonderful and beautiful things of every kind are to be seen by those who have the eyes to see them.

The Mystifying Child

Baron von Brakel of Brakelheim

ONCE UPON A TIME there was a noble gentleman called Baron Thaddeus von Brakel. He lived in the tiny village of Brakelheim, which he had inherited from his deceased father, old Baron von Brakel. Consequently, it became his property. The four farmers, who were the only other inhabitants of the village, called him "Your Lordship," although he was just like they were themselves. He went about his work with messy hair, and he dressed up only on Sundays. That was always the day when he went to church in the neighboring town with his wife and two children, whose names were Felix and Christlieb. That was also the day when he replaced his coarse cloth jacket, which he wore at other times, with a fine green coat and a red vest with a gold braid that suited him nicely.

197

Whenever anyone happened to inquire, "Could you please show me the way to Baron von Brakel's home?" the farmers usually replied: "Go straight through the village and up the hill where those birches are standing. That's where you'll find his lordship's castle."

Now, everybody knows that a castle is large and lofty, with many windows and doors, to say nothing of towers and glittering weathercocks, but there wasn't anything like this on the hill where the birches were. The only thing that could be seen there was a small, ordinary house with several little windows, and you could hardly see anything of the house until you were nearby. Now, generally speaking, in front of a grand castle there is a portal where you are supposed to stop and from which icy air streams out and you are glared at by the lifeless eyes of strange sculpted statues fixed on the walls like fearful mean guards challenging people to turn away. But this is by no means the case with regard to Baron von Brakel's home. First of all, as soon as you come to the beautiful, graceful birches, they bend their leafy branches like arms stretching out to greet you, and their rustling leaves whisper, "Welcome, welcome to you all!" And, after you reach the house, it seems as if charming voices are calling you from the bright windows in sweet, soothing tones and from everywhere among the thick, dark leafage of the vine that covers the walls up to the roof you hear: "Come, come, and take a rest here, dear weary wanderer. We shall make you comfortable and show you hospitality." Indeed, the swallows also confirm this by twittering merrily in and out of their nests, and the stately old stork looks down gravely and wisely from the chimney and says: "I have spent my summers in this place now for many and many a year, and I know no better lodging in all the world. If it were not for my great and innate love of travel, which I can't control, and if it were not so very cold here in the winter and if the forest were not so costly, I would never stir from the spot." So, although Baron von Brakel's house was not a castle, it was charming and delightful.

The Grand Visit

Early one morning, Lady von Brakel stood up and baked a cake. In the process, she put a great many more almonds and raisins into it than she had done with her Easter cake. This is the reason why it had a much more delicious odor

than the other had. While this was in progress, Baron von Brakel thoroughly dusted and brushed his green coat and his red vest, and Felix and Christlieb were dressed in the very best clothes they owned.

"You are not to run around in the forest to-day as you generally do," the baron said to them. "Instead, you are to sit still in the room so that you may look neat and clean when your grand and benevolent uncle arrives!"

The sun was by now bright and smiling through the clouds and beaming golden rays through the window, while out in the forest there was an early morning breeze. The finches and the nightingales were all rejoicing together and warbling the loveliest songs in chorus. Christlieb sat silently at the table, deep in thought. Now and then she smoothed and arranged the bow of her pink sash, while she also busily tried to continue her knitting, which somehow was causing her difficulties that morning. Meanwhile, Felix, who had been given a fine picture book by the baron, did not read at all. Instead, he looked over the tops of the pages toward the beautiful birch trees, where he would run and jump about to his heart's content for an hour or two every other morning but this.

"Oh! Isn't it beautiful out there!" he sighed to himself. To make matters worse, the big yard dog, named Sultan, came barking and leaping in front of the window. Then he dashed away a short distance in the direction of the forest and ran back again, barking and growling, as if he were asking Felix, "Aren't you coming to the forest today? What on earth are you doing in that stuffy room?"

Felix became impatient and could not restrain himself anymore, so he cried out to his mother, "Dear Mama, please let me go out for a little while!"

But Lady von Brakel answered, "No, no, stay in the room, like a good boy! I know very well what will happen if you go. Then Christlieb will want to go, too, and you'll both scamper away helter-skelter through the bushes and briar, and you'll climb the trees. Later you'll return, all hot and dirty, and your uncle will say: 'What kind of ugly peasant children are these? Brakel children are never to look like that, whether big or little.'"

Felix slammed the book shut in a rage and, as tears of disappointment came into his eyes, said, "If our grand uncle talks about ugly peasant children, I'm sure he has never seen Peter Vollrad or Annie Hentschel, or any of the other children in the village here. There aren't any more beautiful children in the world than here!"

The Mystifying Child

199

"I'm sure of that," said Christlieb, as if suddenly waking from a dream. "And isn't Maggy Schulz a beautiful child, too, even if she doesn't have anything as pretty as the ribbons I have."

"Don't talk such stupid nonsense," their mother said. "You don't understand what your uncle means to us."

Why on this of all days, the children argued, when it was so glorious outside, did they have to stay inside because of the uncle? Yet, their arguments were in vain. Felix and Christlieb had to stay in the room, and this was all the more painful because the cake, which was sitting on the table to honor the grand visitor, spread the most delicious odors, and yet, it could not be cut and served until their uncle arrived.

"Oh! If he would only come! If he would only come!" both children cried, and they almost wept with impatience. At last, they heard a vigorous tramping of horses, and a carriage appeared. It was so bright and so richly covered with golden ornaments that the children were amazed, for they had never seen anything like it before. A tall and very gaunt man, helped by the arm of the footman, who opened the carriage door, glided into the arms of Baron von Brakel, whose cheek he gently kissed two times and whispered softly, "Bonjour, my dear cousin. Now, no ceremony, I implore!"

Meanwhile, the footman had also helped a short, stout lady with very red cheeks and two children, a boy and a girl, slide down from the carriage with great dexterity so that each of them landed softly on the ground. After they were all thus safely deposited, Felix and Christlieb came forward, as they had been duly prepared by their mother and father to do. Then they each seized a hand of the tall, haggard man, which they kissed, and said, "We are very glad you have come, noble uncle."

Then they did the same with the hands of the stout lady and said, "We are very glad you have come, noble aunt."

Then they went to the children, but stood before them quite dumbfounded, for they had never seen children of this sort before. The boy had on long pantaloons, a little jacket of scarlet cloth embroidered all over with golden knots, and a little dazzling saber at his side. His head was adorned by a strange, red cap with a white feather, and he peeped shyly from under the cap with his yellow face and his heavy, bleary eyes. The girl had on a white dress very much like Christlieb's but with a frightful quantity of ribbons and tags, while her hair was

strangely frizzed up into knots and twisted on the top of her head, where there was also a little shining crown.

Christlieb plucked up courage and offered her hand to the girl. However, she withdrew hers hurriedly and made such an angry, tearful face that Christlieb became frightened and let her alone. Felix wanted to have a closer look at the boy's saber and stretched his hand to it, but the youngster began to cry, "My saber, my saber! He's going to take my saber!" and ran to the thin man, behind whom he hid himself. Consequently, Felix grew red in the face and, much annoyed, said: "I don't want to take your saber, stupid jerk!"

The last two words were murmured between his teeth, but Baron von Brakel seemed to have heard everything and was very upset about it, for he fingered his vest nervously and said: "Oh, Felix, what are you saying!"

Then the stout lady said, "Adelgunda! Herrmann! The children won't harm you! Don't be so silly."

The thin gentleman added, "They just want to get to know you."

Upon saying this, he took Lady von Brakel by the hand and conducted her to the house. Baron von Brakel followed him with the stout lady, while Adelgunda and Herrmann clung to their mother's skirt. Christlieb and Felix came after them.

"The cake will be cut now," Felix whispered to his sister.

"Oh, yes! Oh, yes! Yes!" she answered with delight.

"And then we'll be off into the forest," continued Felix.

"And we won't have to bother any more with these stupid idiots," added Christlieb.

Felix jumped for joy, then they went into the room. Adelgunda and Herrmann were not allowed to have any of the cake because their father and mother said it was not good for them. So, each of them had a little biscuit, which the footman produced from a bag that he had brought with him. Felix and Christlieb bravely bit into a substantial piece of cake that their mother had given to each of them, and they were very pleased.

Other Things That Happened during the Grand Visit of Their Relatives

The thin gentleman, whose name was Cyprianus von Brakel, was first cousin to Baron Thaddeus von Brakel, but a man of far greater distinction. Aside from

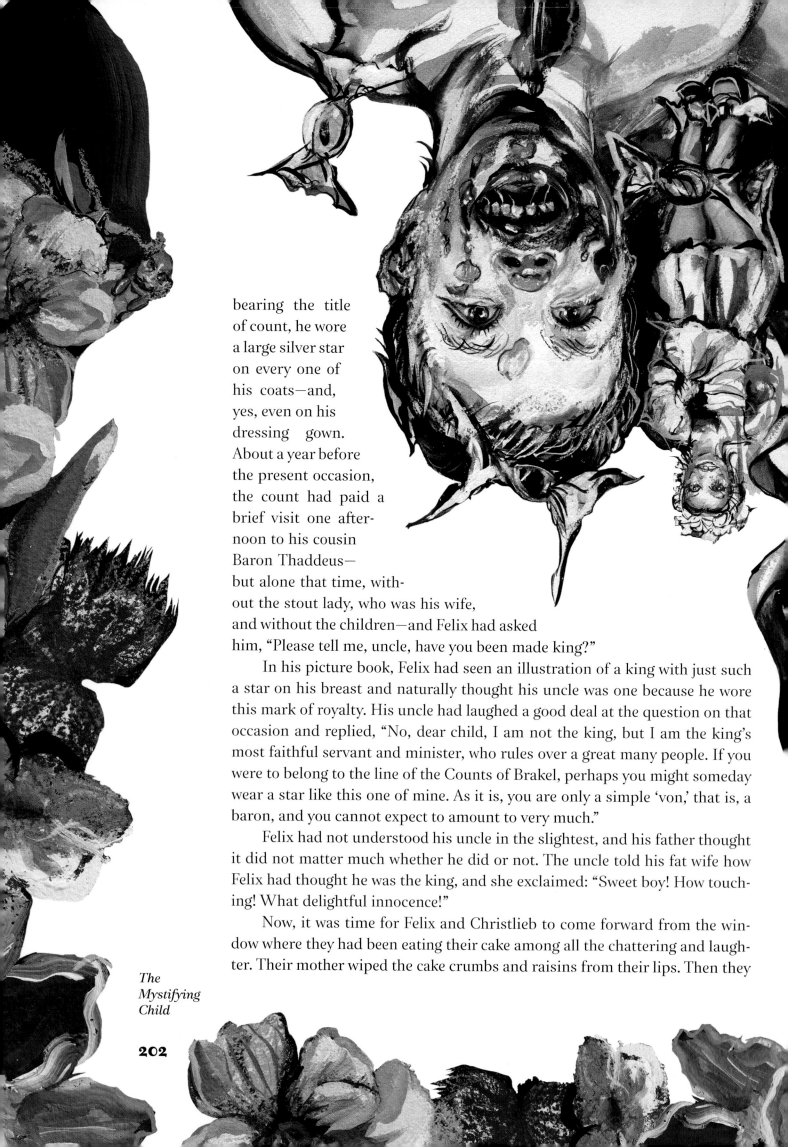

bearing the title
of count, he wore
a large silver star
on every one of
his coats—and,
yes, even on his
dressing gown.
About a year before
the present occasion,
the count had paid a
brief visit one after-
noon to his cousin
Baron Thaddeus—
but alone that time, with-
out the stout lady, who was his wife,
and without the children—and Felix had asked
him, "Please tell me, uncle, have you been made king?"

In his picture book, Felix had seen an illustration of a king with just such a star on his breast and naturally thought his uncle was one because he wore this mark of royalty. His uncle had laughed a good deal at the question on that occasion and replied, "No, dear child, I am not the king, but I am the king's most faithful servant and minister, who rules over a great many people. If you were to belong to the line of the Counts of Brakel, perhaps you might someday wear a star like this one of mine. As it is, you are only a simple 'von,' that is, a baron, and you cannot expect to amount to very much."

Felix had not understood his uncle in the slightest, and his father thought it did not matter much whether he did or not. The uncle told his fat wife how Felix had thought he was the king, and she exclaimed: "Sweet boy! How touch-ing! What delightful innocence!"

Now, it was time for Felix and Christlieb to come forward from the win-dow where they had been eating their cake among all the chattering and laugh-ter. Their mother wiped the cake crumbs and raisins from their lips. Then they

The
Mystifying
Child

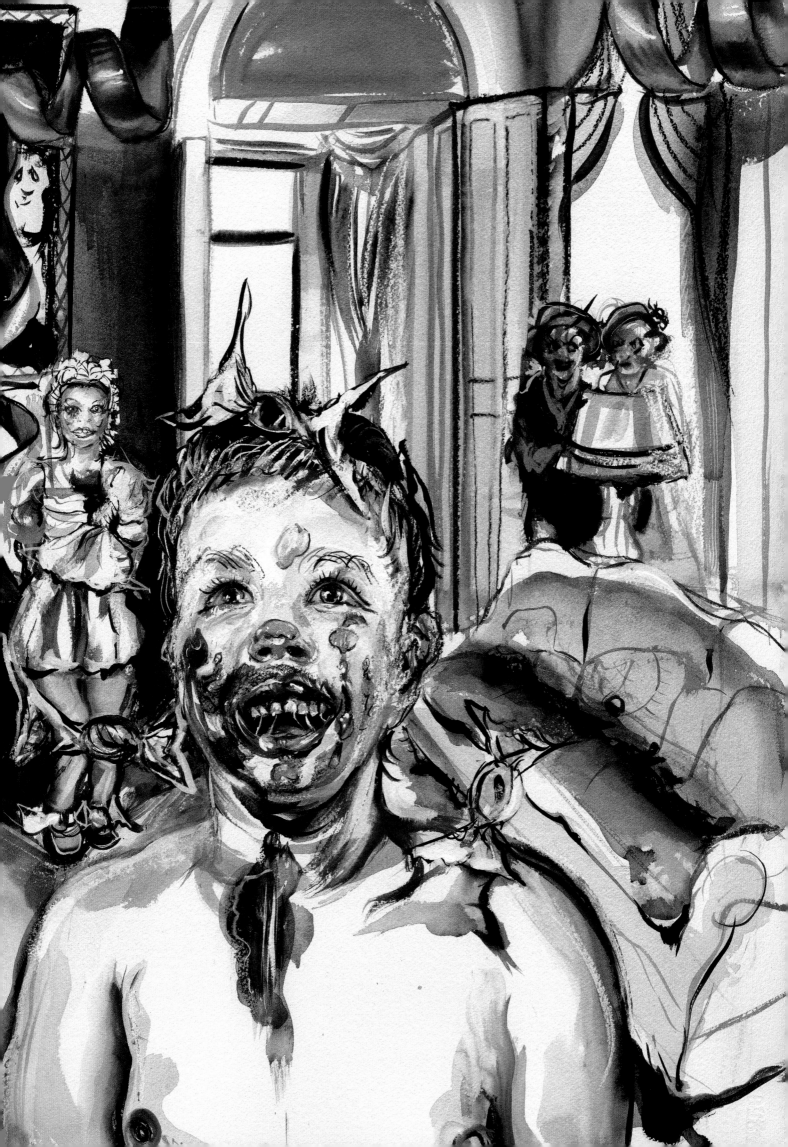

were handed over to their gracious uncle and aunt, who kissed them with loud exclamations: "Oh, sweet and darling nature! Oh, what rural simplicity!" And they placed big paper bags in their hands. Tears came to the eyes of Baron Thaddeus von Brakel and to those of his wife over this condescension of their grand relatives. Meanwhile, Felix had opened his paper bag and found candy in it. Therefore, he immediately set to work and munched vigorously. Soon, Christlieb followed his example.

"My children, my children!" cried their gracious uncle. "That is not the way to do it. You will ruin your teeth! You must suck them gently until the sugar dissolves in your mouth."

But Felix laughed loudly and said, "Gracious uncle, do you think I am a baby and haven't got teeth to bite them with?"

Upon saying that, he put a bonbon in his mouth and gave it such a bite that everything rattled and crumpled.

"Delicious naivete!" the fat lady cried.

The uncle agreed, but drops of perspiration stood on Baron Thaddeus von Brakel's forehead. He was ashamed of Felix's lack of polish, and his mother whispered to the boy hurriedly: "Don't make such a clattering noise with those teeth of yours. Only slobs do that!"

This remark made Felix very upset, for he wasn't aware that he had been doing anything wrong. So, he took the half-eaten bonbons out of his mouth, put them into the paper bag, and handed the whole thing back to his uncle.

"Take back your sugar!" he cried. "That's all I care about. If I am not allowed to eat it, I don't want it."

Since Christlieb was accustomed to follow Felix's example in all things, she did the same with her paper bag. This was too much for poor Baron Thaddeus, who declared: "Ah! My honored and gracious cousin! Please do not be annoyed by the foolishness of these simple children. Really, when you live in the country and are under meager conditions, alas! Who can bring up children in the style in which you have brought up yours?"

Count Cyprianus smiled courteously as he glanced at Herrmann and Adelgunda. They had long since finished eating their biscuits and were now sitting as mum as mice upon their chairs without showing the slightest expression on either of their faces or their limbs. The fat lady smiled, too, and said with a lisp, "Yes, you are right, my dear cousin. The education of our children lies nearer to our hearts than anything in the world."

The Mystifying Child

Then she made a sign to Count Cyprianus, who immediately turned to Herrmann and Adelgunda and asked them all sorts of questions, which they answered with utmost readiness. The questions were about towns, rivers, and mountains many thousands of miles away and with the oddest names. In addition, they could recount what every kind of animal was like and which animals were found in the most remote quarters of the globe. Then they talked about plants, trees, and shrubs, just as if they had seen them themselves and had eaten the fruits. Herrmann gave a detailed description of everything that had happened at a great battle about three hundred years ago, and he was able to recite the names of all the generals who had taken part in it. Finally, Adelgunda even described the stars and stated that there were all kinds of beasts and strange figures in the sky.

All this made Felix quite anxious and scared, and so he moved closer to his mother and whispered, "Ah, Mama, dearest Mama! What is all this nonsense that they're blabbering about?"

"Hold your tongue, you stupid boy!" his mother murmured. "These are the scientific facts."

Felix became silent.

"Astonishing!" Baron Thaddeus exclaimed. "Quite unparalleled! To know all this at their age!"

And Lady von Brakel sighed, "Oh, my lord! What little angels! What in the world will become of our little ones out in this desolate countryside?"

Baron Thaddeus now joined and supported his wife's laments, while Count Cyprianus comforted their hearts by promising to send them a man of great erudition, especially skilled in the education of children. Meanwhile, the splendid coach had driven up to the door, and the coachman entered carrying two large boxes, which Herrmann and Adelgunda took and handed to Felix and Christlieb. Then Herrmann made a polite bow and asked, "Are you fond of toys, *mon cher*? I have brought you some of the finest kind."

Felix hung his head and was dejected. He felt sad and didn't know why. He held the box in his hands without expressing any gratitude. "I'm not *mon cher*!" he blurted. "And I don't speak in a formal language like you do. I just use plain, common language!"

Meanwhile, Christlieb was close to crying, rather than laughing. The most delicious smells from all kinds of dainty candy were emanating from the box that Adelgunda had handed her. Sultan, Felix's faithful friend and darling pet dog, was dancing and barking as usual, and Herrmann was so frightened by

him that he ran back into the room, hid himself in a corner, and began to cry.

"He won't bite you!" Felix cried. "He's only a dog. Why are you howling and screaming? You know all about the most terrible wild beasts in the world, don't you? And even if he were going to attack you, aren't you wearing a sword?"

But Felix's words were of no avail. Herrmann went on howling until the servant took him in his arms and carried him off to the coach. In the meantime, Adelgunda was suddenly infected by her brother's fright—or heaven knows from what other cause! So, she, too, began to scream and howl, and all this affected poor Christlieb so much that she began to cry, too. Amid the children's yelling and screaming, Count Cyprianus von Brakel took his departure from Brakelheim, and this is how the visit of those grand and distinguished relatives ended.

The New Toys

After the coach containing Count Cyprianus von Brakel and his family had rolled down the hill, Herr Thaddeus von Brakel quickly took off his green coat and his red vest, then, just as quickly, he put on his loose jacket, passed his large comb two or three times through his hair, drew a deep breath, stretched himself, and cried, "Thank God!"

The children, too, got out of their Sunday clothes, and felt happy, if not relieved.

"To the forest! To the forest!" cried Felix, jumping higher in the air than he had ever jumped.

"But don't you want to see what Herrmann and Adelgunda brought you before you dash off?" their mother asked.

And Christlieb, who had been staring at the boxes with longing eyes while she was changing her clothes thought this would be a good thing to do first, and that they would have plenty of time to go to the forest afterward. However, Felix was very hard to convince, and he asked, "Just how important are those gifts that the stupid fellow with pretty pants and his sister covered with ribbons brought us? What about the 'sciences,' as you call them? He chatters away as finely as you please and talks about bears and lions and elephants. And then he's afraid of my dear dog Sultan! Even though he's wearing a sword, he crawls under the table! Do you really think he'll make for a good hunter one day?"

"My good Felix!" pleaded Christlieb. "Just let us see for a minute or two what's inside the boxes."

And, since Felix always did anything he could to please his sister, he abandoned his plan to run off into the forest and patiently sat down with her at the table on which the boxes had been placed. Then their mother opened them. And, lo and behold, my very dear readers! I am sure that it made you extremely happy to attend the annual fair and take part in the events at Christmas when your parents and your friends showered you with presents of every kind. Remember how you danced for joy when handsome soldiers and little fellows with barrel organs, beautifully dressed dolls, delightful picture books, and all the rest were placed before you?

Felix and Christlieb now experienced the joy and happiness that you often did. Indeed, a truly splendid assortment of the loveliest toys came out of those boxes, and all sorts of delicious things to eat as well so that the children clapped their hands again and again and cried out: "Wow, how nice that is!"

However, Felix laid aside one box of bonbons with contempt, and when Christlieb begged him not to throw the glassy sugar out the window just as he was about to do, he gave up that idea and only chucked some of the candy to Sultan, who had come in wagging his tail. Sultan sniffed at them, then turned his back disdainfully.

"Do you see, Christlieb," Felix cried. "Sultan won't have anything to do with the wretched stuff!"

Nevertheless, on the whole, Felix was very satisfied with the toys, most of all with a certain magnificent hunter, who put his gun to his shoulder and fired at a target about three feet in front of him, whenever Felix pulled a little string that stuck out beneath his jacket. He was also very fond of a little fellow who bowed and tweaked and twinkled on a little harp when you turned a winding key. But the things that pleased him more than anything else were a wooden gun and a hunting knife also made of wood, both covered with silver. Moreover, he liked the handsome cap of a hussar and an ammunition pouch. Christlieb was equally delighted with a beautifully dressed doll and a set of charming furniture. Indeed, the children forgot all about the forest and enjoyed themselves with their toys until quite late in the evening. Then they went to sleep.

What Happened to the New Toys in the Forest

The next day, the children began again where they had left off the night before. That is to say, they retrieved the boxes, brought out the toys, and amused themselves with them in many different ways. The sun shone brightly and kindly through the windows, just as the day before, and the birches, greeted

by the sighing morning breeze, whispered and rustled. The birds rejoiced and sang the loveliest songs of joy. However, Felix became wistful and melancholy as he played with the hunter, the little fellow and his harp, his gun, and the ammunition pouch.

"Oh," he cried, "it's much more beautiful outside! Come, Christlieb, let's head for the forest!"

Christlieb had just undressed her big doll and took great pleasure in putting the clothes on again. For that reason, she preferred not to go out just then. So, she asked, "Wouldn't it be better if we stayed here and played a little longer, Felix dear?"

"I'll tell you what we'll do, Christlieb. Let's take the best of our toys out to the forest with us. I'll take my hunting knife and carry the gun over my shoulder. Then, you see, I'll be like a real hunter. I'll carry the little hunter and the harpist with me, and you can take your big doll and the best of your other things with you. C'mon! Let's take off!"

Christlieb quickly dressed her doll, then they both set off to the forest with their toys. Once there, they settled down on a nice, grassy place, and after they had played for a while and Felix was conducting his harpist to play his little tune, Christlieb said, "Do you know, Felix, that harpist of yours doesn't play all that nicely. Just listen to how awful it sounds out here in the forest, with its eternal 'ting-a-ling, ping-ping.' The birds peep down from the trees as though they were disgusted with that stupid musician who insists on accompanying them."

Felix turned the winding key more and more strenuously, and after a while, he cried, "I think you're right, Christlieb. The little fellow's music sounds horrible. I'm quite ashamed to see those thrushes there looking down at me with such penetrating eyes. He must do better."

Upon saying this, Felix turned the winding key with such force that—"crack! crack!"—the whole box on which the harpist stood flew into a thousand splinters, and his arms fell down, broken.

"Oh, oh!" Felix cried.

"Ah! Poor little harpist!" sighed Christlieb.

Felix looked at the broken toy for a minute or two and then said, "Well, he was a stupid, senseless fellow after all is said and done. He played terribly poor music, made faces, and bowed and scraped the floor like Cousin Fancy Pants."

Upon saying this, Felix threw the harpist as far as he could into the thicket.

"I prefer my hunter," he went on to say. "He makes a bull's-eye every time

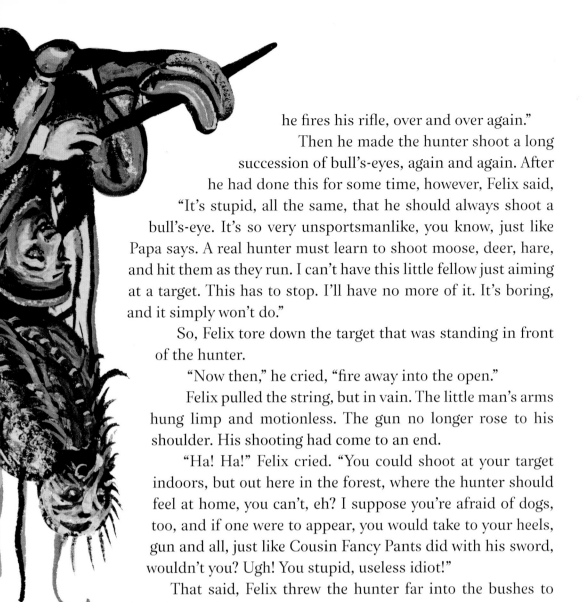

he fires his rifle, over and over again."

Then he made the hunter shoot a long succession of bull's-eyes, again and again. After he had done this for some time, however, Felix said, "It's stupid, all the same, that he should always shoot a bull's-eye. It's so very unsportsmanlike, you know, just like Papa says. A real hunter must learn to shoot moose, deer, hare, and hit them as they run. I can't have this little fellow just aiming at a target. This has to stop. I'll have no more of it. It's boring, and it simply won't do."

So, Felix tore down the target that was standing in front of the hunter.

"Now then," he cried, "fire away into the open."

Felix pulled the string, but in vain. The little man's arms hung limp and motionless. The gun no longer rose to his shoulder. His shooting had come to an end.

"Ha! Ha!" Felix cried. "You could shoot at your target indoors, but out here in the forest, where the hunter should feel at home, you can't, eh? I suppose you're afraid of dogs, too, and if one were to appear, you would take to your heels, gun and all, just like Cousin Fancy Pants did with his sword, wouldn't you? Ugh! You stupid, useless idiot!"

That said, Felix threw the hunter far into the bushes to join the harpist.

"Come, let's run around a bit," he said to Christlieb.

"Ah, yes! Let's!" said she. "This lovely doll of mine will run with us, too. That will be fun."

So, Felix and Christlieb each took an arm of the doll, and off they went full steam ahead through the bushes, down the hillside, and on and on till they came to a small lake, surrounded by water plants, that was on their father's property, and where he sometimes went to shoot wild duck. Here they came to a standstill, and Felix said, "Suppose we wait here a little. I have a gun now, you know, and perhaps I can hit a duck among the rushes, like Papa."

But at that moment, Christlieb screamed, "Oh! Just look at my doll. What's the matter with her?"

Indeed, that poor thing was in miserable condition. Neither Felix nor Christlieb had paid much attention to her as they were running around in the forest, and so the bushes had torn the doll's clothes off her back. Both her beautiful legs were broken, and there was scarcely a trace remaining of her pretty waxen face, which was now scratched and hideous.

"Oh, my poor, beautiful doll!" cried Christlieb, bursting into tears.

The Mystifying Child

"There, now you see what trashy things those two stupid creatures brought us. That doll of yours is nothing more or less than a dumb, idiotic schnook! She can't even go for a little run with us without getting her clothes all torn off her back and herself ripped apart and destroyed. Give her to me."

Christlieb sorrowfully complied and could scarcely restrain a cry of "Oh, oh!" as he chucked the doll into the lake without much ado.

"Don't worry, my dear!" Felix said, consoling his sister. "Forget all about the wretched thing. If I could shoot a duck, I'd give you the best of the colored wing feathers."

Just then, they heard a rustle in the reeds, and Felix instantly took aim with his wooden rifle. But he quickly lowered it from his shoulder saying, "What a fool I am!"

He became thoughtful for a few minutes, then continued softly: "How can anyone try to shoot a shotgun without powder and shot? And am I carrying either one or the other with me? Besides, it's impossible to put powder into a wooden gun! What's the use of this stupid wooden thing? And the hunting knife is wooden, too. It can neither cut nor stab. Of course, my cousin's sword was wooden as well! That was why he couldn't draw it when he was afraid of Sultan. I see what it all boils down to: Cousin Fancy Pants was making a fool of me with his toys, which are only flimsy, useless things!"

Upon saying that, Felix threw his gun, the hunting knife, and, finally, the cartridge pouch into the lake. But Christlieb was still terribly distressed about her doll, and Felix couldn't help but feeling annoyed by the way things had turned out. So, it was in this gloomy mood that they returned to their house, and when their mother asked them what had become of their toys, Felix honestly told her how they had been deceived by the harpist, the gun, the knife, and the ammunition pouch, not to mention the doll.

The Mystifying Child

210

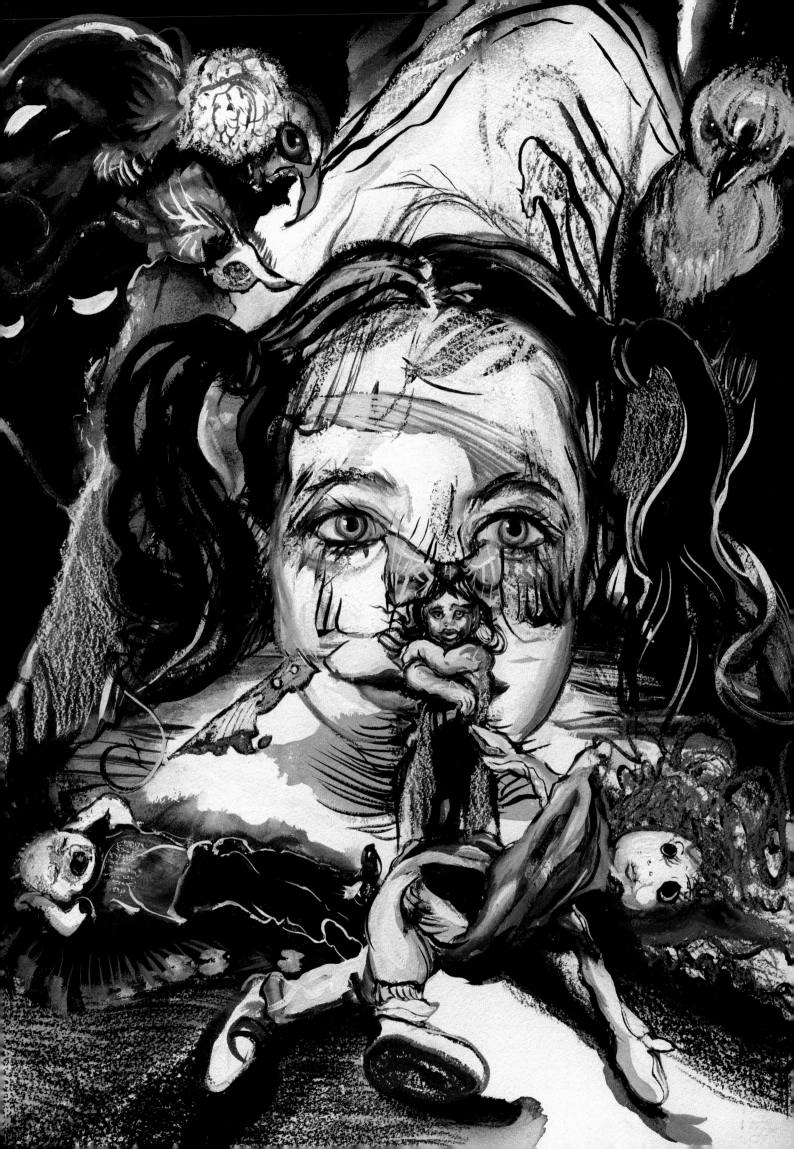

"Ah! You foolish children!" cried Lady von Brakel, half angrily. "You don't know how to play with such nice toys of this kind."

But the baron, who had listened to Felix's tale with evident satisfaction, said, "Leave the children alone. When all is said and done, I'm honestly glad they got rid of these toys. Since they didn't understand them, they became confused and frightened."

Yet, neither Lady von Brakel nor the children understood what the Baron meant in saying that.

The Mystifying Child

Early one morning, soon after these events, Felix and Christlieb ran off to the forest. Their mother had told them they did not have much time to play because they had to stay in the house and read and write a great deal more than they were used to doing so that they would make a good impression on the tutor, who was expected to arrive very soon.

In response, Felix said, "Let's jump and run around as much as we can for the little time we are allowed to stay out here. So, let's go!"

So, they immediately began to play hare and hounds, chasing each other. But very soon they became bored of playing that game, and also every other that they tried to play. Indeed, the games became tedious after a second or two. The children had no inkling why, on that particular day, a thousand annoying things kept happening to them. The wind swept Felix's cap into the bushes, then, as he was running his best, he stumbled and fell down, hitting his nose. Christlieb caught her clothes in thorn bushes and banged her foot against a sharp stone so that she shrieked in pain. They soon abandoned their games and trudged along dejectedly through the forest.

"Let's go home," said Felix. "There's nothing we can do about all this."

But instead of doing so, he threw himself down beneath a shady tree. Soon, Christlieb followed his example, and there the children lay, depressed and irritated, staring at the ground.

"Ah!" said Christlieb. "If we only had our nice toys."

"Come on!" growled Felix. "What good would they do us? We'd only smash them and destroy them again. I'll tell you what the problem is, Christlieb. Mother is not so wrong, I suspect. The toys were all just fine, but we didn't

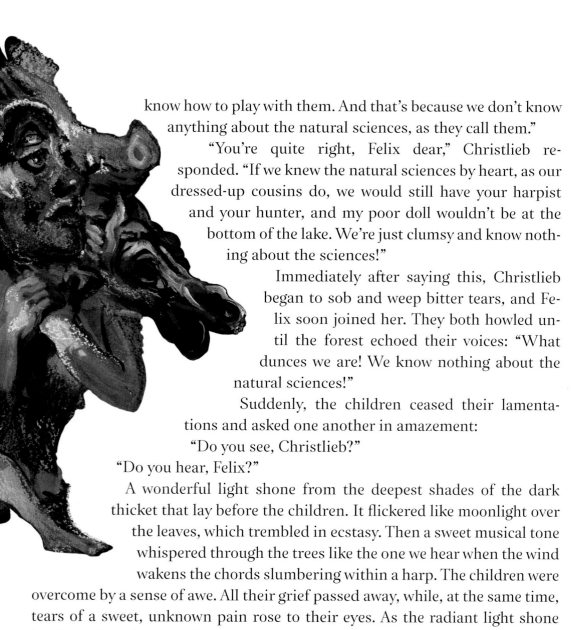

know how to play with them. And that's because we don't know anything about the natural sciences, as they call them."

"You're quite right, Felix dear," Christlieb responded. "If we knew the natural sciences by heart, as our dressed-up cousins do, we would still have your harpist and your hunter, and my poor doll wouldn't be at the bottom of the lake. We're just clumsy and know nothing about the sciences!"

Immediately after saying this, Christlieb began to sob and weep bitter tears, and Felix soon joined her. They both howled until the forest echoed their voices: "What dunces we are! We know nothing about the natural sciences!"

Suddenly, the children ceased their lamentations and asked one another in amazement:

"Do you see, Christlieb?"

"Do you hear, Felix?"

A wonderful light shone from the deepest shades of the dark thicket that lay before the children. It flickered like moonlight over the leaves, which trembled in ecstasy. Then a sweet musical tone whispered through the trees like the one we hear when the wind wakens the chords slumbering within a harp. The children were overcome by a sense of awe. All their grief passed away, while, at the same time, tears of a sweet, unknown pain rose to their eyes. As the radiant light shone brighter through the bushes, and the marvelous musical tones grew louder and louder, the children's hearts beat faster. They stared at the brightness, then they saw the face of the most beautiful child, smiling at them from a thicket as the sun beamed in all its splendor.

"Oh, come to us! Come to us, darling child!" cried Christlieb and Felix, as they stretched their arms with an indescribable longing toward the beautiful creature.

"I'm coming! I'm coming!" a sweet voice cried from the bushes. And then, as if borne on the wings of the morning breeze, the Mystifying Child seemed to fly and hover above Christlieb and Felix.

How the Mystifying Child Played with Felix and Christlieb

"I heard you weeping and lamenting from a distant place," said the Mystifying Child. "And then I felt very sorry for you. What's the matter, my dear children?

Are you missing something?"

"Ah!" Felix exclaimed. "We didn't quite know what we wanted. But now, as far as I can make out, what we wanted was just you, yourself."

"Yes, that's it!" Christlieb agreed. "Now that you are with us, we are happy again. What took you so long?"

In fact, both children felt as though they had already known and played with the Mystifying Child for a long time, and that their unhappiness had only been due to their beloved playmate's absence.

"You see," Felix continued, "we really don't have any more toys. I, like a stupid fool, destroyed several of the very finest toys that Cousin Fancy Pants gave me. I just threw them away. But, never mind, we'd still like to play some games with you."

"How can you say such a thing?" asked the Mystifying Child, laughing out loud.

"Certainly, the stuff you threw away wasn't worth much, but you and Christlieb are surrounded by the most exquisite playthings ever seen."

"Where . . . Where are they?" Felix and Christlieb wondered.

"Look around you," the Mystifying Child responded. And Felix and Christlieb then saw all sorts of glorious flowers peeping out of the thick grass and the soft moss. Their bright eyes were gleaming, for sparkling and shining colored stones and crystalline shells were between them, while little golden insects danced up and down, humming sweet songs.

"Now, we shall build a palace," said the wondrous stranger. "Help me gather the stones together."

Upon saying this, the Mystifying Child stooped down and began choosing various colored stones, while Felix and Christlieb helped the child set the stones on top of one another so that soon they created tall columns, shining in the sun like polished metal. As they were doing this, an aerial golden roof vaulted itself over them. Then the Mystifying Child kissed the flowers that were peeping from the ground. Whispering sweetly, they shot up higher and embraced each other lovingly, forming scented arcades and covering walks, which allowed the children to dance about full of joy.

Now the Mystifying Child clapped, and the golden roof of the palace, which had been formed by the golden wings of insects, flew apart with a hum. The pillars melted away into a splashing silver stream, on whose banks various flowers took up their positions and peered inquiringly into its ripples, moving their heads from side to side and listening to its childish pattering. Then the

The Mystifying Child

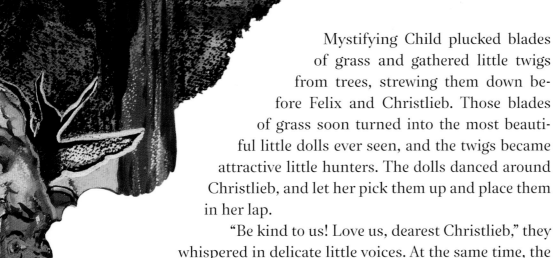

Mystifying Child plucked blades of grass and gathered little twigs from trees, strewing them down before Felix and Christlieb. Those blades of grass soon turned into the most beautiful little dolls ever seen, and the twigs became attractive little hunters. The dolls danced around Christlieb, and let her pick them up and place them in her lap.

"Be kind to us! Love us, dearest Christlieb," they whispered in delicate little voices. At the same time, the hunters rushed here and there and blew their horns.

"Tally ho! Tally ho! It's time to hunt," they shouted.

Then some rabbits darted from the bushes, with dogs chasing after them, followed by the hunters, who fired their guns. This was delightful.

After a while, everything disappeared, and Christlieb and Felix cried:

"What's happened to the dolls? Where are the hunters?"

The Mystifying Child responded, "Oh, they are all at your disposal. They are with you all the time, and whenever you want them. But wouldn't it be fun now to wander through the forest a little?"

"Oh, yes! Oh, yes!" Felix and Christlieb exclaimed.

The Mystifying Child grabbed hold of their hands and cried: "Come on! Come on!"

And off they ran. But it could not really be called "running," for the children floated in the sky, lightly and easily through and among the trees. Meanwhile, all the birds fluttered beside them, singing and warbling in the merriest fashion. Then, all of a sudden, they soared higher into the sky.

"Good morning, children! Good morning, my friend Felix!" cried the stork, flying past them.

"Don't hurt me! Don't hurt me!" screamed the vulture. "I'm not going to touch your little pigeons."

And the vulture flew away as fast as his long wings could carry him, afraid of the children. Felix shouted with delight, but Christlieb was frightened. "Oh, I'm out of breath!" she cried. "I'm going to fall to the ground!"

And, just at that moment, the Mystifying Child let them softly down to the ground again and said: "Now, I'll sing you 'The Forest Song' as a goodbye for today. I shall come again tomorrow."

Upon announcing this, the Mystifying Child took out a small horn from a pocket. Its golden windings looked almost as if it was made of wreaths of flowers, and the child began to play it so beautifully that the entire forest echoed with lovely music. Meanwhile, the nightingales (which had come fluttering up

The Mystifying Child

215

as if in answer to the horn's summons and which were now sitting on the branches, as close as they could get to the children) sang their sweetest songs. But all at once, the music grew fainter and fainter until nothing of it remained but a soft whisper that seemed to come from the thicket into which the Mystifying Child disappeared.

"Tomorrow! Tomorrow I'll come again!" The children could just about hear the Mystifying Child's voice, as if it came from an immense distance. However, they could not explain their feelings, for never had they experienced such happiness and joy in their lives.

"Oh, I wish it were tomorrow now!" Felix and Christlieb cried, and they rushed home as fast as they could to tell their parents all that had happened.

What Baron von Brakel and His Wife Said about the Mystifying Child, and What More Happened with the Child

Felix and Christlieb could not stop talking about the Mystifying Child and all that they had experienced—their new friend's sweet character, the exquisite music, the wonderful games they played. "I'd like to believe that the children actually dreamt all of this," the baron said to his wife. "But then, when I remember that they could not both have dreamt precisely the same things at the same time, really, when all is said and done, I cannot get to the bottom of it."

"Don't let it trouble you, my dear," Lady von Brakel responded. "I think this Mystifying Child was actually the schoolmaster's boy, Gottlieb, from the village. He must have come to the forest and filled the children's heads with all this nonsense. We must prevent him from doing this anymore."

However, the baron did not agree with his wife and wanted to know more about the children's story. So, he summoned the children and asked them to describe minutely what the child was like—how the child was dressed and so forth. With respect to their friend's appearance, both Felix and Christlieb agreed that the child had a face as white as a lily, cheeks like roses, cherry lips, bright blue eyes, and curly golden hair, and was more beautiful than words could describe. With regard to their new friend's clothing, all they knew was

The Mystifying Child

216

that the child certainly did not have a blue-striped jacket and pants, or a black leather cap, such as the schoolmaster's son, Gottlieb, wore. On the other hand, all they said of the clothes sounded utterly fabulous and absurd. Christlieb said the child was wearing a beautiful and glistening dress as if it were made of rose petals, while Felix maintained that the child was wearing a light golden-green suit that sparkled like spring leaves in the sunshine. Felix added that the child could not possibly have any connection with such a person as a schoolmaster because the child was too deeply acquainted with hunting and must consequently belong to a family that knew all about forestry and the like. Indeed, Felix believed that the child was going to be the greatest hunter in the world.

"Oh, Felix!" Christlieb interrupted. "How can you say that this dear little girl could ever become a hunter? She may, perhaps, know a good deal about that, too, but I'm sure she knows a great deal more about housekeeping. Otherwise, how could she have dressed those dolls for me so beautifully and made such delicious dishes?"

In short, Felix thought the Mystifying Child was a boy, and Christlieb, a girl, and their contradictory opinions could not be reconciled. Lady von Brakel thought it was a waste of time to discuss such nonsense anymore with the children, but the baron thought differently and said, "I would only have to follow the children into the forest to find out what wondrous sort of creature this is who comes to play with them, but I can't help feeling that if I did, I'd spoil something that is a great pleasure for them, and for that reason I won't do it."

The next day, when Felix and Christlieb went off to the forest at the usual time, they found the Mystifying Child waiting for them. And, if their play had been gratifying the previous day, on this day the Mystifying Child did the most miraculous things imaginable so that Felix and Christlieb kept shouting for joy over and over again. During their play, it was amusing and most enjoyable to see the Mystifying Child talking so gently and sensitively with the trees, the bushes, the flowers, and the brook that ran through the forest, and they all answered in a language that Felix and Christlieb could understand. At one point, the Mystifying Child said to the alder bushes, "Hello over there! What are you muttering and whispering about to each other again?"

In response, the branches began shaking more vigorously, and they

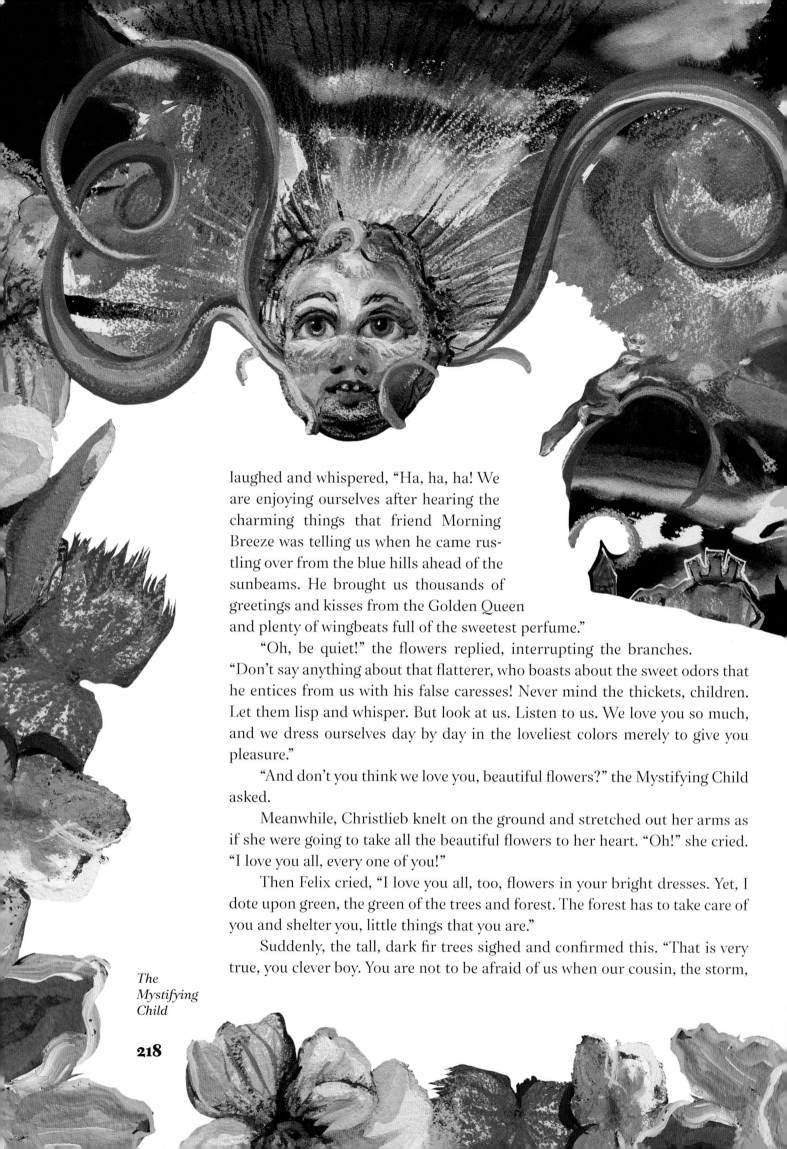

laughed and whispered, "Ha, ha, ha! We are enjoying ourselves after hearing the charming things that friend Morning Breeze was telling us when he came rustling over from the blue hills ahead of the sunbeams. He brought us thousands of greetings and kisses from the Golden Queen and plenty of wingbeats full of the sweetest perfume."

"Oh, be quiet!" the flowers replied, interrupting the branches. "Don't say anything about that flatterer, who boasts about the sweet odors that he entices from us with his false caresses! Never mind the thickets, children. Let them lisp and whisper. But look at us. Listen to us. We love you so much, and we dress ourselves day by day in the loveliest colors merely to give you pleasure."

"And don't you think we love you, beautiful flowers?" the Mystifying Child asked.

Meanwhile, Christlieb knelt on the ground and stretched out her arms as if she were going to take all the beautiful flowers to her heart. "Oh!" she cried. "I love you all, every one of you!"

Then Felix cried, "I love you all, too, flowers in your bright dresses. Yet, I dote upon green, the green of the trees and forest. The forest has to take care of you and shelter you, little things that you are."

Suddenly, the tall, dark fir trees sighed and confirmed this. "That is very true, you clever boy. You are not to be afraid of us when our cousin, the storm,

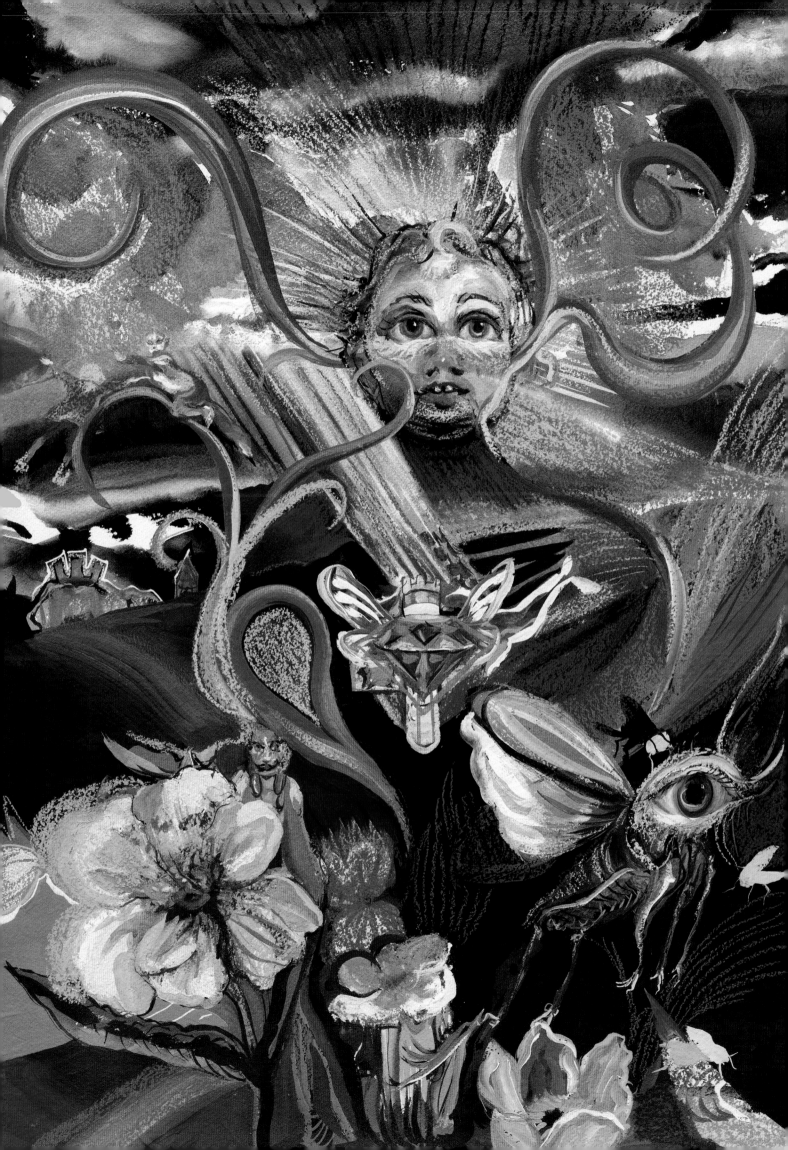

comes rushing at us, and we have to tangle and argue with that rough customer."

"All right," Felix commented. "Groan, sigh, and snarl as much as you like, you amazing green giants, for that's when the real woodsman's heart begins to rejoice."

"You are quite right about that," the forest brook splashed and murmured. "But what is the good of always hunting, always rushing in storms and roaring winds? Come, and sit down nicely on the moss and listen to me. I come from far away where there is a deep, dark, rocky ravine. I have delightful fairy tales to tell you and always something new, wave after wave, forever and ever. And I will show you the loveliest picture, if you will only look straight into this clear mirror of mine—the hazy blue of the sky, golden clouds, bushes, flowers and trees, and your very selves, you beautiful children. I shall draw you lovingly into the depths of my bosom."

"Felix, Christlieb," said the Mystifying Child, looking around with bliss. "Just listen to how they all love us. But the sun is beginning to set in the rosy-red sky, and evening is rising behind the hill. Indeed, the nightingale is calling me home."

"Oh, but let us just fly a little, as we did yesterday," Felix pleaded.

"Yes," said Christlieb, "but not quite so high. It makes my head dizzy."

Then the Mystifying Child took them by the hands again, and they went soaring up into the golden purple of the evening, while the birds crowded and sang all around them in jubilation. Meanwhile, Felix saw beautiful castles made of rubies and other precious stones that sparkled and wavered in the glowing clouds.

"Look, look! Christlieb!" he cried, full of rapture. "Look at all those splendid palaces! Let us fly as fast as we can, and we shall get to them."

Christlieb saw the castles, too, and forgot her fear, because she was not looking down this time, but up before her.

"Those are my beloved castles in the air," the Mystifying Child said. "But I don't think we shall go any farther today."

Felix and Christlieb seemed to be in a dream, and they had no idea at all how they came to find themselves back at home with their father and mother.

The Mystifying Child

All about the Mystifying Child's Home

During another visit to the forest, Felix and Christlieb found that the Mystifying Child had built a glorious tent, made of tall, slender lilies, glowing roses, and brightly colored tulips, in the most beautiful part of the forest beside the brook and between whispering bushes. Felix and Christlieb sat down with the Mystifying Child and listened to the brook as it went on babbling the strangest things imaginable.

"I must admit," Felix said to the child, "I can't understand what the brook is saying, but I somehow feel that you could tell me clearly what it is that the brook is murmuring. But most of all I'd like you to tell me where you come from, and to where you fly so rapidly that we can never make out how you do it."

"Do you know, dear little girl," Christlieb added, "our mother thinks you are the schoolmaster's boy, Gottlieb."

"Be quiet, you dumb thing!" Felix cried. "Mother has never seen this darling boy, or she would have never talked about the schoolmaster's Gottlieb. But come now, tell us where it is you live, dear boy, because we want to go and see you at your home in the wintertime when it storms and snows, and nobody can trace a track in the woods."

"Yes, yes!" said Christlieb. "Please tell us where your home is and all about your father and mother. Moreover, please reveal what your name is."

The Mystifying Child looked very thoughtfully at the sky, almost sadly, and uttered a deep sigh. Then, after some moments of silence, the Mystifying Child said, "Oh, my dear children, why ask about my home? Isn't it enough for you that I come every day and play with you? I might tell you that my home lies behind those distant hills, which look like jagged clouds. But even if you were to travel day after day, forever and ever, until you stood on those hills, you would always see other ranges of hills farther and farther away, and even if you reached them, you would still see others farther away and would have to go to them. So, you would never come to where my home is."

"Oh, no!" sighed Christlieb. "Then you must live hundreds and hundreds of miles away from us. So, you're only here on a sort of visit, is that it?"

"Dear Christlieb," the Mystifying Child replied, "whenever you long to see

me with all your heart, I'll be with you immediately, and I'll bring you all those games and wonders from my home. Isn't that quite as good as if we were together in my home and were playing there?"

"Not at all," Felix said, "because I believe your home must be the most gorgeous place in the world and is full of all sorts of delightful things that you bring here with you. I don't care how hard you may say the path to your home is. I intend to travel there right now—to work my way through forests, to walk difficult paths, to climb mountains, to wade rivers, to break through all sorts of thickets, and to climb over rugged rocks. I'll do whatever a true woodsman would do, and I'm going to do it!"

"And so, you will!" replied the Mystifying Child, with a pleasant laugh. "It's clear that when you make up your mind to do something, it is as good as done. The country where I live is, in truth, so beautiful that I can't describe it. My mother reigns over that gorgeous country as queen, and it is splendid."

"Ah, then, you are a prince!"

"Ah, then, you are a princess!"

The two children, amazed and almost terrified, spoke at the same time.

"I certainly am," the Mystifying Child replied.

"Then you live in a beautiful palace?" Felix asked.

"Yes," said the Mystifying Child, "my mother's palace is far more beautiful than those glimmering castles that you saw in the evening clouds. The gleaming pillars of her palace are made of the purest crystal. Slender and tall, they soar into the blue heaven. They are covered by a great, wide canopy, and beneath that canopy, the shining clouds sail back and forth on golden wings. The sun rises and sets in a glowing red, and the sparkling stars dance and sing in circles. My dear friends, I'm certain you've heard of fairies, who can bring about the most glorious miracles, something that humans cannot do. My mother is one of the most powerful fairies of all. She embraces everything that lives and moves on earth with all her heart and in the purest and truest love. Yet, to her great dismay, many adult human beings deny that fairies exist. My mother loves children most of all, and this is the reason why the festivals that she holds in her kingdom for children are the most glorious. This is when beautiful spirits who belong to my mother's kingdom fly carefully through the sky, weaving a shining rainbow from one end of her palace to another. Under these rainbows, they build my mother's throne with diamonds that appear to be and smell like lilies,

roses, and carnations. Then, when my mother takes her place on her throne, the spirits play their golden harps and their crystal cymbals, while her musicians sing with voices so marvelous that one might die from sheer pleasure to hear them. Now, those musicians and singers are beautiful birds, bigger even than eagles, with purple and red feathers. There is nothing like this in the world. And, as soon as their music begins, everything in the palace, the forest, and the gardens moves and sings, and all around are thousands of beautiful children in charming outfits, romping and playing. They chase each other among the bushes and throw flowers at each other in play. They climb trees, where the winds swing them and rock them. They gather glittering golden fruit, which has a taste like nothing on earth, and they play with tame deer and other charming creatures that come bounding up to them from among the trees. Then they run up and down the rainbows, or they ride on the golden pheasants, which fly up among the gleaming clouds with them on their backs."

"How delightful that must be!" Christlieb and Felix cried with joy. "Oh, take us with you to your home! We want to stay there forever!"

But the Mystifying Child said, "I can't take you with me to my home. It is too far away. You would have to be able to fly as far and as strongly as I can."

Felix and Christlieb were very disappointed and looked sadly at the ground.

The Wicked Minister at the Golden Queen's Court

"Anyway," the Mystifying Child continued, "anyway, you might not be so happy as you think you'd be at my mother's court. Indeed, it might be dangerous for you to go and live there. Many children cannot bear the singing of those purple-and-red birds, glorious as though it might be; it breaks their hearts, and they die immediately. Others, who are too bold and adventurous when they run up and down the rainbows, slip and fall. And many are so thoughtless and awkward that they hurt the golden pheasants when they ride on them. Then those birds, though they are good-natured, take this amiss and tear those children's breasts open with their sharp beaks so that they fall from the clouds and bleed to death.

"My mother is sorry and grief-stricken when children have such accidents, although it is their own fault when they do. She would be only too happy if all

the children in the world could enjoy the pleasures of her court and kingdom. But, although there are plenty who can fly strongly enough and far enough, they are often either too aggressive or too timid, and cause her only sorrow and pain. That is why she allows me to fly away from my home and take all sorts of delightful games and toys to kind children like you."

"Oh," cried Christlieb, "I am sure I would never do anything to hurt those beautiful birds. Nor could I ever run up and down a rainbow. I'm certain about that! I never could. I wouldn't like that."

"Now that is just the thing I would enjoy," Felix said. "And this is the very reason why I want to go and see your mother, the queen. Couldn't you bring one of those rainbows here with you?"

"No," the Mystifying Child said. "I can't do that. And I must tell you that I have only been able to visit you by sneaking away from home. Once upon a time, I was quite safe everywhere just as if I were at home, and my mother's beautiful kingdom seemed to extend all over the world. But now, a bitter enemy of hers, whom she has banished from her kingdom, is roaming all over the world, and I cannot be safe from being pursued and persecuted."

"Well," Felix cried, jumping up and waving the thorny, wooden stick, which he was carving into the air, "I'd like to see anyone who might try to do any harm to you! He'd have to deal with me in the first place. Then I'd send for Father, and he would have him arrested and locked up in the tower."

"Ah," the Mystifying Child said, "my bitter enemy can little harm me when I am at home, but he is terribly dangerous when I am not, and neither weapons nor prisons can protect me from him!"

"What sort of a nasty creature is it, then, that can do you so much harm?" Christlieb asked.

"I have told you that my mother is a mighty queen," the Mystifying Child said, "and you know that queens, like kings, have courts and ministers who belong to them."

"Yes, yes," said Felix. "My own uncle, the count, is one of those ministers and wears a star on his breast. Do your mother's ministers wear stars like he does?"

"No," the Mystifying Child said, "not exactly. Most of them are shining stars themselves, and others do not wear any coats on which they could stick

The Mystifying Child

224

things of that kind. I must tell you that my mother's ministers are all powerful spirits, either flying about in the sky, or swimming in the seas. They are everywhere and carry out my mother's orders.

"Once, a long time ago, a stranger arrived in our country, and he called himself Pepasilio. He said he was very learned and that he could do more and accomplish greater things than any one of us. So, my mother gave him a position among the other ministers, but his natural spite and wicked ways very soon became apparent. Not only did he try to undo all that the other ministers had done, but he tried to spoil all the happy games of the children. He had pretended to the queen that he was better than anyone and could make the children happy so they would enjoy themselves. Instead, he attached himself with a weight of lead to the tails of the pheasants, so they weren't able to fly anymore, and when the children climbed the rose bushes, he would drag them down by their legs, so they would fall to the ground with bloody noses. As for the children who wanted to dance and romp about, he made them crawl on their hands and legs with bent heads. He also treated those children and birds, who loved to sing, very harshly by cramming all sorts of nasty stuff into their mouths so that they had to stop. Indeed, he hated singing. As for the tame animals, he always tried to eat the poor things, instead of playing with them, because he believed that was what they were meant for. The worst was that he and his followers had a putrid black ink with which they used to smear all the sparkling jewels of the palace, the brightly colored flowers, the roses and lilies, and even the shining rainbows so that all their glory and beauty were ruined, and everything became sorrowful and dead. After he had accomplished this, he laughed loudly and said everything was now just as he wished it to be. But when, at last, he declared that he did not consider my mother to be queen at all, and that the country really belonged to him alone, and when he went flying above the palace in the shape of an enormous fly, with flashing eyes and a large proboscis, buzzing and humming in an abominable manner all around my mother's throne, then she and the rest of her court finally realized that this malignant monster, who had joined us under the fine name of Pepasilio, was none other than Pepser, the gloomy and sinister King of the Gnomes. But he had foolishly overestimated his power as well as the courage of his followers. My mother's ministers of the Department of Air surrounded her and fanned her

The Mystifying Child

with a sweet fragrance, while other ministers rushed up and down in billows of flame. Once they cleaned the beaks of the singing birds, the musicians chanted the most full-voiced choruses so that the queen neither saw nor heard the ugly Pepser, and she was protected from his evil-smelling breath. Moreover, at that moment, the Pheasant Prince seized Pepser with his glittering beak and gripped him so tightly that he screamed with agony and rage. Soon after, the Pheasant Prince dropped him down to the earth from a height of three thousand miles so that he was unable to stir either hand or foot until his aunt and crony, the Great Blue Toad, took him on her back and carried him home. Meanwhile, five hundred fine, sprightly children armed themselves with fly swatters and swatted Pepser's horrible followers to death because they were still swarming about and intending to destroy all the beautiful flowers. Now, as soon as Pepser was gone, all the black ink that had covered everything dribbled away, and order was restored. Soon, palace and flowers were beaming and blooming as gloriously as ever. You might believe that the horrid Pepser lost his power in my mother's kingdom. But he knows that I often venture out, and he follows me everywhere in disguises of every kind so that I often unfortunately don't know where to hide myself. That's why I often leave you so quickly; I don't want you to see what might happen to me. Therefore, things must go on just as they are, and I can assure you that if I were to try to take you with me to my home, Pepser would be sure to lie in wait and kill us."

Christlieb wept bitterly about the danger that plagued the Mystifying Child. But Felix said, "If that horrible Pepser is nothing but a monstrous fly, I'll fight him with Father's large fly swatter. And once I give him a good swat on the nose, Aunty Toad will have quite a job getting him home. You can bet your life on that!"

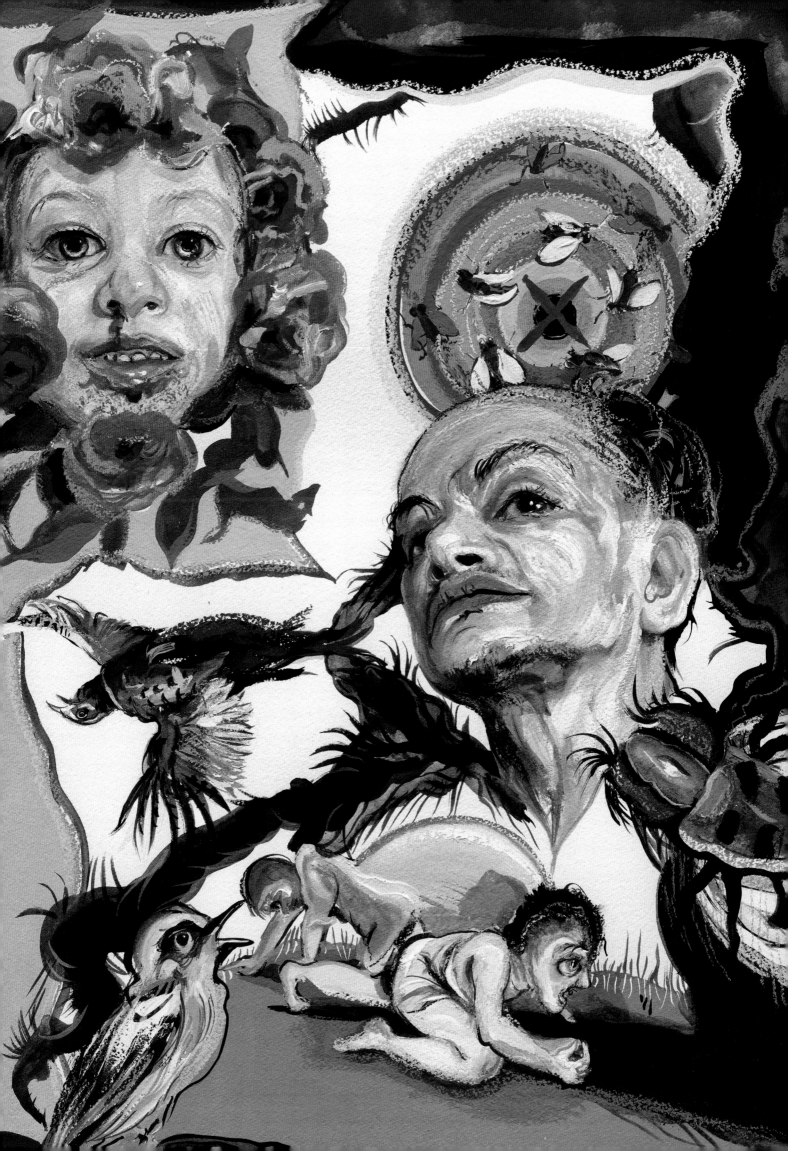

How the Tutor Arrived and How the Children Were Frightened by Him

Felix and Christlieb ran home as fast as they could, weeping as they went.

"Oh! The Mystifying Child is a handsome prince!"

"Oh! The Mystifying Child is a beautiful princess!"

Felix and Christlieb were delighted and in a hurry to tell this to their parents, but they came to a sudden stop at the door of their home, frozen like marble statues, when the baron met them there with a stranger at his side, an extraordinary looking man who muttered to himself, half intelligibly: "Ah, they seem to be a nice pair of brats."

The baron took the man by the hand and said, "This gentleman is the tutor whom your gracious uncle has sent. So, show your proper manners and say, 'How do you do, Sir?'"

But the children looked askance at the man and were unable to move either their hands or their feet. This was because they had never seen such an odd-looking creature. He was scarcely more than half a head taller than Felix, and he was a bit on the fat side. His spidery little legs formed an astonishing contrast with his body, which was stout and powerful. His shapeless head could be described as rectangular, and his face was almost too ugly to describe. Not only was his nose much too long and sharply pointed and unmatched with his chubby brownish cheeks and his wide mouth, but his prominent little eyes glittered so alarmingly that one hardly liked to look at him. Moreover, a black periwig was crammed on his four-cornered head, and he was dressed in black from top to toe. To conclude this dreadful description, his name was Tutor Inkblot.

Now, as the children stood staring, their mother became angry and cried, "Good gracious, children, what do you think you are doing? This gentleman will take you for a pair of country bumpkins! Come now and shake hands with him!"

The children took deep breaths and did what their mother told them to do. But as soon as the tutor took hold of their hands, they jumped back with loud cries: "Oh! Oh! It hurts."

The tutor laughed out loud and displayed a needle that he had hidden in his hand to prick the children. Christlieb wept, but Felix growled and said under his breath, "Just you try that again, Fatty!"

The Mystifying Child

"Why did you do that, Master Inkblot?" Baron von Brakel asked, rather annoyed.

The tutor answered, "Well, it's just the way I am! I can't change myself."

After that response, he placed his hands on his hips and went on laughing until his laughter finally sounded as bad as the noise of a broken rattle.

"You seem to be fond of your little jokes, Master Inkblot," the baron remarked. But he and his wife, and most particularly the children, were starting to feel very uncomfortable.

"Well, well," said Tutor Inkblot, "tell me, now, to what level have these little crabs crawled in their studies? Pretty well grounded in the sciences? We'll soon see."

With that, he began to question Felix and Christlieb just like their uncle and aunt had examined their cousins. But, when they both declared that, as yet, they didn't know any of the sciences by heart, Tutor Inkblot clapped his hands over his head and cried out like a man possessed: "What a pretty story, indeed! No sciences! Then we've got our work cut out for us! However, we shall soon make a job of it."

Both Felix and Christlieb could write fairly well, and they had read many old books that their father had given them. Indeed, they were fond of reading and had learned many interesting stories and could repeat them. But Tutor Inkblot despised all this and said it was stupid nonsense.

What a shame! Now, there was to be no more romping around in the forest. Instead, the children had to sit within the four walls of the house all day long and repeat things after Tutor Inkblot that they didn't understand. It was really a heartbreaking business!

The poor children looked at the forest with longing eyes! They frequently seemed to hear the Mystifying Child's voice calling to them among the cheerful songs of the birds and the rustling of the trees: "Felix! Christlieb! Aren't you coming any more to play with me? Oh, come! I've built a palace made entirely of flowers for you. We will sit there, and I'll tell you all sorts of beautiful stories. Then we'll soar into the air and build ourselves cloud castles. Come! Oh, come!"

The children's thoughts were continually drawn to the woods, and neither of them saw nor heard their tutor any longer. Consequently, the tutor would become very angry and would begin thumping on the table with both his fists, muttering, growling, and buzzing: "Bizz! Buzz! Knurr, knack! What's going on? Wait a little!"

The Mystifying Child

Felix, however, could not endure this very long. Finally, he jumped up and cried, "Don't bother me with your stupid nonsense, Master Inkblot! I'm going to the forest! You should leave us and start teaching Cousin Fancy Pants instead! That's the sort of stuff for him. Come with me, Christlieb! The Mystifying Child is waiting for us!"

However, as soon as they started off, Tutor Inkblot sprang after them with remarkable agility and grabbed them just outside the door. Felix fought bravely, and was on the verge of getting the worst of it when the faithful Sultan came to Felix's aid. Generally, Sultan was a good, kind, and well-behaved dog, but he had taken a strong dislike to Tutor Inkblot the moment he set eyes on him. Whenever the tutor came near him, he growled and waved his tail so vigorously that he nearly knocked the tutor down, managing to hit him deftly with great thumps on his little spindly legs. So, Sultan came dashing up when Felix was holding the tutor by the shoulders, and the dog clung to his coattails. At this point, Tutor Inkblot yelled shrilly, and this brought the baron to the rescue. The tutor let go of his hold on Felix, and Sultan let go of his hold on the tutor's coattails.

"He said we weren't allowed to go to the forest anymore," cried Christlieb, weeping and lamenting. And although the baron gave Felix a good scolding, he was very sorry that the children were not allowed to wander in the forest among the trees and bushes as they used to do. So, he told the tutor that he wanted him to go into the forest with them for a certain time every day. The tutor did not like the idea at all and said, "Herr Baron, if you only had a well-trimmed garden with nicely clipped bushes and fences, one might take the children for a little walk at midday. But what good is it at all to go into a wild forest?"

The children did not like their father's proposal either and said, "Why does Tutor Inkblot have to come with us to our dear forest? What business is it of his what we do there?"

How Tutor Inkblot Took the Children for a Walk in the Forest and What Happened on This Occasion

"Master Inkblot, isn't it delightful in our forest?" Felix asked, as they made their way through the rustling thickets. Tutor Inkblot grimaced and answered,

"Stupid nonsense! There's no proper path or bridge. We shall just tear our stockings. Moreover, it's impossible to have a conversation or hear a sensible word because of the abominable screeching of the birds."

"Ha, ha, Master Inkblot," Felix replied. "I see you don't know anything about singing! And I dare say you don't hear when the morning wind is talking with the bushes, and the old forest brook is telling all those delightful tales."

"And you don't even love the flowers," Christlieb joined the conversation. "Do you, Master Inkblot?"

Upon hearing this, the tutor's face became an even deeper cherry brown than usual, and he threw up his arms as if in despair.

"What stupid, ridiculous nonsense you are talking!" he cried. "Who has put such junk into your heads? Who ever heard that forests and streams are capable of engaging in rational conversation? And certainly, there's nothing of meaning in the chirping of birds. I like flowers well enough when they are nicely arranged in a room in vases. They smell then, and one doesn't require a bottle of perfume. However, there are no proper flowers in the forest."

"But don't you see those dear little lilies of the valley peeping up at you with such bright, loving eyes?" Christlieb asked.

"What? What?" the tutor screamed. "You think that flowers have eyes? Ha, ha! Nice eyes indeed! These useless things don't even have what you would call a smell!"

Upon saying this, Tutor Inkblot bent down and plucked up a handful of mayflowers, roots and all, and chucked them into the thickets. To the children it seemed almost as if they heard a cry of pain resound in the forest. Christlieb could not stop herself from weeping bitter tears, and Felix grit his teeth in anger. Just then, a little greenfinch fluttered near the tutor's nose. It landed on a branch and began a joyous song.

"That's a mockingbird, I think," said the tutor, and he picked up a stone and threw it at the poor bird, which it struck. There was silence as the bird fell dead from the green branch to the ground. Felix could no longer restrain himself and shouted, "You horrible tutor! What had this bird ever done to you so that you felt you had to kill it? Ah, where are you, dear Mystifying Child? Oh, please come! Please come now! Let us fly far, far away. I don't want to be here with this nasty man anymore. I want to go to your home with you."

Christlieb joined her brother, sobbing and weeping bitterly. "Oh, darling

child!" she cried. "Come to us! Save us! Save us! Tutor Inkblot is killing us, just like he killed the flowers and the bird."

"What do you mean by 'mystifying child'?" Tutor Inkblot asked.

But, suddenly, there was a loud whispering and rustling among the bushes, mingled with melancholy and heartbreaking tones. It was as if muffled bells were tolling far in the distance. Then a shiny cloud came sailing above them, and they saw the beautiful face of the Mystifying Child. Soon it came wholly into view, wringing its little hands while tears like glittering pearls streamed down its rosy cheeks.

"Ah, dear friends," cried the Mystifying Child in tones of sorrow, "I cannot come to you anymore. You will never see me again. Farewell, farewell! The gnome Pepser has you in his power. Oh, you poor children, goodbye, goodbye!"

And with these words, the Mystifying Child soared up far into the sky.

But, behind the children there was a horrid and fearsome sort of buzzing and humming. Then, snarling and growling, Tutor Inkblot had transformed himself into an enormous, frightful fly. And the horrible part of all this was that he had a man's face and was still wearing some of his clothes. He began to fly up into the air, slowly and with difficulty, evidently with the intention of following the Mystifying Child. Meanwhile, Felix and Christlieb were overcome with terror and ran out of the forest as quickly as they could. They did not dare look at the sky until they were far from the forest. When they did, they could see a shining speck, glittering among the clouds like a star and apparently coming nearer, and downward.

"That's the Mystifying Child!" Christlieb cried.

The star grew bigger and bigger, and as it did, they could hear a fanfare of trumpets. Soon they saw that the star was a splendid bird with magnificent shining plumage. It came soaring down to the forest, flapped its mighty wings, and sang loud and clear.

"Ha!" Felix exclaimed. "This is the Pheasant Prince. He will peck Tutor Inkblot to death. The Mystifying Child has been saved—and so are we! Come, Christlieb, let's get home as fast as we can and tell Father all about it."

The Mystifying Child

232

How Baron von Brakel Sent Tutor Inkblot Packing

Baron von Brakel and his wife, Lady von Brakel, were sitting outside the door of their simple dwelling, looking at the bright sunset, which was beginning to flare up behind the blue mountains in golden streamers. Their supper was laid out on a little table. It consisted of a large jug of delicious milk and a plate of bread and butter.

"I don't know," the baron began saying, "why Tutor Inkblot is staying out so long with the children. At first, there was no getting him to go into the forest, and now there's no getting him back from it. He really is a very strange fellow, this Tutor Inkblot, and all in all, I sometimes wish he had never come here. To begin with, I did not like his pricking the children with that needle, and I don't think his knowledge of the sciences amounts to very much either. He blabbers and spouts a lot of stuff that nobody can understand, and he can tell you what kind of gaiters the Great Mogul wears. But once he goes into nature, he can't tell a linden tree from a chestnut tree, and his behavior has always struck me as being most bizarre."

"I feel just as you do, my dear," Lady von Brakel said. "And, glad as I was that your great cousin took an interest in the children's education, I feel quite sure now that he might have done it in other and better ways than by saddling us with this Tutor Inkblot. With regard to his knowledge of the sciences, I don't pretend to understand much myself, but I know that I like this dark creature with his little spindly legs less and less every day. He has such a nasty way of gobbling things. He can't see a few drops of beer at the bottom of a glass, or milk at the bottom of a jug, without gulping them down his throat. And if he finds the sugar box open, he's at it in a moment, sniffing at the sugar and dipping his fingers inside until I clap the lid shut in his face. Then away he darts, humming and buzzing in a manner that's most disgusting and abominable."

The baron was going to continue this conversation further when Felix and Christlieb came running through the birch trees.

"Hooray! Hooray!" Felix kept shouting. "The Pheasant Prince has pecked Tutor Inkblot to death!"

"Oh, Mama dear," cried Christlieb, out of breath, "Tutor Inkblot is not a tutor at all! He's really Pepser, the King of the Gnomes, a large, monstrous fly, but a fly with a wig and shoes and stockings!"

The parents gazed at their children in utter amazement as they went on

The Mystifying Child

233

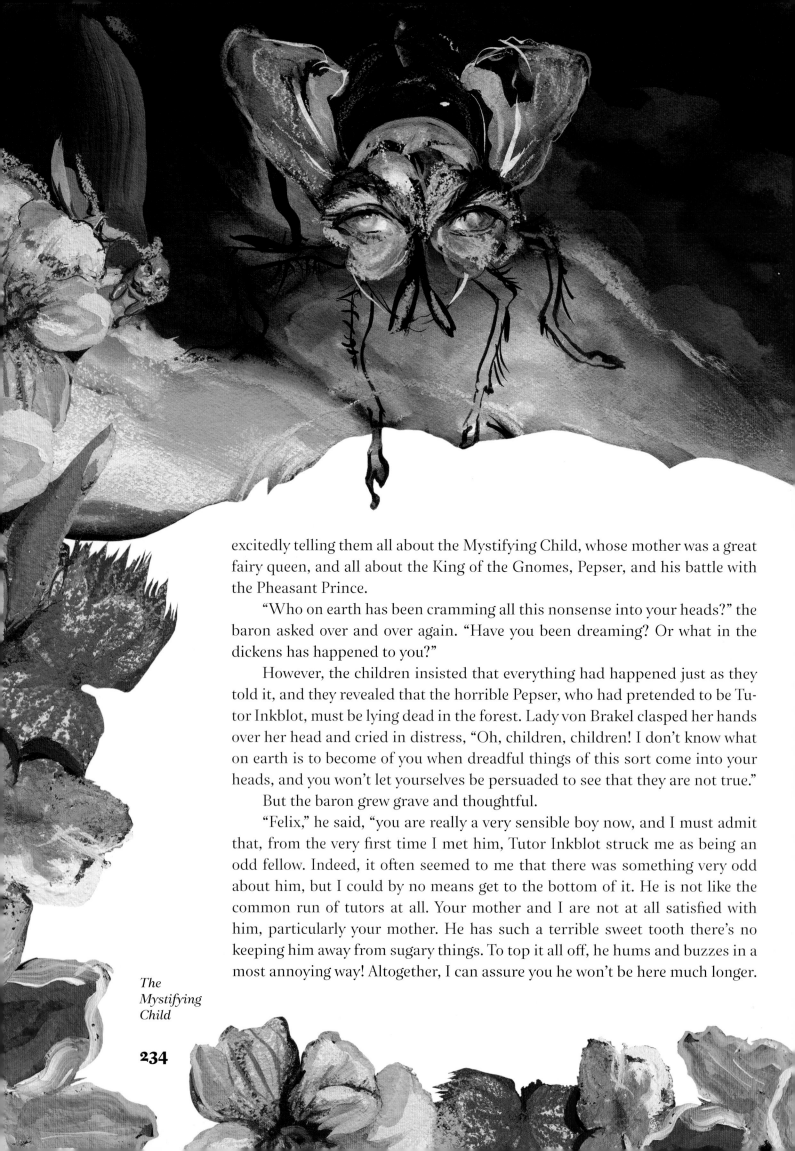

excitedly telling them all about the Mystifying Child, whose mother was a great fairy queen, and all about the King of the Gnomes, Pepser, and his battle with the Pheasant Prince.

"Who on earth has been cramming all this nonsense into your heads?" the baron asked over and over again. "Have you been dreaming? Or what in the dickens has happened to you?"

However, the children insisted that everything had happened just as they told it, and they revealed that the horrible Pepser, who had pretended to be Tutor Inkblot, must be lying dead in the forest. Lady von Brakel clasped her hands over her head and cried in distress, "Oh, children, children! I don't know what on earth is to become of you when dreadful things of this sort come into your heads, and you won't let yourselves be persuaded to see that they are not true."

But the baron grew grave and thoughtful.

"Felix," he said, "you are really a very sensible boy now, and I must admit that, from the very first time I met him, Tutor Inkblot struck me as being an odd fellow. Indeed, it often seemed to me that there was something very odd about him, but I could by no means get to the bottom of it. He is not like the common run of tutors at all. Your mother and I are not at all satisfied with him, particularly your mother. He has such a terrible sweet tooth there's no keeping him away from sugary things. To top it all off, he hums and buzzes in a most annoying way! Altogether, I can assure you he won't be here much longer.

The Mystifying Child

234

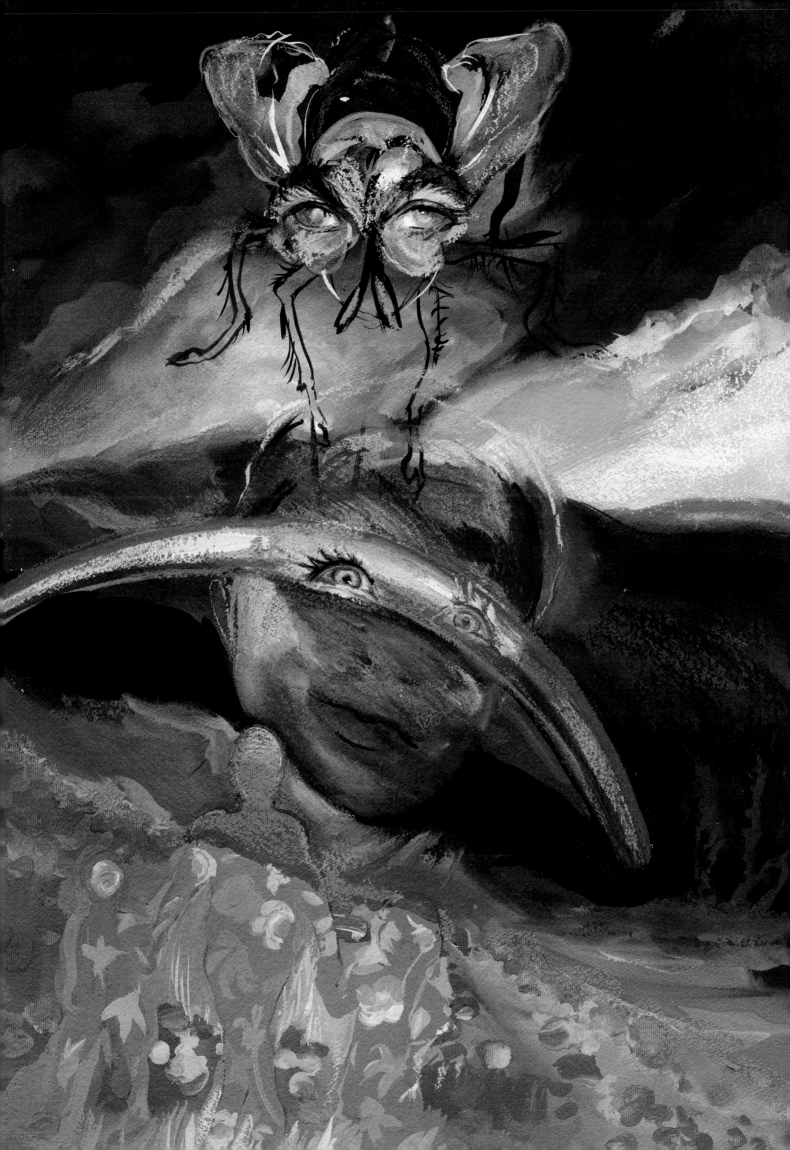

No! But now, my dear boy, just think about this calmly: Even if such nasty things as gnomes really existed in the world—I ask you now to think it over calmly and rationally—could a tutor really be a fly?"

Felix looked his father straight in the face with his clear blue eyes, as his father repeated the question. Then he replied, "Well, I never thought very much about that. In fact, I would not have believed it myself if the Mystifying Child had not said so, and if I had not seen with my own eyes that the tutor is a horrible, nasty fly and only pretends to be Tutor Inkblot." The baron shook his head in silence, like one who does not know quite what to say or think. "And then," continued Felix, "see what Mother says about his fondness for sweet things. Isn't that just like a fly? Flies are always sniffing at sweet things. And then, his hummings and buzzings!"

"Be quiet!" cried the baron. "Whatever Tutor Inkblot may really be, one thing is certain: the Pheasant Prince has not pecked him to death, for here he comes out of the forest!"

As soon as they saw the tutor, the children uttered loud screams and fled into the house. Indeed, Tutor Inkblot was approaching on the path that led from the forest through the birch trees. But he looked wild and bewildered with ghastly eyes and his wig in a mess. He was buzzing and humming and leaping high off the ground, first to one side, then to another, banging his head against the birches until the trees resounded. When he got to the house, he dashed to the milk jug, plunged his face in so the milk spilled over the sides, and gulped it down, making a horrible swallowing noise.

"For the love of heaven, Master Inkblot," cried Lady von Brakel. "What are you doing?"

"Are you out of your mind?" the baron asked. "Is the devil after you?"

But, Tutor Inkblot ignored these queries, and as soon as he lifted his face from the milk jug, he threw himself down on the dish of bread and butter. Then he fluttered over it with his coattails and somehow managed to raise his spindly legs to smooth the butter down all over. Then, with a louder buzzing, he headed for the door, but he couldn't get into the house. So, he staggered here and there as if he were drunk, banging against the windows until they rattled and rang.

"It's time for you to stop, my good friend!" cried the baron. "This is no way to behave. Look out, or you'll come to grief before you know where you are!"

And Baron von Brakel tried to catch Tutor Inkblot by the coattails, but

The Mystifying Child

236

the tutor managed to elude him. At this point, Felix came running out with his father's big fly swatter in his hand, and he gave it to the baron.

"Here you are, Papa!" he cried. "Swat the horrible Pepser to death!"

The baron took the fly swatter, and they all began chasing Tutor Inkblot. Felix, Christlieb, and their mother took table napkins and waved them in the air, driving the tutor backward and forward and here and there, while the baron kept running after him with the fly swatter, which, unfortunately, did not hit the tutor because he took good care never to stay a moment in the same spot. And so, the chase went on and on.

"Bzzz, bzzz, bzzz," went the tutor, who stormed all over the place. "Huss, huss!" went the table napkins in pursuit of the tutor. "Clip, clap." The baron took many swipes at the tutor. At last, the baron managed to hit the tutor's coattails, and he fell down with a groan. But just as the baron was getting a second chance to hit him, the tutor bounced into the air with renewed strength. Then he rushed from the house, humming and buzzing away through the birches, and was never seen again.

"A good job!" the baron said. "Now we are well rid of the horrible Tutor Inkblot. Never shall he cross my threshold again!"

"No, he definitely will not!" said Lady von Brakel. "Tutors with such objectionable manners can do nothing but mischief, just when the opposite should be the case. He bragged about his sciences but flops into the milk jug. I must say, he's nothing but a putrid tutor!"

The children laughed and shouted, "Hip, hip, hooray! Everything's all right now! Father has hit Tutor Inkblot on his nose, and we've got rid of him for good."

What Happened in the Forest after Tutor Inkblot Was Banished

Now Felix and Christlieb were able to breathe freely again. A great weight had been taken off their hearts. Above all, they could hope that the Mystifying Child would be able to return and play with them again because the threat of the horrid Pepser was gone. So, they ran into the forest full of happy expectations. But everything in the forest was silent and desolate. The cheerful finches and siskins were not singing, and instead of the merry rustling of the bushes and

the joyous voice of the brook, there were mainly sorrowful sighs in the air, and the sun cast only faint glimpses through the clouded sky. Soon, great dark clouds began to form. Thunder growled in the distance. A stormy wind howled, and the tall fir trees creaked and groaned. Christlieb clung to Felix in alarm. But he said, "What's come over you? Why are you afraid? There's going to be a thunderstorm. Do you understand? We must get home as fast as we can!"

So, they set off running, but somehow—and they didn't know why—instead of leaving the forest, they kept going farther and farther into it. It became darker and darker. Large raindrops fell, faster and faster, thicker and thicker, and flashes of lightning zoomed through the sky, hissing as they passed. The children came to a stop at the edge of tangled bushes.

"Let's get some shelter here for a while, Christlieb," Felix said. "The storm won't last long."

Christlieb was crying from fear, but she did as Felix requested. Yet, scarcely did they sit down among the thick bushes, when they heard harsh, nasty voices behind them:

"Stupid things! Dumb creatures! You despised us, and didn't know how to treat us or what to do with us. So, now you can do without any toys, stupid things that you are!"

Felix looked around and felt eerie and uncomfortable when he saw the hunter and the harpist rise out of that thicket, where he had thrown them. Moreover, they stared at him with dead eyes and waved and gesticulated with their hands. The harpist plucked his strings so violently that they produced a horrible sound, clinking and rattling. Meanwhile, the hunter went so far as to take a deliberate aim at Felix with his gun, and both toys croaked: "You just wait a little, boy! And you, too, girl! We are obedient pupils of Tutor Inkblot. He'll be here soon, then you'll be nicely paid for despising us."

The children were terrified, and despite the rain, which was now streaming in torrents, and the thunder, which was now rattling in peals, and the stormy wind, which was now roaring through the firs, they ran away from the thicket and came to the brink of the little lake that bordered the forest. But as soon as they arrived there, Christlieb's big doll, which Felix had thrown into the water, rose out of the weeds and squeaked in a grating voice, "Wait a little, boy and girl! Stupid things! Dumb creatures! You despised me, and didn't know how to treat me or what to do with me. So, now you can do without any toys, stupid

things that you are! I am an obedient pupil of Tutor Inkblot. He'll be here soon. Now you'll be nicely paid for despising me."

Then the vicious doll sent great splashes of water at Felix and Christlieb, though they were already wet from the rain. Felix could not endure this horrible haunting. Poor Christlieb was half dead. So, they ran off again as fast as they could. But, when they reached the middle of the forest, they threw themselves down on the ground, exhausted by fear and terror. Then, they heard a humming and a buzzing behind them.

"Oh, my heaven!" cried Felix. "Here comes Tutor Inkblot!"

At that moment, both he and Christlieb fainted and fell to the ground.

When they regained consciousness, they found themselves lying on a bed of soft moss. The storm was over. The sun was shining brightly and gently, and the raindrops were hanging on the glittering bushes and trees, like sparkling jewels. The children were surprised to find that their clothes were quite dry, and that they no longer felt cold or wet.

"Oh!" cried Felix, stretching his arms to the sky. "The Mystifying Child must have protected us."

And then they both shouted so loud that the forest reverberated with their cries: "Oh, dear child, please come to us again! We long to see you and cannot live without you!"

And it seemed as though a bright ray of light came darting through the trees, making the flowers lift their heads as it touched them. Even though the children called for their friend ever more movingly, nothing was to be seen. Since there was no response, they trudged home in silence and sadness. However, their parents were very glad to see them, especially because they had been exceedingly anxious about them during the storm.

"It is a good thing that you are home again," the baron declared, with a welcome. "I must confess I was afraid that Tutor Inkblot was still roaming somewhere in the forest and on your trail."

Then Felix told them all about their adventures in the forest and what had happened.

"That is all stupid nonsense," their mother said. "If you're going to dream such foolish dreams in the forest, you won't be allowed to go there anymore. You'll have to stay home."

And, indeed, no such thing happened, for when they begged to go back

The Mystifying Child

239

to the forest, their mother yielded. Then, as time passed, they didn't care very much about romping and playing in the forest. Sadly, the Mystifying Child never appeared again, and whenever they went deep into the forest, or reached the lake, they were jeered at by the harpist, the hunter, and the doll, who shouted: "Stupid things! Miserable creatures! You'll have to play without toys! You treated us poorly, we who are so clever and cultivated and above you! You stupid things! What foolish people you are!"

Since this was unbearable, the children preferred to stay at home.

Conclusion

"I don't know," said the baron to his wife, Lady von Brakel, one day, "what has been the matter with me the last few days, but I feel so strange that I really think Tutor Inkblot has put some kind of spell on me. Ever since I smashed him with the flyswatter, my limbs have felt like lead."

And, indeed, the baron did really grow weaker and paler, day by day. He gave up walking about his grounds. He no longer went bustling about the house, cheerfully ordering things, as he used to do. He sat hour after hour, deeply meditating, and would ask Felix and Christlieb to repeat to him over and over again all the stories about the Mystifying Child. Then, when they talked excitedly about the miraculous incidents connected with the Mystifying Child and about the beautiful kingdom that was the child's home, he would turn melancholy and smile. Tears would come to his eyes.

Meanwhile, Felix and Christlieb could not believe that the Mystifying Child did not want to see them anymore and that the child had left them exposed to the nasty behavior of those troublesome toys in the thicket. This was why they didn't like to frequent the forest much at all. But one bright and beautiful morning, the baron said to Felix and Christlieb, "Come along, children. Let's go to the forest together. I won't let Tutor Inkblot's nasty pupils do you any harm."

So, he took them by their hands, and all three went together into the forest, which that day was brimming with bright sunshine, delicious odors, and beautiful songs. Once they laid down among the tender grass and the sweet-scented flowers, the baron began as follows: "My dear children, for some time I have

The Mystifying Child

had a great longing to tell you something important, and I cannot delay doing so any longer. Once upon a time, I knew the odd Mystifying Child who used to show you such lovely things in the forest. In fact, I knew him just as well as you did yourselves. When I was about your age, the child used to come to me, too, and he played with me in the most wonderful way. I cannot quite remember why the child eventually left me, and I don't understand how I had so completely forgotten all about it until you spoke to me about what had happened to you. At first, I didn't believe you, though I often had a sort of faint recollection and suspected that what you told me was the truth. But within the last few days, I have been remembering and thinking about the delightful days of my own boyhood in a way that I have not been able to do for many a long year. And then that magical child jolted my memory, bright and glorious, and I saw the child just as you yourselves saw this creature. Also, the same longing that filled your hearts ignited mine, too. But it is breaking my heart! I know quite well this is the last time that I shall ever sit beneath these lovely trees and bushes. I am going to leave you very soon, and when I am dead and gone, you must cling tightly to that beautiful child."

Felix and Christlieb were grief-stricken, and burst into tears.

"No, no, Papa," they lamented. "You are not going to die! You are going to live with us for a long time yet. You'll play with us and with the Mystifying Child together."

But the very next day, the baron lay sick in his bed. A tall, thin man came, felt his pulse, and announced, "You'll soon be better!"

But he did not become better. On the third day, Baron von Brakel was no longer alive. Oh, how Lady von Brakel mourned! How the children wrung their hands and cried, "Oh, Papa! Our dear, dear Papa!"

Soon, when the four peasants of Brakelheim had carried their master to his grave, some nasty fellows, who looked like Tutor Inkblot, appeared, and they told Lady von Brakel that they had come to take possession of the entire estate, the house and everything in it, because the deceased baron owed all that and more to his cousin, Count Cyprianus von Brakel, who could not wait any longer for his money.

In short, Lady von Brakel became destitute and was forced to leave the pretty little village of Brakelheim, where she had spent so many happy years. So, she decided to go live with a relative not very far away. She and the children

packed up whatever little clothes and effects they owned. Then, grief-stricken, they left the house. As they crossed the bridge and heard the loud voice of the forest stream, Lady von Brakel fell down, and Felix and Christlieb kneeled beside her. They wept with many sobs and tears.

"Oh, how unfortunate we are!" Felix and Christlieb cried. "Is there nobody who will take any pity on us?"

All of a sudden, the distant roar of the forest stream seemed to turn into beautiful music. The thickets uttered wondrous sighs, and the entire forest radiated with sparkling lights. Soon, the Mystifying Child appeared out of the sweet-smelling leafage surrounded by such a brilliant light and radiance that Felix and Christlieb had to close their eyes. Then they felt themselves gently touched, and the Mystifying Child's beautiful voice said, "Oh, dear friends, do not mourn! Do you think that I don't love you anymore? Can I ever leave you? No, no! Although you may not see me with your eyes, I shall always be with you and around you, doing all that I can to help you with all my power so that you will always be happy and fortunate. Keep me in your hearts as you have done up to now. Neither the wicked Pepser, nor any other wicked creature will have power over you or will harm you. Only continue to love me truly and faithfully."

"We shall! We shall!" the children cried. "We love you with all our hearts!"

When they were able to open their eyes again, the Mystifying Child had vanished, but all their misery and pain had disappeared, and they felt a heavenly joy had ignited within their hearts. Lady von Brakel recovered slowly from her swoon and said, "Children, I saw you in a dream. You seemed to be standing in a blaze of gleaming gold, and this image has strengthened and refreshed me in a wonderful way."

Upon hearing this, the children's eyes beamed with delight, and their cheeks turned bright red. They told their mother how the Mystifying Child had come to them and comforted them. And their mother said, "I don't know why I feel compelled to believe in this story of yours today, nor how my believing in it seems to have taken away all my sorrow and anxiety. Let us continue on our way with confidence."

When they arrived at the house of their relatives, they were kindly welcomed, and everything that the Mystifying Child had promised was realized. Whatever Felix and Christlieb undertook was bound to succeed, and they and their mother became quite happy. And, as their lives went on, they still played with the Mystifying Child in their dreams, which never ceased to bring them the loveliest wonders from the child's fairy realm.

The Mines of Falun

ON A BRIGHT SUNNY DAY in July, the people of Göteborg gathered at the waterside to greet the splendid ship, the *East Indiaman*, which lay at anchor in the Klippa Harbor, having safely returned home from trading and doing business with foreign countries. Swedish flags fluttered and waved cheerfully in the blue sky. Hundreds of boats, skiffs, and other small crafts were packed with jubilant sailors, and they drifted back and forth on the crystal waves of the Gotha Elf. Meanwhile, the cannons of Masthuggstorget thundered, sending greetings that echoed across the wide-open sea. The gentlemen of the East Indies Company wandered back and forth along the quay, and, with smiling faces, they calculated how much they had benefited from

243

their prosperous undertaking. They were especially delighted with their daring enterprise, which had increased every year and enabled their beloved city of Göteborg to flourish and bloom gloriously from their overseas trade. As a result, with pleasure and pride, everyone admired these valiant gentlemen because their profits added vigor to the bustling life of the entire city.

The crew of the *East Indiaman* was about one hundred and fifty men strong, and they came to the land in many boats, well dressed for the occasion, for it was time to celebrate the festival of Hönsning, which often lasted several days. The musicians, dressed in wondrous, bright costumes, arrived before them, playing enthusiastically on violins, flutes, oboes, and drums, while others sang all kinds of merry songs. They were followed by members of the crew in pairs, some with colorful ribbons on their jackets and hats, who were waving and fluttering streamers. Others danced and jumped, and as they shouted and rejoiced, the boisterous racket echoed far and wide.

So it was that the merry groups of people formed a parade and marched through the streets until they came to Haga, the neighborhood where they were awaited in a tavern by a banquet of food and booze, which they were expected to consume. Now the best wine and beer flowed, toast after toast was made, and mugs were emptied. As is always the case when sailors return home from a long journey, all kinds of dressy ladies joined them. Then, as soon as dancing began, it became so wild that the celebration burst with joy and became loud and crazy.

Only one single sailor—a slender, handsome young man, not more than twenty—crept away from the tumult and sat down alone outside on the bench at the door to the tavern. A couple of sailors went over to him, and one of them laughed and cried out: "Elis Fröbom! Elis Fröbom! Are you playing the sad fool again and ruining our wonderful celebration by sulking? Listen, Elis, if you're not going to participate in our Hönsning celebration, then you should stay away from our ship altogether. Anyway, you don't have the making of a good and proper sailor. You certainly have enough courage when there's danger, but you don't know how to booze at all. You'd rather keep the ducats in your pocket than spend them generously and throw them into the pockets of the landlubbers. Drink, my boy! If you don't, Näcken, the sea devil, and all the trolls will come and attack you!"

Elis Fröbom jumped up quickly from the bench, glared at the sailor with a scorching look, grabbed the mug that was filled to the top with brandy, and emptied it in one swig. Then, after sitting down again, he said: "You see, Joens,

I can hold my liquor as well as anyone, and it's up to the captain to decide whether I'm fit to be a sailor. So, shut that filthy mouth of yours, and get out of my sight! I detest your wild celebrating. It's no concern of yours what I'm doing out here by myself!"

"Now, now," Joens replied. "I know for sure you were born a Nericka, and that Nerickas are gloomy, and they don't enjoy a lively sailor's life! But just wait here, Elis. I'm going to send someone who'll soon tear you from that venerable bench to which you seem to have been nailed by the sea devil."

It didn't take long before a beautifully dressed girl came out of the tavern and sat down next to the melancholy Elis, who was still sitting silently and pensively on the bench. It was easy to discern from her appearance that she had unfortunately succumbed to a terrible calling. However, the life she was leading had not yet marred the delicacy of the wonderfully tender features of her sweet face. There was no trace of repressive impudence. No, instead, a quiet, sad longing emanated from her dark eyes.

"Elis, don't you want to take part in the celebration of your comrades? Don't you feel happy at all now that you've escaped the danger of the sea's deceptive waves and have returned home again safe and sound?"

The girl spoke in a soft, gentle voice, while she put her arm around him. Then, as if he had been wakened from a dream, Elis Fröbom looked into her eyes and took her hand. He pressed her to his chest, and it was clear that her words had sunk deeply into his heart.

"Ah!" he finally began. "Ah, it's no use at all talking about enjoying myself or celebrating the festivities. I have no desire to take part in all the romping and rollicking of my comrades. Go back inside, my dear girl, celebrate and shout with the others, if you can. But leave the gloomy Elis alone out here. He would only spoil your pleasure. But wait a minute! I like you, and I want you to think of me when I'm sailing on the sea again."

Upon saying this, he took two shining ducats out of his side pocket and a beautiful Indian kerchief from his breast pocket and gave them to the girl. But tears burst from her eyes, and, as she stood up, she laid the ducats on the bench and said: "Oh, keep your ducats. They make me sad. But I'll wear the beautiful kerchief in your memory. More than likely, you won't find me here next year when you hold your Hönsning in the Haga."

Upon saying this, she slipped away down the street with both her hands pressed against her face. Meanwhile, Elis sank once again into somber dreaming, and when the jubilation in the tavern became too loud and wild, he cried out: "Oh, if only I lay buried in the deepest grave beneath the sea! There is not a single

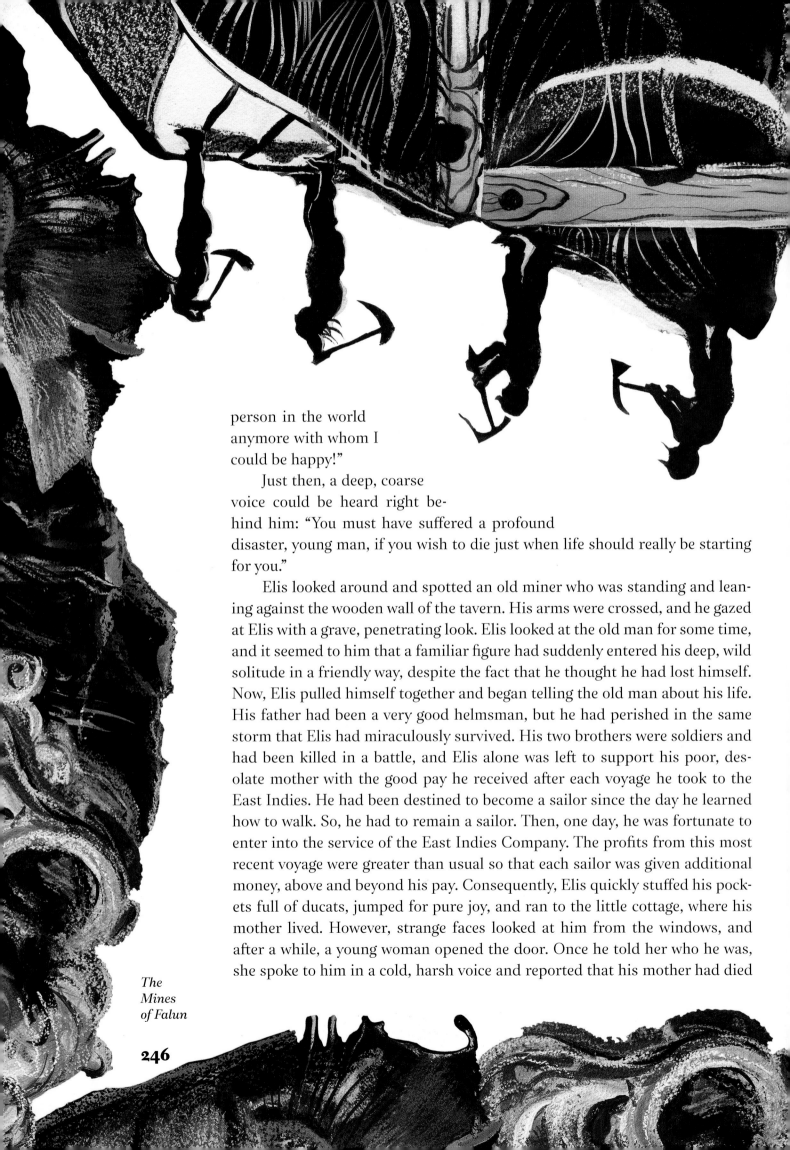

person in the world
anymore with whom I
could be happy!"

Just then, a deep, coarse
voice could be heard right be-
hind him: "You must have suffered a profound
disaster, young man, if you wish to die just when life should really be starting
for you."

Elis looked around and spotted an old miner who was standing and lean-
ing against the wooden wall of the tavern. His arms were crossed, and he gazed
at Elis with a grave, penetrating look. Elis looked at the old man for some time,
and it seemed to him that a familiar figure had suddenly entered his deep, wild
solitude in a friendly way, despite the fact that he thought he had lost himself.
Now, Elis pulled himself together and began telling the old man about his life.
His father had been a very good helmsman, but he had perished in the same
storm that Elis had miraculously survived. His two brothers were soldiers and
had been killed in a battle, and Elis alone was left to support his poor, des-
olate mother with the good pay he received after each voyage he took to the
East Indies. He had been destined to become a sailor since the day he learned
how to walk. So, he had to remain a sailor. Then, one day, he was fortunate to
enter into the service of the East Indies Company. The profits from this most
recent voyage were greater than usual so that each sailor was given additional
money, above and beyond his pay. Consequently, Elis quickly stuffed his pock-
ets full of ducats, jumped for pure joy, and ran to the little cottage, where his
mother lived. However, strange faces looked at him from the windows, and
after a while, a young woman opened the door. Once he told her who he was,
she spoke to him in a cold, harsh voice and reported that his mother had died

*The
Mines
of Falun*

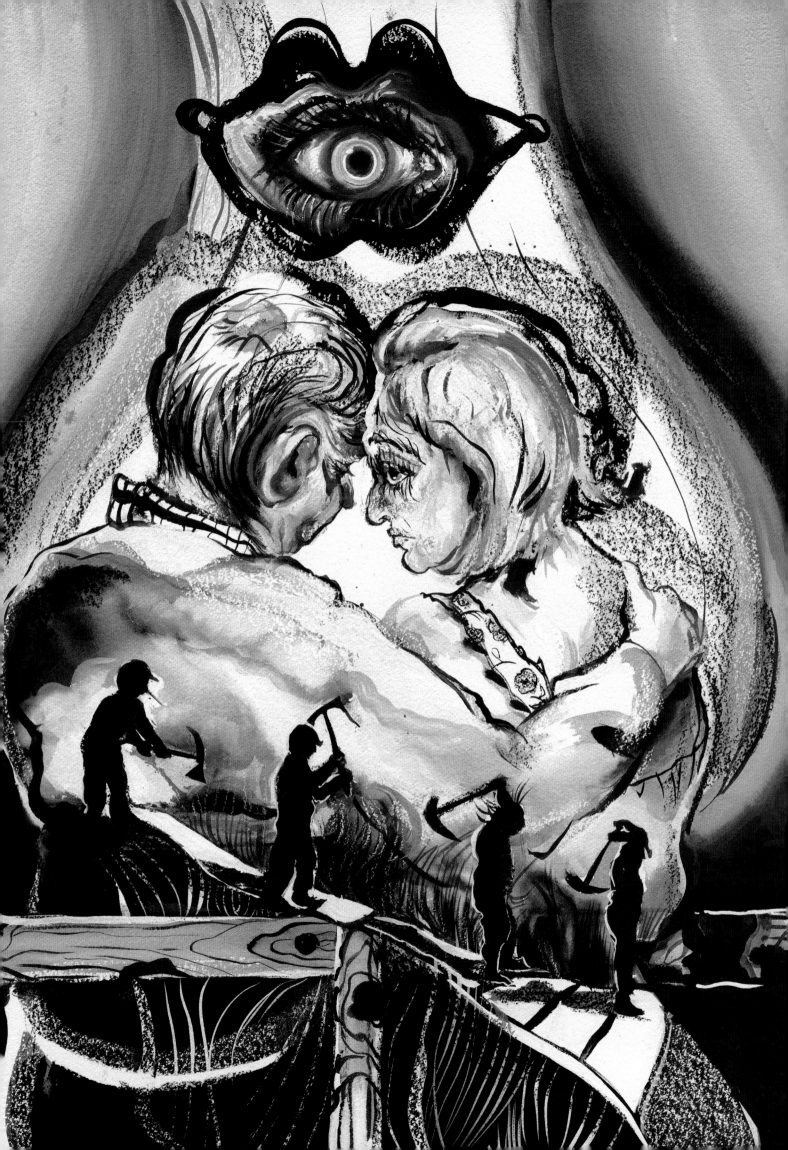

three months before, and that he would find the few things that were left behind at the town hall, but he could only take possession of them after he settled the costs of the funeral.

His mother's death ripped Elis's heart in two, and he felt himself forsaken by everyone—as if he were all alone on a barren reef, miserable and helpless. His life at sea seemed to him to be a muddled, purposeless existence. When he thought of his mother with strangers, hired to look after her and who treated her badly, and when he pictured her dying without consolation, he thought it was a wrong and horrid thing to have gone on a voyage, and that he should have remained at home to look after his poor mother and give her the proper care that she needed. Seeing Elis so depressed, his comrades had convinced him to go with them to the Hönsning festivities to cheer him up, and he himself had thought that the laughter and merriment, along with all the hard drinking, might numb the pain. Yet, instead, all the veins in his body seemed to have burst, and he felt that he might bleed to death.

"Well then," said the old miner, "you'll soon take to the sea again, Elis, then you'll no longer suffer any pain. Old people die. There's nothing you can do about it, and you yourself have admitted that your mother left an arduous life behind her."

"Ah!" Elis responded. "Ah, if only someone would believe in my gloom and agony! People just think I'm foolish. But all this is what is driving me out of the world. Well, I don't like to go to sea anymore. The sailor's life disgusts me. There was a time when my heart pounded as the ship spread its sails like glorious wings and flew over the sea, and the waves splashed and roared in tune to the merry music, and the wind whistled through the rigging. At that time, I could let loose and shout cheerfully with my comrades on the top deck. When I had watch duty on silent dark nights, I used to think of returning home to my good old mother and how she would rejoice when Elis was by her side! Ah, yes! That was a time when I could enjoy Hönsning, when I could shake the ducats into my little mother's lap and give her beautiful shawls and all the other rare gifts that I brought her from foreign lands. Then her eyes would sparkle with joy, and she would clap her hands in pleasure as she ran back and forth in the kitchen, and she would fetch the finest ale that she had stored in the cellar for her son's homecoming. And when I saw her in the evenings, I would tell her about the strange folk I had met, and all about their customs and also about

The Mines of Falun

all the other wonderful things I had encountered during the long voyage. She took great delight in hearing all this, then she would tell me about my father's wonderful journeys in the far north, interspersed with lots of terrifying and strange sailor's yarns that I had heard a hundred times and yet could not hear enough! Oh, how can I ever experience this joy again? No, I shall never return to the sea! I can't bear the company of my comrades, who, anyway, would scorn me, since I no longer have any desire to return to sailor's work, which seems to me to be laborious without any meaning!"

"I hear you," the old man said, when Elis stopped talking. "I've listened to you with great pleasure, my boy. I've been observing you for the last two hours without your knowledge. You've been delightful. Indeed, everything that you've said and done proves to me that you possess a deep, introverted, pious, and childlike disposition. Heaven could not have bestowed upon you more precious gifts. But never in all your born days have you been suited for a sailor's life. How can a quiet, almost somber, Nericka like you—your features and whole disposition reveal all this—follow a wild and unsettled sailor's life on the sea. You are doing the right thing by giving up that life forever. But you're not going to walk around idly with your hands in your pockets, are you? Take my advice, Elis Fröbom! Go to Falun and become a miner. You are young and strong. It won't take long for you to become a qualified miner, then a hewer, master miner, and higher up the ladder. You have a lot of ducats in your pocket. Take care of them. Invest them and add more. In no time, you'll likely get a miner's license and then a share in the works. Take my advice, Elis Fröbom. Become a miner!"

Elis was almost frightened by the old man's words.

"What?" he cried. "What are you advising me to do? Do you want me to leave the beautiful, free earth and the bright, sunny sky that surrounds me, revives me, and refreshes me? Am I to go down into the dreadful depths of hell and dig and bore for minerals and metals just for the sake of a vile profit?"

"That's always the way it is!" cried the old man angrily. "That's the way people are! You all despise what you don't understand! Vile profit? As if all the atrocious struggles happening above ground by commerce are nobler than the labor of a miner, whose knowledge and untiring hard work reveal nature's most secret treasures? You talk about vile profit, Elis Fröbom! But there is something more valid and higher that needs to be taken into consideration. When the mole burrows beneath the ground with blind instinct, it may be that, in the deepest

The Mines of Falun

249

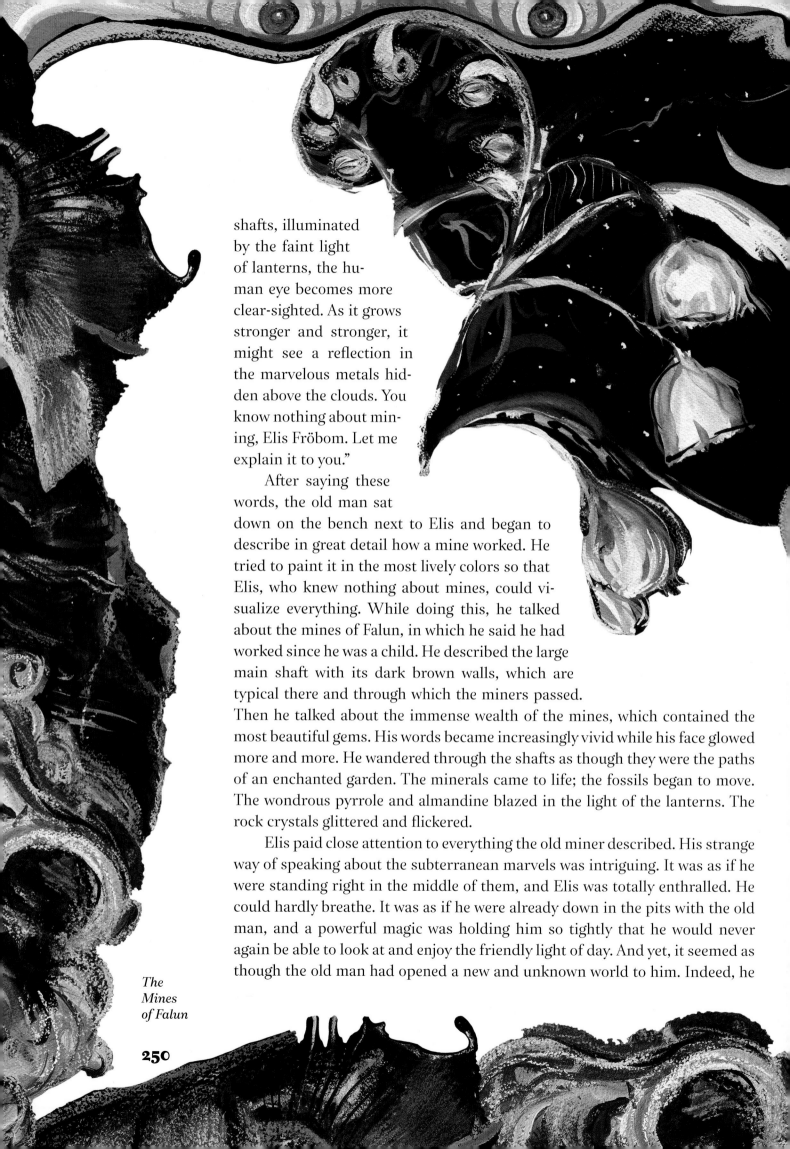

shafts, illuminated by the faint light of lanterns, the human eye becomes more clear-sighted. As it grows stronger and stronger, it might see a reflection in the marvelous metals hidden above the clouds. You know nothing about mining, Elis Fröbom. Let me explain it to you."

After saying these words, the old man sat down on the bench next to Elis and began to describe in great detail how a mine worked. He tried to paint it in the most lively colors so that Elis, who knew nothing about mines, could visualize everything. While doing this, he talked about the mines of Falun, in which he said he had worked since he was a child. He described the large main shaft with its dark brown walls, which are typical there and through which the miners passed. Then he talked about the immense wealth of the mines, which contained the most beautiful gems. His words became increasingly vivid while his face glowed more and more. He wandered through the shafts as though they were the paths of an enchanted garden. The minerals came to life; the fossils began to move. The wondrous pyrrole and almandine blazed in the light of the lanterns. The rock crystals glittered and flickered.

Elis paid close attention to everything the old miner described. His strange way of speaking about the subterranean marvels was intriguing. It was as if he were standing right in the middle of them, and Elis was totally enthralled. He could hardly breathe. It was as if he were already down in the pits with the old man, and a powerful magic was holding him so tightly that he would never again be able to look at and enjoy the friendly light of day. And yet, it seemed as though the old man had opened a new and unknown world to him. Indeed, he

The Mines of Falun

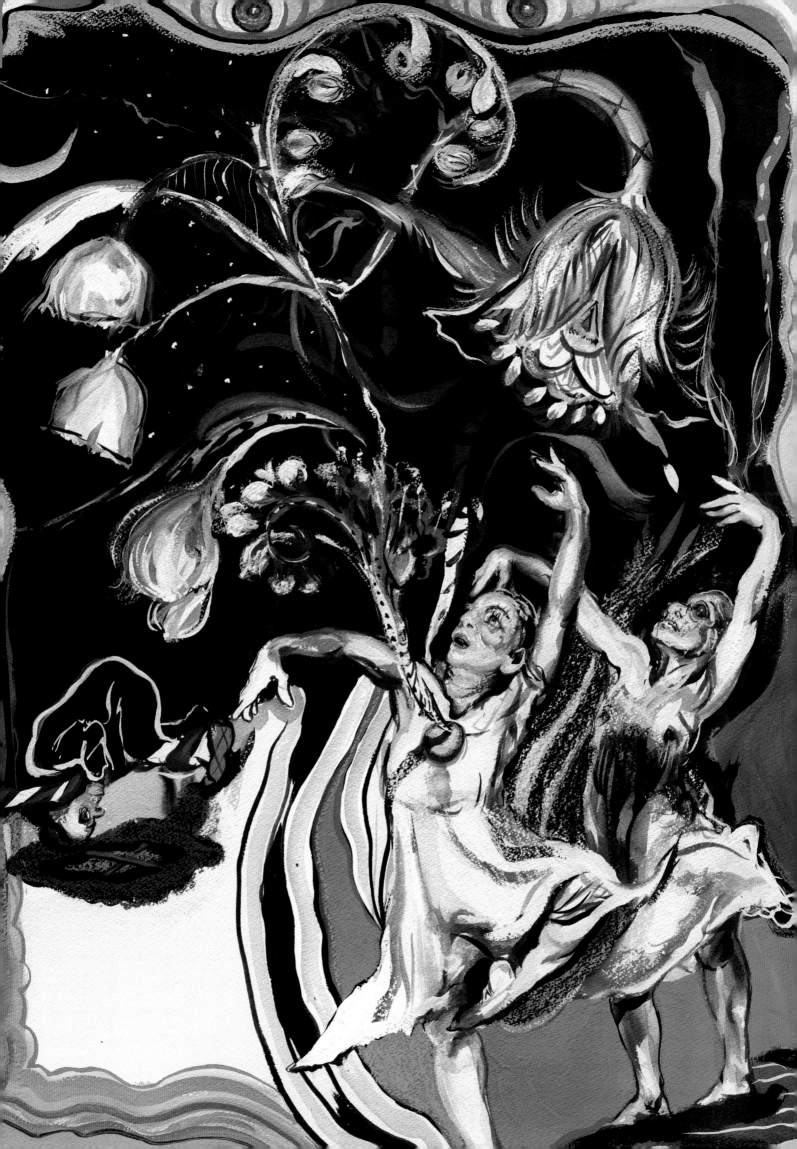

felt he belonged to this world and had somehow felt all its magic in secret forebodings since his childhood.

"I have shown you, Elis Fröbom," the old man said at last, "the splendor of a calling that nature has truly prescribed for you. Now, go and think it over, then do what you feel is best for you."

After saying all this, the old man sprang quickly from the bench and walked away without saying goodbye or even looking at him. He was soon out of sight. Meanwhile, it was silent in the tavern. The strong ale and brandy had triumphed. Many of the sailors had slipped away with the women. Others were lying and snoring in the corners of the tavern. Since Elis could no longer return to his old home, he requested and was given a tiny room to sleep in. Yet, no sooner had he thrown himself onto the bed, exhausted, than dreams began to weave their spell over him. It seemed to Elis that he was sailing on a beautiful ship with a full sail on a sea smooth as glass under a sky overcast with dark clouds. Yet, when he looked down at the waves, he soon saw that what he had thought was the sea was actually a solid, transparent, sparkling mass, and that, in some strange manner, the whole ship melted away in the shimmer of that mass so that he was left standing on a crystal floor and could see over him a vault of shining black stone, which he had at first taken for clouds.

Driven by some unknown power, Elis moved onward. However, just at that moment everything around him began to move, and wonderful plants and flowers made of glittering metal came shooting up out of the crystal mass he was standing on, and they entwined their leaves and blossoms in a graceful manner. The ground was so clear that Elis could easily recognize the roots of the plants. But soon, as his gaze penetrated deeper and deeper, he saw innumerable beautiful maidens embracing each other with gleaming white arms, and from their hearts, the roots, plants, and flowers were sprouting. When these maidens smiled, a sweet sound rang throughout the vault above, and the wonderful metal flowers, waving their leaves and branches in joy, shot up higher. Soon an indescribable feeling of pain and pleasure gripped Elis—a world of love, longing, and burning desire exploded within him.

"Down, down to you!" he cried, as he flung himself with outstretched arms on the crystal floor. However, it gave way under him, and he seemed to be floating in shimmering ether.

"Now what, Elis Fröbom? How do you like all this splendor?" a booming voice yelled.

Elis looked around and became aware that the old miner was standing next to him. But the more he gazed at the old man, the more it seemed that he had grown into a gigantic figure in glowing bronze. Elis was almost horrified, but just at that moment a flash of light zoomed from the deep abyss, and the earnest face of a powerful lady became visible. Elis felt the rapture of his heart growing and growing until it almost erupted into dreadful agony. Then, the old man grabbed him and cried out: "Beware, Elis Fröbom. Here is the queen! You may look up to her now."

He turned his head involuntarily and became aware that the stars of the nocturnal sky were shining through a crack in the vault. A soft voice, as if in inconsolable sorrow, called his name. It was the voice of his mother. He thought he saw her figure through the crack overhead. But it was a beautiful young woman who was calling his name and stretching her hands down into the vault.

"Pick me up and carry me," she cried to the old man. "I belong to the upper world and its friendly sky."

"Watch out!" the old man cried in a muffled voice. "Take care of yourself, Elis Fröbom! Be true to the queen to whom you have surrendered your life!"

But now, when the young man looked once again at the solemn face of the beautiful lady, he felt himself melting and dissolving into the glittering minerals. Overwhelmed with fear, he screamed aloud and awoke from the wondrous dream, whose bliss and horror echoed deep within his being.

When he pulled himself together, Elis said to himself: "I suppose it couldn't have been otherwise. It really could not have been otherwise. It's clear: I had to have a strange dream like this. Didn't the old miner tell me so much about the splendors of the underworld that he filled my head with all sorts of ideas? But never in my life have I felt like I do now. Perhaps I'm still dreaming. No, no. I'm probably only sick. It's time to get some fresh air. The sea breeze will soon cure me."

Elis pulled himself together and ran to the Klippa Harbor, where the boisterous celebration of Hönsning had resumed. But he soon found that he really couldn't enjoy himself, that he couldn't keep his mind on anything, and that ideas and wishes, which he was unable to put into words, crisscrossed in his mind. He thought of his mother's death with the most bitter sorrow. Yet, then again, it seemed that what he longed for most was to see that girl again—the one to whom he had given the handkerchief as a gift—who had spoken so friendly

The Mines of Falun

253

to him the evening before. And yet, he was afraid that if he were to encounter her on some street, she would turn out to be the old miner in the end. Indeed, Elis was afraid of the old miner, even though he would have liked to hear more about the splendors in the mines.

While torn by all these thoughts, he looked down into the water and imagined he saw the silver ripples harden into a sparkling glimmer in which the beautiful great ships dissolved, while the dark clouds, which were beginning to gather and obscure the blue sky, seemed to sink down and thicken into a vault of rock. He was dreaming again and gazing into the solemn face of the powerful lady, and the disturbing anxiety of passionate longing took possession of him once again.

All of a sudden, Elis's shipmates shook him from his daydreaming and sought to get him to join their revelry. However, a mysterious voice seemed to whisper in his ear: "Why are you still here? Away, away! Your home is in the mines of Falun. All the splendors that you saw in your dream are awaiting you. Away, away to Falun!"

For three days, Elis wandered through the streets of Göteborg, constantly haunted by the wondrous images of his dream, continually warned by the unknown voice. On the fourth day, he was standing at the gate through which the road to Gävle goes, when a tall man passed him as he walked through the gate. Elis believed that he recognized the old miner and ran after the man but could not catch up to him. Helplessly, he trailed after him. Elis knew with certainty he was on the road to Falun, and this circumstance calmed him in a curious way, for he felt certain that the voice of destiny had spoken to him through the old miner, and that he was now leading Elis to his appointed place and fate. In fact, many times, when he was uncertain about the road he was following, the old man would suddenly appear out of some ravine, or from thick bushes or dark rocks, and walk ahead of him, without turning around. Then he would quickly disappear again.

At last, after many difficult and weary days wandering on the roads, Elis saw two large lakes in the distance with thick steam rising between them. As he climbed the hill westward, he was able to distinguish some towers and black roofs rising through the smoke. All at once, the now gigantic old man appeared before him. With an outstretched arm, he pointed toward the steam, then disappeared again among the rocks.

"That's Falun!" cried Elis. "That's Falun, my journey's destination!"

He was right. And people, coming up from behind him, confirmed that the town of Falun lay between the lakes Runn and Varpan, and that the hill he was

climbing was the Guffrisberg, where the entrance to the main shaft of the mine was located. So, he walked onward with his mind reassured. But when he reached the enormous abyss, which looked like the jaws of hell itself, his blood curdled in his veins, and he stood as if he had been turned to stone at the sight of this colossal work of destruction.

It is well known that the main entrance to the Falun mines is some twelve hundred feet long, six hundred feet broad, and one hundred and eighty feet deep; its dark brown sides descend, for the most part, perpendicularly down at first, until about half way, when they slope, with enormous accumulations of stones and refuse, inward toward the center. The remains of old shafts, formed by strong tree trunks set close together and strongly joined at the ends, in the way that block houses are built, peeped out here and there. Not a tree, not a blade of grass, was to be seen in all the bare, blank, crumbling disorder of stony chasms. The jagged, indented masses of rock displayed wondrous forms all around, often appearing as monstrous animals or colossal human beings turned to stone. In the abyss, there was wild confusion—stones, slag, and scoria, and an eternal, stupefying sulfur vapor rose from the depths, as if hell broth, reeking poisons and killing all the green air of nature, were being brewed down below. One would think this was where Dante went down and saw the Inferno, with all its horrors and morbid agony.

As Elis looked down into this monstrous gullet, he remembered what an old helmsman on his ship had once told him. At a time when he was down with fever, this shipmate thought the sea had suddenly gone dry, and the boundless depths of the abyss had opened under him, so he could see all the horrible creatures of the deep that were twining and writhing about in dreadful contortions among thousands of extraordinary shells and groves of coral until they died with all their mouths gaping. The old helmsman said that to see such a vision meant death in the waves before long, and, in fact, very soon thereafter, he did fall overboard, no one knew exactly how, and he drowned because nobody could rescue him.

Elis thought of that because the abyss seemed to him to be a good deal like the bottom of the sea run dry, and the black rocks, and the blue and red slag and scoria were like horrible monsters extending polypus arms toward him. Just then, some miners happened to be coming up from their work in the mine, and in their dark mining clothes and with their grimy black faces they resembled ugly, diabolical creatures of some sort, slowly and painfully crawling and forcing their way up to the surface.

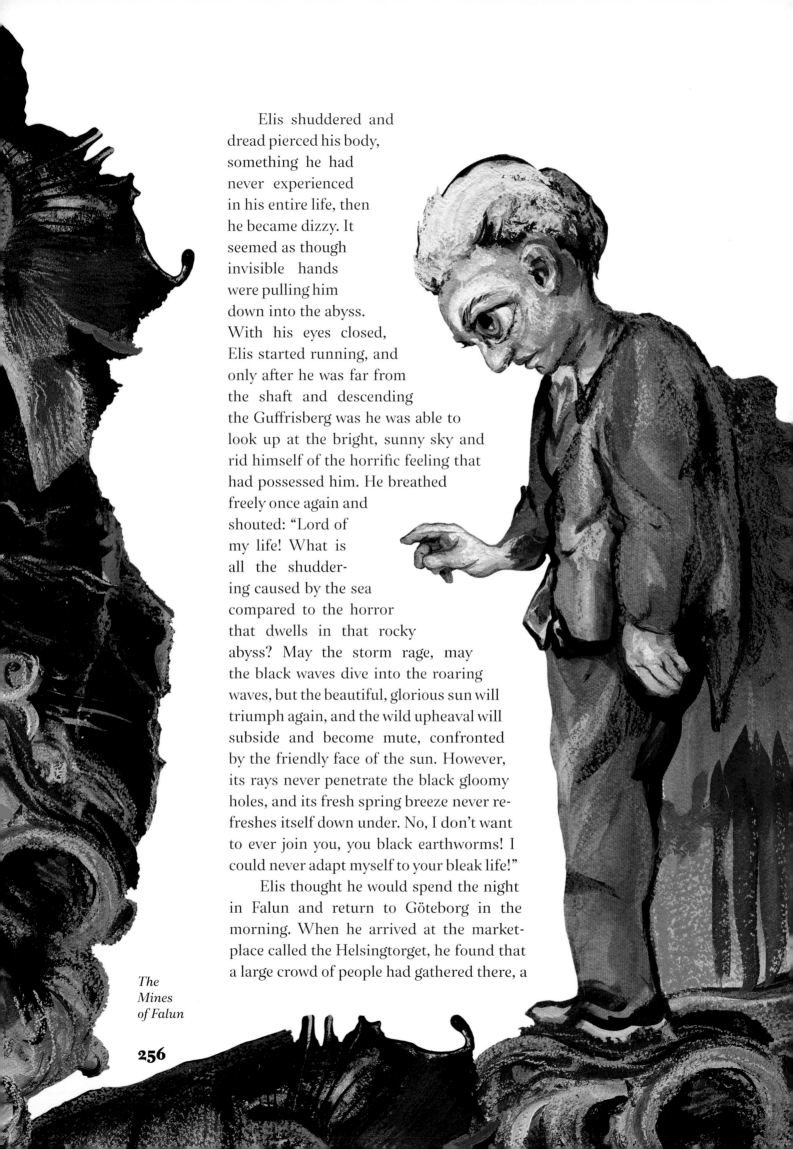

Elis shuddered and
dread pierced his body,
something he had
never experienced
in his entire life, then
he became dizzy. It
seemed as though
invisible hands
were pulling him
down into the abyss.
With his eyes closed,
Elis started running, and
only after he was far from
the shaft and descending
the Guffrisberg was he was able to
look up at the bright, sunny sky and
rid himself of the horrific feeling that
had possessed him. He breathed
freely once again and
shouted: "Lord of
my life! What is
all the shudder-
ing caused by the sea
compared to the horror
that dwells in that rocky
abyss? May the storm rage, may
the black waves dive into the roaring
waves, but the beautiful, glorious sun will
triumph again, and the wild upheaval will
subside and become mute, confronted
by the friendly face of the sun. However,
its rays never penetrate the black gloomy
holes, and its fresh spring breeze never re-
freshes itself down under. No, I don't want
to ever join you, you black earthworms! I
could never adapt myself to your bleak life!"

Elis thought he would spend the night
in Falun and return to Göteborg in the
morning. When he arrived at the market-
place called the Helsingtorget, he found that
a large crowd of people had gathered there, a

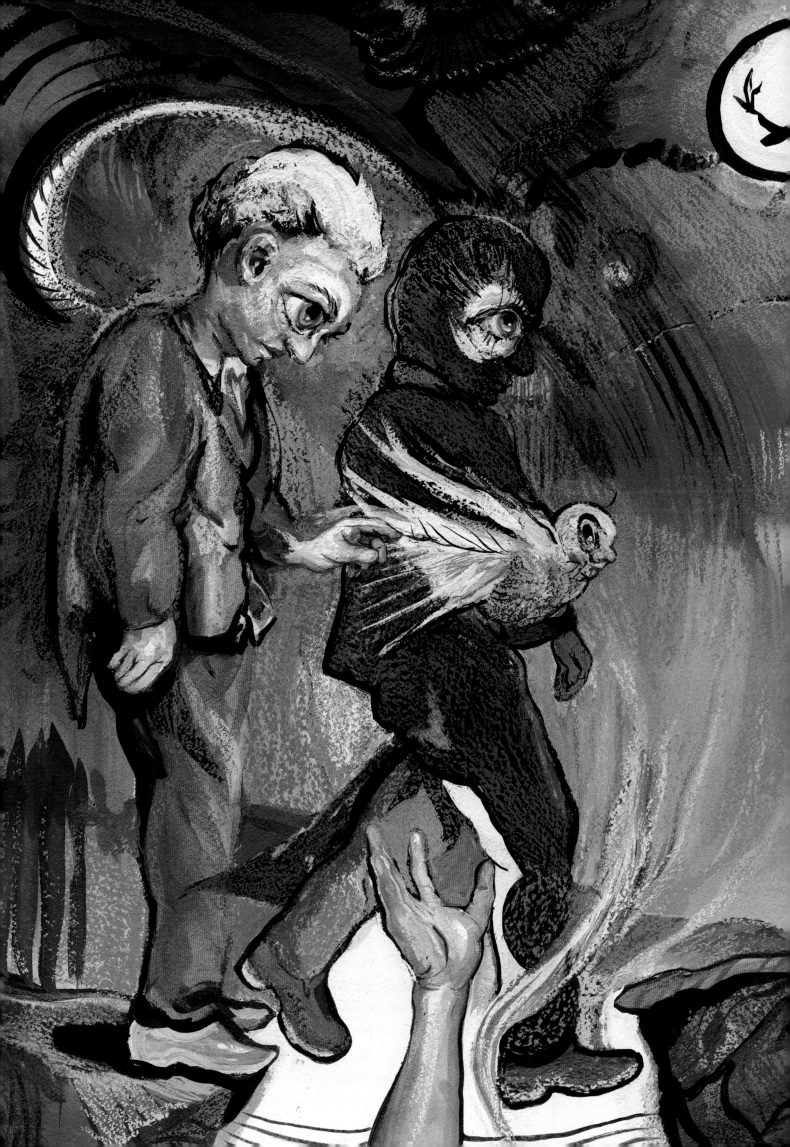

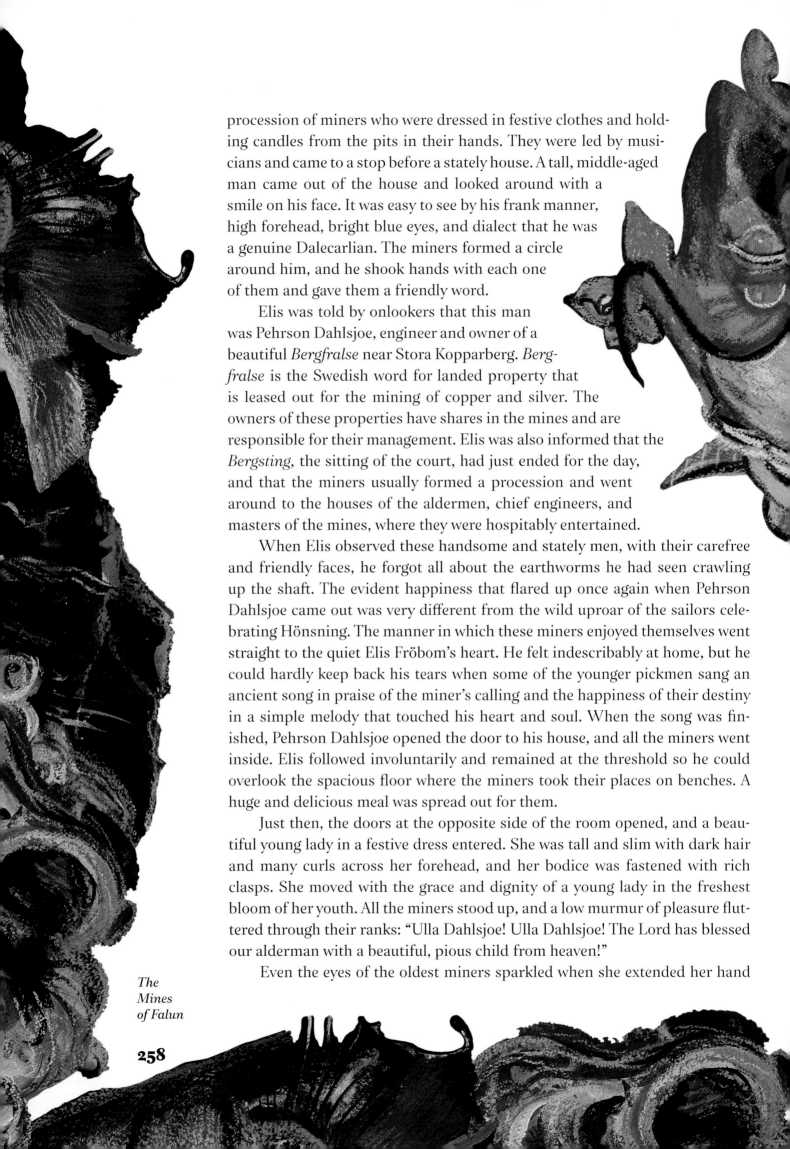

procession of miners who were dressed in festive clothes and holding candles from the pits in their hands. They were led by musicians and came to a stop before a stately house. A tall, middle-aged man came out of the house and looked around with a smile on his face. It was easy to see by his frank manner, high forehead, bright blue eyes, and dialect that he was a genuine Dalecarlian. The miners formed a circle around him, and he shook hands with each one of them and gave them a friendly word.

Elis was told by onlookers that this man was Pehrson Dahlsjoe, engineer and owner of a beautiful *Bergfralse* near Stora Kopparberg. *Bergfralse* is the Swedish word for landed property that is leased out for the mining of copper and silver. The owners of these properties have shares in the mines and are responsible for their management. Elis was also informed that the *Bergsting*, the sitting of the court, had just ended for the day, and that the miners usually formed a procession and went around to the houses of the aldermen, chief engineers, and masters of the mines, where they were hospitably entertained.

When Elis observed these handsome and stately men, with their carefree and friendly faces, he forgot all about the earthworms he had seen crawling up the shaft. The evident happiness that flared up once again when Pehrson Dahlsjoe came out was very different from the wild uproar of the sailors celebrating Hönsning. The manner in which these miners enjoyed themselves went straight to the quiet Elis Fröbom's heart. He felt indescribably at home, but he could hardly keep back his tears when some of the younger pickmen sang an ancient song in praise of the miner's calling and the happiness of their destiny in a simple melody that touched his heart and soul. When the song was finished, Pehrson Dahlsjoe opened the door to his house, and all the miners went inside. Elis followed involuntarily and remained at the threshold so he could overlook the spacious floor where the miners took their places on benches. A huge and delicious meal was spread out for them.

Just then, the doors at the opposite side of the room opened, and a beautiful young lady in a festive dress entered. She was tall and slim with dark hair and many curls across her forehead, and her bodice was fastened with rich clasps. She moved with the grace and dignity of a young lady in the freshest bloom of her youth. All the miners stood up, and a low murmur of pleasure fluttered through their ranks: "Ulla Dahlsjoe! Ulla Dahlsjoe! The Lord has blessed our alderman with a beautiful, pious child from heaven!"

Even the eyes of the oldest miners sparkled when she extended her hand

The Mines of Falun

258

in a kindly greeting, which she did with everyone there. Then she brought the beautiful silver mugs, filled them with splendid ale (the way it can only be done in Falun), and handed them to the guests with a face beaming all the time with innocent pleasure. As soon as Elis caught sight of her, it seemed as though a flash of lightning went through him and kindled all the heavenly bliss, longing for love, and passionate ardor that was locked within him. It was Ulla Dahlsjoe who had held out the hand of rescue to him in his wondrous dream. Now he thought he understood the profound meaning of that dream and thanked the stroke of fortune that had brought him to Falun, without remembering the role that the old miner had played in his destiny. Then, all of a sudden, Elis felt he was but an unknown stranger, wretched, hopeless, and desolate, and he wished he had left before encountering Ulla Dahlsjoe, for he sensed that he would now perish miserably out of love and longing. He could not take his eyes off the majestic maiden, and when she passed close to him, he pronounced her name in a low, trembling voice. Immediately, Ulla turned around and noticed poor Elis standing there with glowing red cheeks and downcast eyes. He was petrified and could not utter a word.

So, Ulla approached him and spoke to him with a sweet smile. "I suppose you are a stranger, my friend. I can tell that from your sailor's clothes. Now, tell me why you are standing at the door. Come inside and enjoy yourself with us."

Upon saying this, she took his hand, led him into the hall, and gave him a full tankard of beer.

"Drink," she said. "Drink, my dear friend, and may you feel welcome in our house!"

Elis felt as if he were in the blissful paradise of a glorious dream from which he would soon awaken and then fall into indescribable misery. So, he mechanically emptied the tankard that Ulla had given him, and just then, Pehrson Dahlsjoe came up to him, and after kindly shaking hands with Elis, he asked him where he came from and what had brought him to Falun. Elis felt the warming power of the noble beer in all his veins. As he looked straight into the eyes of the valiant Pehrson, he felt cheerful and courageous. Elis told him he was the son of a seaman and had been brought up on the sea since his childhood. Then, he explained that he had just returned from a journey to the East Indies and found that his mother, whom he had supported with his wages, had died. So, he was now alone in the world, and the wild life on the sea had become completely distasteful to him. Consequently, his deepest instincts had

led him to the mines of Falun, where he was going to try to find a job as miner. Everything he said was contrary to what he had recently decided. And yet, his words were spoken involuntarily. It was as if he could not have revealed anything but this to the alderman. Indeed, it was as if he expressed the most ardent desire of his soul, although he had not known it until that moment.

Pehrson Dahlsjoe looked earnestly at the young man, as if he wanted to read his heart, then said: "I sense, Elis Fröbom, that sheer fickleness isn't the only thing driving you from your former profession, and I hope that you have given serious thought to all the hardships and difficulties of a miner's life before making your decision to devote yourself to mining. There is an old belief among us that the powerful elements with which the miner has to deal, and which he must master, will destroy him unless he exerts himself entirely and learns to control them and put aside all other thoughts that weaken the vigor that he has to reserve wholly for his constant conflict with earth and fire. But if you have sufficiently tested the sincerity of your inner calling and protected it, then you have come at a good time. I need workers in my part of the mine. If you like, you can stay with me now, and tomorrow morning the mine inspector will take you down to the mines and show you what to do.

Elis felt his heart beating when he heard Pehrson Dahlsjoe's words. He was relieved, and no longer thought about the terror of the horrible abyss of hell that he had encountered. Instead, he was filled with rapture when he contemplated seeing the marvelous Ulla every day and living under the same roof with her. He now had the sweetest hopes for a different future.

Pehrson Dahlsjoe informed the miners that a young man had just arrived to work in the mines and introduced Elis to them. They all looked approvingly at the spry, well-built young man, and thought he was born to be a miner, especially when they regarded his strong arms and legs. Moreover, they felt he had the necessary zeal and devotion for the job. One of the miners, an elderly man, went up to him and cordially shook his hand. Then he told him that he was the head foreman in Pehrson Dahlsjoe's part of the mine and would be very glad to give him any help and instruction that he needed. Elis sat down beside this man, who took a mug of ale and began to describe in detail the kind of work all the miners had to do. Elis was reminded of the old miner whom he had met in

Göteborg, and strange to say, he knew almost everything the old man had to say and could repeat it.

"Ay!" the foreman cried in astonishment. "Where did you learn all this, Elis Fröbom? There's no doubt about it. You'll soon be the finest pickman in the mine."

The beautiful Ulla moved about among the guests and waited on them, often nodding in a friendly way to Elis and encouraging him to be happy about all this.

"Now, you are no longer a stranger, you know," she said, "but one of the household. You belong here and not on the treacherous sea. The rich mines of Falun are your home."

Heaven itself opened with bliss when he heard Ulla's words. It was clear that she liked to be near him, and Pehrson Dahlsjoe also observed his quiet earnestness with evident satisfaction.

Elis's heart beat fast when he stood once again by the smoking abyss of hell and went down the deep shaft with the foreman in a mining outfit and wearing heavy, iron-shod Dalecarlian shoes on his feet. Within a very short time, the hot vapors attacked his chest and sought to suffocate him. Then the candles flickered in the piercing gust of cold air that blew in the lower levels. They managed to continue and went down deeper and deeper on iron ladders scarcely a foot wide. Elis found that all his experience and dexterity climbing in the rigging of ships was of no use to him here. Finally, they reached the lowest depths of the mine, and the foreman showed him what work he was to do. Elis could think of nothing but the majestic Ulla, as though she were a radiant angel. Indeed, he saw her floating over him, and he forgot about all the terror of the abyss and the hardship of the arduous work. It was now eminently clear to him that if he worked in Pehrson Dahlsjoe's mine with all his mind and soul and with all the strength of which his body was capable, he could devote himself to mining and he could also fulfill his sweetest hopes. And so it happened that in an incredibly short time, Elis became as good a miner as the most experienced worker in the mine. Moreover, staunch Pehrson Dahlsjoe grew more and more fond of this industrious, pious young man and often bluntly declared that he found in him not only a wonderful miner but also a dear son. In addition, Ulla's deep regard for Elis became more and more apparent. Often, when Elis went to work and something dangerous was ahead, she would beg him, with tears in her eyes, to take care of himself. And then, when he returned from work, she would

The Mines of Falun

261

come running
cheerfully to meet
him and carry the finest ale with her as well as
some delicious meal so he could refresh himself.

Elis's heart trembled with joy when Pehrson Dahlsjoe said one time that, since he had brought a good amount of money with him, there could be no doubt that, given his industry and thrift, he would soon own a share in a mine or even become a mine owner. Consequently, the time would come when no mine owner in Falun would ever deny his request to wed his daughter. Elis should have immediately told him how absolutely he loved Ulla, and how all his hopes for happiness were based on her. But his insurmountable shyness, and his doubt about whether Ulla really loved him, even though he sometimes suspected she did, sealed his lips.

Now, one day, while Elis happened to be working in the deepest shaft of the mine, shrouded in thick, sulfur vapor, his candle shed only a feeble glimmer so he could hardly distinguish the different veins of the stones. Suddenly, he heard a knocking sound that came from some deeper shaft, as if somebody was working with a pick hammer. Since that kind of work was scarcely possible at such a depth, and since he knew nobody was down there that day except himself—the foreman had sent the other miners to work in another part of the mine—all this knocking and hammering struck him as very strange. Elis put down his tools and listened to the hollow sounds, which seemed to come nearer and nearer. All at once, he became aware of a black shadow right next to him, and when a blast of cold air blew away the sulfuric vapor, he recognized the old miner whom he had met in Göteborg.

"Good luck!" the old man cried. "Good luck, Elis Fröbom, down here among the stones! Tell me now, comrade, how do you like this life?"

Elis wanted to ask him how he had miraculously managed to work his way into this shaft, but the old miner kept striking his hammer with such force that the fire sparks went whirling all around and the shaft resounded with distant thunder. Then, the old miner shouted in a dreadful voice: "This is a wonderful trap vein, but a despicable, shabby scoundrel sees nothing but a narrow streak, not worth a blade of grass. Down here, you are a blind mole, and you'll always

The Mines of Falun

262

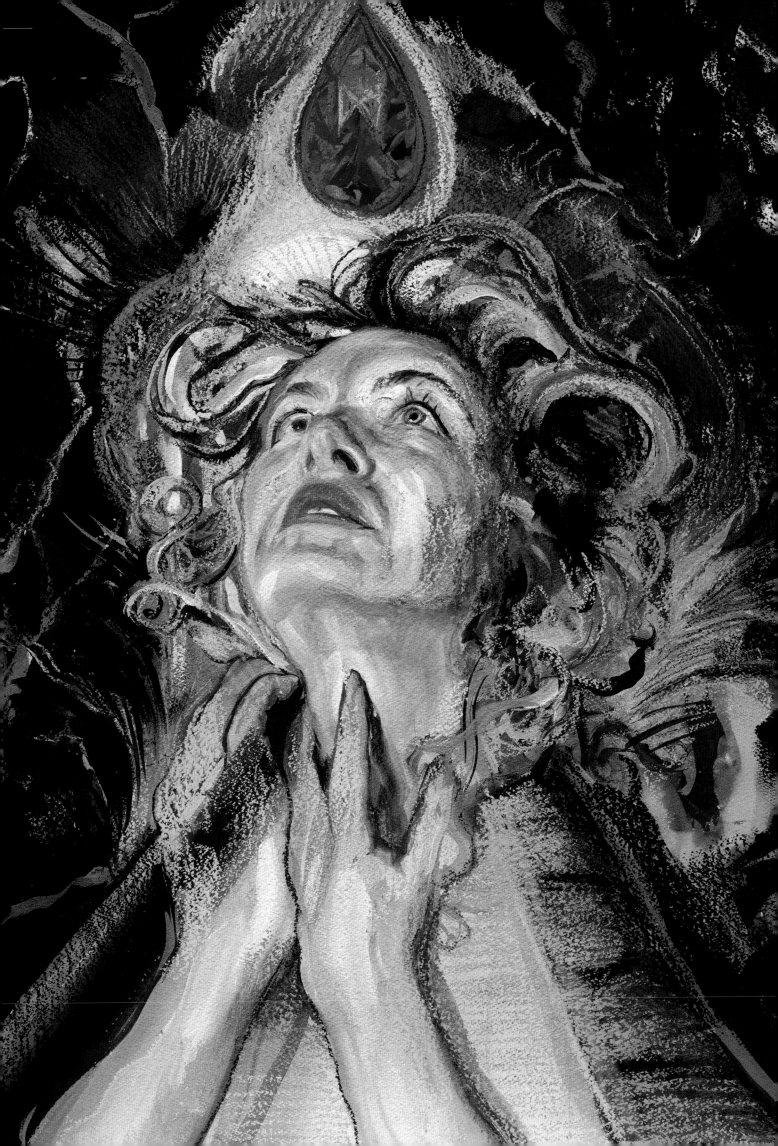

be a mere abomination to the Metal Prince. Up above, you are also worthless. No matter how you try to be the king and possess the pure stones, you never will! Hey! So, you want to wed Pehrson Dahlsjoe's daughter, Ulla, and this is the reason you're working down here, neither caring for your work, nor thinking about it? Well, be careful and mind what you're after, double-face, and make sure that the Metal Prince, whom you scorn, doesn't grab you and hurl you against the sharp rocks until all your bones are broken! And Ulla will never be your wife. That much I can tell you!"

Elis was enraged by the old man's disdainful words and cried: "What are you doing? What are you doing here in Herr Pehrson Dahlsjoe's shaft, where I am working as hard as I can and am following my profession? Get out of here the way you came, or we'll see who'll be the first to bash the other's brain to pieces!"

Upon saying these words, Elis stood defiantly in front of the old man and swung the iron hammer with which he had been working. The old man broke into a scornful laugh, and Elis watched with horror how he nimbly scampered, like a squirrel, up the narrow rings of the ladder and disappeared into the darkness. Elis felt as if his limbs were paralyzed, and he couldn't continue working. So, he climbed out of the shaft. When the foreman, who had been busy in another part of the mine, caught sight of him, he cried: "For Christ's sake, Elis, what has happened to you? You seem disturbed and look as pale as death. Right! I think it must be the sulfuric gas, which you're not accustomed to yet. Now, take a drink, my good fellow. This will do you good."

Elis took a swig of brandy from the flask that the foreman handed to him, and as soon as he felt better, he told him about everything that had happened in the shaft as well as how he had become acquainted with the strange old man in Göteborg. The foreman listened calmly, then shook his head dubiously and said: "Elis Fröbom, you must have encountered old Torbern, and now I see there really is something credible in the unusual tales that people here tell about him. More than one hundred years ago, there was a miner by the name of Torbern. People say he was one of the first to bring mining to Falun, so the city flourished, and in his day, the profits far exceeded anything we have now. Nobody at that time knew as much about mining as Torbern, who had great scientific knowledge and who thoroughly understood all the ins and outs of mining. The richest lodes seemed to reveal themselves to him, as if he had been

equipped with extraordinary powers. But since he was a gloomy, deep-thinking man, without wife or child, without his own home in Falun, and since he seldom came up to the surface and was constantly digging in the shafts, stories were spread about him that he had a compact with a secret power that dwells in the bowels of the earth and fuses the metals. Indeed, Torbern always predicted that some calamity would happen if the miners' impulse to work ceased to be a sincere devotion to the marvelous metals and ores, but the people of Falun disregarded his solemn warnings and continued to enlarge the excavations more and more for the sake of mere profit until, on St. John's Day of the year 1678, there was a terrible collapse of all the mines, which ended in the formation of our present, enormous main shaft and in the destruction of all the shafts that were in the process of being built. Only after many months of difficult labor were several of the shafts made workable again. Nothing was seen or heard of Torbern, the first to bring mining to Falun. There seemed to be no doubt that he had been working down below at the time of the catastrophe, so there could be no question as to what his fate had been. But not long after, and particularly when the work was beginning to improve, the miners started saying they had seen old Torbern in the mine, and that he had given them all kinds of good advice by pointing out rich lodes. Others came across him at the top of the main shaft, walking around, sometimes sadly lamenting, and sometimes angrily shouting. Other young miners have come here just as you have, saying that an old miner advised them to become miners and showed them the way to Falun. This often happened when there was a scarcity of workers. Very likely, it was Torbern's way of helping the miners. So, if you really exchanged angry words in the shaft with Torbern, and if he talked about a rich lode, no doubt there is a large vein of ore in that part of the mine. So, tomorrow we must try to trace it and find it. Of course, you remember that we call rich veins of this kind 'trap runs,' and a 'trum' is a vein that subdivides into various smaller veins and more than likely will break up."

Rattled by his thoughts, Elis Fröbom entered Pehrson Dahlsjoe's home later, but Ulla did not greet him as usual with a friendly smile. Instead, she was sitting with a downcast gaze and seemed to have been weeping. Beside her was a handsome young man, holding her hand in his and trying to entertain her with all sorts of friendly and amusing things. But she appeared to pay

little attention. Elis stared at the couple and was seized by a horrid premonition until Pehrson Dahlsjoe took him into another room and said: "Well then, Elis Fröbom, you will soon be able to prove your love and faithfulness to me. I have always looked upon you as my son, and soon you will really become my son entirely. The man, whom you see over there is the wealthy merchant Eric Olavsen from Göteborg. I have granted him permission to wed my daughter. He will take her to Göteborg, then you will remain alone here with me, my only support in my old age. Why don't you say something? You look pale. I hope my decision doesn't displease you and that you, too, won't leave me now that my daughter must depart. But, listen, I hear Olavsen calling my name. I must go."

After saying that he went back into the room.

Elis's heart felt torn to pieces by a thousand blazing red-hot knives. He couldn't speak. He couldn't weep. He ran out of the house in wild despair. He ran straight to the large mine shaft. If the monstrous chasm was terrifying by daylight, it was much more awful now that night had fallen and the moon was rising. The desolate crags looked like an infinite horde of horrible monsters, the dreadful brood of hell, rolling and writhing in wildest confusion. They were all around its reeking sides and clefts and flashed fiery eyes and glowing claws to clutch poor human beings.

"Torbern! Torbern!" Elis screamed in a desolate voice that echoed throughout the shaft. "Here I am, Torbern! You were right. I am crooked, and I had foolish hopes to do well on the earth's surface. But my true treasure, my life, all lies here below the earth, Torbern! Take me down with you! Show me the richest veins, the lodes of ore, the glowing metal. I shall dig and bore and toil. Never, never will I return to see the light of day. Torbern, Torbern, take me down with you!"

Elis took his flint and steel from his pocket, lit his lamp, and descended to the shaft where he'd been working, but the old man did not appear. Yet, at the deepest point in the shaft, he noticed a vein of metal with such utmost clarity that he could trace every one of its streaks and faults. So, as he looked more and more closely at the wonderful vein in the rock, a dazzling light seemed to come shining through the shaft, and the walls of rock grew as transparent as pure crystal. The disastrous dream that had tormented Elis in Göteborg came back to him. He gazed upon heavenly fields, where lovely, metallic trees and plants grew along with fruit and flowers as well as precious stones streaming

with fire. He saw the maidens and gazed into the face of the powerful queen. She grabbed hold of him, drew him to her, and pressed him to her breast. Then, a glowing ray flashed through his heart, and he was only conscious of floating in waves of some blue, transparent mist.

"Elis Fröbom! Elis Fröbom!" cried out a strong voice from above, and the reflections of torches began shining in the shaft. It was Pehrson Dahlsjoe, who had come with the foreman to the mine to search for Elis, who had been seen running like a madman in the direction of the main shaft. They found him standing as if he had been frozen, with his face pressed to the cold, hard rock.

"What are you doing here at nighttime, you rash young man?" Pehrson yelled. "Pull yourself together and come up with us. Who knows what good news you may hear?"

In deep silence, Elis followed Pehrson Dahlsjoe, who did not stop scolding him for exposing himself to such danger. The sun had already risen by the time they arrived at the house. Ulla threw herself onto Elis's chest with a loud cry and called him by the sweetest names, while Pehrson Dahlsjoe cried out: "You fool! Do you suppose that I haven't known for a long time that you love Ulla, and probably wouldn't have worked so energetically and so hard in the mine, if it weren't for her sake? Do you think I hadn't noticed that Ulla loves you with all her heart? Could I not wish for a better son-in-law than a brave, hardworking, and honest miner than you, my good Elis? But your silence annoyed and vexed me!"

"We scarcely knew ourselves," Ulla said, interrupting her father. "We weren't aware how fond we were of each other."

"No matter how that may be," Pehrson Dahlsjoe continued, "I was annoyed that Elis was not open and honest about his love for you, and did not speak to me about it. This is the reason—and also because I wanted to test him. So, I invented the fairy tale about Eric Olavsen, which soon brought you to your senses. You foolish man! Eric Olavsen has been married for a long time, and as far as you are concerned, my good Elis Fröbom, I give my daughter to you, and I shall say it again, I couldn't wish for a better son-in-law."

Tears of joy ran down Elis's cheeks. He had not expected so much bliss. Indeed, he could scarcely believe it was anything but a sweet dream! Now Pehrson Dahlsjoe invited all the miners to a noon meal to celebrate this event. Ulla put on her most gorgeous dress and looked lovelier than ever so that all the guests shouted altogether: "Ey! What a lovely bride our good Elis Fröbom has won! Now may

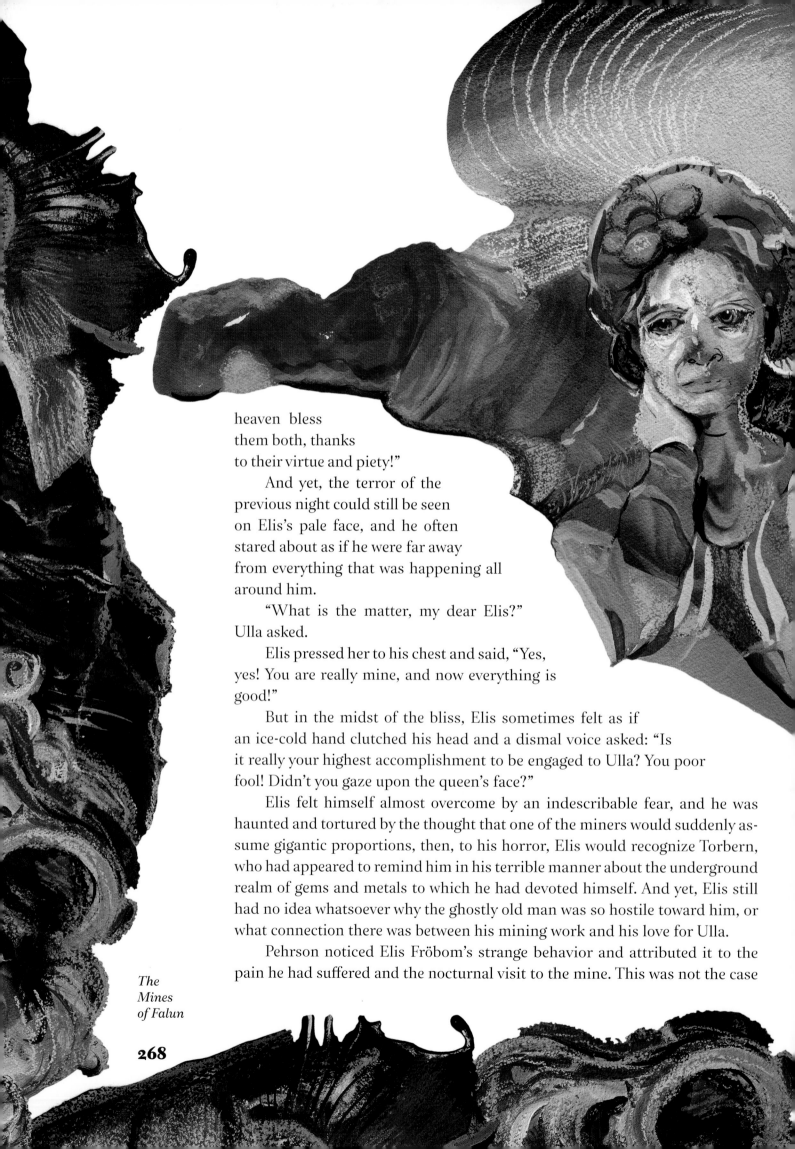

heaven bless
them both, thanks
to their virtue and piety!"

And yet, the terror of the
previous night could still be seen
on Elis's pale face, and he often
stared about as if he were far away
from everything that was happening all
around him.

"What is the matter, my dear Elis?"
Ulla asked.

Elis pressed her to his chest and said, "Yes,
yes! You are really mine, and now everything is
good!"

But in the midst of the bliss, Elis sometimes felt as if
an ice-cold hand clutched his head and a dismal voice asked: "Is
it really your highest accomplishment to be engaged to Ulla? You poor
fool! Didn't you gaze upon the queen's face?"

Elis felt himself almost overcome by an indescribable fear, and he was
haunted and tortured by the thought that one of the miners would suddenly as-
sume gigantic proportions, then, to his horror, Elis would recognize Torbern,
who had appeared to remind him in his terrible manner about the underground
realm of gems and metals to which he had devoted himself. And yet, Elis still
had no idea whatsoever why the ghostly old man was so hostile toward him, or
what connection there was between his mining work and his love for Ulla.

Pehrson noticed Elis Fröbom's strange behavior and attributed it to the
pain he had suffered and the nocturnal visit to the mine. This was not the case

The
Mines
of Falun

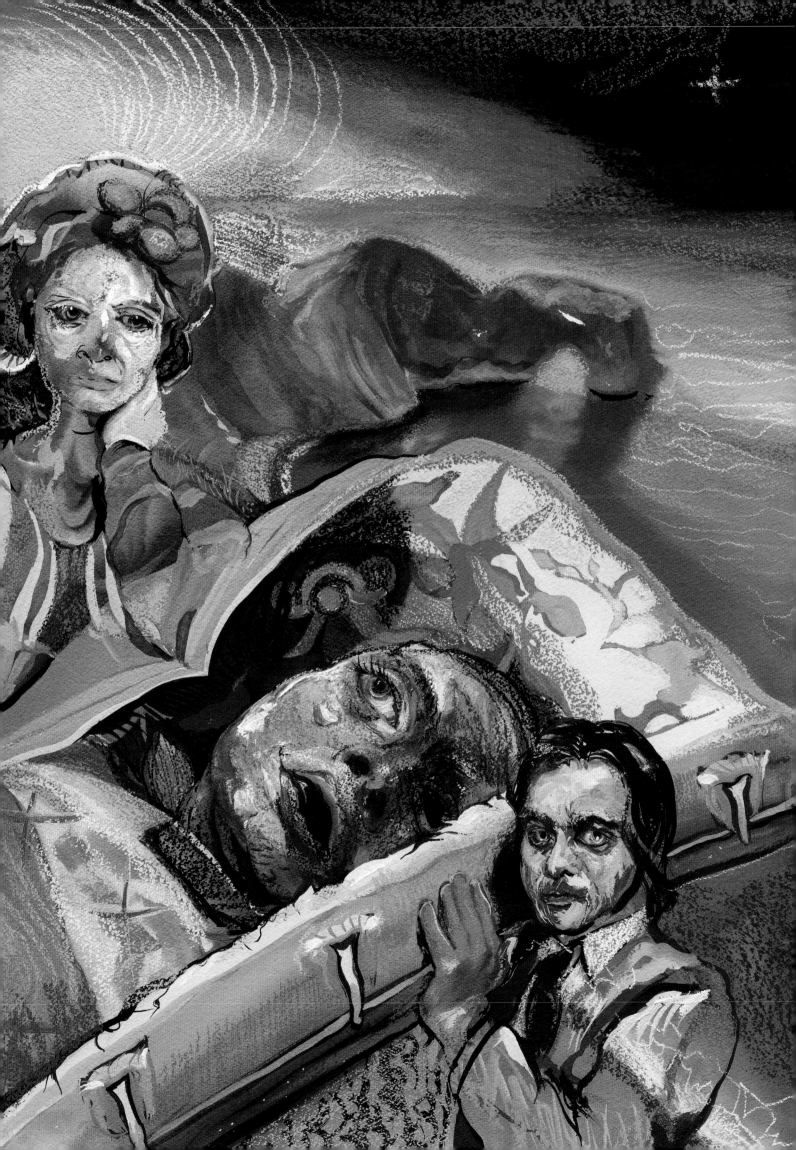

with Ulla, who was bothered by a secret dread and pressed him to tell her what terrible thing had happened that cut him off from her so completely. All this almost broke his heart, and he tried vainly to tell his dearest Ulla about the marvelous face that had revealed itself to him in the depths of the mine. It was as if an unknown power was forcibly sealing his mouth, and as if the terrible face of the queen were looking out from his heart so that, if he were to mention her name, it would be like catching sight of Medusa's horrific face, and everything about him would turn to stone and to dark black rock. All the magnificence and glory that had filled him with great ecstasy deep in the mine seemed now to be a hell of inconsolable torture, deceptively embellished to allure him to his ruin.

Pehrson Dahlsjoe told Elis he must stay home a few days so he could recuperate from the sickness from which he seemed to be suffering. During this time, Ulla's affection, which now streamed bright and clear from her childlike, pious heart, drove away the memory of his fateful adventure in the shaft of the mine. Elis revived completely in this atmosphere of joy, and he again believed that his happiness could not be destroyed by any evil power.

When he went down in the mine again, everything appeared quite different from what it had been. The glorious veins lay right before his eyes, and he worked with twice as much vigor as before. Indeed, he forgot everything. When he returned to the surface, he had to force himself to remember Pehrson Dahlsjoe or even Ulla. He felt as if he had been cut in two, as if his better self, his real self, remained down in the depths of the earth, resting in the arms of the queen, while in Falun, the other half dwelled in a gloomy atmosphere. When Ulla spoke of their love and the happiness of their future life together, he would talk about the splendors of the mines, and the innumerable, precious treasures that lay hidden there. As he talked, he became desperate and so incomprehensible that poor Ulla became alarmed and anxious, for she could not determine how Elis had become so different from his former self.

When Elis worked in the mine, he would call the foreman and Pehrson Dahlsjoe himself with great pleasure and tell them that he had discovered the richest veins and most magnificent seams, and when they turned out to be nothing but barren rock, he would laugh contemptuously and declare that only he understood the secret signs, the significant writing with hidden meaning that the queen's own hand had inscribed on the rocks, and that it was sufficient

to understand those signs without making clear what the meaning was. The old foreman looked sorrowfully at Elis, who spoke with wild, gleaming eyes about the glorious paradise that glowed down in the womb of the earth.

"That terrible old Torbern has been at him," he whispered in Pehrson Dahlsjoe's ear.

"Not at all! Not at all! Don't believe those yarns that the miners tell," responded Pehrson Dahlsjoe. "Elis is a deep-thinking, serious fellow, and love has turned his head. That's all. Wait until the wedding is over. Then we'll hear no more about rich seams, veins, treasures, and an underground paradise."

At last, the wedding day set by Pehrson Dahlsjoe arrived. Elis had been quiet—more serious, deeper in thought than previously. Yet, on the other hand, he showed more affection for Ulla than ever before. He didn't leave her side for a moment and didn't go down the mine shafts at all. He seemed to have forgotten all about his restless excitement about working in the mine. He also didn't allow a word about an underground realm to cross his lips. Ulla was all rapture. Her fear that Elis might succumb to the dangerous powers of the underground world had left her. She was no longer afraid about the miners' stories or that Elis might be lured to his death. Also, Pehrson Dahlsjoe said to the foreman, laughing: "You see, Elis Fröbom had become dizzy in his head out of love for my Ulla!"

Early on the morning of the wedding day, which happened to be St. John's Day, Elis knocked on the door of Ulla's room. When she opened, it, she jumped backward, terrified at the sight of Elis, already dressed in his wedding clothes, deadly pale, with dark and flaming eyes.

"I only want to tell you, my beloved Ulla," he said in a faint, trembling voice, "that we are standing on the brink of the greatest happiness that humans can experience on earth. It was all revealed to me last night. Down in the depths below, hidden in chlorite and mica, there's a cherry-colored sparkling almandine on which our lifelines are engraved. I want to give it to you as a wedding present, because it is more splendid than the most glorious blood-red carbuncle. When we are united in true love and look into its steaming splendor together, we shall see and understand the particular manner in which our hearts and souls have grown together into the wonderful branch that shoots from the queen's heart at the center of the world. Now I must go and bring this stone to the surface of the earth, and I am going to do this as fast as I can.

The Mines of Falun

271

Meanwhile, take care of yourself, my beloved. I shall return to you very soon."

Ulla implored him with bitter tears to give up any idea of such a dreamlike undertaking, for she felt a strong inkling that this would lead to disaster. But Elis declared he would never know a moment's peace or happiness without this stone, and there wasn't a danger of any kind. Then, he embraced her fervently and departed.

Now, the guests were already assembled to accompany the bridal pair to the church of Kopparberg, where Ulla and Elis were to be married, and a crowd of girls who were to be bridesmaids and to walk in the procession before the bride, as was the custom of the country, were laughing and having fun with Ulla. The musicians were tuning their instruments to begin a wedding march. It was almost noon, and Elis had yet to make his appearance. Suddenly, some miners rushed up to the gathering with horror in their pale faces. Indeed, there had been a terrible catastrophe that had destroyed Pehrson Dahlsjoe's entire part of the mine.

"Oh, Elis! My, Elis! You are gone!" screamed Ulla wildly, falling to the ground as if she were dead. Then, Pehrson Dahlsjoe learned for the first time from the foreman that Elis had gone down the main shaft that morning. Nobody else had been in the mine, since all the miners had been invited to the wedding. Dahlsjoe and all the others, without caring for their own lives, rushed to search for Elis. However, it was all in vain! Elis Fröbom was not to be found. There was no doubt that the landslide had buried him in the mine. So, misery and mourning swept over the house of the good Pehrson Dahlsjoe, just at the moment that he thought he would be assured of peace and happiness for the remainder of his days.

Many years passed, and the intrepid mine owner Pehrson Dahlsjoe had long since been dead. His daughter, Ulla, had disappeared and was forgotten. Nobody in Falun remembered them. Fifty years had gone by since Elis Fröbom's unlucky wedding day, and it so happened that some miners were making a connection between the passages of two shafts. When they reached three hundred yards, they found the body of a young miner buried in vitriolized water. When they brought it to daylight, it turned to stone. The young man looked as if he were lying in a deep sleep, so perfectly preserved were the features of his face. Also, his new suit of miner's clothes were without a trace of decay, as were the flowers in his buttonhole. The people in the neighborhood gathered around

the young man, but no one recognized him or could say who he was, and none of the workers were missing. The body was about to be taken to Falun, when an old woman appeared in the distance, walking painfully and slowly on crutches.

"Here's the old St. John's grandmother!" the miners cried out. They had given her this name because she appeared at the main shaft every year on St. John's Day. Then, she would look down into the depths, weeping, lamenting, and wringing her hands as she walked around the abyss before leaving. However, the moment she saw the body, she threw away her crutches, lifted her arms to heaven, and cried in the most heartrending tones of deepest sorrow.

"Oh! Elis Fröbom! Oh, my sweet, sweet bridegroom!"

She kneeled down beside the body, took the stony hands, and pressed them to her heart, chilled with age, but throbbing still with the fondest love, like some naphtha flame under the icy surface.

"Ah!" she cried, looking around at the spectators. "Nobody, nobody among you can remember poor Ulla Dahlsjoe, this poor boy's happy bride fifty long years ago. When I went away in my terrible sorrow and despair to Ornäs, old Torbern comforted me and told me I would see my poor Elis, who had been buried in the landslide on our wedding day, yet once more on this earth. And I have come here every year and looked for him out of longing and faithful love. And now, this blessed meeting has been granted to me on this day. Oh, Elis! My beloved husband!"

Then, Ulla embraced Elis as if she would never part from him again, and all the people stood around deeply moved by the old woman. Her sobs and sighs grew fainter and fainter, until they ceased to be audible. The miners moved closer to her and would have helped her stand. However, she had breathed her last breath on her bridegroom's body, which was beginning to crumble into dust. The appearance of petrification had been deceptive. In the Kopparberg church, where they were to be married fifty years before this, his ashes were laid to rest, and with them, the body of the bride who had been faithful to him until her bitter death.

BIBLIOGRAPHY

E.T.A. Hoffmann's Works in German

For the best contemporary collected edition in German, see:

Sämtliche Werke in 6 Einzelbänden. Ed. Walter Müller-Seidel, Friedrich Schnapp, et al. Munich: Winkler, 1960-81.

Selected Works in English

There is no single edition in English of Hoffmann's *Fantasy Pieces, The Serapion Brothers,* or *Night Pieces.* However, the following collections include most of the more important tales published by Hoffmann during his lifetime. The translations vary in quality.

Bleiler, Everett Franklin, ed. *The Best Tales of Hoffmann.* New York: Dover, 1967.
Bullock, Michael, ed. and trans. *The Tales of Hoffmann.* New York: Ungar, 1963.
Cohen, J. M., ed. and trans. *Tales from Hoffmann.* London: The Bodley Head, 1951.
Hollingdale, R. J., ed. *Tales of Hoffmann.* Harmondsworth, Middlesex, England: Penguin, 1982.
Kent, Leonard J., and Elizabeth C. Knight, eds. and trans. *Tales of E.T.A. Hoffmann.* Chicago: University of Chicago Press, 1972.
Kirkup, James, trans. *Tales of Hoffmann.* London: Blackie, 1966.
Lange, Victor, ed. *E.T.A. Hoffmann: Tales.* New York: Continuum, 1982.
Lazare, Christopher, ed. and trans. *Tales of Hoffmann.* New York: Wyn, 1946.
Robertson, Ritchie, ed. and trans. *The Golden Pot and Other Tales.* Oxford: Oxford University Press, 1992.

Secondary Works

Beardsley, Christa-Maria. *E.T.A. Hoffmann: Die Gestalt des Meisters in seinen Märchen.* Bonn: Bouvier, 1975.
Blamires, David. "E.T.A. Hoffmann's Nutcracker and Mouse King." In *Telling Tales: The Impact of Germany on English Children's Books, 1780-1918,* 223-44. Cambridge: Open Book Publishers, 2009.
Brown, Hilda Meldrum. *E.T.A. Hoffmann and the Serapiontic Principle: Critique and Creativity.* Rochester, NY: Camden House, 2006.

Daemmrich, Horst. *The Shattered Self: E.T.A. Hoffmann's Tragic Vision*. Detroit: Wayne State University Press, 1974.

Elardo, Ronald J. "E.T.A. Hoffmann's 'Nussknacker und Mausekönig': The Mouse-Queen in the Tragedy of the Hero." *Germanic Review* 55 (1980): 1-8.

Ewers, Hans-Heino. "Nachwort." In C. W. Contessa, Friedrich Baron de la Motte Fouqué, and E.T.A. Hoffmann, *Kinder-Märchen*, edited by Hans-Heino Ewers, 327-50. Stuttgart: Reclam, 1987.

Fischer, Jennifer. *"Nutcracker" Nation: How an Old World Ballet Became a Christmas Tradition in the New World*. New Haven: Yale University Press, 2003.

Frank, Arthur W. *The Wounded Storyteller: Body, Illness, and Ethics*. Chicago: University of Chicago Press, 1995.

Günzel, Klaus, ed. *E.T.A. Hoffmann: Leben und Werk in Briefen, Selbstzeugnissen und Zeitdokumenten*. Berlin: Verlag der Nation, 1976.

Heintz, Günter. "Mechanik und Phantasie: Zu E.T.A. Hoffmanns Märchen 'Nußknacker und Mausekönig.'" *Literatur in Wissenschaft und Unterricht* 7 (1974): 1-15.

Hewett-Thayer, Harvey W. *Hoffmann: Author of the Tales*. Princeton: Princeton University Press, 1948.

Kleßmann, Eckart. *E.T.A. Hoffmann oder die Tiefe zwischen Stern und Erde*. Stuttgart: Deutsche Verlags-Anstalt, 1988.

Mainland, W. F., ed. *Der goldene Topf: Ein Märchen aus der neuen Zeit*. Oxford: Blackwell, 1967.

McGlathery, James. *Mysticism and Sexuality: E.T.A. Hoffmann*, 2 vols. Frankfurt: 1981-85.

Negus, Kenneth. *E.T.A. Hoffmann's Other World: The Romantic Author and His "New Mythology."* Philadelphia: University of Pennsylvania Press, 1965.

Purcell, Elizabeth. "The Crisis of Subjectivity: The Significance of *Darstellung* and Freedom in E.T.A. Hoffmann's 'The Sandman.'" *Philosophy and Literature* 40, no. 1 (April 2016): 44-58.

Robertson, Ritchie, ed. and trans. "Introduction." In *The Golden Pot and Other Tales*, vii-xxxii. Oxford: Oxford University Press, 1992.

Safranski, Rüdiger. *E.T.A. Hoffmann: Das Leben eines skeptischen Phantasten*. Munich: Hanser, 1984.

Schönfelder, Christa. *Wounds and Words: Childhood and Family Trauma in Romantic and Postmodern Fiction*. Bielefeld, Germany: Transcript Verlag, 2013.

Scullion, Val, and Marion Treby. "The Romantic Context of E.T.A. Hoffmann's Fairy Tales, *The Golden Pot*, *The Strange Child*, and *The Nutcracker and the Mouse King*." *English Language and Literature Studies* 10, no. 2 (2020): 40-52.

Steinecke, Hartmut. *Die Kunst der Fantasie: E.T.A. Hoffmanns Leben und Werke*. Frankfurt: Insel Verlag, 2004.

Wiley, Roland John. *Tchaikovsky's Ballets: Swan Lake, Sleeping Beauty, Nutcracker*. Oxford: Clarendon, 1985.

Wittkop-Ménardeau, Gabrielle. *E.T.A. Hoffmann: Mit Selbstzeugnissen und Bilddokumenten*. 2nd ed. Hamburg: Rowohlt, 1992.

Wright, Elizabeth. *E.T.A. Hoffmann and the Rhetoric of Terror: Aspects of Language Used for the Evocation of Fear*. London: University of London, 1978.

ABOUT THE CONTRIBUTORS

Natalie Frank (b. 1980) is an interdisciplinary artist whose drawings, paintings, and work in performance design focus on the intersection of sexuality and violence in feminist portraiture. Her publications include *The Island of Happiness* (2021), *O* (2018), *The Sorcerer's Apprentice* (2017), and *Tales of the Brothers Grimm* (2015). In 2019, Frank served as artistic director of *Grimm Tales*, a production staged by Ballet Austin, in which she collaborated with artists on producing sets, costumes, animations, and textile designs. In 2021, PBS premiered *Jarful of Bees*, a newly commissioned opera incorporating Frank's drawings, composed by Paola Prestini and starring Met Opera soprano Eve Gigliotti. Her drawing survey show, *Unbound*, appeared at the Kemper Museum of Contemporary Art, Missouri, in 2021-22. Frank is a Fulbright Scholar and holds a BA from Yale University and an MFA from Columbia University School of the Arts.

Jack Zipes is Professor Emeritus of German and comparative literature at the University of Minnesota. He has published widely on folk and fairy tales, and some of his most recent publications include Felix Salten's *Original Bambi: The Story of a Life in the Forest* (2022), Rolf Brandt's *Haunting and Hilarious Fairy Tales* (2022), Gower Wilson's *Green, Silver, and Red Tales* (2023), and a collection of essays, *Buried Treasures: The Power of Political Fairy Tales* (2023).

Karen Russell is the author of three story collections, most recently *Orange World and Other Stories* (2019), the novella *Sleep Donation* (2014), and the novel *Swamplandia!* (2011), the winner of the New York Public Library Young Lions Fiction Award and a finalist for the Pulitzer Prize. She has received a MacArthur Fellowship and a Guggenheim Fellowship, the Bard Fiction Prize, and a Shirley Jackson Award. Born and raised in Miami, she now lives in Portland, Oregon, with her family.

Marian Bantjes is an internationally known Canadian graphic artist and designer. An extensive monograph of her work, *Pretty Pictures*, was published by Thames & Hudson in 2013. She is a member of Alliance Graphique International.

ABOUT THE BOOK

The book's design and typesetting is by
Marian Bantjes.

The text is set in Afterall,
a typeface designed by Henrik Kubel of
A2/SW/HK + A2-TYPE.

Color separations are by
Prographics, Rockford, Illinois.

Printing and binding are by
1010 Printing International Limited
in China.

The paper is 140gsm Oji Top Kote
Matt Art Paper.

The drawings by Natalie Frank are
gouache and chalk pastel on Arches
paper and measure 30 x 22 inches.

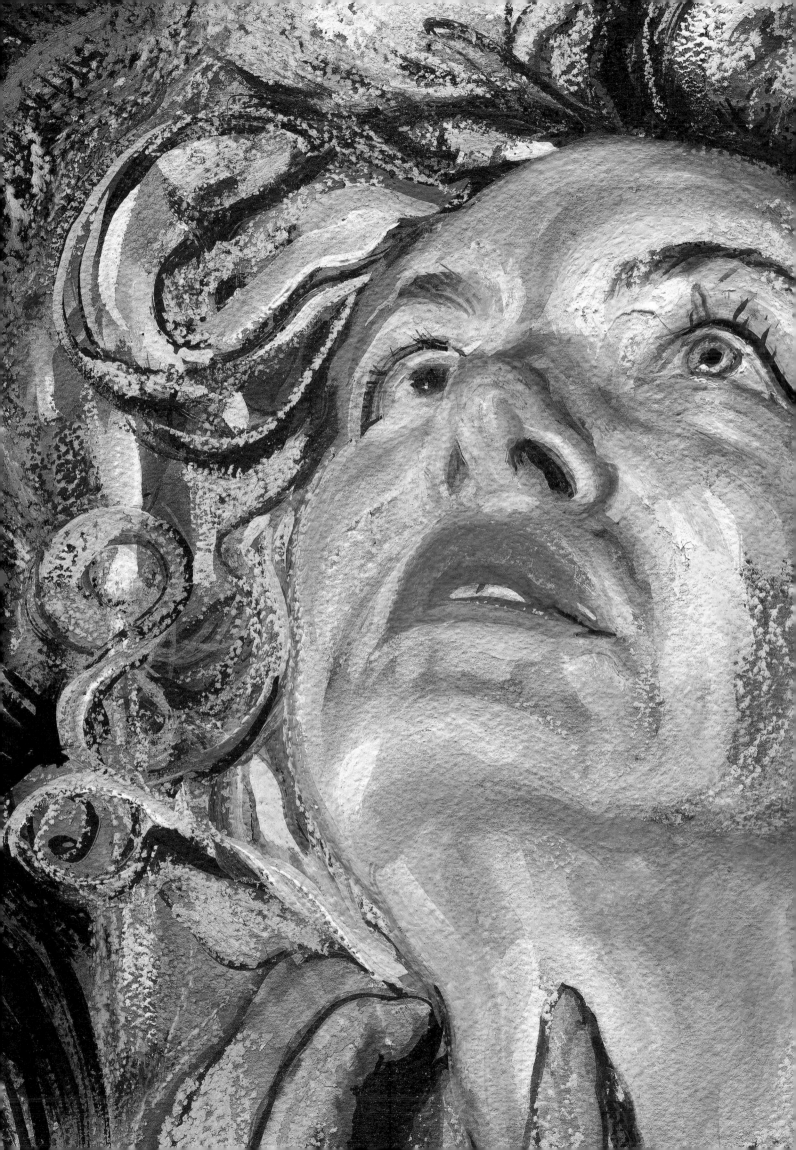